Monet's London

ARTISTS' REFLECTIONS ON THE THAMES

1859 – 1914

Monet's London

ARTISTS' REFLECTIONS ON THE THAMES
1859 – 1914

Essays by

John House

Petra ten-Doesschate Chu

Jennifer Hardin

Museum of Fine Arts, St. Petersburg, Florida

This catalogue was published in conjunction with the exhibition

Monet's London

ARTISTS' REFLECTIONS ON THE THAMES
1859 – 1914

Museum of Fine Arts, St. Petersburg, Florida
16 January – 24 April 2005

Brooklyn Museum of Art
27 May – 4 September 2005

The Baltimore Museum of Art
2 October 2005 – 31 December 2005

Co-published by the Museum of Fine Arts, St. Petersburg,
Florida, and Snoeck Publishers, Ghent, Belgium.
All rights reserved. No portion of this publication may
be reproduced without written permission.

Coordination for the catalogue
Museum of Fine Arts, St. Petersburg, Florida

Project Managers
Diane Freedland and Robin O'Dell

Production Coordination
Thomas U. Gessler and Thaddeus Root

Editing
Denise Bergman

Design
Ashted Dastor, Typearea Limited, London

Printing
Snoeck-Ducaju & Zoon, Ghent, Belgium

Exhibition Coordination
Lisa McVicker and Louise Reeves

Library of Congress Cataloging-in-Publication Data

*Monet's London: Artists' Reflections
on the Thames, 1859–1914*
Catalogue of an exhibition organized by the
Museum of Fine Arts, St. Petersburg, Florida,
and curated by Jennifer Hardin.
ISBN 1-878390-07-4 (Museum of Fine Arts)
ISBN 90-5349-545-2 (Snoeck Publishers)
Legal Deposit D/2004/0012/37

Image credits

Page 14, from cat. 37:
Claude Monet (French, 1840–1926)
Houses of Parliament, Effect of Fog, 1904
Museum of Fine Arts, St. Petersburg, Florida

Page 38, from cat. 10:
André Derain (French, 1880–1954)
View of the Thames, 1906
National Gallery of Art, Washington, D.C.

Page 106, from cat. 109:
James McNeill Whistler (American, 1834–1903)
Nocturne: The River at Battersea, 1878
S. P. Avery Collection, Miriam and Ira D. Wallach Division of Art,
Prints and Photographs; The New York Public Library, Astor, Lenox,
and Tilden Foundations

Page 166, from cat. 42:
Joseph Pennell (American, 1857–1926)
The Obelisk, c. 1910
Prints and Photographs Division, Library of Congress, Washington, D.C.

This exhibition is supported by the Focardi Family in honor of Claude C. Focardi;
the Stuart Society of the MFA; Indemnity from the Federal Council on the Arts and
the Humanities; the St. Petersburg / Clearwater Area Convention and Visitors
Bureau; WEDU; Bright House Networks; SunTrust; DEX Imaging; Ruth Eckerd Hall;
RBC Dain Rauscher; the Pinellas County Arts Council; the City of St. Petersburg; the
State of Florida, Department of State, Division of Cultural Affairs; the Florida Arts
Council; St. Petersburg Women's Chamber of Commerce; and the National Endow-
ment for the Arts. Media sponsor: *St. Petersburg Times.* Official host hotel: Renais-
sance Vinoy Resort & Golf Club.

Fortieth Anniversary presenting sponsor: Progress Energy.

The Museum of Fine Arts, St. Petersburg, Florida, is fully accredited by the American
Association of Museums.

Contents

Lenders to the Exhibition

The Baltimore Museum of Art

Brooklyn Museum of Art

Carnegie Museum of Art, Pittsburgh

Chrysler Museum of Art, Norfolk, Virginia

The Cleveland Museum of Art

Corcoran Gallery of Art, Washington, D.C.

George Eastman House International Museum of
 Photography and Film, Rochester, New York

Guildhall Art Gallery, London

Guildhall Library, Corporation of London

High Museum of Art, Atlanta

Hirshhorn Museum and Sculpture Garden,
 Smithsonian Institution, Washington, D.C.

Library of Congress, Washington, D.C.

The Metropolitan Museum of Art, New York

Mississippi Museum of Art, Jackson

Musée d'Art moderne, Troyes, France

Musée Marmottan-Monet, Paris

Museum of Art, Rhode Island School of
 Design, Providence

Museum of Fine Arts, Boston

Museum of Fine Arts, St. Petersburg, Florida

Museum of London

The Museum of Modern Art, New York

National Gallery, London

National Gallery of Art, Washington, D.C.

National Museum of Photography, Film, &
 Television, Bradford, England

The New York Public Library

Philadelphia Museum of Art

Private collections

The Saint Louis Art Museum

Spanierman Gallery, LLC, New York

Victoria and Albert Museum, London

Wakefield Art Gallery, Wakefield, England

Walker Art Gallery, Liverpool

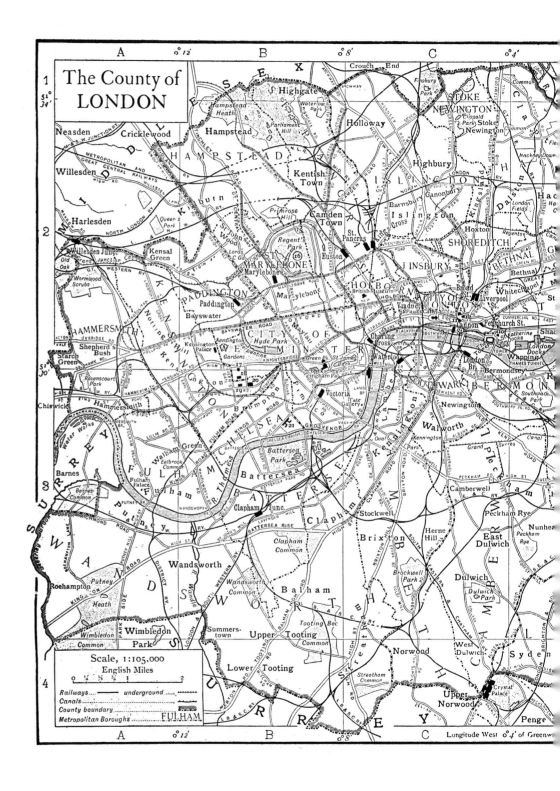

"London," *Encyclopedia Britannica*, 1911 ed.

Director's Foreword

I n honor of our 40th anniversary, the Museum of Fine Arts has organized exhibitions for 2005 that highlight stellar works in our collection. We begin with one of the great paintings in the Museum and one of our public's favorites, Claude Monet's *Houses of Parliament, Effect of Fog.*

In this exhibition, we reunite paintings of London by Monet, including some canvases that, along with ours, were in his celebrated 1904 exhibition at the Durand-Ruel Gallery in Paris. As importantly, we compare them to works by other artists of the period who treated the same themes in very different ways and in different media. Although exhibitions on artists' images of London have been held in that city over the years, this is the first time an American museum has treated this theme in such a broad context. The only related American exhibition, *Monet in London*, at the High Museum in 1988, focused solely on paintings by Monet.

As our authors point out so elegantly in this catalogue, London was a vibrant economic center in the nineteenth century and a magnet for artists seeking inspiration as well as sales of their work. Monet was one of a number of well-known, and less-well-known, artists drawn to that city. London fascinated the American expatriate James McNeill Whistler, whose *Thames Set* of 1859–61 became one of the period's most influential series of prints and the chronological starting point for this exhibition. Whistler's work in London encouraged other artists, including Monet, to cross the Channel, just as Monet's successful 1904 exhibition enticed Paris dealer Ambroise Vollard to send André Derain to paint a more avant-garde series of London views.

All of the works in the exhibition focus on the Thames at London, but they represent a wide range of modernist tendencies—impressionism, neo-impressionism, fauvism—as well as the more traditional academic, naturalist, and topographic views of the River. We have included paintings, watercolors, drawings, photographs, and a large number of prints, which brought the sights of London to the attention of an even greater audience. Overall, one isstruck by the sheer beauty of the art on display. Together,these works capture a sense of place—sometimes familiar, sometimes not—and a sense of time.

Although Monet's work is at the center of the exhibition, the Thames and London inspired some of the most gifted artists of the period. We hope visitors will share our delight in works by Monet's compatriots, such as Tissot, Le Sidaner, Bastien-Lepage, and Derain, and by American artists such as Hassam and Coburn. Some of these are rare subjects for artists like Pissaro, Daubigny, and Homer. We also hope that this exhibition will bring the viewer new discoveries by fine American artists, such as Pennell, Addams, and Bertha Jaques, who deserve to be reconsidered, as do numerous British artists, who remain relatively unknown to the American public. Indeed, it was British artist David Roberts who began the whole idea of painting a Thames series, and who set the stage for Whistler's and Monet's more progressive imagery.

We are deeply indebted to the directors, curators, registrars, and staff of the lending institutions in Europe and the United States, and to the private collectors, for their generosity in sharing so many of their prestigious works of art with a very grateful public. Doreen Bolger, Director of the Baltimore Museum of Art, and Arnold L. Lehman, Director of the Brooklyn Museum of Art, have been wonderful and dedicated partners in this project. The following colleagues and key staff at lending institutions have greatly aided us: Jay Fisher, Melanie Harwood, and Sarah Sellers at the Baltimore Museum of Art; Kevin Stayton, Judith Dolkart, and Liz Reynolds at the Brooklyn Museum of Art; Richard Armstrong, Louise Lippincott, and Allison Revello at the Carnegie Museum of Art; William J. Hennessey at the Chrysler Museum of Art; Katherine Lee Reid at the Cleveland Museum of Art; David C. Levy and Jacquelyn D. Sewer at the Corcoran Gallery of Art; Anthony Bannon at George Eastman House; Michael E. Shapiro, Philip Verre, and David Brenneman at the High Museum of Art; Ned Rifkin at the Hirshhorn Museum; Philippe de Montebello, Gary Tinterow, and George R. Goldner at The Metropolitan Museum of Art; Betsy Bradley, René Paul Barilleaux, and Robin Dietrick at the Mississippi Museum of Art; Philippe Chabert at the Musée d'Art moderne in Troyes; Jean-Marie Granier and Marianne Delafond at the Musée Marmottan-Monet; Lora S. Urbanelli and Deana Setzke at the Museum of Art, Rhode Island School of Design; Malcolm Rogers, George Shackleford, and Erica Hirschler at the Museum of Fine Arts, Boston; Glenn Lowry, John Elderfield, Joachim Pissarro, Cora Rosevear, and Jennifer Field at the Museum of Modern Art; Earl A. Powell III and Alan Shestack at the National Gallery of Art in Washington; Anne d'Harnoncourt, Joseph J. Rishel, and Shannon Schuler at the Philadelphia Museum of Art; and Julian Treuherz and Godfrey Burke at the Walker Art Gallery in Liverpool.

Additionally, numerous individuals provided support and advice, including William Acquavella and Michael Findlay at Acquavella Galleries, Elizabeth Fraser of the Department of Art and Art History at the University of South Florida in Tampa, Michael McManus, Conservateur du Patrimoine Jean-François Mozziconacci, Paul R. Provost of Christie's in New York, Ay-Whang Hsia at Wildenstein & Company, Katharine A. Lochnan of the Art Gallery of Ontario in Toronto, Evelyn Rosenthal at Harvard University Art Museums, Ryan Ross at Arcature Gallery in Palm Beach, and Alice Whelihan at the National Endowment for the Arts.

It is through the enlightened commitment of individuals and corporations that we, and our sister institutions, can present significant projects such as this. Our sponsors are recognized elsewhere in this book, but I want to mention our lead sponsor in St. Petersburg, the Focardi family, who has generously supported the Museum for many years and whose initial funding allowed us to undertake this important exhibition. Indemnification from the Federal Council on the Arts and the Humanities was also essential to its realization.

We want to express our thanks to our authors: Dr. John House, Walter H. Annenberg Professor, Courtauld Institute of Art, London, and one of the world's foremost authorities on Monet and impressionism; Dr. Petra ten-Doesschate Chu, Professor of Art History at Seton Hall University and renown scholar of nineteenth-century art; and our Museum's Chief Curator, Dr. Jennifer Hardin, for allowing us to appreciate with new eyes a richer vision of London and the Thames.

Jennifer Hardin joins me in thanking colleagues without whose support this exhibition would not have been as wide-ranging and visually appealing, especially the exhibition's in-house curators at our two other venues: Elizabeth Easton, Chair of the Department of Nineteenth-Century Painting and Sculpture at the Brooklyn Museum of Art, and Katy Rothkopf, Curator of Painting and Sculpture at the Baltimore Museum of Art. The following colleagues also

graciously allowed Jennifer Hardin access to artworks and documentation, contributed substantially to the exhibition, and ensured that important works would be included: Jay Fisher and Susan Dackerman at the Baltimore Museum of Art encouraged the loan of major prints from their collection, especially those by Whistler; Katherine L. Blood, Carol Johnson, and Sara Duke in the Prints and Photographs Division of the Library of Congress, as well as the Library's Assistant Registrar Rachel Waldron, helped her navigate through their vast holdings, particularly from the Pennell bequest; Roberta K. Waddell, Curator of Prints, Roseann Panebianco, Loans Administrator, and Tom Lisanti, Head of Photographic Services at The New York Public Library, facilitated loans and photography of objects; John Fisher at Guildhall Library Print Room was most helpful coordinating loans and providing images for the catalogue. Also extremely generous were Mark Bills, Mike Seaborne, Alex Werner, and Antonia Charleton of the Museum of London, as well as Robert Aspinwall, Librarian and Archivist at the Museum of London's Museum in Docklands; Christopher Riopelle and Anne Robbins at the National Gallery, London; Philip Conisbee, Kimberly Jones, and Jeffrey Weiss at the National Gallery of Art, Washington, D.C.; Vivien Knight, Jeremy Johnson, and Naomi Allen at Guildhall Art Gallery in London; Eric Denker and Sarah Cash at the Corcoran Gallery of Art; Kristen Hileman at the Hirshhorn Museum; H. Barbara Weinberg, Thayer Tolles, and Kit Basquin at The Metropolitan Museum of Art; Margaret O'Brien at the Museum of Art, Rhode Island School of Design; Jane Fletcher and Russell Roberts at the National Museum of Photography, Film & Television in Bradford, England; Gavin Spanierman at Spanierman Gallery; Mark Haworth-Booth, Martin Barnes, Charlotte Cotton, and Janet Skidmore at the Victoria and Albert Museum; and Margaret Warren at Wakefield Art Gallery. Interns in

Jennifer Hardin's department at the Museum over the last three years provided invaluable research support, especially Liza Oliver, an M.A. student at the University of South Florida, who helped compile the bibliography and chronology, and Heather Blackmon, Joseph Buccina, and Shayna McClelland.

Monet's London is undoubtedly one of the most ambitious exhibitions ever undertaken by the Museum of Fine Arts. It could not have been accomplished without the untiring efforts of the great number of people noted here. The curator of the exhibition, Dr. Jennifer Hardin, did the lion's share of the work and deserves special mention. She was ably assisted by Exhibition Coordinator Lisa McVicker, Registrar Louise Reeves, Librarian Jordana Weiss, Exhibition Specialists Thaddeus Root and Thomas Gessler, Curatorial Assistant Robin O'Dell, and Acting Assistant Curator Diane Freedland. Their enthusiasm, expertise, and diligence have brought this project to fruition. I want to also express my personal appreciation to the Board of Trustees and to all the Museum staff and volunteers for their enthusiastic support and hard work to make this exhibition a reality, and to the people at Snoeck Publishers, who have been wonderful partners in the publication of this catalogue.

We are extremely proud to present this work to our public. We know that you will enjoy the journey, as we travel along the Thames, and discover the extraordinary responses of different artists to the scale, complexity, and atmosphere of Monet's London.

Dr. John E. Schloder
Director
Museum of Fine Arts
St. Petersburg, Florida

Introduction Jennifer Hardin

In 1996, shortly after joining the Museum, I was stopped in the galleries by a visitor. Although from St. Petersburg, she had never been in the building. "Surely," she asked, "many of the works are copies? The Monet, for example, it couldn't possibly be real!" Little did she realize that she referred to one of the most important artworks, historically and aesthetically, in the Museum's collection. It was also among the thirty-seven paintings selected by Monet for the first exhibition of his Thames series in 1904. This chance meeting would instigate efforts to focus part of the Museum's exhibitions program on major works in the collection.

With its subtle effects and laboriously worked surface, the Museum's *Houses of Parliament, Effect of Fog* (cat. 37) exemplifies the subjective approach that evolved in the later part of Monet's career. Clearly the most important in his three-part series of the Thames, his Parliament paintings convey a monumentality, which is enhanced by the impact of the building's massive architecture. Even today, the object of Monet's paintings, more precisely known as the New Palace of Westminster, dominates the river in the heart of London. In contrast to the Gothic architecture of his Rouen Cathedral series (1892–94), Monet's Parliament depicts a nineteenth-century, Gothic revival structure. One of the century's greatest buildings, it was designed by Charles Barry and A. W. Pugin, begun in 1836 and finally completed in 1870, ten years after Barry's death (although the Houses of Parliament had opened earlier in 1847). Barry's and Pugin's edifice was just one of a number of major architectural projects that occurred during Queen Victoria's reign (1837–1901), including bridges and other buildings on the Thames.

Arguably the Western world's most depicted river in the nineteenth century, London's Thames provided rich inspiration in its sights and sounds, people of different occupations, nations, and classes, and—to delight the nautical eye—boats of every variety: wherries, lighterboats, barges with red-clothed sails, tugs, steamers, and clipper ships. Between 1859 and 1914, London's Thames attracted a wide range of artists as diverse in their artistic approaches and media as David Roberts, James McNeill Whistler, Alvin Langdon Coburn, and André Derain. The architectural and urban developments along the river drew many artists whose images were more documentary in nature. Topographical artists such as E. Hull (cats. 16, 17) and T. Raffles Davison (cat. 57) described the site and its surroundings. Other artists stepped outside their usual roles to produce more subjective evocations of the river, for example the illustrators Joseph Pennell (cats. 39–42) and H. E. Tidmarsh (cat. 50). Painter-etchers and pictorial photographers produced compelling Thames imagery (cats. 59, 116). Some were commissioned to document architecture in London that was fast disappearing (cats. 5, 16, 17).

Against this diverse backdrop, Claude Monet arrived in London in 1899 to begin his long-awaited Thames paintings, which came in the wake of his Poplars, Grainstacks, Rouen Cathedral, and Morning on the Seine series. Among other factors, discussed in the essays that follow, Monet was likely inspired to paint in London by his friend and colleague, the American expatriate James McNeill Whistler.[1] Whistler died in 1903, the year before Monet first showed his *Views of the Thames* at Paul Durand-Ruel's Paris gallery. While Monet's paintings are notably distinct from those of Whistler, his Thames paintings share Whistler's subject matter and subjectivity. Whistler and his art have been acknowledged as highly influential on his contemporaries, as well as on younger generations of painters, printmakers, and photographers during this era—a time of great social and cultural change. Whistler's first responses to London's river were in the medium of etching, and a number of them were later gathered in his influential series, the *Thames Set* (1871).

The British Empire reached its apogee during this period, with London as its governmental and financial center, and the Thames as the terminus of global trade routes. Already perceived as vast at the beginning of the nineteenth century— indeed, in the modern era the word "metropolis" was first used to describe London—the city's population reached over two million by 1861 and tripled between 1800 and 1871.[2] In the 1850s, the Thames was viewed as a symbol of corruption. Rampant poverty, disease, and crime were especially associated with London's East End, which included the docklands and wharves, and maps even delineated the city's areas of wealth and poverty.[3]

Yet the Thames could also be perceived as a kind of urban sublime. The overwhelming nature of London's river in the later nineteenth century appears again and again in travel writing of the day, to which John House insightfully calls attention in his essay. In a recollection significant for understanding of the Thames with relation to art and industry, the French historian and philosopher Hippolyte Taine published his reactions to his arrival by river in London near the docklands in *Notes on England*:

Docks, warehouses, ship-building and repairing yards, workshops, dwelling houses, part-processed materials, accumulations of goods. . . . Astonishment gives way to indifference; it is too much. Above Greenwich the river becomes no more than a street, a mile and more wide with an endless traffic of ships going up and down stream between two rows of buildings. . . . To the west of us a forest of masts and rigging grows out of the river: ships coming, going, waiting, in groups in long files, then in one continuous mass, at moorings, in and among the chimneys of houses and the cranes of warehouses—a vast apparatus of unceasing, regular and gigantic labour.[4]

While Taine communicated a sense of awe at the sight of maritime activity and congestion along the river, he nevertheless called attention to the atmosphere that enshrouded this spectacle on the river. In a passage that suggestively parallels the palette of Monet's painting in the Museum's collection and the series' essential subject, Taine found in this chaotic scene of human industry a certain aesthetic appeal. The view was

enveloped in a fog of smoke irradiated by light. The sun turns it to golden rain, and the water, opaque, shot with yellow, green and purple, gleams and glitters as its surface lifts and falls, with strange and brilliant lights. The atmosphere seems like the heavy, steamy air of a great hot-house. Nothing here is natural: everything is transformed.[5]

Taine points to the environment's effect of artificiality, a major theme on which Whistler would later expand in his art and one that Monet would make his subject—the veil between himself and the object he painted.

Described in an elegant book of etchings, accompanied by a literary travelogue, as the "Grey River," with all its Whistlerian connotations, the Thames was more commonly referred to as "London's High Street" and, most frequently, the "Silent Highway," although a contemporary admitted that the latter had little to do with the actual place.[6] The Thames, as noted by Petra ten-Doesschate Chu and House, symbolized the British Empire's wealth and power. Literally, it was the means by which that wealth and power was achieved. Between 1800 and 1810, a series of massive docks was constructed east of the Tower of London; St. Katherine's Docks, nearer the Tower, were built in 1828, and others were added to receive larger ships between 1855 and 1886. The docks allowed for increased shipping traf-

fic and tonnage of goods to be brought into the country, and provided security in nearby warehouses for storing such valuable commodities as wine and tobacco. Topographic prints from the early 1800s project the new dockland areas (e.g., William Daniell's series, 1802–13, Museum of London and Guildhall Library) as vast, orderly, and efficient, in stark contrast to how the docks were and were imaged in the late nineteenth and early twentieth centuries, with a flurry of river traffic and ramshackle areas along the wharves (cats. 20, 48).

Akin to the broad, bustling boulevards of Paris, or New York's Broadway and Fifth Avenue, the Thames was so closely identified with London that guidebooks directed the visitor to begin their tour of London at London Bridge and look upstream and downstream to get a sense of the city and its commercial lifeline.[1] As Chu discusses, art commerce and an opportunity to show their work outside the confines of French official exhibitions attracted French artists. What they and other Continental and American artists discovered there— London's particular brand of urban energy and its enigmatic atmospheric qualities of rain, mist, fog, and smoke—may have fueled their desire to return. The earlier generation made works based on observation and were informed by prior picturesque and romantic modes, as in the painting of David Roberts (cat. 43). Whistler and those who followed his lead produced more subjective evocations of the river and its surroundings. Especially poignant is the case of Monet, who for decades wished to revisit London and to create a series of Thames views. His thoughts were first documented in 1880,[8] nearly a decade after his initial sojourn in 1870–71. Finally, in 1899, he began the series with the major sites of Charing Cross Bridge (i.e., Hungerford Bridge), Waterloo Bridge, and the Houses of Parliament. The Thames and the effects of weather on it were central to his project.

In 1859 Whistler moved to London and, through the medium of prints, made his first efforts imaging the Thames and those who worked the river. That year also marked his first acceptance at the Paris Salon, which included two of his etchings, as well as one by his brother-in-law, the physician and etcher Seymour Haden.[9] During this period, the notion of the painter-etcher or the painter-printmaker reinvigorated the realm of artistic printmaking. The etching revival consisted in part of prints by painters who did not normally make them—artistic prints valued for aesthetic reasons rather than for documenting or communicating information. Later, the notion spread

that printmakers also painted. Two critical figures in the etching revival were the Parisian printer Auguste Delâtre and the publisher and art dealer Alfred Cadart who opened his Paris gallery in 1859. Interest grew in creating and distributing prints that were artistic and affordable.

Concurrently, the period was dominated by a new medium of visual expression—photography. A relative novelty in the 1850s, photography by the onset of World War I would become deeply embedded in Western visual culture, influencing ways of seeing and understanding. The decade saw the founding of the influential Photographic Society of London and the advent of the albumen print, which along with the stereograph and Photochrom largely replaced images made through such techniques as wood engraving and lithography (cats. 81, 124).[10] An important catalyst for documentation due to the photographer's ability to create multiple images with greater ease and clarity, the albumen print led to the abandonment in Europe of the mirrorlike daguerreotype, which was a unique image, and the diffuse "fuzzy"-surfaced salt print, or calotype, by 1860.[11]

At the same time, influential critics and writers weighed in on the role of photography in contemporary society in Britain, the United States, and France. In London, Lady Elizabeth Eastlake struggled with the idea of photography as art in 1857, and two years later in the United States, Oliver Wendell Holmes wrote his homage to the stereograph. Meanwhile, back in Paris, Charles Baudelaire's review of the 1859 Salon, the first Salon exhibition to include a showing of photography, denigrated the medium for pandering to the masses by producing slavish imitations of nature that were also dominating the art world.[12]

Nevertheless, a number of photographers fought for recognition in the wider world of art. In Britain during the 1850s, Oscar Rejlander and Henry Peach Robinson exhibited photographs modeled on genre and academic painting and made from composite negatives. Robinson would later participate in the Linked Ring, along with Colonel Joseph Gale (cat.127), Charles Job (cat.128), and Coburn (cats. 116–121), but this exhibition group epitomized the more subjective and "impressionist" branch of artistic photography that split with the Royal Photographic Society in 1892.[13] George Davison, a founder of the Ring, had in 1890 articulated the idea that photography could be highly artful, particularly through soft-focus lenses, painting on the print (as in the gum-bichromate process), and use of textured papers. Davison's *Impressionism in Photography* invoked the actions of the 1874 impressionists in their aggressive stance against the reigning academic modes. He called attention to photographers who were trying to capture nature and emphasize effects of light in their works.[14]

Yet, the impressionists by this late date had moved on. This is nowhere better exemplified than in *Charing Cross Bridge* (cat. 38), Camille Pissarro's painting informed by neo-impressionism, also of 1890, and in Monet's series paintings begun in the same decade, which became increasingly subjective by 1900, as in the case of his *Views of the Thames*.

The essays in this catalogue expand on these themes. House provides a rich setting of verbal and visual interpretations of the Thames, as a means by which to understand how the river was perceived during the period, and discusses Thames works by major artists in the exhibition, including Whistler, Monet, and Derain. Chu focuses on the important exchange between European and British artists, patrons, and dealers in London, highlighting the activities of Monet's dealer, Paul Durand-Ruel. The third essay offers an overview of Thames imagery in paintings, prints, and photographs between 1859 and 1914. Inspired and motivated by such diverse issues, these works—whether based in fact or in the imagination—invite us to travel the Thames at London through the eyes of their makers.

1. Whistler's relationship with Monet has recently been explored in depth by Katharine A. Lochnan et al., *Turner, Whistler, Monet: Impressionist Visions*, exhibition catalogue, Toronto: Art Gallery of Ontario in association with the Tate Gallery, 2004. For a definitive accounting of Monet's Thames series, see Grace Seiberling, *Monet in London*, exhibition catalogue, Atlanta: High Museum of Art, 1988.

2. Ken Young and Patricia L Garside, *Metropolitan London: Politics and Urban Change, 1837–1981*, New York: Holmes and Meier, [1982,] pp. 1, 16–20. For London's growth and its relationship to the visual arts, see for example, Anne L. Helmreich, "Reforming London: George Cruikshank and the Victorian Age," in *Victorian Urban Settings: Essays on the Nineteenth-Century City and Its Contexts*, Debra N. Mancoff and D. J. Trela, eds. New York and London: Garland Publishing, Inc., 1996, pp. 157, 159.

3. Some of the most thorough studies of wealth and poverty in London produced were color-coded maps by Charles Booth from 1862 to about 1900. Mary Burgan, "Mapping Contagion in Victorian London: Disease in the East End," in *Victorian Urban Settings*, 1996, pp. 43–55.

4. Hippolyte Taine, *Taine's Notes on England*, Edward Hyams, trans. and introduction, Freeport, NY: Books for Libraries Press, 1971, pp. 7–8.

5. Taine 1971, p. 8.

6. The "Grey River" from Justin McCarthy and Mrs. Campell Praed with twelve etchings by Mortimer Menpes, *The Grey River*, London: Messrs. Selley and Co. Ltd., 1889. "London's High Street" from Ben Jonson, *London, Historical and Descriptive: A Reading-Book for Schools*, London: Blackie & Son, 1906, p. 11. An example of the "Silent Highway" from *Black's Guide to London and Its Environs*, Edinburgh: Adam and Charles Black, 1871, p. 219; the protest against this name for the Thames from *Cruchley's London in 1864: A Handbook for Strangers*, London: G. F. Cruchley, 1864, pp. 3, 5.

7. An example of directing tourists to stop at London Bridge to "understand the wealth and immensity of London" from *Cassell's Illustrated Guide to London*, London: Cassell, Petter, and Galpin, 1862, preface [n.p.], and pp. 10–11, 14.

8. "Chronology" in Charles F. Stuckey, *Claude Monet, 1840–1926*, exhibition catalogue, New York: Thames and Hudson; Chicago: Art Institute of Chicago, 1995, p. 206.

9. Katharine A. Lochnan, *The Etchings of James McNeill Whistler*, exhibition catalogue, New Haven and London: Yale University Press, 1984, pp. 68–69. Haden also had an etching accepted at the Salon of 1859, *Thames Fisherman*, which was submitted under the pseudonym of H. Dean. See Lochnan 1984, p. 69.

10. Maidment notes that the great era of popular illustration came to a close by the late 1870s. B. E. Maidment, *Reading Popular Prints, 1780–1870*, Manchester and New York: Manchester University Press, 2nd ed., 2001, pp. xii, 14–15. In the 1880s and 1890s, magazines like *Le Journal illustré*, *Harper's Weekly*, and the *Illustrated London News* began using such processes as half-tone engraving and photogravure to reproduce photographic illustrations in their publications. See also Pierre Albert and Gilles Feyel, "Photography and the Media: Changes in the Illustrated Press," in Michel Frizot, ed. *A New History of Photography*, Cologne: Könemann, 1998, pp. 361–68.

11. The daguerreotype had a longer life in the United States, see Richard Rudisill, *Mirror Image: The Influence of the Daguerreotype on American Society*, Albuquerque: University of New Mexico Press, 1971. The aesthetic qualities of the calotype, however, were later promoted by the Pictorialists.

12. Lady Elizabeth Eastlake's husband, Sir Charles Eastlake, was the first director of the National Gallery in London and the first president of the Photographic Society of London. An art historian and translator of German histories of art, Lady Eastlake's struggle concerned photography's immediate technical limitations, such as capturing motion and rendering colors, but many of these were overcome by the century's end. The Photographic Society of London, which became the Royal Photographic Society in 1894, was founded in 1853, see Michel Frizot, "The Transparent Medium: From Industrial Product to the Salon des Beaux-Arts," in Frizot 1998, p. 96. All three texts are reprinted in Vicki Goldberg, ed., *Photography in Print: Writings from 1816 to the Present*, Albuquerque: University of New Mexico Press, 3rd printing, 1994, pp. 88–99, 100–14, and 123–26, respectively.

13. Margaret E. Harker, *The Linked Ring: The Secession Movement in Photography in Britain, 1892–1910*, London: Royal Photographic Society and Heinemann, 1979, Appendix 2, pp. 179–87. Robinson's *Pictorial Effect in Photography* of 1869 had many editions and translations, see Mike Weaver, "Artistic Aspirations: The Lure of Fine Art," in Frizot 1998, p. 191; Weaver defines pictorialism as "the self-conscious making of pictures according to the principles of painting." See also Anne Hammond, "Naturalist Vision and Symbolist Image: The Pictorialist Impulse," in Frizot 1998, pp. 293–94, 297–98. Hammond notes that a friend of Peter Henry Emerson's was Thomas Frederick Goodall, brother of E. A. Goodall. Emerson's book revolved around naturalistic effects, and he especially appreciated works by Millet and Corot; Whistler may have convinced Emerson to abandon the idea that photography could be art around 1890. Hammond views many pictorialist photographers of the 1890s as part of the symbolist movement, for they were objectifying the subjective, as opposed to the impressionists subjectifying the objective.

14. George Davison was inspired by the naturalist photographer Peter Henry Emerson, but Emerson claimed that he had misunderstood his approach. Harker 1979, p. 31.

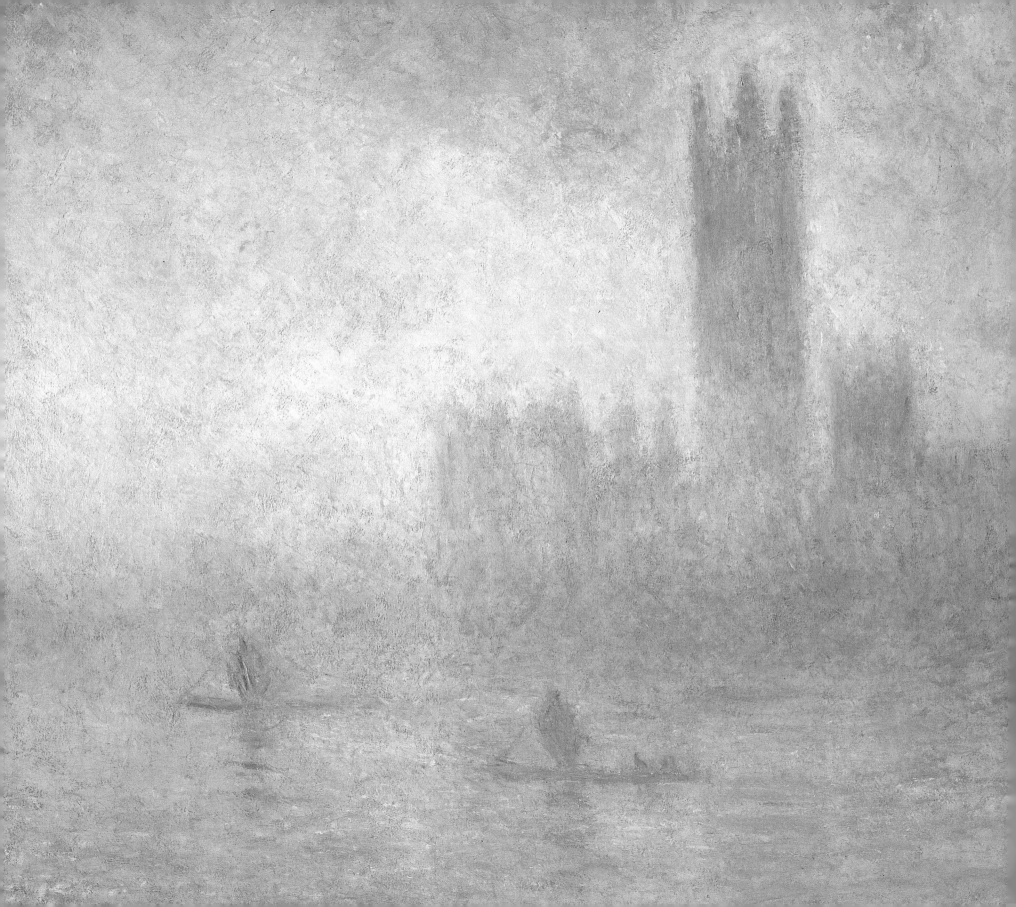

Visions of the Thames

John House

"The noblest commercial river in the world, yet converted into a sewer both above and below London." [1]

Peter Cunningham's description of the Thames in 1849 introduces the two key themes in mid-nineteenth century perceptions of London's river—commerce and dirt. Locals and visitors alike were amazed by the scale of the trade on the river and the splendor of the spectacle it offered; it could readily be viewed as the epitome of the power and wealth of the city, and of England itself. However, they were also shocked by the physical state of the river—by its pollution. On one level, this was a physical problem, which could be resolved; but the state of the river also came to be considered a moral issue, standing for the degradation and corruption at the heart of modern city life. At the same time, London's dense smoke-generated fogs gave the city and its river a unique atmosphere that too could be interpreted in both physical and moral terms.

Views of the Thames in the mid-nineteenth century played on these concerns. However, an alternative perception emerged through the century, one that focused on the aesthetic effect of London's atmosphere, rather than on the associations evoked by the scenes. This was pioneered by foreign visitors to London, first, in words, by the French writer Théophile Gautier, and later by the American artist James McNeill Whistler and the French artist Claude Monet.

For most twentieth-century visitors to London, the Thames was not the focal point of the experience of the city; tourist London was concentrated on the north side of the river, and the river itself was something to be crossed, en route to the few venues on the south bank. Only recently has it come back into a more central view, with the creation of a series of attractions on the south bank, culminating with the opening of Tate Modern in 2000, in a converted power station opposite St. Paul's Cathedral and linked to the church by the celebrated new Millennium Footbridge, the so-called "wobbly bridge."

The experience would have been entirely different for the visitor in the mid-nineteenth century. A primary path for the new arrival was up the Thames from the estuary, with disembarkation in the Pool of London by the Customs House, between the Tower of London and London Bridge—then the farthest downstream of the Thames bridges. Elisée Reclus's 1860 guide to London quoted the English writer Bulwer, in advocating a river approach:

It is by the Thames, Mr. Bulwer says, that the foreigner should enter London. The breadth of the powerful river, the lofty factories with their sombre and funereal appearance which line its sad banks, the thick fog through which one can only with difficulty make out the vague shadows of these gigantic contours, the marvellous silence with which one glides through the City of the nations, alongside all the large ships, symbols of her power—the melancholy, the solemnity, the grandeur, the dimness of all the objects that surround you prepare you for the sight of serious and austere splendours. [2]

Foreign visitors voiced their amazement at the scale of the river and the sheer complexity of the scene: the many different types of shipping, the constantly varied jumble of buildings that opened directly onto the river. At first sight, the scene defied decoding; it was too huge in scale and too multifarious in its ingredients to be intelligible to the newcomer. [3] Reaching London Bridge, Reclus tells us, "one feels oneself in the heart of the world, in the commercial centre to which all the riches of the world flow…. One cannot see this army of ships, come from all corners of the globe, without understanding that London is truly the meeting-point of the nations." [4] The patriotic implications of this view were spelled out by Mr. and Mrs. S. C. Hall in 1859, in *The Book of the Thames*:

From the Tower Stairs the view, looking either way, is very striking; the river is crowded with shipping and steamers, and from this point begins that succession of vessels which affords the voyager so grand an idea of the vast trade of the British metropolis. There are, perhaps, few sights in the world more striking—certainly none more calculated to make an Englishman proud of his country…. "The Pool of the Thames"… is truly a grand and glorious sight; the proudest "station" in the world. [5]

Yet, as Bulwer's text intimates, the viewer's responses to this spectacle were complex—in part political, in part philosophical, in part moral, and in part aesthetic. British political and commercial power came at a cost. In 1853, the German visitor Max Schlesinger celebrated British wealth and rule as the result, not of any abundance of natural resources, but of the best

use that the British made of the resources that they had been given.[6] The river, he wrote, was "the great, living, fabulous, watery high-road in the heart of the British metropolis"; but at the same time he could lament its state: "They have abused thee sadly, thou grey Thames, for the filth of thy waters and the fogs which arise from thee."[7] For Charles Knight in 1851, "The juxtaposition of the magnificent and the common," "the noblest and the humblest things" on the banks of the river were "food for thought" that led him to ponder the forces that had made London what it was.[8]

The moral dimension to the image of the river appears vividly in Charles Dickens's *Our Mutual Friend*, published in 1864–65. From the scavengers on the river in the first chapter of the book to the drownings near the end, the Thames is a constant thread of danger running through the text—a physical threat to life, but also a pestilential magnet that corrupted everyone who came near it. *Our Mutual Friend* introduces another recurrent motif in characterizations of the Thames—the contrast between the river above London and its condition in the city: "...the young river, dimpled like a young child, playfully gliding away among the trees, unpolluted by the defilements that lie in wait for it on its course."[9] The "sombre and funereal appearance" of the factories that Bulwer noted and the "melancholy" that he felt on the river were responses echoed by many foreign visitors.

In these accounts, visual appearance was inseparable from mood, and this mood, in turn, could elicit philosophical and moral reflections. The spectacle of ships unloading in the docks deeply impressed the French writer Francis Wey:

> One is struck by the grandeur and the sadness (*tristesse*) of the spectacle, and one is bewildered by such a solemn and gloomy first welcome to the city. In the presence of so much movement and so little noise, one feels that one is penetrating in full daylight into the empire of shadows. Even the sun, clad with a white shroud, projects only a pallid spectre of its rays over these fantastic scenes.[10]

The French novelist and critic Edmond Duranty wrote of the docks in 1867: "Their appearance is astonishing, extraordinary, particularly in grey foggy weather which gives a special character to the perspective and completes the sense of great *tristesse* which accompanies all modern expressions of commerce and industry."[11]

For other writers, it was London's fogs, created by the com-bination of moisture with coal smoke and industrial emissions, that generated a somber mood. Entering London for the first time, the French writer James Morier noted: "Smoke ruled over all, and covered all things with an eternal mourning."[12] For Flora Tristan, pioneer feminist and grandmother of Paul Gauguin, writing of London in 1840, the fog inspired an apocalyptic vision: "On foggy days, London has a terrifying appearance! One imagines oneself to be wandering in the necropolis of the world, inhaling its sepulchral atmosphere...."[13] The English writer Rollo Russell, in 1880, attributed an explicitly moral dimension to the effects of the fog. For Londoners, he wrote, the fog "contaminates the vital breath of heaven," so that they

> lose... the glorious and almost universal privilege of looking upon the clear azure above them.... They lose... all distant prospects, urban or rural, and the pleasant variations of cloud-shadows which delight us in the views of great continental cities, which are not blurred or blotted out by smoke. These things are sermons from nature which humanity has heed of. London is indeed hideous to look at, but would be less hideous without its smoke.[14]

The fog also plays a crucial role in Conan Doyle's narratives of the exploits of the detective Sherlock Holmes, published late in the century; Holmes's laserlike insight repeatedly pierces through London's fog and unveils the criminals who operate under its cover.[15] Few people shared the English painter Benjamin Robert Haydon's optimistic interpretation of London's atmosphere: "So far from the smoke being offensive to me, it has always been to my imagination the sublime canopy that shrouds the City of the World. Drifted by the wind or hanging in gloomy grandeur over the vastness of our Babylon, the sight of it always filled my mind with feelings of energy such as no other spectacle could inspire."[16]

Yet there was an alternative view of the fog that focused on its appearance alone, and celebrated in the most positive terms the ways in which it transformed the visual experience of the Thames-side landscape. Théophile Gautier, key protagonist of an "art for art's sake" aesthetic in France, seems to have pioneered this vision of London in an essay first published in 1842:

> This smoke, spread over everything, blurs harsh angles, veils the meanness of buildings, enlarges views, gives mystery and vagueness to the most positive objects. In the smoke, a factory chimney readily becomes an obelisk, a warehouse of poor design takes on the airs of

a Babylonian terrace, a grim row of columns changes into the porticos of Palmyra. The symmetrical barrenness of civilisation and the vulgarity of the forms that it adopts all become softened or disappear, thanks to this kindly veil.[17]

As we shall see, this vision was to become hugely influential later in the century.

During the 1860s the first crucial steps were taken to transform the reach of the Thames above London Bridge, both hygienically and aesthetically. The use of the river as the primary outlet of London's sewage had led to increasingly intolerable and insanitary conditions, notably in 1858 when the effect of a hot summer on the river produced what came to be known as the "Great Stink" and led to the evacuation of the Houses of Parliament.[18] The solution was the creation of a new sewage system during the 1860s, together with an underground railway line, beneath a broad embankment and roadway along the north bank of the river, initially from Westminster to Blackfriars Bridge.[19] The vast scale of the building works can be seen in the watercolors by E. A. Goodall and E. Hull (cats. 11, 16, 17). London's other form of pollution, the smoke-generated fog, named "smog" in 1905, continued virtually unabated through the nineteenth century, and was only ended by the Clean Air Acts of the 1950s.

Painters working in London in the nineteenth century were faced with a number of choices. What subjects in the city were fit for fine art, and what values might be attributed to them? Should the new Embankment be seen as an adornment to the city, or as a loss of picturesque qualities? And, most importantly, how should the painter depict the smog—the veil that obscured the city's monuments and physical features?

Since the seventeenth century, the Thames had been a prime subject for artists working in a topographical mode. Canaletto's views of the river—the panorama upstream and downstream from Somerset House and other vantage points, and the view through an arch of Westminster Bridge—depict a serene, sunlit city, its skyline punctuated by church spires and dominated by the monumental forms of St. Paul's Cathedral in one direction, and Westminster Abbey and Westminster Hall in the other. In the 1830s, both John Constable and J. M. W. Turner painted the same reach of the river, in ambitious exhibition pictures commemorating significant events. Constable's *The Opening of Waterloo Bridge* (*Whitehall Stairs, June 18th, 1817*)

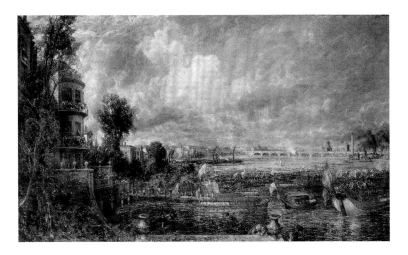

fig. 1 John Constable *(British, 1776–1837)*
The Opening of the Waterloo Bridge (Whitehall Stairs, June 18th, 1817)
Oil on canvas 130.8 x 218 cm
Tate Gallery, London

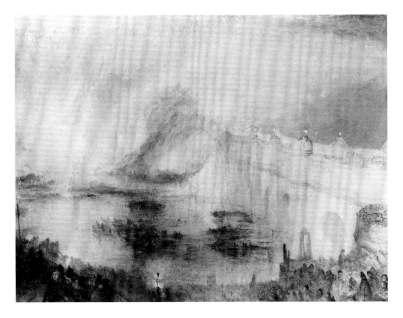

fig. 2 J. M. W. Turner *(British, 1775–1851)*
The Burning of the Houses of Parliament, c. 1835
Oil on canvas 92.13 x 123.27 cm
Philadelphia Museum of Art
John Howard McFadden Collection

(fig. 1), depicting the festivities accompanying the opening of Waterloo Bridge, was exhibited at the Royal Academy in 1832. Three years later, Turner exhibited *The Burning of the Houses of Parliament* (fig. 2), a grandiose, apocalyptic depiction of the great fire that led to the construction of the new neo-Gothic Houses of Parliament, a building that played a central role in the imagery of the river through the nineteenth century. In these two paintings, Constable and Turner elevated the topographical tradition to the status of history painting. Later in the century, a number of artists took up the theme of the monumental reach of the river between Westminster and London Bridge, notably David Roberts in a series of paintings that he undertook in the early 1860s, following a suggestion that Turner had apparently made to him years before. In Roberts's *The Houses of Parliament from Millbank* (cat. 43), exhibited at the Royal Academy in 1862, the new Parliament buildings ride proudly above the jumble of wharves and warehouses on the foreground riverbank.

There was, though, an alternative image of this reach of the Thames in these years, one that presented the banks of the river as the environment of a key figure of Victorian moral fear—the "fallen woman," a collective term at the time for all women who indulged in sex outside marriage and were therefore perceived as having abandoned moral respectability. In a number of images, "fallen women" are depicted beside the river as the final stage in their moral degradation, or as suicides washed up on its banks.[20] J. R. Spencer Stanhope's *Thoughts of the Past* (fig. 3), shown at the Royal Academy in 1859, the year after the Great Stink, makes the association especially vivid. This young woman is clearly identifiable as "fallen" from the attributes of the items alongside her—the coins on the table, the man's walking-stick and glove on the floor. The viewer is invited to imagine that she is pondering her lost innocence. She is placed in front of a topographically accurate view of the river, looking upstream from beside Blackfriars Bridge.[21]

This imagery remained resonant until the end of the century. In 1897, a reprint in a popular guidebook stated:

> How pleasant... to stand upon the bridge [probably Waterloo or Westminster], and leaning idly over, gaze into the silent highway flowing far beneath! And weary men come close beside you, and resting their heavy burdens on the edge, look down into the stream, and think there must be something pleasant in lying idly upon a coal sack and smoking a pipe in the sunny air. And

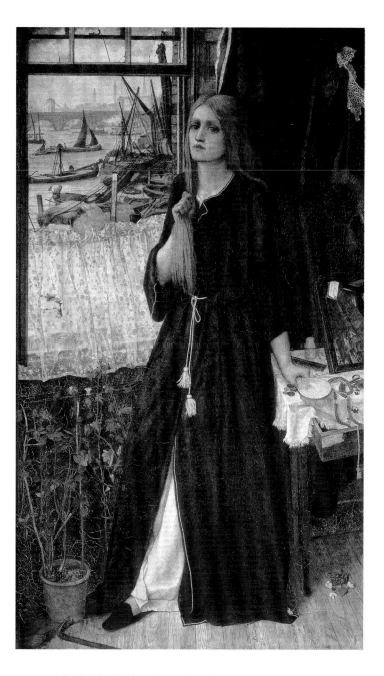

fig. 3 John Roddam Spencer Stanhope *(British, 1829–1908)*
Thoughts of the Past, 1859
Oil on canvas 86.4 x 50.8 cm
Tate Gallery, London

others, pale women, sometimes with burdens heavier far to bear, speculate on the depths of the still waters, and only wait until night; and when the turbid stream is rushing through the bridges and past the quiet houses, and far off into eternity, the sea, it bears upon its bosom a ghastly freight.[22]

The physical improvements on the river's banks beginning in the 1860s gave new impetus to a longstanding debate about the aesthetics of London's river. French visitors to London had often compared Paris's monumental embanked *quais* with the disorder of the Thames banks. In 1842, Gautier was clear which he preferred: "London has its arms plunged up to the elbows in its river; a regular *quai* would destroy the familiarity between the river and the city. It gains from this in picturesque qualities, since nothing is more horrible to the eye than the eternal straight lines, extended despite everything, with which modern civilisation is so idiotically infatuated."[23] Francis Wey developed this argument in the 1850s:

> The absence of *quais* and the irregularity that results from this, the abundance of movement and activity that this arrangement... gives to the shoreline, are very striking to the French, who are so justly proud of the calm beauty and the imposing orderliness of the *quais* of Paris. But the majesty of the Thames, the grandeur of its lines and the diversity of its details... triumph over this fleeting impression... Soon one cannot understand that such a great highway, such a beautiful and busy road, could be enclosed and constrained by the embankments of a *quai*.[24]

After the construction of the Embankment, most English commentators were very clear about the advantages that had resulted. As Charles Dickens junior, son of the novelist, put it in 1883, "few London improvements have been more conducive to health and comfort. The substitution of the beautiful curve of the Embankment, majestic in its simplicity, with its massive granite walls, flourishing trees, and trim gardens, is an unspeakable improvement on the squalid foreshore, and tumble-down wharves, and backs of dingy houses which formerly abutted on the river."[25] The newly monumentalized riverbank between Westminster to Blackfriars, as seen from the terrace of Somerset House, appears in a painting (Museum of London) and a wood engraving (cat. 66) by John O'Connor, works that belong securely to the topographical tradition and are direct tributes to and modernizations of Canaletto's celebrated views of a century earlier. The dome of St. Paul's still dominates the horizon, but now it is seen above two gasometers and alongside factory chimneys with, in the distance at far right, the gleaming roof of the newly built shed of Cannon Street railway station.[26]

By contrast, the urban Thames below London Bridge was not a major attraction for painters before the late nineteenth century. The visual equivalents of the travelers' accounts of the journey up the river appeared in few exhibition pictures before the 1880s. George Vicat Cole's vast canvas *Thames of London* (Tate; fig. 4), shown at the Royal Academy in 1888, evokes the pool itself, looking upstream toward St. Paul's with the turrets of the Tower of London on the right, seen from a viewpoint seemingly in a small boat in midstream, which plunges the viewer into the midst of the activity, dwarfed by the far larger ships that frame the scene. Many of the themes introduced in the travel narratives are explored in W. L. Wyllie's *Toil, Glitter, Grime and Wealth on a Flowing Tide* (fig. 5), exhibited in 1883 (Royal Academy, London). The view here looks downstream toward Greenwich, with the twin domes of the Naval Hospital in the central far distance. The picture's title plays on contrasts: the workers' toil set against the value of their cargo and the wealth of its owners; and the glitter of the sunlight reflected on the filthy water and seen through the grime of the smoke and the mist. The theme was eloquently described by a reviewer in the *Athenaeum*:

> [The picture] depicts the Pool in summer daylight so dimmed by smoke and filth that the glorious silver sheen on the Thames is tarnished and horrible. It is a magnificent illustration of grimy and shining tones and vivid tints disposed in harmonies of a subtle kind. The heaving, turbulent surface of the filthy water here reflects the tawny splendour of the sky and there gives back clouds of dirty vapours. Against the lustrous portion of the river's surface are disposed the dark and grimy hulls of a tug and her train, certain lighters laden with coal. A dim and lurid penumbra surrounds the solid form of these dingy craft, and imparts to their images a verisimilitude which attests the painter's knowledge of nature and his perfect command of the palette.[27]

The slippage here between visual description and emotive language shows how inseparable the two were in the ways in which nineteenth-century viewers interpreted paintings—and indeed, the river itself.

A more overtly morally equivocal view of the docklands appears in James Tissot's *The Thames* (cat. 44), shown at the Royal

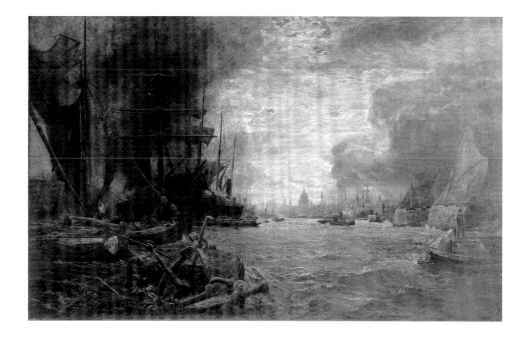

fig. 4 George Vicat Cole *(British, 1833–1893)*
Thames of London, 1888
Oil on canvas 195 x 305.5 cm
Tate Gallery, London

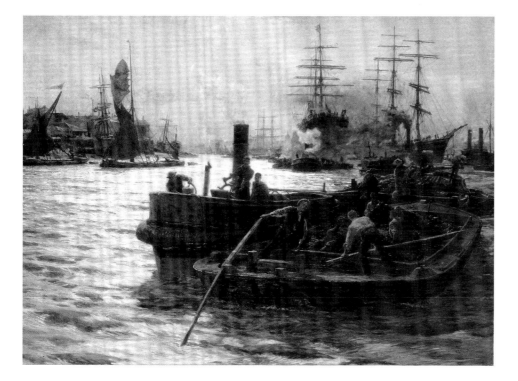

fig. 5 William Wyllie *(British, 1851–1931)*
Toil, Glitter, Grime and Wealth on a Flowing Tide, 1883
Oil on canvas 115.6 x 165.1 cm
Tate Gallery, London

Academy in 1876. The image of two women with one male figure, with no clue from the picture's title or details as to the relationship between them, caused disquiet to contemporary critics; the champagne bottles in the boat, the murky waters of the lower Thames, and the pointed detail of the bare-breasted female figurehead on the boat above the man's head added to the sense of unease. Reviewers of the painting harped on the notion of dirt, evidently drawing an analogy between the physical state of the river and the implicitly immoral social grouping in the boat.[28] From their behavior and demeanor, these looked like "fallen women," but there was no sign of an impending fate awaiting them.

The imagery of London's docks had appeared in fine art some years earlier, in James McNeill Whistler's series of etchings of 1859 to 1861, subsequently named the "Thames Set" (cats. 95–104). The first major work that Whistler undertook after settling in London, these prints depict the banks of the river in the area around Wapping and Rotherhithe, with houses and warehouses abutting directly onto the water, and boats and the boatmen plying their trades. In contrast to grandiose set pieces like Wyllie's and Vicat Cole's canvases, Whistler's compositions are deliberately informal. Often asymmetrical and seemingly casual, the arrangement of forms appears incidental, as everyday moments that we are witnessing in passing. The emphasis on irregularity and on old and ramshackle buildings conforms to conventional notions of the "picturesque." Individual details in the scenes, such as the background buildings in *Black Lion Wharf* and *Eagle Wharf* (cats. 96, 97), are depicted with great precision, but taken as a whole, the scenes have none of the narrative content that played such a major role in British images of the river, for example Stanhope's *Thoughts of the Past*. Nor do they give any hint of the reputation of London's docklands as an infamous and dangerous zone that middle-class viewers entered at their peril: no sign that this was, in Dickens's words, "where accumulated scum of humanity seemed to be washed from higher grounds, like so much moral sewage, and to be pausing until its own weight forced it over the bank and sunk it in the river."[29]

Only in one picture, *Wapping* (fig.6), the single major oil painting that Whistler devoted to London's docklands, did he engage in any way with the stock imagery of the region. He had first treated this scene in 1860, in the etching *Rotherhithe*

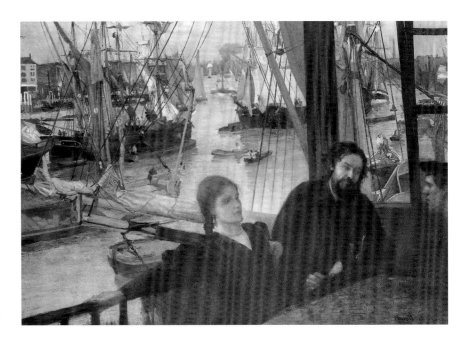

fig. 6 James McNeill Whistler *(American, 1834–1903)*
Wapping, 1860–64
Oil on canvas 72 x 101.8 cm
National Gallery of Art, Washington, D.C.
John Hay Whitney Collection

(cat. 104), and had peopled the foreground with two male fig-
ures. In the painting as he originally conceived it, and as he de-
scribed it in a letter in 1861, the female figure was depicted with
a deep décolletage, flaunting herself in front of the sailor on the
right of the canvas.[30] In this form, it was in a sense a travesty of
canvases like Stanhope's, presenting the "fallen woman" in a po-
sition of power, rather than as a victim. However, in the form in
which the picture was finally completed and exhibited at the
Royal Academy in 1864, the narrative had been eliminated, and
we are given no clear indication of the nature of the relationship
between the three figures on the balcony overlooking the river.

Beginning in the early 1860s, mist and fog became an in-
creasingly central element in Whistler's paintings of the
Thames. This new direction had a fundamental impact on the
ways in which the river was depicted over the next half century.
The first of these representations, *The Thames in Ice* (fig. 7),
painted in 1860, shows ships in the frozen river with factory
chimneys silhouetted in the mists on the horizon; the overall
tonality is dictated by the enveloping atmosphere. Here, there
is little sense of a specific location; in a sequence of views of the
river through the 1860s, detail is similarly subordinated to ef-
fect, but Whistler retained clearly recognizable topographical
features that located and characterized the scenes precisely.[31]
As in his docklands etchings, Whistler generally focused on the
older and more decayed features of the riverbanks, such as the
eighteenth-century wooden structure of Old Battersea Bridge
in *Brown and Silver: Old Battersea Bridge* (fig. 8), or on mundane
buildings, as in *Battersea Reach* (cat. 46). Even when he depicted
the building of the new Westminster Bridge in 1862, shortly be-
fore the beginning of the construction of the Embankment, he
gave the canvas the title *The Last of Old Westminster* (cat. 45), thus
highlighting the remains of the old bridge in the foreground,
rather than its successor, seen amid the scaffolding behind it.[32]

A fascinating fusion of the topographical with the atmos-
pheric appears in Wyllie's *London from the Monument* (fig. 9),
shown at the Royal Academy in 1870. The high viewpoint of-
fers a near-panoramic view of the city looking to the southwest:
beyond the shed and bridge of Cannon Street railway station
we see the industrial landscape of the south bank, with, in the
far distance at the center, the distinctive silhouette of the Hous-
es of Parliament. However, the treatment of the middle ground
and distance avoids the conventional precision of the topo-
graphical view, instead characterizing London by the successive
silhouettes of its buildings, receding into the distance, viewed

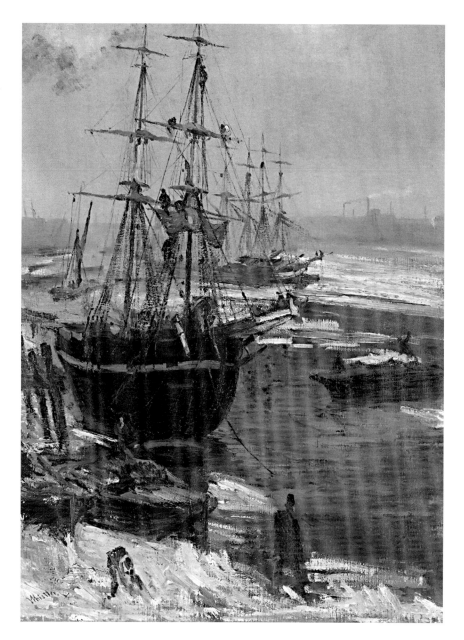

fig. 7 James McNeill Whistler *(American, 1834–1903)*
The Thames in Ice, 1860
Oil on canvas 74.6 x 55.3 cm
Freer Gallery of Art, Smithsonian Institution, Washington, D.C.
Gift of Charles Lang Freer

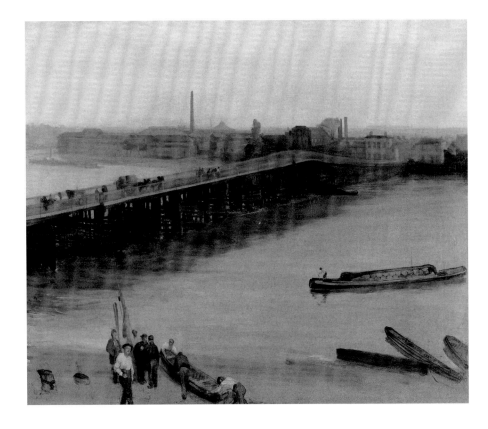

fig. 8 James McNeill Whistler *(American 1834–1903)*
Old Battersea Bridge, 1863 (brown and silver)
Oil on canvas 72 x 101.8 cm
Addison Gallery of American Art
Phillips Academy, Andover, Massachusetts
Gift of Mr. Cornelius N. Bliss

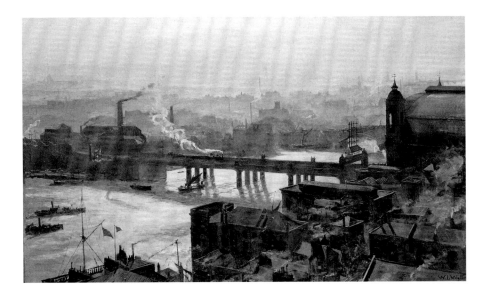

fig. 9 William Wyllie *(British, 1851–1931)*
London from the Monument, 1870
Oil on canvas 72.3 x 120.6 cm
Collection of Lord Lloyd Webber

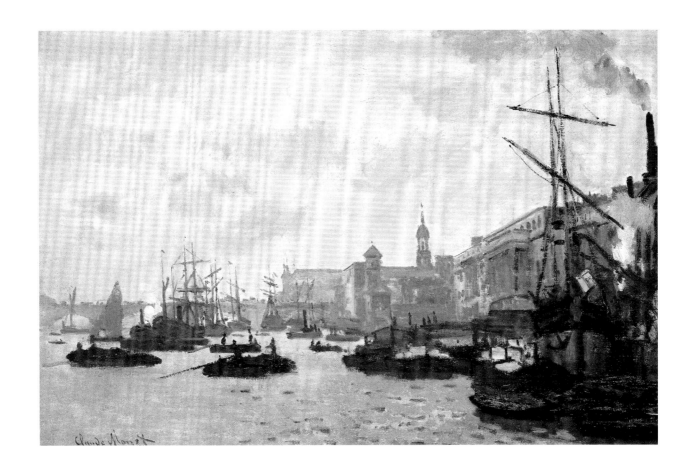

fig. 10 Claude Monet *(French, 1840–1926)*
The Thames at London, 1871
Oil on canvas 48.5 x 76.5 cm
National Museum and Galleries of Wales
Amgueddfeydd ac Orielau Cenedlaethol Cymru

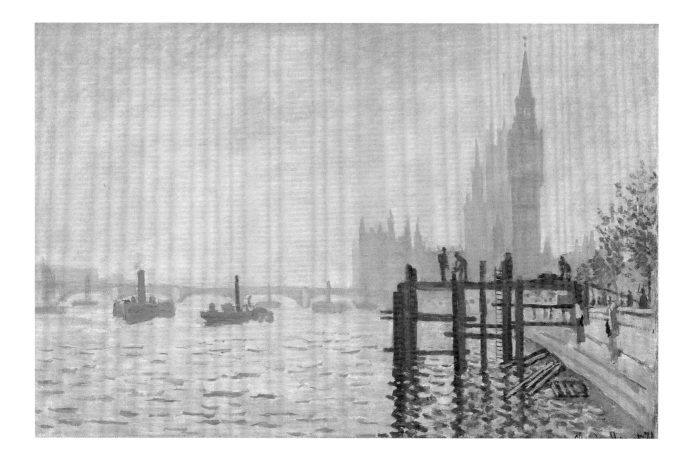

fig. 11 Claude Monet (*French, 1840–1926*)
The Thames below Westminster, 1871
Oil on canvas 47.6 x 73.8 cm
National Gallery, London

against the light through the city's distinctive smoky haze. This *contre-jour* view bears comparison with Claude Monet's paintings thirty years later of Charing Cross Bridge seen from the Savoy Hotel (cats. 23–27) though there is no evidence that he could have known Wyllie's canvas.

When Monet visited London for the first time in 1870–71 to avoid conscription during the Franco-Prussian War,[33] he chose two Thames sites to paint, the Pool of London (fig. 10) and the newly built stretch of the Embankment, looking toward the Houses of Parliament (fig. 11). The Pool is treated in ways that echo the accounts of the travelers, emphasizing the bustle of varied shipping, set against the backdrop of London Bridge, with the Customs House and the tower of the church of St. Magnus the Martyr on the right, and the long shed of Cannon Street Station beyond. By contrast, *The Thames below Westminster* shows an almost wholly new London: the Houses of Parliament, completed during the 1860s; the new Westminster Bridge; the still-unfinished St. Thomas's Hospital in the distance on the left; and, on the right, the Embankment itself—structurally complete, but without its decorative lamp-standards, and with the sharply silhouetted grid of what seems to be a landing-stage under construction.

If the Pool canvas represents the traditional travelers' view of the Thames, the other presents an absolutely up-to-date view of the "new" London, in its focus on urban improvements. However, both share one crucial feature—the misty atmospheric conditions: both pictures are exercises in variegated colored gray tones, punctuated by a few small more highly colored accents. These effects, and the treatment of the canvases in broad sweeps of quite liquid oil color, strongly suggest that Monet was aware of Whistler's contemporary work; it was at just this moment that Whistler was beginning his first Thames Nocturnes, such as *Nocturne in Blue and Silver: Cremorne Lights* (fig. 12).[34]

While in London, Monet was in contact with Charles-François Daubigny, whose vision of the Thames was similarly misty and atmospheric. *St. Paul's from the Surrey Side* (cat. 6) shows the cathedral above the newly rebuilt Blackfriars Bridge. On the right we see the old wharves and warehouses of the south bank, with a mass of coal-barges across the foreground, while the indistinct smudge along the far bank on the left shows the newly built Embankment. Unlike Monet, Daubigny did not foreground the changes that were transforming this reach of the river at this moment; in his landscapes of French

scenes, too, he rarely included explicit markers of modernity.

In Whistler's painted Nocturnes of the 1870s (cat.47, figs. 12–14) and his contemporary lithotints of the river (cats. 106, 108, 109), the forms are still more indistinct than in his Thames scenes of the 1860s. The choice of a nocturnal effect need not lead to the suppression of detail, as Atkinson Grimshaw's *The Thames by Moonlight with Southwark Bridge* (cat. 12) shows; but Whistler's consistent choice of misty conditions reduces the forms in the paintings to mere silhouettes. The paintings wholly reject the information-bearing function of topographical cityscape painting. Whistler himself described the values that he found in these night scenes in a famous passage in his "Ten O'Clock" lecture of 1885:

> And when the evening mist clothes the riverside with poetry, as with a veil, and the poor buildings lose themselves in the dim sky, and the tall chimneys become *campanili*, and the warehouses are palaces in the night, and the whole city hangs in the heavens, and fairyland is before us—then the wayfarer hastens home; the working man and the cultured one, the wise man and the one of pleasure, cease to understand, as they have ceased to see, and Nature, who, for once, has sung in tune, sings her exquisite song to the artist alone.[35]

As we have seen, these ideas were not new. Gautier had described the transformative effects of London's fogs in his 1842 essay, and in 1883 Aaron Watson anticipated one of the most striking images in Whistler's text, describing boats on the river seen "against a background in which warehouses and wharves seem to have no more substantiality than a dream. Whoever hurries by such a scene, and merely observes that 'it is a dull morning,' has yet to feel the power and to make acquaintance with the beauty of the Thames."[36] Watson also vividly evoked the effects of mist on the river in terms that parallel Whistler's:

> [T]here is a marvellous quality in our London atmosphere. It brings quite near to us the effects that we ordinarily associate with distance; it enfolds all ugliness in a purple haze, and subdues it. That row of dusky buildings, of various heights, and with tall chimneys looking like towers, makes the best of possible backgrounds for the vivid colours of the Thames barges... There is no portion of the Lower Thames which is more majestic and impressive that that which lies between the Houses of Parliament and Waterloo bridge... The farther bank is just far enough away to lose its natural harshness in

the softening influences of a dim atmosphere. On the south bank there is ugliness and squalor enough… everywhere great poverty is visible side by side with the sources and the materials of great wealth. One knows all this leaning over the Embankment and looking towards the Surrey side; but the knowledge of it does not disturb the picture, in which all that is ugly and dismal "glides into colour and form."[37]

It was Whistler who, in painting, most thoroughly realized this ambition to transform physical grime and squalor into pictorial beauty. Yet, as Watson's text reminds us, visions such as these cannot wholly shed the associations evoked by their material subjects. *Nocturne in Blue and Silver: Cremorne Lights* (fig. 12) includes no detail that allows us to identify the lights, seen on the right across the river from the distinctive silhouette of Battersea's church and factories; but local knowledge, together with the picture's title, would have told the picture's original viewers that this site was Chelsea's notorious pleasure ground, whose nocturnal entertainments were the subject of widespread moral anxiety in these years.[38]

Whistler himself was well aware that his paintings would be viewed and judged according to the stock criteria of the period. He wrote in "The Red Rag" in 1878:

The vast majority of English folk cannot and will not consider a picture as a picture, apart from any story which it may be supposed to tell. My picture of "A Harmony in Grey and Gold" is an illustration of my meaning—a snow scene with a single black figure and a lighted tavern. I care nothing for the past, present, or future of the black figure, placed there because the black was wanted at that spot. All that I know is that my combination of grey and gold is the basis of the picture. Now this is what my friends cannot grasp. They say, "Why not call it 'Trotty Veck' [a postman from Charles Dickens's *The Chimes*], and sell it for a round harmony of golden guineas?"—naïvely acknowledging that, without baptism, there is no… market! [...] Not even the popularity of Dickens should be invoked to lend an adventitious aid to art of another kind from his. I should hold it a vulgar and meretricious trick to excite people about Trotty Veck when, if they really could care about pictorial art at all, they would know that the picture should have its own merit, and not depend on dramatic, or legendary, or local interest.[39]

On one level, this is a declaration of his own categorical independence from these values; yet his choice of subject in this picture, *Nocturne—Grey and Gold Snow, Chelsea* (fig. 13), a solitary figure trudging through the snow to the brightly lit door of an inn, invites just the sort of anecdotal reading that the treatment of the picture, like Whistler's text, repudiates. Here, as in the Nocturnes, his aestheticization of the image of London gained its critical edge through the overt references to traditional imagery and stock chains of association.

Through his paintings, prints, and writings, Whistler's vision of London became highly influential from the later 1880s onward in the paintings and prints of younger artists, both British and American, such as Joseph Pennell (cats. 67–80), Theodore Roussel (cat. 82) and Thomas Way (cats. 91–93), and photographers such as Alvin Langdon Coburn (cats. 116–121). Oscar Wilde's seemingly paradoxical statement in 1889 was more justified than it appears at first sight:

Where, if not from the Impressionists, do we get those wonderful brown fogs that come creeping down our streets…? To whom, if not to them and their master [Whistler], do we owe the lovely silver mists that brood over our river, and turn to faint forms of fading grace curved bridge and swaying barge? The extraordinary change that has taken place in the climate of London in the last ten years is entirely due to this particular school of art.… One does not see anything until one sees its beauty. Then, and only then, does it come into existence. At present, people see fogs, not because there are fogs, but because poets and painters have taught them the mysterious loveliness of such effects. There may have been fogs for centuries in London. I dare say there were. But no one saw them, and so we do not know anything about them. They did not exist till Art had invented them.[40]

Only with the emergence of Whistler's "impressionist" aesthetic had it become possible to view the fog as something that deserved to be viewed in its own right; before that, it had merely been a cloak that hid the material objects behind it. In the same year, Wilde created a literary equivalent to Whistler's art in his poem "Symphony in Yellow," in which the viewer's sensory experiences of the foggy river alone are evoked, without any narrative content.[41]

However, the Thames continued to be viewed through these years in more emotive terms. In an earlier poem, "Im-

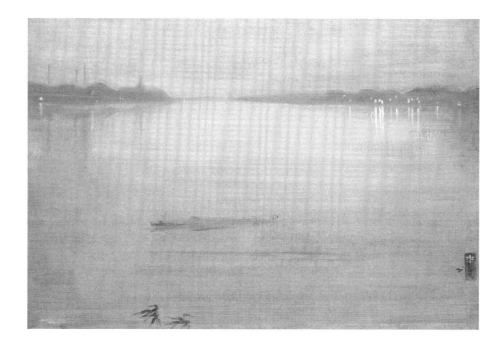

fig. 12 James McNeill Whistler *(American, 1834–1903)*
Nocturne in Blue and Silver: Cremorne Lights, 1872
Oil on canvas 50.2 x 74.3 cm
Tate Gallery, London

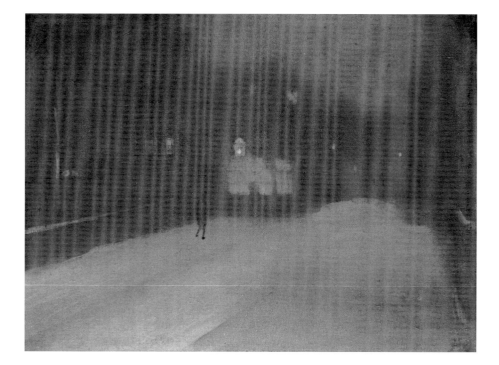

fig. 13 James McNeill Whistler *(American, 1834–1903)*
Nocturne—Grey and Gold Snow, Chelsea, 1876
Oil on canvas 46.36 x 62.87 cm
Courtesy of the Fogg Art Museum, Harvard University Art Museums
Bequest of Grenville L. Winthrop

pression du Matin," first published in 1882, Wilde had used the changing colors of the fog over the river as the scenario for an image of a solitary "pale woman... with lips of flame and heart of stone"—a clear descendent of the "fallen women" in paintings like Stanhope's.[42] In the early 1890s, W. E. Henley used the mood-landscape of London's fogs in a number of poems as the background for images of loss and death; one of these was dedicated to Whistler.[43] Likewise, Henry James was fascinated by the intersection of the aesthetic and the emotive that he found in London and on the Thames:

> I like [the river] best when it is all dyed and disfigured with the town and you look from bridge to bridge— they seem wonderfully big and dim—over the brown, greasy current, the barges and the penny-steamers, the black, sordid, heterogeneous shores. This prospect, of which so many of the elements are ignoble, etches itself into the eye of the lover of "bits" with a power that is worthy perhaps of a better cause.[44]

Most strikingly, Joris-Karl Huysmans in *A Rebours* (1884) used the image of London and the Thames as an imaginative figure for the desire of his "hero" Des Esseintes to escape from his world of private artifice and immerse himself in an apocalyptic landscape of urban modernity:

> The works of Dickens, which he had recently read in the hope of soothing his nerves, but which had produced the opposite effect, slowly began to act upon him in an unexpected way, evoking visions of English life which he contemplated for hours on end... Des Esseintes began dreaming of his coming journey. The appalling weather struck him as an instalment of English life paid him on account in Paris; and his mind conjured up a picture of London as an immense, sprawling, rain-drenched metropolis, stinking of soot and hot iron, and wrapped in a perpetual mantle of smoke and fog. He could see in imagination a line of dockyards stretching away into the distance... swarming with men... All this activity was going on in warehouses and on wharves washed by the dark, slimy waters on an imaginary Thames, in the midst of a forest of masts, a tangle of beams and girders piercing the pale, lowering clouds. Up above, trains raced by at full speed; and down in the underground sewers, others tumbled along, occasionally emitting ghastly screams or vomiting floods of smoke through the gaping mouths of air-

shafts... Des Esseintes shuddered with delight at feeling himself lost in this terrifying world of commerce, immersed in this isolating fog, involved in this incessant activity.[45]

Paintings by foreign visitors to London did not take up Huysmans's apocalyptic vision, but rather reinterpreted Whistler's aestheticized vision of London's atmosphere in terms of the vivid color of French Impressionist painting. Camille Pissarro in 1890, looking upstream from Waterloo Bridge, showed a sunlit panorama of the monumental Thames, crossed by the geometric forms of Charing Cross Bridge, with the Egyptian obelisk known as Cleopatra's Needle on the Embankment on the right, and the silhouettes of Westminster Abbey and the Houses of Parliament in the soft haze of the distance (cat. 38). By contrast, in 1892 the Belgian Georges Lemmen depicted an explicitly industrial scene in *Thames Scene, The Elevator* (cat. 18); the hazy background is reminiscent of Whistler, but the whole painting is treated in the small dot-like brushstroke of neo-impressionism. Later, in 1906–07, Henri Le Sidaner chose a subject close to the one that Daubigny had treated, but depicted the view of St. Paul's from the south bank in soft warm pastel hues (cat. 19).

It was Monet, however, who created the definitive impressionist vision of the Thames. After his first visit to London in 1870–71, he had the ambition to return and paint there again; in 1887, when invited by Whistler to contribute paintings to the exhibition of the Royal Society of British Artists, he wrote that he wanted to "try to paint some fog effects on the Thames."[46] However, it was not until 1899 that he found the opportunity; in three spells in London, in autumn 1899 and in the early months of 1900 and 1901, he began his series of Thames views.

In 1896, Whistler had executed a group of small lithographs (cats. 110–114) of views from the Savoy Hotel, newly erected overlooking the Embankment between Waterloo and Charing Cross Bridges, and it was very possibly Whistler's example that led Monet to establish his base at the Savoy Hotel during his time in London.[47] The hotel was evidently an ideal site for a painter who wanted to paint fogs on the Thames in conditions of relative comfort. Indeed the hotel itself used its panoramic views over the misty Thames as a central element in its advertising; Dudley Hardy's painting of the view from the hotel's roof terrace toward Charing Cross Bridge and the Houses of Parliament was reproduced on the cover of a publicity booklet for the hotel.[48]

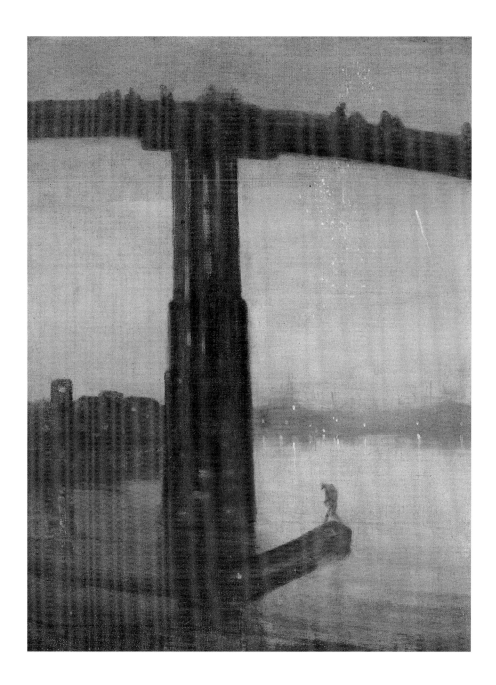

fig. 14 James McNeill Whistler *(American, 1834–1903)*
Nocturne in Blue and Gold: Old Battersea Bridge, 1872–77
68 x 51.2 cm
Tate Gallery, London

On his first visit, Monet painted only the views from the Savoy, looking east across Waterloo Bridge and the industrial landscape of the south bank, and south toward Charing Cross Bridge and the Houses of Parliament. In 1900 and 1901 he continued work on these motifs, but also undertook a series of canvases of the Houses of Parliament seen across the river from St. Thomas's Hospital—the hospital that had appeared in the misty distance in *The Thames below Westminster* (fig. 11; see also cat. 142), painted during his visit of 1870–71.

All in all, on his three visits Monet began around one hundred canvases. By this date he had adopted a serial method, seeking to complete sequences of canvases showing the same subjects in different effects of light and weather. His exhibitions over the prior ten years had been devoted to series conceived in this way, including those of grain stacks, exhibited in 1891, and Rouen Cathedral, exhibited in 1895. He told an interviewer in 1891 that his series paintings "only acquire their full value by the comparison and succession of the entire series."[49]

Monet was already well used to depicting changing light and misty conditions in northern France, but London's weather caused him particular problems. In letters from London to his wife, he expressed his frustration at the constantly changing light and fog;[50] and in 1901 he told an interviewer, "My practiced eye has found that objects change in appearance in a London fog more and quicker than in any other atmosphere, and the challenge is to get every change down on canvas."[51] Many years later, he recalled these experiences:

> At the Savoy Hotel, or at St. Thomas's Hospital, from where I took my viewpoints, I had over a hundred canvases on the go—for a single subject [*sic*]. By searching feverishly through these sketches I would choose one that was not too far away from what I could see; in spite of everything, I would change it completely. When I had stopped work, shuffling through my canvases I would notice that I had overlooked precisely the one which would have suited me best and which was at my fingertips. Wasn't it stupid![52]

The result of these problems was that, even after spending a total of more than six months in London, he felt that none of his canvases were ready for exhibition when he left the city at the end of his final visit. It was only three years later, in spring 1904, after extended periods reworking the paintings during the winters in his studio at Giverny, that he was prepared to declare the series complete and exhibit thirty-seven of the canvases.

In two crucial ways, Monet's London series was different from Whistler's Thames scenes. First, Whistler normally worked from memory, and distilled his experiences into a very small number of clearly individualized paintings, while Monet's methods, as he painted directly in front of the scene, led to the multiplication of canvases. Second, Whistler's vision of the Thames was essentially tonal and Monet's was colored.

It would be a mistake, however, to make a categorical distinction between Whistler's methods as "synthetic" and Monet's as "analytic." Certainly, Whistler was seeking to create canvases that conveyed the essence of what he saw in the scenery of the Thames at night, rather than focusing on the transitory effects of light and weather that preoccupied Monet. Yet Monet too, by this date, was seeking to go beyond the rapid sketch and, as he said in a conversation in 1892, to introduce "more serious qualities" into his paintings, in the hope that their viewers might be able to "live for longer" with them.[53] On one occasion in London, he voiced concern that some of the canvases that he had begun were "not London-like enough (*pas assez londoniennes*),"[54] indicating that he was trying to convey some essential quality in his Thames scenes that might be lacking in his everyday face-to-face experiences of London's weather effects.

When reworking the London paintings back in his Giverny studio, Monet was painting in part from what he had already notated on the canvases in front of the subject, in part from memory, and in part from his notion of what was "London-like." We do not know exactly how Monet developed and altered the London canvases, but many of them show signs of extensive reworking, both in the placing of their forms and in their color schemes. Moreover, he evidently completed the canvases by reference to each other; he wrote of them in March 1903: "For the work that I am doing it is indispensable to have them all before my eyes, and, to tell the truth, not one is definitively finished. I'm bringing them all along together, or at least a certain number of them."[55] We can assume that he was seeking to bring the group that he planned to exhibit into a state in which the canvases, both individually and as an ensemble, expressed his sense of the essential qualities of the fog-bound landscape of the Thames in winter.

Color was central to Monet's vision of London. He told an interviewer in 1901: "The fog in London assumes all sorts of colors; there are black, brown, yellow, green and purple fogs, and the interest in painting is to get the objects as seen

through all these fogs."[56] Fog in Whistler is a generically, essentially colorless veil, in Monet it acts as a dynamic and ever-changing agent in forming and re-forming the scene. The coloristic effects that are so central to Monet's Thames series are heightened by his use of sunlight. In each of the three groups of paintings, he generally painted *contre jour*, looking toward the sun, painting the view eastward over Waterloo Bridge from the Savoy in the morning, and southward over Charing Cross Bridge in the middle of the day, and then moving across the river to St. Thomas's Hospital to depict the sun setting over the Houses of Parliament. A very active presence, the sun is sometimes seen directly through the mists (cat. 30), sometimes unseen but inflecting them with warm hues (cats. 27, 33), and sometimes reflected on the water surface in the foreground (cats. 25, 30, 34, 35).

It seems likely that the final color effects of the finished paintings were the product of retouching in the Giverny studio. The completed paintings are very carefully coordinated in color; each canvas has a dominant scheme, and the same colors reappear in varied combinations all across the canvas. The signature on each painting is in a color that meshes with the painting's color scheme, often in the dominant color. The starting point for these complex color harmonies may indeed have been Monet's observations of light on the Thames, but the final results are an artful re-creation that goes far beyond any naturally observed effect.[57]

But what is the status of the subject matter in Monet's London series? In what sense was he engaging with the Thames itself, and with the multiple associations that it carried? He had first visited London during a phase of his career when he was exploring an explicitly contemporary form of landscape painting; the London paintings of 1870–71 fall readily into this pattern with their newly constructed buildings and overt markers of modernity. However, by the 1890s he had abandoned this project, and was instead preoccupied by what he described as "'instantaneity,' above all the enveloping atmosphere (*l'enveloppe*), the same light spread everywhere."[58] On a number of occasions after 1890, Monet insisted that the physical subjects that he painted were insignificant in his art: "For me, a landscape does not exist in its own right, since its appearance changes at every moment; but the surrounding atmosphere brings it to life, the air and the light, which vary continually.... For me, it is only the surrounding atmosphere that gives subjects their true value...."[59] On another occasion he commented:

"To me the motif itself is an insignificant factor; what I want to reproduce is what lies between the motif and me."[60]

The river series that Monet had exhibited shortly before returning to London to paint in 1899 showed a quiet backwater of the Seine in the mists of early morning. Color appears in the greens of the foliage and the varying tints of the emerging sunlight, while the mist acts as an essentially colorless veil. There is not a trace of the contemporary world in the pictures, which evoke a mood of stillness and contemplation. At the same time as he was painting London, he was embarking on his first series of the water-garden that he had built for himself at Giverny. These contemporary projects suggest that the London paintings should not be viewed as a return to an explicitly "modern life" aesthetic; and yet both the scenes that he painted there and the causes of London's multicolored fogs were explicitly modern.

Monet insisted that the fog was his prime interest in London:

> I adore London, it is a mass, an ensemble, and it is so simple. What I like most of all in London is the fog. How could English painters of the nineteenth century have painted its houses brick by brick? Those fellows painted bricks that they didn't see, that they couldn't see.... I so love London! But I only like it in the winter. In summer, it is fine with its parks, but that is no match for the winter with the fog, because, without the fog, London would not be a beautiful city. It is the fog that gives it its marvellous breadth. Its regular, massive blocks become grandiose in this mysterious cloak.[61]

In the paintings, everything is absorbed into the ambient atmosphere: the factory chimneys and the Gothic silhouette of the Houses of Parliament, the busy traffic on Waterloo Bridge, and the trains that cross Charing Cross Bridge. The elevated viewpoint in the pictures distances us from their material subjects, and their brushwork and richly harmonized color compositions further remove us from the physical experiences that were their starting points.

Moreover, Monet made one crucial alteration to the view of Charing Cross Bridge from the Savoy: in all the finished versions of the scene, he omitted Cleopatra's Needle, the ancient Egyptian obelisk that had been erected on the Embankment in 1878 and that punctuated the foreground of the view. In only two canvases (cat. 23; private collection, Cairo), presumably the first that he began, does the Needle appear, and neither of

these was exhibited with the other pictures from the series. It seems likely that he omitted the Needle because its insistent foreground form interrupted the overall atmospheric harmony that he saw as the essential element in the series.

However, the series does offer the possibility of alternative readings. Critics at the time could perceive the paintings as expressions of the essence of city life—the absorption of the individual into a vast anonymous organism. The omission of Cleopatra's Needle, emblem of British imperialist ambitions in the "Middle East," could also be interpreted politically.[62] As a Frenchman, Monet would probably not have been aware of the range of associations and meanings that British artists and writers found in the Thames. It is a pity that a planned exhibition of the series in London in 1905 did not materialize, since it would have been fascinating to know how far British critics sought to read the pictures in terms of local preoccupations.

The comments of Monet's friend the novelist Emile Zola, after his first visit to London in 1893, make a fascinating contrast with Monet's approach to the city. Zola agreed with Monet about the aesthetics of fog, as an article in an English newspaper noted: "Reminded of his experiences of a London fog, M. Zola said he believed that it suited the London landscape better than the sunlight. Westminster Abbey and the Thames looked heightened in artistic effects in its folds." But, beyond this, Zola expressed his fascination for the scale of London and the sense of power that it conveyed—responses far closer to those of French visitors earlier in the century:

[T]he big city made an indelible impression on my mind. Its beauty is not in its monuments, but in its immensity; the colossal character of its quays and bridge [sic], to which ours are as toys. The Thames from London Bridge to Greenwich I can only compare to an immense moving street of ships, large and small, something suggestive to the Parisian mind of an aquatic Rue de Rivoli. The docks are stupendous buildings, but what impressed me most were the splendid arrangements for unloading vessels, which came close up to the quays, and disembarked their cargoes into the shops as it were. One can understand the secret of London's greatness after having seen these things. The Thames is, in fact, the heart or stomach, if you like, of London, as the West End is the head of its wonderful organism.... On the whole, I came away from London with a profound admiration of its wealth, grandeur, and immensity. Each

bridge is a Cyclopean structure. We have nothing in France to equal such things, nothing to be compared to the port of London....[63]

Monet's distanced vision treated London not as a "wonderful organism" but as an aesthetic spectacle; in his series the visual experience of London is categorically cut off from the social.

In the wake of the success of the exhibition of Monet's London series at the gallery of Paul Durand-Ruel in Paris, the rival dealer Ambroise Vollard commissioned André Derain to visit London in 1906, in order to paint a more "avant-garde" series of London views. In one sense, the resulting pictures reflect the themes in this essay, but in another they present a startlingly different vision of the city.

The subjects that Derain chose to paint on the riverbanks fit closely into the patterns that we have been exploring. One group of paintings, perhaps the first to be executed, explores the area that Monet had painted in the recent series. However, unlike Monet, Derain approached the sites—the Houses of Parliament and Westminster and Charing Cross Bridges—from a wide range of viewpoints, on both sides of the river. In some canvases, such as *Big Ben, London* (cat. 8) and *The Houses of Parliament from Westminster Bridge* (cat. 7), the Houses of Parliament are the prime focus and the echoes of Monet's paintings are very direct; but in others, such as *Charing Cross Bridge, London* (National Gallery of Art, Washington, John Hay Whitney Collection), the bridge and parliament buildings are set beyond a foreground that highlights the busy commercial life of the warehouses on the south bank—a far cry from Monet's integrated and harmonized scenes.

In a number of canvases Derain turned to the Pool of London—painted, as we have seen, by Monet in 1870–71 and celebrated in almost every travel account. The recently built Tower Bridge often appears in the background (cat. 10), its distinctive silhouette treated more as a backdrop than as the focus of the composition, as it is in Wyllie's etching (cat. 115) executed soon after the bridge's completion.[64] The central feature in most of Derain's scenes of the Thames below Westminster is not the buildings and monumental bridges, but rather the river traffic and the activity on the banks; in his pictures of bridges, such as *London Bridge* (cat. 9), and of the Embankment, too, great emphasis is placed on the traffic that animates the scene. In these terms, his paintings belong more closely to the lineage of French paintings of modern urban life than Monet's did.

However, it was the color and execution of Derain's Thames paintings that thoroughly broke the mold. They are brilliantly and intensely colored, in a range of hues that sometimes hint at the results of direct observation, such as the misty blue back grounds in many of the paintings, but often they are blatantly anti-naturalistic, for instance the red and yellow Houses of Parliament in cat. 7 and the green silhouette of Tower Bridge in cat. 10. Derain had developed the use of vivid nonnaturalistic color while working with Henri Matisse at Collioure on the Mediterranean coast in summer 1905. But those experiments, as he described them in a letter to Maurice de Vlaminck, were crucially related to the problem of finding a pictorial equivalent for the effects of the sunlight of the south;[65] it was their Collioure paintings that led the artists to be named the Fauves. When reapplied to the misty atmosphere of London, this use of color lost its initial *raison d'être*. Derain's colored London becomes a world of imagination and fantasy that cannot be explained by any notion of naturalism. Likewise his brushwork—ranging from a loosely applied pointillism in *Big Ben, London* (cat. 8) to zones of flat bright color reminiscent of the work of Paul Gauguin—emphasizes the artifice of the making of the pictures and their autonomy as works of art. In the letters that he wrote to Matisse from London, Derain was preoccupied with the possibilities of developing a form of painting that abandoned its ties to direct representation of the visible world.[66]

Unlike Monet, Derain spent very little time in London when at work on his London paintings: he made two visits of less than two weeks each, in March 1906 and January–February 1907, during which he spent much time at the museums. He sold thirty London views—all of them substantial paintings—to Vollard in July 1907.[67] His recently published London sketchbook includes preparatory drawings for many of the paintings, and probably included others on pages that are now missing; many of the drawings precisely map out the compositions of paintings, and many also include handwritten verbal color notations.[68] The existence of these drawings, together with the very short time that Derain spent in London, raises the possibility that the paintings were largely, or even entirely, executed back in Paris; their execution is quite rapid, but it seems implausible that they were wholly executed on site. Certainly their bold schematic colors and draftsmanship are a far cry from Monet's painstakingly reworked surfaces and integrated color harmonies, and indicate a quite different approach to picture making and to the relationship between art and observation.

fig. 15 Gustave Doré *(French, 1832–1883)*
The New Zealander
Wood engraving from *London: A Pilgrimage,* London: Grant & Co., 1872
Museum of Fine Arts, St. Petersburg, Florida
(See also cat. 58)

Though Monet's pictures were reworked at Giverny, his consistent intention remained that they should suggest the effect of "London-like" atmospheric conditions. By contrast, although the forms of Derain's paintings demonstrate his close observation of actual sites on the Thames, their execution is a bold declaration of the categorical distinction between nature and art.

The Thames as it appeared in painting between the mid-nineteenth and early twentieth centuries was an epitome of the "modern" in art, but it represented the modern in two very different senses. In the mid-nineteenth century, the river was viewed as an expression of the essence of the life of London—of its commercial power, but also of the physical and moral degradation that accompanied the emergence of the first industrial metropolis. Through the rest of the century, this vision accompanied the emergence of another way of seeing the Thames—pioneered in painting by Whistler—in terms of aesthetic effect rather than as a social or moral exemplar. Monet's London series is the most comprehensive expression of this viewpoint. Derain's London paintings make a fascinating coda, in their renewed engagement with the busy everyday activities of Londoners, a theme that Whistler and Monet had shunned, coupled with a radically anti-naturalistic technique that insisted, unlike Monet's series, that a truly modern work of art was an autonomous creation, and in no way a reflection of the artist's experience of the external world.

* * *

In the later nineteenth century, a number of writers and thinkers, faced with the explosive pace of change that had accompanied the Industrial Revolution, speculated about the possible futures of London and the Thames. The end of Gustave Doré's *London: A Pilgrimage*, published in 1872, quotes Thomas Babington Macaulay's image of the New Zealander, a tourist in the far future, come to look on the ruins of London's grandeur, and pondering the end of empires. Doré's accompanying illustration (fig. 15) places the New Zealander on the banks of the Thames, peering across the river at the broken remains of London's warehouses and wharves, crowned by the shattered dome of St. Paul's Cathedral. In William Morris's *News from Nowhere*, published in 1890, the Thames-side warehouses and factories have been swept away and replaced by well-spaced and "fanciful" little buildings[69] but of course this Utopian vision of a post-industrial London turns out to be a dream. In a sense both visions have come true: the British Empire is no more, and the Thames is no longer flanked by docks and warehouses. The old buildings that have been demolished have, in the main, been replaced by housing—up-market residential developments—and those that have survived on the riverbanks have been converted into shopping arcades or entertainment complexes. The life beside the Thames after the end of Empire is scarcely the life of which Morris dreamed.

Over the years, I have discussed the issues raised in this essay with many friends and colleagues. I owe a special debt to Nancy Rose Marshall for sharing with me her thoughts and material about the representation of London, for reading the first draft of this essay, and for sharing the experience of London itself. I am indebted, too, to Fronia Simpson, whose wise comments helped me bring the essay to its final form. For a valuable discussion of Monet's London series in the context of London imagery, see *Monet in London*, exhibition catalogue by Grace Seiberling, High Museum of Art, Atlanta, 1988–89. See also Claire Hancock, *Paris et Londres au XIXe siècle: Représentations dans les guides de voyage*, Paris: CNRS, 2003.

1 Peter Cunningham, *Hand-Book of London, Past and Present*, London, 1850 (first published 1849), pp. 487–88.

2 Elisée Reclus, *Guide du voyageur à Londres et aux environs*, Paris, [1860], p. 12 (translated from Reclus's French text). Many foreign visitors began their accounts of London with a description of the approach up the river and the effect of the scene; see for example, Théophile Gautier, "Une Journée à Londres," *Revue des deux mondes*, April 15, 1842; Francis Wey, *Les Anglais chez eux*, new edition, Paris, 1856; Hippolyte Taine, *Notes on England*, London, 1872; the text in Gustave Doré and Blanchard Jerrold, *London: A Pilgrimage*, London, 1872, also adopts this as a rhetorical device.

3 See for example, Gautier, 1842; Wey, 1856; Taine, 1872.

4 Reclus [1860], p. 384.

5 Mr. and Mrs. S. C. Hall, *The Book of the Thames*, new edition, London, [1877] (first published 1859), p. 418.

6 Max Schlesinger, *Saunterings in and about London*, translated by Otto Wenckstern, London, 1853, pp. 137–38.

7 Schlesinger 1853, p. 32.

8 Charles Knight, "The Silent Highway," in Charles Knight (ed.), *London*, 1851, I, p. 15.

9 Charles Dickens, *Our Mutual Friend*, London, 1865, Book Three, Chapter Eight.

10 Wey 1856, p. 13.

11 Edmond Duranty, "Aspects de Londres," *Revue libérale*, May 10, 1867, p. 433.

12 James Morier, *Martin Toutrond; or, Adventures of a Frenchman in London*, London 1849, p. 33.

13 Flora Tristan, *Promenades dans Londres*, Paris, 1840, new edition, edited by François Bédarida, Paris: Maspero, 1978, p.72

14 Albert Rollo Russell, *London Fogs*, 1880, pp. 31–32.

15 See for example, Arthur Conan Doyle, "The Bruce-Partington Plans," first published in *His Last Bow*, London, 1917; the action in this story is set in 1895.

16 Benjamin Robert Haydon, *Autobiography*, London, 1853, quoted from new edition, Oxford, 1927, pp. 50–51. This autobiography, based on Haydon's diaries, was published after the painter's suicide in 1846.

17 Gautier 1842, p. 282; Gautier's essay was republished in his much-reprinted volume of essays *Caprices et zigzags*.

18 See Jonathan Ribner, "The Thames and Sin in the Age of the Great Stink: Some Artistic and Literary Responses to a Victorian Environmental Crisis," *British Art Journal*, vol. 1, no. 2, spring 2000, pp. 38–46.

19 For a diagrammatic cross-section of the Embankment, see Lynda Nead, *Victorian Babylon*, New Haven and London: Yale University Press, 2000, pp. 54–55.

20 See for example, George Frederick Watts, *Found Drowned*, c. 1850, Watts Gallery, Compton; Dante Gabriel Rossetti, *Found*, begun 1853, compositional drawing, British Museum, London, unfinished painting, Delaware Art Museum, Wilmington; the third picture in Augustus Egg's series *Past and Present*, 1858, Tate, London; Abraham Solomon, *Drowned!*

Drowned!, 1860, present whereabouts unknown; and Hablot K. Browne, "The River," illustration to Dickens, *David Copperfield*, August 1850. On the last three of these images, see Lynda Nead, *Myths of Sexuality: Representations of Women in Victorian Britain*, Oxford: Blackwell, 1988.

21 See *The Pre-Raphaelites*, exhibition catalogue, Tate Gallery, London, 1984, p. 174; Julia Thomas, *Victorian Narrative Painting*, London: Tate Publishing, 2000, p. 72; Ribner 2000, pp. 38–42. Ribner misidentifies the bridge in the distance as Blackfriars Bridge; the proximity of the Hungerford Suspension Bridge, together with the silhouettes of Nelson's Column, the Duke of York's Column, and the steeple of the church of St. Martin in the Fields, are all consistent with an identification of Waterloo Bridge; Stanhope's studio, from which the view was taken, was in Chatham Place, which flanked the northern approach to Blackfriars Bridge before the construction of the Embankment, a further confirmation that the bridge seen in the background here must be Waterloo, not Blackfriars.

22 Reverend Robert Gwynne (ed.), *Charles Taylor's Illustrated Guide to London and its Suburbs*, London, [1897], p. 198; the text also appears in George Frederick Pardon, *Routledge's Guide to London and its Suburbs*, revised edition, London, 1867, p. 172. I owe this quotation to Jennifer Hardin, and the earlier reference to Nancy Rose Marshall.

23 Gautier 1842, p. 275.

24 Wey 1856, p. 17.

25 Charles Dickens, *Dickens's Dictionary of the Thames, from its Source to the Nore*, London, 1883, p. 239.

26 For discussion of O'Connor's painting, see Nead 2000, p. 56.

27 "The Royal Academy (Fifth and Concluding Article)," *Athenaeum*, June 16, 1883, p. 769. I owe this reference to Nancy Rose Marshall.

28 See Michael Wentworth, *James Tissot*, Oxford: Clarendon Press, 1984, pp. 108–10; *The Image of London: Views by Travellers and Emigrés*, exhibition catalogue by Malcolm Warner, Barbican Art Gallery, London, 1987, p. 155; *James Tissot: Victorian Life – Modern Love*, exhibition catalogue by Nancy Rose Marshall and Malcolm Warner; American Federation of Arts, Yale University Press, 1999, Yale Center for British Art, New Haven, 1998, p. 66; for a more extended discussion, see Nancy Rose Marshall, *"Transcripts of Modern Life": The London Paintings of James Tissot, 1871–1882*, Ph.D. dissertation, Yale University, 1997, pp. 42–63.

29 Dickens, *Our Mutual Friend*, Book One, Chapter Three, quoted in Katharine A. Lochnan, *The Etchings of James McNeill Whistler*, New Haven and London: Yale University Press, 1984, p. 81. For an overview of the image of East London and the fears its aroused, see Judith R. Walkowitz, *City of Dreadful Delight: Narratives of Moral Danger in Late-Victorian London*, Chicago: University of Chicago Press, 1992, pp. 26–34; Blanchard Jerrold's chapter on "The Docks" in Doré and Jerrold 1872, pp. 27–32, gives a sense of this climate of physical and moral fear.

30 See Robin Spencer, "Whistler's Subject Matter: Wapping 1860–1864," *Gazette des Beaux-Arts*, October 1982, pp. 131–42 (letter published on pp. 132–33).

31 See *Turner Whistler Monet*, exhibition catalogue, Art Gallery of Ontario, Toronto / Grand Palais, Paris / Tate, London, 2004–05, pp. 120–25.

32 On Whistler's attitude toward London's urban "improvements," see Robin Spencer, "The Aesthetics of Change: London as Seen by James McNeill Whistler," in *The Image of London: Views by Travellers and Emigrés*, exhibition catalogue by Malcolm Warner et al, Barbican Art Gallery, London, 1987, pp. 49–72.

33 On the details of this visit, see John House, "New Material on Monet and Pissaro in London in 1870–71," *Burlington Magazine*, October 1978.

34 Any knowledge of Whistler's work must have been through personal contact, since Whistler did not exhibit any paintings in London during Monet's stay there; however, there is no documentary evidence that they met at this point.

35 *Mr. Whistler's "Ten O'Clock,"* first published London, 1888, reprinted in Whistler, *The Gentle Art of Making Enemies*, London, 1890, p. 144.

36 Aaron Watson, "The Lower Thames, I," *Magazine of Art*, September 1883, p. 487.

37 Aaron Watson, "The Lower Thames, III," *Magazine of Art*, March 1884, p. 109.

38 On Cremorne and its reputation, see Nead 2000, pp. 109–46.

39 Whistler, "The Red Rag," 1878, reprinted in *The Gentle Art of Making Enemies*, 1890, pp. 126–27.

40 Oscar Wilde, "The Decay of Lying," first published in *Nineteenth Century*, January 1889; here quoted from revised version in *Intentions*, 1891, p. 40.

41 Oscar Wilde, "Symphony in Yellow," first published in *Centennial Magazine* (Sydney) I, February 5, 1889.

42 Oscar Wilde, "Impression du Matin," first published in *Poems*, London, 1882.

43 W. E. Henley, "Largo e mesto" ("Out of the poisonous east…"), number four of his *London Voluntaries*, 1890–92, views the fogs in terms of pestilence and death; it was titled "Fog" when published in W. E. Henley (ed.), *A London Garland*, London and New York, 1895, pp. 201–3. Henley's "Nocturn" ("Under a stagnant sky…") was accompanied by a reproduction of a Whistler Nocturne in *A London Garland*, p. 195, and was dedicated to Whistler when republished in *Poems*, London, 1898, pp. 229–30.

44 Henry James, "London," *Century*, December 1888, p. 237.

45 Joris-Karl Huysmans, *A Rebours*, 1884, translated by Robert Baldick as *Against Nature*, Harmondsworth, 1959, pp. 132–34.

46 Letter from Monet to Théodore Duret, October 25, 1887, in Daniel Wildenstein, *Claude Monet: Biographie et catalogue raisonné*, Lausanne: La Bibliothèque des arts, III, 1979, letter 797.

47 See *Turner Whistler Monet* 2004–05, pp. 184–87.

48 *Homes of the Passing Show*, London, 1900, cover illustration reproduced in Eric Shanes, *Impressionist London*, New York: Abbeville, 1994, p. 95.

49 W. G. C. Bijvanck, *Un Hollandais à Paris en 1891: Sensations de littérature et d'art*, Paris, 1892, p. 177.

50 These letters are published in Daniel Wildenstein, *Claude Monet: Biographie et catalogue raisonné*, Lausanne: La Bibliothèque des arts, IV, 1985.

51 E. Bullet, "Macmonnies, the sculptor, working hard as a painter," *The Eagle* (Brooklyn), September 8, 1901.

52 Monet, as quoted in Duc de Trévise, "Le Pèlerinage de Giverny," *Revue de l'art ancien et moderne*, February 1927, p. 126.

53 Theodore Robinson, Diary, June 3, 1892, Frick Art Reference Library, New York; on this passage, see John House, *Monet: Nature into Art*, New Haven and London: Yale University Press, 1986, pp. 220–25.

54 Letter from Monet to Alice Monet, March 25, 1900, in Wildenstein 1985, letter 1521.

55 Letter from Monet to Paul Durand-Ruel, March 23, 1903, in Wildenstein 1985, letter 1690.

56 Bullet 1901.

57 On Monet's signature and his use of the studio, see House 1986, pp. 151–53, 178–79.

58 Letter from Monet to Gustave Geffroy, October 7, 1890, in Wildenstein 1979, letter 1076.

59 Bijvanck 1892, p. 177.

60 Interview with H. Johsen in Norway in 1895, quoted in French translation in Jean-Paul Hoschedé, *Claude Monet, ce mal connu*, Geneva: Pierre Cailler, 1960, p. 110.

61 René Gimpel, *Journal d'un collectionneur, marchand de tableaux*, Paris: Calman-Lévy, 1963, pp. 88, 156, diary entries for November 28, 1918, and February 1, 1920.

62 I owe this point to Nancy Rose Marshall.

63 "Emile Zola interviewed after his visit to London, the Guardian October 3, 1893," *Guardian*, January 3, 2004.

64 Wyllie had also executed a monumental canvas of the ceremonial opening of Tower Bridge in 1894 (Guildhall Art Gallery, London), clearly intended as a form of modern history painting, and as a tribute to Constable's *Opening of Waterloo Bridge*.

65 Letter from Derain to Vlaminck, July 28, 1905, in André Derain, *Lettres à Vlaminck*, Paris: Flammarion, 1955, pp. 154–55.

66 Derain's letters to Matisse and Vlaminck from London are published in full in Rémi Labrousse and Jacqueline Munck, "André Derain in London (1906–07): letters and a sketchbook," *Burlington Magazine*, April 2004, pp. 243–60; see especially the letter from Derain to Matisse, between March 7 and March 15, 1906, published here, pp. 254–56. This article is a crucial reexamination of the evidence about Derain's visits to London.

67 See Labrousse and Munck 2004, pp. 245–46 and note 19.

68 See Labrousse and Munck 2004, pp. 250–52, 257–60.

69 William Morris, *News from Nowhere and Other Writings*, new edition, London: Penguin, 1993, p. 48; I am indebted to David Faldet for drawing my attention to the role of the Thames in *News from Nowhere*, in a talk in the symposium "Impressionism and the Aesthetics of Pollution," at the Art Gallery of Ontario, Toronto, June 2004, in connection with the exhibition *Turner Whistler Monet*.

The Lu(c)re
of London

FRENCH ARTISTS AND ART DEALERS IN THE BRITISH CAPITAL, 1859–1914

Petra ten-Doesschate Chu

"must absolutely go to England every year instead of going to Paris." Thus the French painter Gustave Courbet wrote to his sister in 1859, suggesting that he would have a better chance to exhibit and sell his paintings in London than in his home town.[1] Though he failed to heed his own advice, Courbet was not mistaken.[2] England was on the verge of an art market boom that, from an economic point of view, would make the country attractive for European as well as American artists in decades to come. Beginning in the early 1860s, they would travel in increasing numbers to London, departing, more often than not, from Paris. London offered the best economic climate for the arts, but Paris would long remain the foremost center of art training. It also retained, at least until World War I, the reputation of a place conducive to creativity for its history, its physical beauty, its museums, and its ambiance of cafés, dance halls, and cabarets. For the novelist Léon Gozlan, writing in the *Nouveau Tableau de Paris* (1834), London was the Thames, meaning commerce and industry, but Paris was the Louvre—art, beauty, and entertainment.[3] Hence the trajectory of many young artists, both French and non-French, who would study in Paris at the famed Ecole des Beaux-Arts or in one of the many private ateliers in the city (such as the Ateliers Julian or Colarossi),[4] then travel to London in hope of making sales. Whether or not they were successful in their commercial ventures, many of them became drawn to the modern grandeur of its urban landscape. The Thames with its bridges and its busy boat traffic; the Houses of Parliament, mysteriously veiled in London's famous "smog"; the sprawling public parks so different from the formal *jardins* in Paris; even the docks in London's East End—all had the fresh appeal of modernity.[5] And for some artists, such as James McNeill Whistler, Camille Pissarro, Claude Monet, and André Derain, the experience of the modern beauty, or perhaps we should say the sublimity, of London, had a decisive impact on their work, helping to give it "a resolutely modernist turn."[6]

The International Exposition of 1855
and the French Perception of the British Art Scene

In 1855, the government of Napoleon III organized France's first major international exposition in response to the highly successful Crystal Palace Exhibition in London four years earlier.[7] The French knew they could not compete with the British in the fields of technology and industry, the products of which had been shown to splendid effect in the Crystal Palace. Hence it was decided to create a new focus for the Paris exhibition by adding a major international art show, housed in its own building. Twenty-eight nations were represented in the Palais des Beaux-Arts, where their artistic accomplishments were measured against one another. Though the French had made sure that they would dominate the show, the British also cut a striking figure. Indeed, the British school was singled out by many Parisian critics as the only one that could rival the French, because it had not succumbed to its influence.[8]

Unlike the French exhibit, which was centered on grand-style history painting, the British show was dominated by genre pictures. Both its admirers and detractors saw the predominance of this "lower genre" over history painting as a consequence, at once, of the limited control of the British Academy and of a different patronage system. In France, the major art patrons during the middle of the nineteenth century were the state and the church; British artists were working primarily for the art market. Their works were bought by bourgeois collectors who preferred genre paintings, as well as portraits, landscapes, and still lifes, over paintings of historical and biblical scenes. While conservative French critics felt that this "submission to the whims of rich collectors" was the cause of the decline of British art, progressive ones saw the existence of a flourishing art market as a positive sign. They argued that it gave British artists an independence that their French counterparts lacked.[9] For French artists, the liberal stance of the Royal Academy, the presence of many alternative exhibition opportunities, and the realization of the existence of an art market catering to bourgeois collectors made London a place of great interest.

Artists' Moves from Paris to London, 1859–1870

Beginning in the middle of the century, French artists increasingly looked to London as a place to showcase and sell their works. The city offered numerous exhibition possibilities. Besides the annual exhibits of the Royal Academy (founded 1760), which were the British counterpart of the French Salons, there were the periodic shows of the British Institution (1806–1867), the (Royal) Society of British Artists (founded 1824), the Royal Watercolour Society (founded 1805), and the Royal Institute (founded as the New Water-colour Society in 1832). Additional art clubs and exhibition societies were established, and by the mid-1880s there were about forty such associations in England and Scotland,[10] a far cry from Paris where

fig. 16 Henri Fantin-Latour *(French, 1836–1904)*
Homage to Delacroix: Cordier, Duranty, Legros, Fantin-Latour, Whistler, Champfleury, Manet,
Bracquemond, Baudelaire, A. de Balleroy, 1864
Oil on canvas 160 x 250 cm
Musée d'Orsay, Paris

In this painting, the three members of the Société des trois are prominently shown on the left side of
Delacroix's portrait. Fantin, dressed in a white blouse, is seated between Legros, standing behind him
to the left, and Whistler, standing in front of him on the right.

the exhibition society of the impressionists, the Société anonyme des artistes, peintres, sculpteurs, graveurs, etc., was still considered pioneering when it was founded.

In addition to numerous group shows, London had a long tradition of private one-person exhibitions.[11] In the eighteenth century, artists such as John Singleton Copley, Henry Fuseli, and Benjamin West had organized periodic exhibitions of one or more of their own works. This practice continued in the nineteenth century and proved attractive to French artists. In 1820, Théodore Géricault showed his *Raft of the Medusa* (Paris, Musée du Louvre) in Bullock's Roman Gallery in London, before touring it in the British provinces.[12] More than forty years later, Gustave Courbet arranged a tour of his scandalous painting *The Return from the Conference* in England.[13] And though he never acted on it, Edouard Manet gave serious consideration to a private show in London in 1868.[14] Apparently, there was enough of an art public in London, both in terms of spectators and patrons, to support these many and varied exhibitions, as well as those organized by art dealers, about which we'll have more to say later.

To take advantage of the possibilities offered by London, the American artist James McNeill Whistler, who had been living in Paris since 1856, decided to move to England in 1859. As a student in the atelier of Charles Gleyre, he had met several British art students, including Edward Poynter, Thomas Armstrong, and George Du Maurier, who must have briefed him about the London art scene.[15] When his first major painting, a large-scale genre picture called *At the Piano* (Cincinnati, Taft Museum), was refused by the jury of the 1859 Salon, Whistler may have thought that his chances of having his works shown and sold would be better in London.[16] He was right. The following year, *At the Piano* was hung in the Royal Academy exhibition and bought by the Scottish painter John Phillip. Meanwhile, Whistler had taken rooms in Wapping on the Thames and had embarked on a series of etchings of life on and near the river. Shown in Paris in 1861, the *Thames Set* was the first sustained effort by a non-British artist to capture the modern beauty of the Thames River (see cats. 95–104).

While still in Paris, Whistler had met two Greek students, the brothers Luke and Alexander ("Alec") Ionides. Back in London, they introduced Whistler to their father, Alexander, who was a major patron of contemporary art. By then, Alec and Luke had themselves begun to collect art and both became patrons of Whistler, buying some of his most important works and introducing him to other art lovers in the Greek community of London, such as the Spartalis and the Dilbergoglous. These collectors liked to surround themselves with artists and often bought from them directly rather than through the intermediary of dealers.

In 1858, Whistler had closely befriended two French artists, Henri Fantin-Latour and Alphonse Legros, with whom he had formed the Société des trois (Society of Three; fig. 16). After his move to London, he encouraged them to join him. Fantin, whose paintings had likewise been refused by the jury of the 1859 Salon, crossed the Channel in July of that same year. Though his first visit did not lead to any sales, Fantin returned to England in 1861 to stay with a judge-turned-artist, Edwin Edwards. At Edwards's house in Sunbury, he painted several still lifes, which were admired by everyone who saw them. This prompted Fantin to ask Edwards to send one of his still lifes to the Royal Academy exhibition in 1862. In the meantime, Whistler, acting as Fantin's agent, showed some of them to his collector friends. In 1864, he convinced Fantin to bring several still lifes, almost all of which found buyers in London. Henceforth, Fantin regularly sent still lifes to the Royal Academy exhibitions, submitting a total of sixty-eight between 1862 and 1890 (see appendix). He made four trips to London, the last in 1881, but was never tempted to move there. Lacking all interest in outdoor scenery, he seems to have stayed away from the Thames, limiting his sightseeing to museums. But if there are no landscape paintings to commemorate his London trips, he did paint several portraits in England, including one of Mrs. Edwards (Paris, Musée du Petit Palais) and another of Mrs. Potter, the wife of a Manchester industrialist (whereabouts unknown). In 1864, he made an etching of Edwards and his wife playing music, which he entitled *A Piece by Schumann* (fig. 17).[17] It offers a glimpse into the daily life of the well-to-do and educated bourgeoisie that collected modern art in Victorian England.

Legros, the third member of the Société des trois, traveled to London in 1863. Though his works were well received by Parisian critics, he had been unable to sell them in France. Whistler introduced him to the Greek community in London. As a result, the Ionides, and especially Constantine, the older brother of Alec and Luke, became important patrons of Legros. Like Whistler, Legros eventually settled in England where, in 1876, he became a professor at the Slade School.

Several other French artists explored England in the 1860s

as a market for their work. Among those who sent works to the British Academy exhibitions were Rosa Bonheur and her two brothers François-Auguste and Jules Isidore, Félix Bracquemond, Jean-Baptiste Corot, Charles-François Daubigny, Emil Signol, and François-Xavier Winterhalter (see appendix). Some artists even traveled to London to explore the art market firsthand. Daubigny, for example, visited London in 1865, with the dealer and print publisher Alfred Cadart. He returned in 1866 and made several drawings and watercolors in London, some of which became the basis for finished paintings executed upon his return to France. Among these were *The Thames at Erith*, now in the Louvre (fig. 18) and the *Thames at Woolwich* (current whereabouts unknown), which Daubigny exhibited at the Royal Academy exhibition in 1867. *St. Paul's from the Surrey Side* (cat. 6), was the product of a later trip, undertaken in October 1870 to escape the Franco-Prussian War. During his stay in London, which was to last until May 1871, Daubigny made a number of sketches. Some of these served as the basis of finished paintings, executed even as late as 1873, which is the date inscribed on *St. Paul's from the Surrey Side*.

While several French artists were trying to gain a foothold in London on their own, some English dealers also promoted French art in the British capital. Foremost among them was the Belgian-born Ernest Gambart (see fig. 19). The son of a printer and bookseller in Courtrai, Gambart had moved to Paris in his late teens. There he became interested in the print trade. As a representative of the well-known printselling firm of Adolphe Goupil, he moved to England in 1840 to sell prints after French paintings. Before long, however, he decided to strike out on his own, starting a business that combined the sale of reproductive prints and authentic works of art. Beginning in 1846, Gambart regularly organized exhibitions of contemporary artists in his gallery at Pall Mall, which would become extremely successful, thanks to his clever cultivation of art critics and wealthy art patrons.[18]

Taking advantage of his Belgian background, Gambart regularly showed French, Belgian, and Dutch paintings, though his mainstay was British art. To mark the rapprochement between France and England as a result of the Crimean War, he began, in 1854, a series of yearly exhibitions of French art, which caused his gallery to become known as the "French Gallery." For the most part these group shows featured the works of academic and *juste-milieu*, or "middle-of-the-road," artists such as François Biard, Alfred Dedreux, Edouard

fig. 17 Henri Fantin-Latour *(French, 1836–1904)*
A Piece by Schumann, September 1864
Etching in brown ink with plate tone on paper
24 x 34.6 cm plate: 18.6 x 27.7 cm
National Gallery of Canada, Ottawa

This etching represents Fantin-Latour's British friends and patrons Edwin Edwards and his wife, Ruth, making music together in their house at Sunbury, where the artist visited them several times.

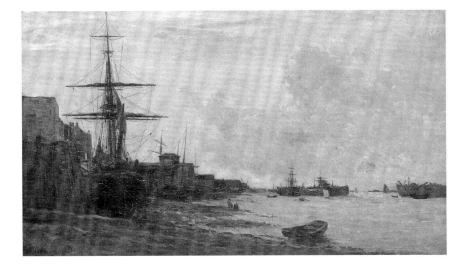

fig. 18 Charles-François Daubigny *(French, 1817–1878)*
The Thames at Erith, 1866
Oil on wood panel 38 x 67 cm
Museé du Louvre

fig. 19 Sir Lawrence Alma-Tadema *(British, 1836–1912)*
The Picture Gallery, 1874
Oil on canvas 218.4 x 166.4 cm
Townley Hall Art Gallery, Burnley, Lancashire, England

The painting was commissioned by Ernest Gambart for his house in Nice.
Gambart himself is standing in the center. His nephew Charles Deschamps is in the lower left,
leaning forward to inspect a painting.

Dubufe, Edouard Frère, Jean-Auguste-Dominique Ingres, Ernest Meissonnier, Antoine Plassan, and Ary Scheffer. Gambart also promoted the artists of the Barbizon school, notably Jules Dupré, Théodore Rousseau, and Constant Troyon,[19] and he represented some realist painters, most importantly Fantin-Latour, whose *Homage to Delacroix* (fig. 16) he bought in 1864.[20] Realizing the popularity of animal painting in England, Gambart aggressively promoted French *animaliers*.[21] Rosa Bonheur, painter of the famous *Horse Fair* (New York, Metropolitan Museum of Art), became his "special project" to the mutual benefit of both.[22]

The Franco-Prussian War and French Artists' Discovery
of London's Urban Landscape

The years 1870 and 1871, saw something of an exodus of artists from Paris. They traveled to England to escape military service and the dangers of the Franco-Prussian War, as well as to find a place where they could work in peace and, hopefully, sell their works—something that seemed impossible in Paris as the city was ravaged first by the Prussians, then by the civil war that was the Commune. Among the numerous artists who went to England were François Bonvin, Charles Daubigny, Jean-Léon Gérôme, Ferdinand Heilbuth, Claude Monet, Camille Pissarro, Guillaume Régamey, Jules de la Rochenoire, and Edmond Wagrez.[23] Others, who participated in the Commune, left Paris later, in order to escape the punishments and retributions that were meted out to ex-communards. The painter James Tissot may have been one of them.[24]

Though several of these artists initially contemplated living in London for a long time or even permanently, most of them ended up staying for no more than a year, leaving as soon as order had returned to France. Unable to speak English, they felt alienated in London and disappointed by the lack of interest in their art. Bonvin wrote to his dealer Hector Brame, who had taken refuge in Belgium, "I had intended to try to support myself in London, but the trouble I've had making myself understood is leading me to abandon the idea."[25] Pissarro was even more disenchanted. To his friend Théodore Duret he wrote:

> Indeed, my dear M. Duret, I won't stay here. Only when one is abroad, one realizes how beautiful, grand, and hospitable France is. What a difference with this place, where we encounter nothing but contempt, indifference, and even incivility; [and], among colleagues, jeal-

ousy and the most selfish diffidence. Here, there is no art, it is all a matter of business.[26]

With all their misgivings about the London art world, Bonvin and Pissarro both became fascinated with the city's urban scenery. Bonvin made a series of drawings and watercolors of the Thames (fig. 20), which, back in France, he would translate into finished paintings.[27] Pissarro, who lived in the suburb of Lower Norwood, painted several small canvases representing local scenery, as well as some well-known London sights, such as *Dulwich College* (private collection) and *The Crystal Palace* (fig. 21). These works, as well as some paintings by Monet of the Pool of London, the wide section of the Thames at the western end of the former London Docks (see fig. 10) are among the first impressionist paintings to feature industrial progress. In addition to the Crystal Palace, emblematic of this theme, they show harbors, trains, and factories.[28]

While some French artists felt alienated in London, others felt right at home. Gérôme, who had been an honorary member of the Royal Academy since 1869, was represented in its exhibitions in 1870 as well as 1871.[29] He had many friends in England and good connections with dealers, such as Henry Wallis, who had taken over Gambart's French Gallery in 1867, and the people at Goupil's. Gérôme's meticulously detailed orientalist genre scenes were well received in London, in part because they already were known through print reproductions that were widely circulated in England.[30]

James Tissot also had some contacts in London when he arrived. Having drawn cartoons for *Vanity Fair*, he knew the magazine's owner, Thomas Gibson Bowles, who introduced him to artists and collectors in London. Tissot welcomed the market opportunities in London and decided to stay in England, at least until 1882.[31] Like Gérôme, Tissot had already exhibited at the Royal Academy.[32] He now resumed doing so, exhibiting sixteen paintings between 1872 and 1881. *The Thames* (1876; cat. 44), a painting in this exhibition, was among the works he showed there. This highly finished picture of fashionable life in London, with its mild erotic tinge, exemplifies the style and subject matter that made Tissot popular in London. It is interesting to note the dramatic difference between his vision of the Thames and that of Bonvin, Monet, and even Whistler. While those artists foregrounded commercial activity, labor, and industry, Tissot pushed these elements to the background to prominently feature the bourgeois leisure life that they made possible. It is no wonder that the captains of industry, who were

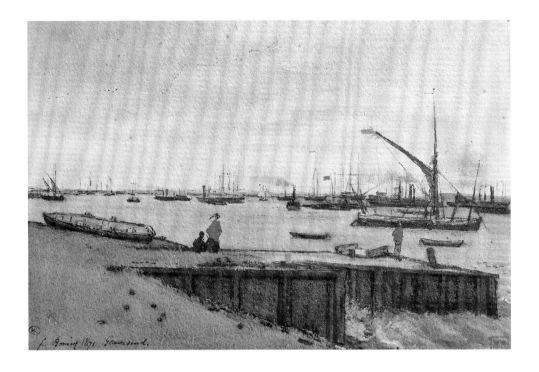

fig. 20 François Bonvin *(French, 1817–1887)*
Gravesend, 1871
Watercolor and pen and ink on paper 15.8 x 23.8 cm
Musée du Louvre

fig. 21 Camille Pissarro *(French 1830–1903)*
The Crystal Palace, 1871
Oil on canvas 47.2 x 73.5 cm
The Art Institution of Chicago
Gift of Mr. and Mrs. B. E. Bensinger

the major art collectors in England, preferred the works of Tissot over those of his French colleagues. They would rather contemplate the fruits of labor than labor itself.

Just as Whistler had tried to persuade his friends Fantin-Latour and Legros to come over to England, so Tissot worked on his close friend Edgar Degas.[33] The latter had made a brief trip to London in October 1871, during which he had been in touch with both Whistler and Legros. A year later, he had traveled to Liverpool to board the *Scotia* bound for the United States. After a visit with family living in New Orleans, he wrote to Tissot that he had "acquired the taste for money."[34] With that in mind, he seriously considered moving to London, where he felt there might be a market for his work. Indeed, his *Cotton Market at New Orleans* (Pau, Musée des Beaux-Arts), conceived in New Orleans but finished in Paris, was made with a British buyer in mind. In February 1873, he wrote to Tissot that it was "destined for Agnew," a reference to the well-known gallery of Thomas Agnew and Sons, which had its main branch in Manchester. Degas felt that Agnew would have a good chance of selling it to the wealthy spinning-mill owner and art collector William Cottrill, which, as he wrote, "would suit me and would suit Agnew even better."[35] None of these plans materialized, however. Degas had miscalculated the interest of British collectors in industrial scenes. The *Cotton Market* was bought, instead, by the museum at Pau, which delighted Degas, who found it "terribly flattering" for his work to enter a public collection.[36] The artist renounced his contemplated move to London, which, like most of his French contemporaries, he saw as a dirty industrial city. In a letter to Tissot he wrote that if he ever were to move to London, he would have to "sweep the said place a little, and clean it by hand."[37]

Durand-Ruel and Impressionism in London

If artists saw London as a better marketplace than Paris-in-ruins, so did art dealers. At the outbreak of the Franco-Prussian War, Paul Durand-Ruel (fig. 22) moved the contents of his gallery from Paris to London. With the assistance of Henry Wallis, the new owner of the French Gallery, he found a temporary storage and exhibition space at 7 Haymarket.[38] There, in November, he held a makeshift exhibition of works in his stock, for the most part paintings by Barbizon and realist artists, including, among others, Gustave Courbet, Camille Corot, César de Cock, Daubigny, Dupré, Rousseau, and Georges Bellenger.[39] In December, Durand-Ruel found better

fig. 22 Anonymous
Portrait of Paul Durand-Ruel, c. 1910
Photograph, Durand-Ruel, Paris

quarters at 168 New Bond Street in an exhibition space that, ironically, was known as the "German Gallery." To discourage patrons from using that name, Durand-Ruel decided to organize all his exhibitions under the aegis of the so-called Society of French Artists, which he founded for the express purpose.[40] On December 10, he opened an exhibition of paintings from his stock as well as some works he had acquired from French artists then living in London. Among them were three recent works by Monet and Pissarro, including Monet's *Entrance to Trouville Harbor* (Budapest, Szépmüvészeti Múzeum), Pissarro's *Fox Hill, Upper Norwood* (fig. 23) and the same artist's *A Snow Effect*, both painted in England.[41] Durand-Ruel had only just met the two future "impressionists." Monet had been introduced to him by Daubigny; Pissarro had dropped off a painting at the gallery, after which Durand-Ruel had written him a note inviting him to come back.[42] Thus London played an important role in forging the connection between Durand-Ruel and the impressionists, whose relationship would prove highly successful for both.[43]

Durand-Ruel maintained his Society of French Artists in London until 1875. After his return to Paris in 1872, he found a manager in Charles Deschamps, the nephew of Ernest Gambart (see fig.16). During the four years of its existence, the Society of French Artists featured on the average two yearly exhibitions of French art, which included an ever-growing number of impressionist paintings.[44] In addition to Monet and Pissarro, visitors could become acquainted with works by Manet, Renoir, Sisley, and Degas.

It took some time before the exhibitions of the Society of French Artists, and particularly the avant-garde impressionist paintings they featured, were recognized. The British public apparently was not ready for them in the 1870s. When Monet and Pissarro submitted works to the Royal Academy exhibition of 1870, they were refused.[45] Their paintings, two each, entered by Durand-Ruel in the French section of the First International Exhibition in South Kensington in the spring of 1871, remained unnoticed. It was not until three years later that an anonymous critic of the *Times* complimented Durand-Ruel for acquainting the British public with new French art: "Mr. Durand-Ruel… is a Frenchman, influenced by contemporary French modes in art, and thus secures for some of the more daring and eccentric of these a representation which but for him they would fail altogether to obtain in London."[46] The same critic was ready to admit, however, that the British public

might not be ready for the "very strong and raw diet as this new school serves up," and he reassured his readers that they could also find "examples of a more delicate kind of work in this gallery."[47]

British collectors of the works by the new impressionist painters were few and far between. A notable exception was Captain Henry Hill from Brighton. Hill had started to collect in the early 1860s, first buying nineteenth-century British paintings. He later became interested in contemporary French art, acquiring works by Barbizon artists as well as realist painters such as Bonvin, Fantin-Latour, Antoine Vollon and the female artist Marie Cazin. In 1874, he made his first visit to the Durand-Ruel Gallery; less than two years later he had bought seven paintings by Degas, including the famous *Absinthe Drinkers* (Paris, Musée d'Orsay) and six ballet scenes. It is noteworthy that he focused on Degas's paintings, whose genre subjects and relatively academic early painting style made his work more acceptable in England than that of Monet and Pissarro.

Despite the purchases of Hill and occasional sales of works by Barbizon artists to other collectors, Durand-Ruel could not keep his gallery in London afloat; in 1875, he decided to close it. His manager, Deschamps, organized one more exhibition in the gallery in 1876, entitled *French and Other Foreign Painters*, which received a positive review but only because it contained "less than the usual proportion of protest-provoking pictures."[48] The few impressionist paintings that it did feature, such as Manet's *Les Canotiers* (Tournai, Musée des Beaux-Arts), received nothing but scorn. "Cynicism in conception," "singularly offensive," "unpleasing," "exaggeration of the coarsest methods"— described the painting, which according to the critics represented an "unaccountable deviation of French taste."[49]

French Art in London, 1875–1899

After Durand-Ruel's departure from Paris and Deschamps's move to 1A New Bond Street, where he opened his own gallery, the presence of French art and artists in London was greatly diminished. Swept up by the national enthusiasm to rebuild their country and sharing in the optimism that took hold of the French nation, French artists stayed at home and focused on France. Influenced by British initiatives such as the Society of British Artists or the Royal Watercolour Society, young French painters and sculptors began to organize their own exhibitions, independently from the Salon or art dealers. The Société anonyme des artistes, peintres, sculpteurs,

graveurs, etc., an exhibition society founded in 1873, organized eight exhibitions between 1874 and 1886 and put impressionism on the map, aided by Durand-Ruel, who organized regular exhibitions of their works in his Paris gallery

But the London market was not forgotten. In the summer of 1882, Durand-Ruel rented a gallery at 13 King Street, St. James, where he showed a small number of impressionist paintings. The exhibition made little impact, so the following year Durand-Ruel organized a much larger show in the Dowdeswell Galleries at 133 Bond Street under the title *La Société des Impressionistes*. Containing no less than sixty-five works, by all major impressionist artists, it was widely reviewed. Since the last impressionist show in 1876, the British may have been a little better informed about impressionism than they were a decade earlier, as a number of articles had appeared in British papers reviewing the impressionist exhibitions in Paris. Previously, the impressionists had received an overwhelmingly negative press, but now reviews tended to be positive and full of praise. Wrote the anonymous reviewer for the *Daily Telegraph*: "[The exhibition at Dowdeswell Galleries] is abundantly striking and admirable."[50]

As Durand-Ruel was trying to regain a foothold in England in the 1880s, the French Goupil Gallery was also beginning to sell paintings in London. The firm of Goupil & Co had been established by Adolphe Goupil as a print publishing house in 1827. By partnering with Léon Boussod in 1856 and with the Dutch dealer Vincent van Gogh (an uncle of the painter) in 1861, Goupil turned it into an international fine arts firm with branches in Paris, London, Berlin, The Hague, and New York.[51] Like the other Goupil affiliates, the London branch began as a wholesale outlet of print and photograph reproductions of contemporary French and Old Master paintings. When the young Vincent van Gogh joined it as an assistant in 1873, the London gallery still did little more than that, though his boss Charles Obach was charged with expanding its activities to the sale of paintings and drawings.[52] In 1875, Obach organized a first major group show, which included works by such academic artists as Jean-Léon Gérôme and Ernest Meissonier, as well as Barbizon painters like Camille Corot, Jules Dupré, Jean-François Millet, and Constant Troyon.

In 1878, the management of the gallery was taken over by David Croal Thomson. He had a special interest in Whistler and the artists of the Barbizon school, about which he wrote a book in 1890. Perhaps inspired by Whistler, Thomson tried to

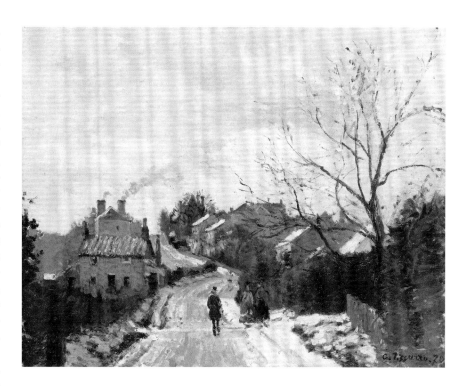

fig. 23 Camille Pissarro *(French, 1830–1903)*
Fox Hill, Upper Norwood, 1870
Oil on canvas 35.3 x 45.7 cm
National Gallery, London

break into the impressionist market, organizing a show of twenty paintings by Monet in 1889. Two critics who reviewed the show for the *Times* and *Artist* respectively acknowledged Monet's originality. But the *Times* critic warned that Monet's work might "severely strain the faith of the ordinary British visitor." As he saw it, "*le gros public…* would as soon think of dining off caviare as of satisfying itself with these strange and wayward productions."[53] The show was not a success, either in terms of visitors or buyers. Thomson would not repeat the experiment though he would include occasional impressionist paintings in group shows he organized in subsequent years.

While the impressionists avoided England during the last quarter of the nineteenth century, as they saw it as a country where collectors were only interested in academic art and Barbizon landscapes, some of their contemporaries as well as slightly younger French artists saw London as a viable marketplace. The naturalist painter Jules Bastien-Lepage, Monet's junior by eight years, first visited England in June 1879 and returned every summer until 1882, two years before his premature death at age thirty-six. He formed fast friendships with Lawrence Alma Tadema and Edward Burne-Jones and arranged to have his works exhibited at the Royal Academy (see appendix) and the Grosvenor Gallery.[54] Though his paintings had a mixed reception in London, where many critics felt the artist had broken with the academic tradition and his works lacked sentiment,[55] Bastien-Lepage was to have a considerable following in England among artists slightly younger than himself, such as George Clausen and Henry Herbert La Thangue.[56]

The British capital inspired not only Bastien-Lepage's famous *London Bootblack* (Paris, Musée des arts décoratifs) and *Flower Girl* (private collection), but also most of the rare landscapes in his oeuvre, such as *Blackfriars Bridge and the Thames* (Philadelphia Museum of Art), *A Bridge in London* (Paris, Musée des Beaux-Arts), and *The Thames, London* (cat. 1). Other French artists had connections with England as well during the last quarter of the nineteenth century. Théodore Roussel moved to England in 1878. Largely self-taught, he was an eclectic artist who painted scenes from modern life in styles derived from the Old Masters. In England, he became acquainted with Whistler, who greatly influenced his artistic development. Roussel took up etching and produced prints of London urban scenes, such as *Chelsea Palaces* (cat. 82) and *The Street, Chelsea Embankment* (Newcastle-upon-Tyne, Hatton Gallery),[57] which have much in common with Whistler's etchings of the same subject matter (see cats. 94–97).

But perhaps most important for the relations between Paris and London was the presence in England of Pissarro's son Lucien, who moved there in 1890. Through his frequent travels back to France and the visits of his father, Camille, to England (see cat. 55), Lucien Pissarro would gain an influential place in the English art world by acting as a *trait-d'union* between England and the Continent.

London in Paris

Thomson's choice of Monet as the first (and only) impressionist artist to feature in the London Goupil Gallery may have been inspired by Whistler. The two artists, who had known each other at least since 1865, had become increasingly close in the 1880s. In December 1887, as president of the Royal Society of British Artists, Whistler had invited Monet to contribute two paintings to the annual exhibition. Eight months later, Monet visited London, perhaps in the company of John Singer Sargent, with whom he may have struck up a friendship as early as 1867.[58]

Was Monet inspired by Whistler's etchings and paintings of the Thames when he began to contemplate doing a London series? Whistler's *Thames Set* had been well received when it was published in London in 1871, in an edition of one hundred, leading the artist to paint several views of the Thames in the course of the 1870s. As early as December 1880, Monet planned to return to London to paint his own series of views of the river.[59] These plans did not materialize until nearly twenty years later, though in the intervening time Monet traveled to London twice, first in 1887, then again in 1891. In 1899, however, he set out on a series of trips to London to paint a Thames series that ultimately would include nearly one hundred canvases.[60] In May and June 1904, Durand-Ruel exhibited this series in his Paris gallery. Billed as *Claude Monet: Vues de la Tamise à Londres,* it included thirty-seven paintings that had been selected jointly by Monet and Durand-Ruel. The exhibition was subdivided into three groups of paintings: "Charing Cross Bridge," "Waterloo Bridge," and "Parliament."

Vues de la Tamise was a critical success, if only for the sheer number of reviews that were devoted to it.[61] It was also a financial boon for both Monet and Durand-Ruel. The latter immediately bought twenty-four of the thirty-seven canvases in the exhibition; in 1905 and 1906, he would acquire twenty-two

more Thames views. Durand-Ruel had little trouble selling these paintings to collectors as well as to museums, for prices ranging from 15,000 to 20,000 francs.

Though the success of the Thames paintings had much to do with Monet's high reputation as an artist by the beginning of the twentieth century, it may also have been caused by their motif. For while early in the nineteenth century, London had been criticized for its ugliness, particularly by Frenchmen who compared its *laideur* with the graceful beauty of Paris, from the 1860s onward there had been a growing appreciation for its industrial center. Beginning with the Crystal Palace exhibition in 1851, French tourism to the city had steadily increased. Initially, French travel guides had warned visitors that they should expect a city different from Paris. The *Nouveau Guide à Londres pour l'Exposition de 1851* called London "above all a city of business and commerce."[62] Another guide, written that same year, defined the city as "work and action, stirring in immensity."[63] But two years later A. de Colombel wrote, "London is a city that astounds, Paris a city that pleases," differentiating between the aesthetic qualities of the two cities in terms that resemble Edmund Burke's definitions of the "sublime" and the "beautiful."[64] The Englishman William Blanchard Jerrold, visiting Paris in 1855, invited the French to discover London's poetic side: "It is left to the French to discover that poetry can sometimes reside in London."[65] Four years later, he convinced a Frenchman, Gustave Doré, to produce together with him a comprehensive "portrait of London." Published in 1872, *London: A Pilgrimage* made London fashionable (see cat. 58). The book was adapted to the French market by Louis Enault, whose *Londres,* published in 1876, became enormously successful in Paris and on the European continent in general. It and other books published about England at the same time, such as Alphonse Esquiros's *L'Angleterre et la vie anglaise* (1869) and Hippolyte Taine's *Notes sur l'Angleterre,* made England, and especially London, increasingly fashionable in France. To all these literary effusions we may add the effect of the pictorial views of London, by such artists as Whistler, Daubigny, Bonvin, Bastien-Lepage, and Pissarro, which also contributed to change French opinion of England's capital city.

That the success of Monet's *Views of the Thames* exhibition had much to do with the new popularity of London was readily understood by the dealer Ambroise Vollard (fig. 24), who in 1906 sponsored Derain and in 1911 Maurice de Vlaminck to travel to London to likewise paint series of views of the city.

fig. 24 Pierre Bonnard *(French, 1867–1947)*
Portrait of Ambroise Vollard, c. 1904
Oil on canvas 73 x 60 cm
Foundation E. G. Bührle Collection, Zürich

fig. 25 Maurice de Vlaminck
Tower Bridge, 1911
Oil on canvas
New York, private collection

This was an unusual move for a dealer, and Vollard was, as he wrote himself, "bitterly reproached for having taken these artists "out of their element," by directing them from their "usual subjects."[66] But apparently Vollard was so convinced of the popularity of the "London theme" in France, that he considered it a smart thing to do. It appears that the artists themselves did not object, even though they were well aware of Vollard's strategy.[67] Derain, for one, welcomed the opportunity, offered by Vollard, to emulate Monet in a series of paintings that would show a new approach to the painting of urban scenery. He had visited the Monet exhibition in 1904 and had written to Vlaminck that, as much as he admired Monet's works, he himself was looking for something quite different: "As for me, I am looking for something else, something that, in contrast [to Monet's paintings] has something solid (*fixe*), eternal, complex."[68] It is in keeping with Derain's new approach that he only spent ten days in London, as opposed to the multiple and lengthy stays of Monet. Indeed, of the thirty views he painted of London (see cats.7–10), few were done *sur place*. Unlike Monet, to whom the visual perception of the scenery was the essential theme, to Derain the scenery was only a trigger, or even a pretext, for the synthesis of the self, "…*synthétiser le Moi-même.*"[69]

Vollard never organized a show of Derain's views of the Thames, as Durand-Ruel had done for Monet, but these paintings, nonetheless, became famous in their own right. The same does not hold true for Vlaminck, whose views of the Thames, such as *Tower Bridge* (fig. 25) failed to become a celebrated part of his oeuvre—this, despite the fact that, painted in the dark, dramatic style that Vlaminck had adopted after 1907, they beautifully convey what the writer Alphonse Esquiros had referred to in 1869 as the "somber, profound, laborious, and powerful" qualities of the Thames.[70]

Conclusion

"Complex" and "tenuous" are the words that best describe artistic relations between France and England in the second half of the nineteenth century. French artists and their dealers looked to London as a major market for art but soon discovered that in this country, which was so "modern" in every other respect, there was little interest in pictures of modernity and in modernist approaches to art. And, if young artists like Whistler, Pissarro, and Monet were decisively influenced in their artistic development by the industrial landscape of London, their

scenes of London and others like it, produced after their return to France, had little appeal to the London captains of industry. Only the dogged attempts of art dealers like Durand-Ruel and, to a lesser extent, Goupil would eventually cause the acceptance of modernist painting in London and the realization that it was eminently suited to the depiction of the city's

scenery. It is interesting that at about this time, London, as a city, came to be appreciated in France. Indeed, the success of the Thames paintings by Monet and Derain in France had much to do with the French acceptance of London, by the late nineteenth century, as a city unequalled in Europe for its "grandeur and immensity."[71]

I thank Jennifer Hardin for inviting me to participate in this exciting project. I am grateful to her staff for their courteous assistance. This essay was written during time spent as a fellow at the Netherlands Institute for Advanced Study in Wassenaar. I am indebted to NIAS for five months of uninterrupted to time to write and reflect. My thanks go as well to Seton Hall University for allowing me a one-semester leave of absence. Important research assistance, particularly for the appendix, was provided by Alia Nour El Sayed. Hsiao Yun Chu's insightful comments were also extremely helpful.

1 Petra ten-Doesschate Chu, ed. and trans., *Letters of Gustave Courbet*, Chicago: University of Chicago Press, 1992, p. 166.

2 Though Courbet claimed as early as 1854 that he had traveled to London (see Chu 1992, p. 132), there is no evidence that he ever made a trip to England. After 1870, some of his works were exhibited in England, thanks in large part to the efforts of Durand-Ruel.

3 See Claire Hancock, *Paris et Londres au XIXe siècle: Représentations dans les guides et récits de voyage*, Paris: CNRS, 2003, p. 87.

4 Two private ateliers that were run by the painter Adolphe Julian and the sculptor Filippo Colarossi.

5 On the French perception of London's modernity, see Hancock 2003, pp. 276–86. See also M. Warner, ed., *The Image of London Viewed by Travelers and Emigrés, 1550–1920*, London: Trefoil Publication and Barbican Art Gallery, 1987, p. 11ff.

6 These are the words used by Joachim Pissarro, who, in his *Camille Pissarro*, New York: Harry N. Abrams, 1993, gives a detailed account of the importance of the experience of London for the development of Pissarro. Joachim Pissarro uses the term "modernist" in the way it is currently used in art historical discourse, to refer to "artistic strategies that seek not just close but essential connections to the powerful forces of social modernity." See *Grove Dictionary of Art Online* (www.groveart.com), s.v. "Modernism."

7 The official name of the exhibition, organized by Henry Cole under the auspices of Prince Albert, had been "The Great Exhibition of the Works of Industry of all Nations."

8 Patricia Mainardi, *Art and Politics of the Second Empire: The Universal Expositions of 1855 and 1867*, New Haven/London: Yale University Press, 1987, p. 105.

9 Mainardi 1987, pp. 106–7.

10 See Lyndel Saunders King, *The Industrialization of Taste: Victorian England and the Art Union of London*, Ann Arbor, MI: UMI Research Press, 1985, p. 204.

11 See Oskar Bätschmann, *The Artist in the Modern World*, Cologne: Dumont/New Haven: Yale University Press, 1997, pp. 29–44.

12 Four years earlier, Guillaume-Guillon Lethière and Jean-Baptiste Wicar had each exhibited a colossal painting in London. Bätschmann 1997, pp. 47–49.

13 Courbet had already imitated the British example of one-man exhibitions earlier by organizing, in 1855, a private exhibition of his work on the grounds of the International Exhibition in Paris. On the British tour of the *Return from the Conference*, which was aborted early on, see Roger Bonniot, *Courbet en Saintonge*, Paris: Klincksieck, 1972, pp. 305–6.

14 In July 1868, Manet visited London and came back full of enthusiasm. He wrote to Emile Zola that he was "enchanted by his visit" and that he had been very well received. "There is something that I can do there, I think, and I will try it next season" ("il y a quelque chose à faire là-bas pour moi, je crois, et je vais le tenter la saison prochaine"). Cited in Paul Jamot and Georges Wildenstein, *Manet*, Paris, 1932, vol. 1, p. 84. Of course, Manet did not specify that he planned a private exhibition but as he had just organized one in Paris in 1867, that is possibly what he had in mind.

15 Du Maurier would later describe the artistic life of these young British artists in Paris in his famous novel, *Trilby* (1894).

16 Whistler's *At the Piano* was seen in Paris as it was exhibited, together with works by Fantin-Latour, Legros, and Théodule Ribot, in the atelier of François Bonvin in the rue Saint-Jacques. See Geneviève Lacambre, "Whistler and France." Essay in Richard Dorment and Margaret F. Macdonald, ed., *James McNeill Whistler*, exhibition catalogue, New York: Harry N. Abrams, 1995, p. 40.

17 Fantin would paint another portrait of Ruth and Edwin Edwards in 1874–75, during their visit to Paris (London, Tate Gallery). By then, the Edwardses had become his sole agents in England; this business relation had led to a gradual cooling of their friendship. All information in this paragraph is derived from Douglas Druick and Michel Hoog, *Fantin-Latour*, exhibition catalogue, Ottawa: National Gallery of Canada, 1983.

18 On Gambart, see Jeremy Maas, *Gambart: Prince of the Victorian Art World*, London: Barrie and Jenkins, 1975.

19 Millet was notably absent from Gambart's gallery, as the dealer did not like his "wooden figures." Maas 1975, p. 274.

20 Fantin had been introduced to Gambart by Haden, during a Royal Academy dinner in 1864. See Druick and Hoog 1983, p. 117.

21 The first one-person show (1849) in his gallery had been devoted to the animal sculptor Pierre-Jules Mène, whose popularity in England owed much to Gambart.

22 See Gabriel P. Weisberg, "La Fortune des oeuvres de Rosa Bonheur en Angleterre et en Amérique," in *Rosa Bonheur 1822–1899*, exhibition catalogue, Bordeaux: Musée des Beaux-Arts, 1997, pp. 55–73.

23 Valuable information on the presence of French artists may be found in the diary of Bonvin. See Gabriel P. Weisberg, *Bonvin*, Paris: Geoffroy-Dechaume, 1979, p. 99. See also *The Impressionists in London*, exhibition catalogue, London: Hayward Gallery, 1973, *passim*.

24 There are questions about Tissot's participation in the Commune, and it is possible that the artist traveled to London for purely economic reasons.

25 Cited in Weisberg 1979, p. 100.

26 Janine Bailly-Herzberg, ed., *Correspondance de Camille Pissarro*, Paris: Presses Universitaires de France, 1980, vol. 1, p. 64. Author's translation.

27 He would exhibit two of these at the Salon of 1876: *La Tamise à Gravesend, Environs de Londres* (based on the watercolor reproduced in fig. 20) and *Le Bateau abandonné: Bords de la Tamise*. Both were painted in 1875 and were last seen in a private collection in the Netherlands. Reproduced in Weisberg 1979, nos. 212 and 213.

28 Pissarro's *Lordship Lane Station* (London, Courtauld Institute Galleries) and *Landscape under Snow: Upper Norwood* (private collection), particularly come to mind.

29 See Gerald Ackerman, *Jean-Léon Gérôme*, Paris: Editions ACR, 2000, p. 90.

30 Prints after Gérôme's work were widely distributed in Europe and the United States by the Goupil firm. See *Gérôme & Goupil: Art and Enterprise*, exhibition catalogue, Paris: Réunion des Musées Nationaux, 2000.

31 Tissot had come to know Bowles intimately as, in 1870, the latter had come to Paris to write his *The Defence of Paris, Narrated as it was Seen*, for which Tissot had drawn the illustrations. For some time, Bowles and Tissot seem to have lived together. See Nancy Rose Marshall and Malcolm Warner, *James Tissot: Victorian Life – Modern Love*, New Haven: Yale University Press, 1999, p. 201.

32 In 1864, he had exhibited a painting that had no title, only a number (408) in the catalogue.

33 On the friendship between Degas and Tissot, see Jean Sutherland Boggs et al, *Degas*, exhibition catalogue, New York: Metropolitan Museum of Art, 1988, pp. 130–32. Degas's *Portrait of James Tissot* is in the Metropolitan Museum of Art in New York.

34 In a letter dated November 19,1872. Cited in Albert Boime, *Art and the French Commune*, Princeton: Princeton University Press, 1995, p. 55.

35 On Degas's business plans for this painting, see Marilyn R. Brown, *Degas and the Business of Art: A Cotton Office in New Orleans*, University Park: Pennsylvania State University Press, 1994, especially 16–17 and 43–46. The citation from Degas's letter to Tissot is found on p. 17.

36 Boggs 1988, p. 185.

37 Marcel Guérin, ed., *Degas Letters*. Marguerite Kay, trans., Oxford: Cassirer, 1947, pp. 70–71.

38 Maas 1975, p. 223.

39 See Anne Distel, *Impressionism, the First Collectors*, 1874–1886. Barbara Perroud-Benson, trans., New York: Harry N. Abrams, 1990, 24.

40 Maas 1975, p. 223.

41 It is difficult to determine exactly which paintings by Pissarro these titles referred to as he painted more than one snow landscape as well as several scenes of Upper Norwood. It is generally assumed that *A Snow Effect* is identical with *Fox Hill, Upper Norwood*, reproduced in fig. 23.

42 Wrote Durand-Ruel: "…you brought me a charming picture and I regret not having been in my gallery to pay you my respects in person. Tell me, please, the price you want and be kind enough to send me others when you are able to. I have to sell a lot of your work here." Cited in Joachim Pissarro, *Camille Pissarro*, New York: Harry N. Abrams, 1993, p. 76.

43 For a detailed account of the early contacts between Durand-Ruel, Monet, and Pissarro in London, see John House, "New Material on Monet and Pissarro in London in 1870–1871," *Burlington Magazine* 120 (October 1978), pp. 636–42.

44 For a complete listing, see Kate Flint, *Impressionists in England: A Critical Reception*. Boston: Routledge/Kegan Paul, 1984, pp. 356–60.

45 See *The Impressionists in London* 1973, p. 29.

46 Flint 1984, p. 34.

47 Flint 1984, pp. 34–35.

48 Flint 1984, p. 36.

49 Flint 1984, pp. 36–37.

50 April 26, 1883, Flint 1984, p. 60.

51 In 1878, Boussod's son-in-law René Valadon became an associate of Goupil's. Six years later, Boussod and Valadon started their own firm, Boussod, Valadon & Cie, with the financial backing of Adolphe Goupil and his son Albert. It became the successor to Goupil et Cie after the retirement of Adolphe two years later, but continued to be popularly referred to as "Goupil."

52 See Martin Bailey et al., *Van Gogh in England: Portrait of the Artist As a Young Man*, exhibition catalogue, London: Barbican Gallery, 1992, pp. 30–31. Van Gogh had worked four years in his uncle's gallery in The Hague, before moving to London.

53 Flint 1984, p. 311.

54 On Bastien-Lepage's stay in London, see Gabriel P. Weisberg, *The Realist Tradition: French Painting and Drawing 1830–1900*, exhibition catalogue, Cleveland, OH: The Cleveland Museum, 1980–81, pp. 196–97, n. 1.

55 See Alastair Ian Wright, "Bastien-Lepage and English Critical Taste," *Gazette des Beaux-Arts*, 6th ser., v. 116 (Sept. 1990), pp. 94–104.

56 See Gabriel P. Weisberg, *Beyond Impressionism: The Naturalist Impulse*, New York: Harry N. Abrams, 1992, p. 108ff.

57 Reproduced in Margret Dunwoody Hausberg, *Prints of Théodore Roussel: A Catalogue Raisonné*, London, 1991, cat. no. 26.

58 On the friendship between Monet and Sargent, see especially Richard Ormond and Elaine Kilmurray, *John Singer Sargent*, New Haven: Yale University Press, vol. 1, pp. 155–56.

59 *The Impressionists in London* 1973, p. 35.

60 On this series, see especially Grace Seiberling, *Monet in London*, exhibition catalogue, Atlanta: High Museum, 1988.

61 For a sampling, see Seiberling 1988, pp. 94–97.

62 "Londres est surtout une ville d'affaires et de commerce." Cited in Hancock 2003, p. 97.

63 "Londres, c'est le travail et l'action se mouvant dans l'immensité." Hancock 2003, p. 97.

64 "Londres est une ville qui étonne; Paris, une ville qui plait." Hancock 2003, pp. 97–98.

65 W. B. Jerrold, *Imperial Paris*, London: Bradbury & Evans, 1855, p. 30–31.

66 Ambroise Vollard, *Recollections of a Picture Dealer*, Violet M. Macdonald, trans., London: Constable, 1936, p. 201.

67 In 1953, Derain wrote to the president of the Royal Academy: "He [Vollard] sent me in the hope of renewing completely …the expression which Claude Monet had so strikingly achieved, which had made a very strong impression on Paris in the preceding years. Cited in *The Impressionists in London* 1973, p. 71. (I made two slight changes in the text to correct what seemed printing errors).

68 Cited in *Derain et Vlaminck*, exhibition catalogue, Lodève: Musée de Lodève, 2001, p. 46.

69 *Derain et Vlaminck* 2001.

70 Alphonse Esquiros, *L'Angleterre et la vie anglaise* (1869). Cited in Hancock 2002, p. 95.

71 Interview with Emile Zola after his visit to London, *The Guardian*, October 3, 1893. For the full interview, see http://books.guardian.co.uk/fromthearchives/story/0,12137,1115135,00.html. Last accessed September 1, 2004.

Catalogue | PAINTINGS, DRAWINGS, AND WATERCOLORS

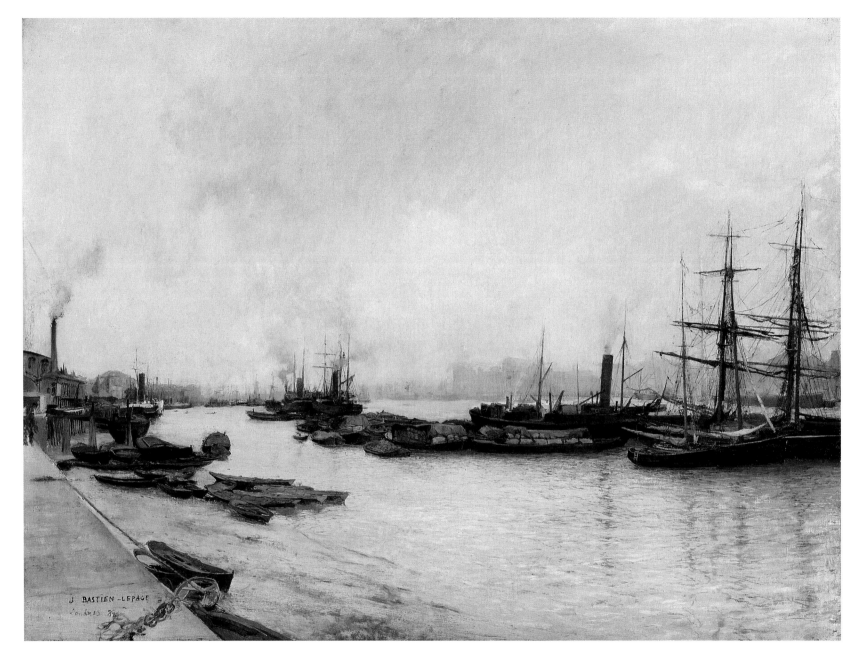

Cat. 1

JULES BASTIEN-LEPAGE *(French, 1848–1884)*

The Thames, London, 1882

Oil on canvas 56.7 x 77.2 cm

Philadelphia Museum of Art, John G. Johnson Collection, 1917

Cat. 2

FRANK MYERS BOGGS *(American, 1855–1926)*

On the Thames, 1883

Oil on canvas 98.4 x 130.8 cm

The Metropolitan Museum of Art
George A. Hearn Fund, 1909

Cat. 3

FRANK MYERS BOGGS *(American, 1855–1926)*

Untitled (The Thames, London), c. 1883–87

Oil on canvas 132.8 x 157.58 cm

Chrysler Museum of Art, Norfolk, Virginia

Gift of Walter P. Chrysler, Jr.

Cat. 4
GEORGE CHAMBERS *(British, active 1848–1862)*
Opening of the New Blackfriars Bridge by Queen Victoria, 1869
Watercolor on paper 33.5 x 54.6 cm
Guildhall Library, Corporation of London

Cat. 5

JOHN CROWTHER *(British, 1837–1902)*

Waterloo Bridge: Ebb Tide Taken from Charing Cross Railway Bridge, 1888

Watercolor on paper 14 x 25.4 cm

Guildhall Library, Corporation of London

Cat. 6
CHARLES-FRANÇOIS DAUBIGNY *(French, 1817–1878)*
St. Paul's from the Surrey Side, 1873
Oil on canvas 44 x 81.3 cm
National Gallery, London

Cat. 7

ANDRÉ DERAIN *(French, 1880–1954)*

The Houses of Parliament from Westminster Bridge, 1906

Oil on canvas 73.6 x 92 cm

The Cleveland Museum of Art

Leonard C. Hanna, Jr., Fund

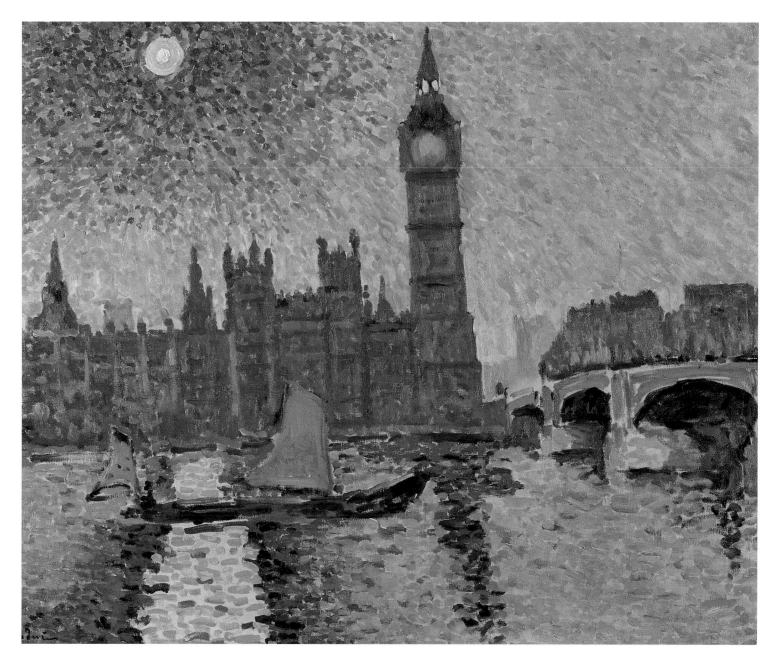

Cat. 8

ANDRÉ DERAIN *(French ,1880–1954)*

Big Ben, London, c. 1906

Oil on canvas 79 x 98 cm

Musée d'Art moderne, Troyes, France

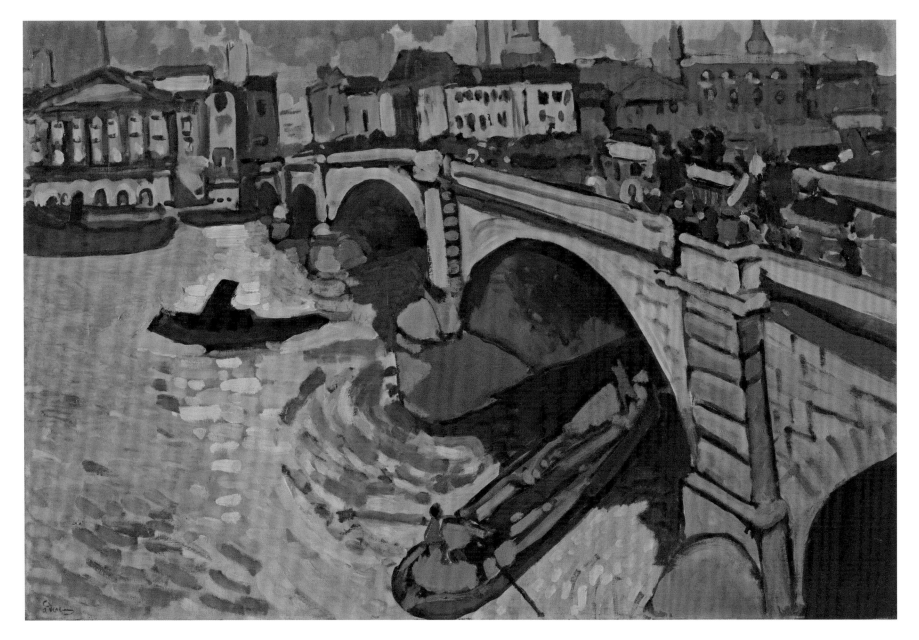

Cat. 9

ANDRÉ DERAIN *(French, 1880–1954)*

London Bridge, 1906

Oil on canvas 66.08 x 99.12 cm

The Museum of Modern Art, New York

Gift of Mr. and Mrs. Charles Zadok

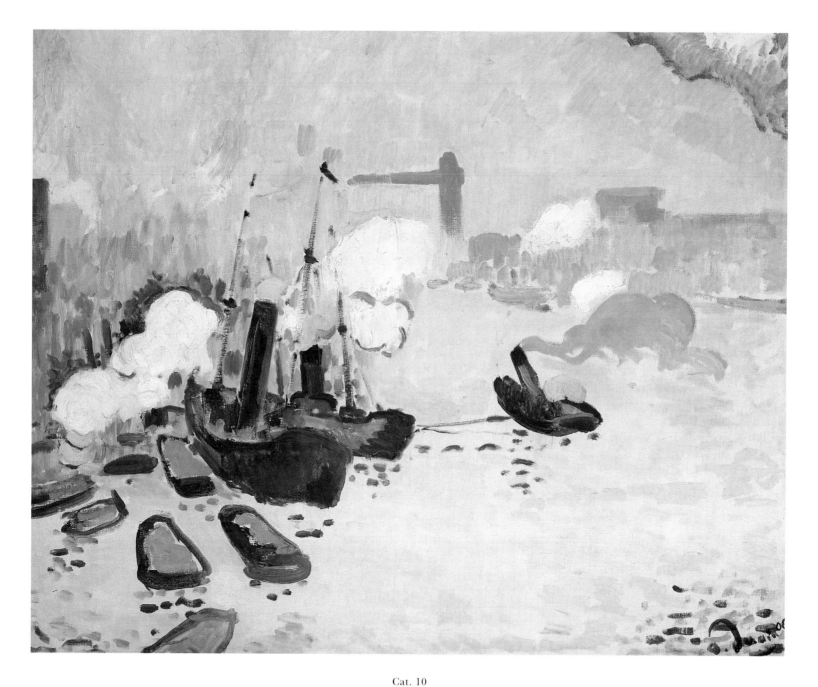

Cat. 10
ANDRÉ DERAIN *(French, 1880–1954)*
View of the Thames, 1906
Oil on canvas 73.3 x 92.2 cm

National Gallery of Art, Washington, D.C.
Collection of Mr. and Mrs. Paul Mellon

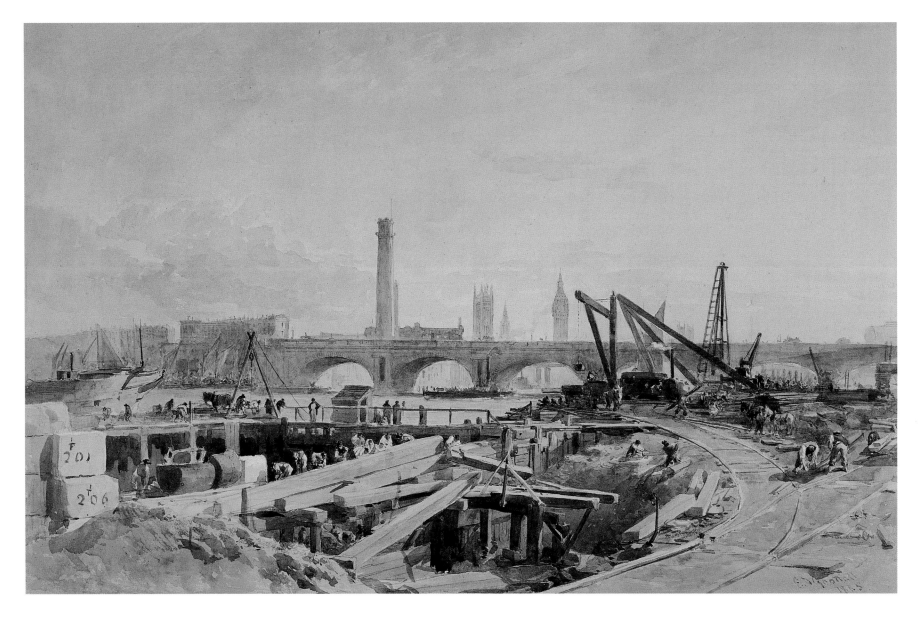

Cat. 11

E. A. GOODALL *(British, 1819–1908)*

Construction of the Victoria Embankment, 1865

Watercolor on paper 35.7 x 55.8 cm

Museum of London

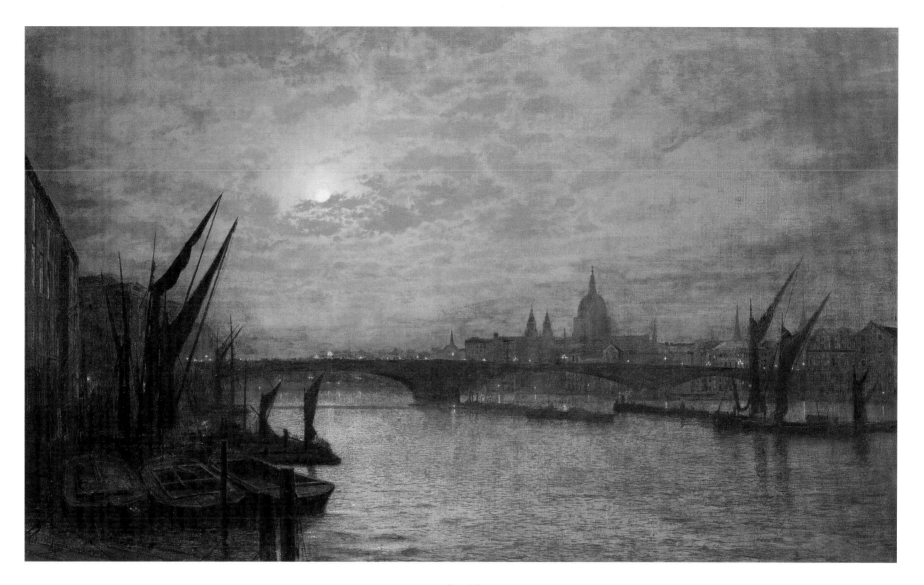

Cat. 12
JOHN ATKINSON GRIMSHAW *(British, 1836–1893)*
The Thames by Moonlight with Southwark Bridge, 1884
Oil on canvas 74.98 x 127.08 cm
Guildhall Art Gallery, London

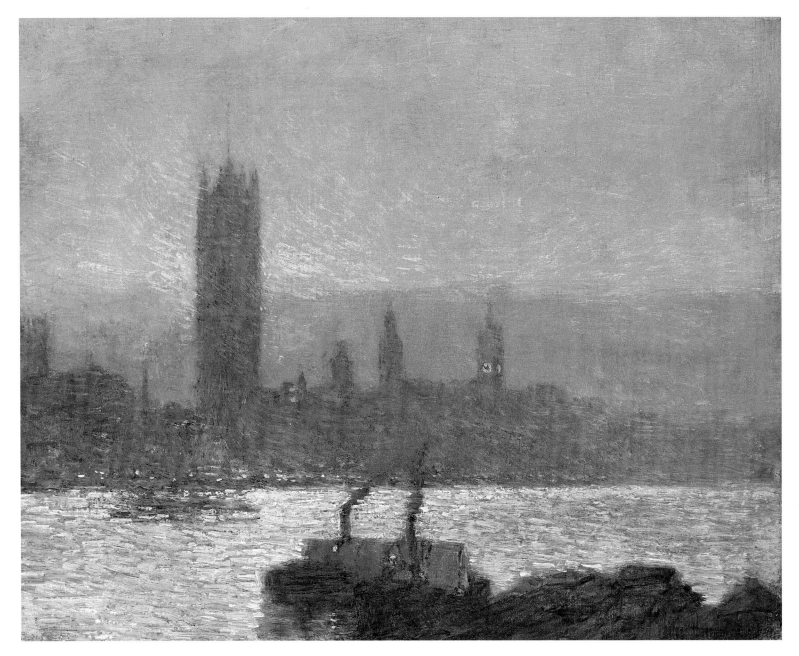

Cat. 13
CHILDE HASSAM *(American, 1859–1935)*
Houses of Parliament, Early Evening, 1898
Oil on canvas 33 x 41.5 cm

Private collection

Cat. 14
CHILDE HASSAM *(American, 1859–1935)*
Big Ben, 1897 or 1907
Gouache and watercolor over charcoal on gray-brown paper 22.24 x 29.55 cm

Corcoran Gallery of Art, Washington, D.C.
Bequest of James Parmelee

Cat. 15

WINSLOW HOMER *(American, 1836–1910)*

The Houses of Parliament, 1881

Watercolor on paper 32.4 x 50.2 cm

Hirshhorn Museum and Sculpture Garden, Smithsonian Institution

Gift of Joseph H. Hirshhorn, 1966

Cat. 16

E. HULL *(British, active 19th century)*

**The Thames Embankment Works between
Charing Cross Bridge and Westminster,** 1865

Watercolor with gouache on paper 24.7 x 36.2 cm

Museum of London

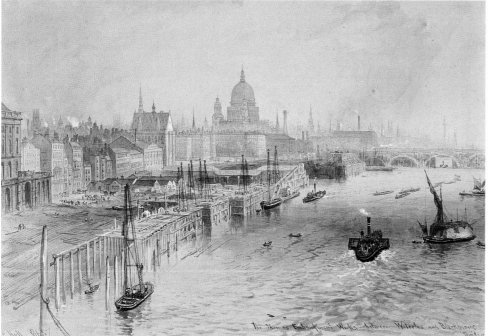

Cat. 17

E. HULL *(British, active 19th century)*

**The Thames Embankment Works between
Waterloo and Blackfriars Bridges,** 1865

Watercolor with gouache on paper 24.3 x 36.2 cm

Museum of London

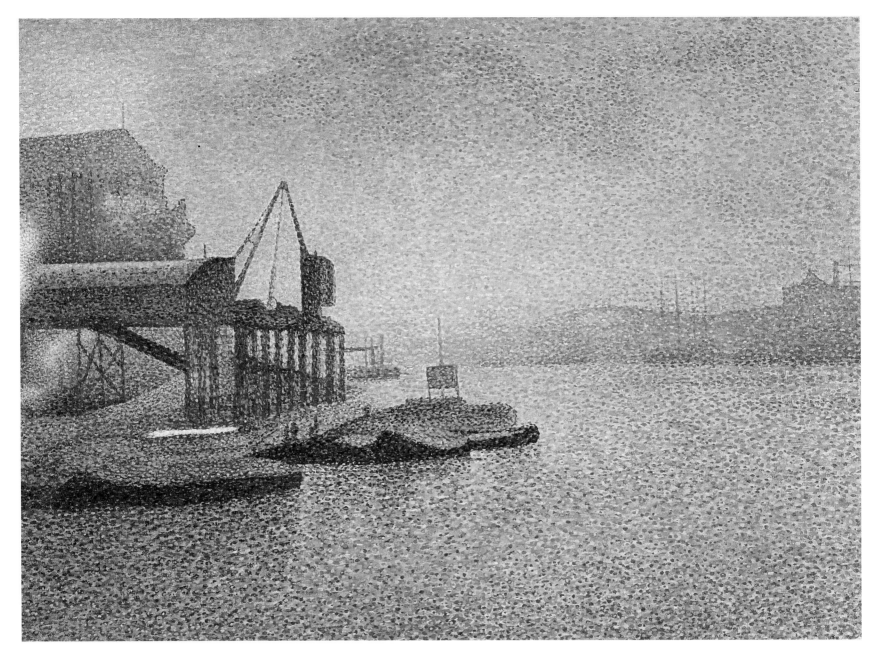

Cat. 18

GEORGES LEMMEN *(Belgian, 1865–1916)*

Thames Scene, the Elevator, c. 1892

Oil on canvas 84.51 x 108.02 cm

Museum of Art, Rhode Island School of Design

Anonymous gift

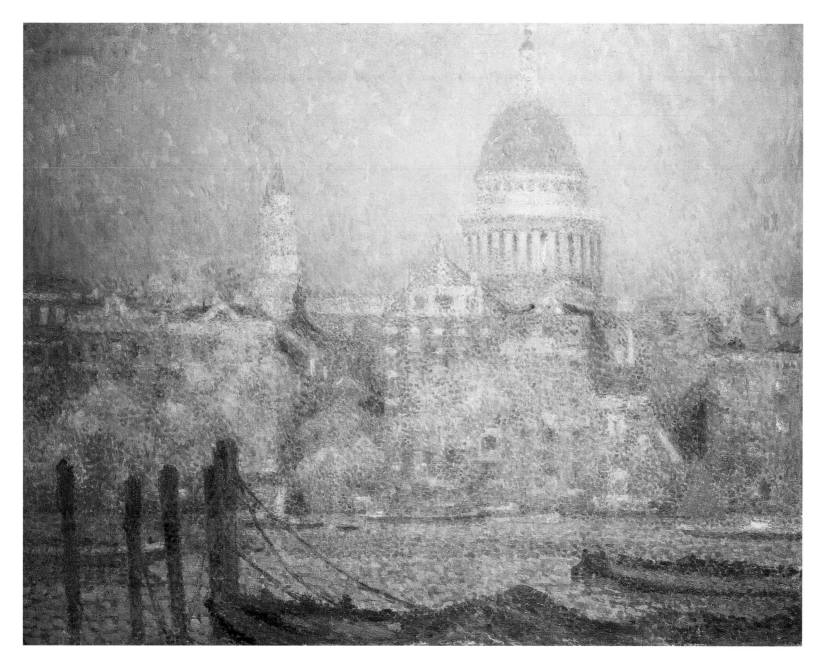

Cat. 19

HENRI LE SIDANER *(French, 1862–1939)*

St. Paul's from the River, 1906–07

Oil on canvas 90.23 x 91.5 cm

Walker Art Gallery, National Museums Liverpool
Board of Trustees of the National Museums and Galleries on Merseyside

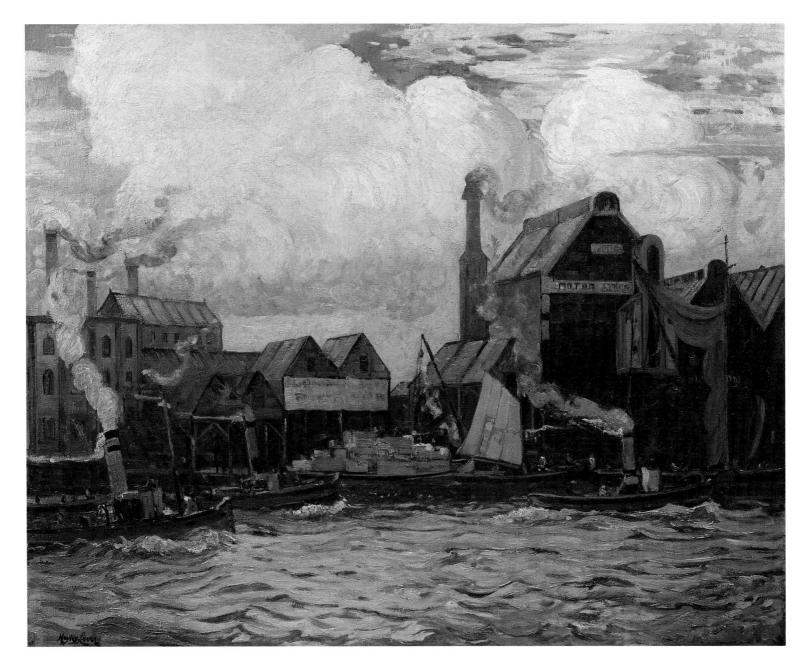

Cat. 20
HAYLEY LEVER *(American, 1876–1958)*
London Docks, c. 1900–10
Oil on canvas 101.67 x 127.08 cm

Spanierman Gallery, LLC, New York

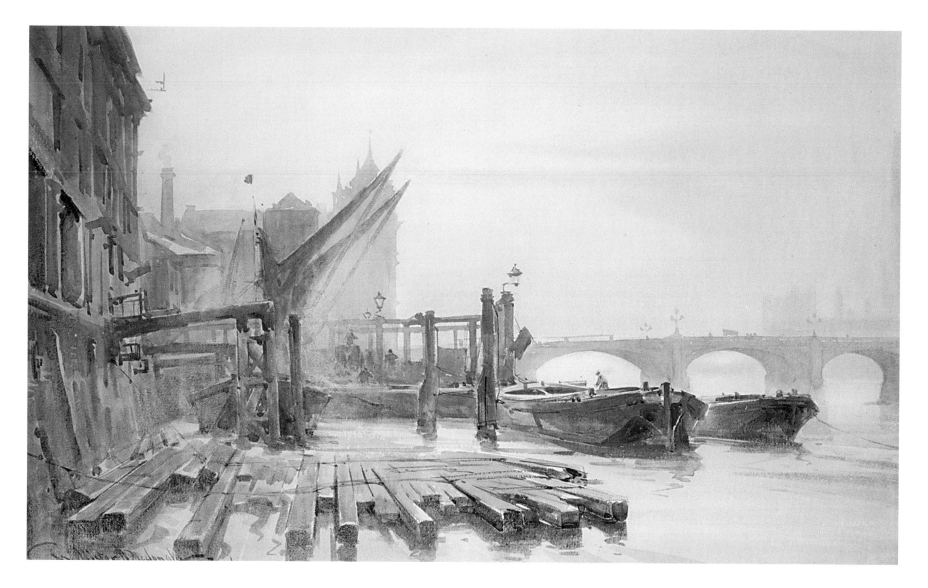

Cat. 21

WILLIAM ALISTER MACDONALD *(British, 1861–1956)*

Timber Wharf and Dust Shoot — Site of County Hall, *1906*

Watercolor on paper 24.4 x 40.6 cm

Guildhall Art Gallery, London

Cat. 22
CLAUDE MONET *(French, 1840–1926)*
London, Towers of the Houses of Parliament
and Boats on the Thames, c. 1900
Studies from the *Thames* series, Sketchbook 3
Graphite on paper 11 x 18 cm
Musée Marmottan-Monet, Paris

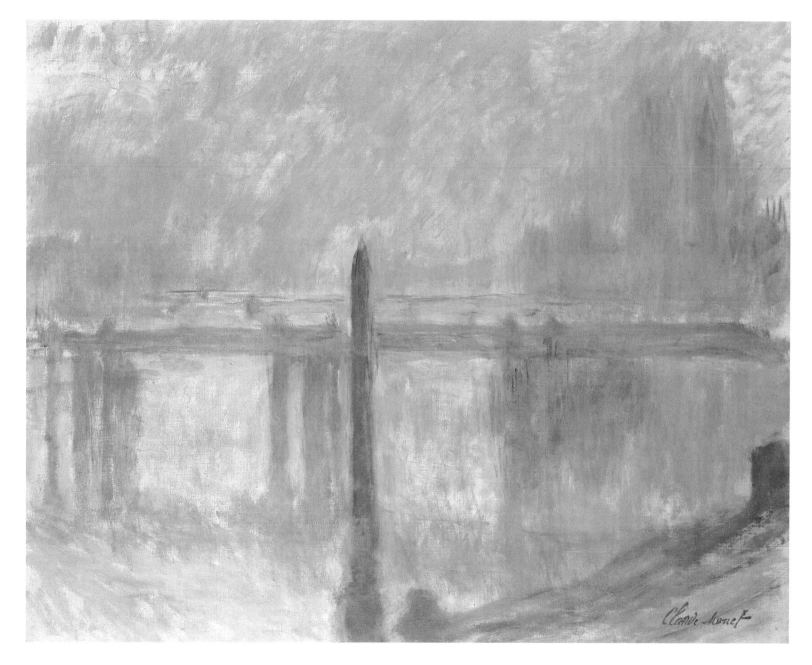

Cat. 23
CLAUDE MONET *(French, 1840–1926)*
Cleopatra's Needle and Charing Cross Bridge, c. 1899
Oil on canvas 64.81 x 81.33 cm

Private collection

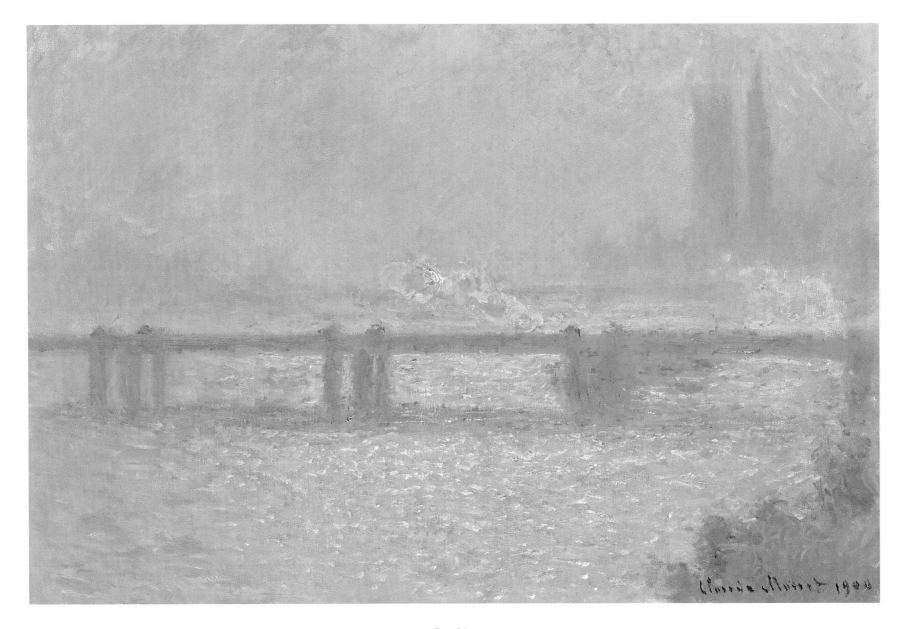

Cat. 24

CLAUDE MONET *(French, 1840–1926)*

Charing Cross Bridge, Overcast Day, 1900

Oil on canvas 60.6 x 91.5 cm

Museum of Fine Arts, Boston

Given by Janet Hubbard Stevens in memory of her mother, Janet Watson Hubbard

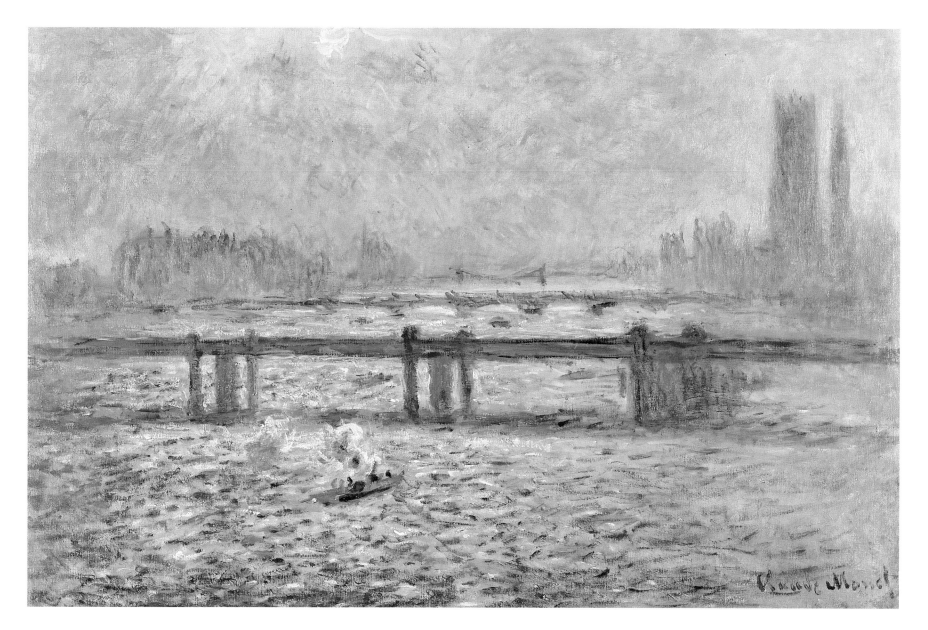

Cat. 25
CLAUDE MONET *(French, 1840–1926)*
Charing Cross Bridge, Reflections on the Thames, 1901–04
Oil on canvas 65.1 x 100.3 cm
The Baltimore Museum of Art
The Helen and Abram Eisenberg Collection

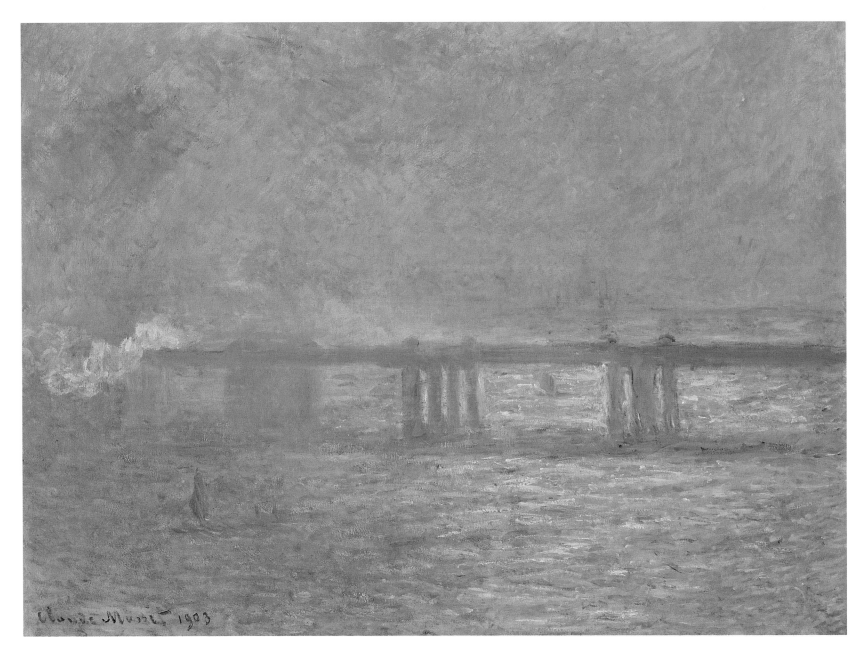

Cat. 26
CLAUDE MONET *(French, 1840–1926)*
Charing Cross Bridge, 1903
Oil on canvas 73.07 x 104.1 cm

The Saint Louis Art Museum
Museum purchase

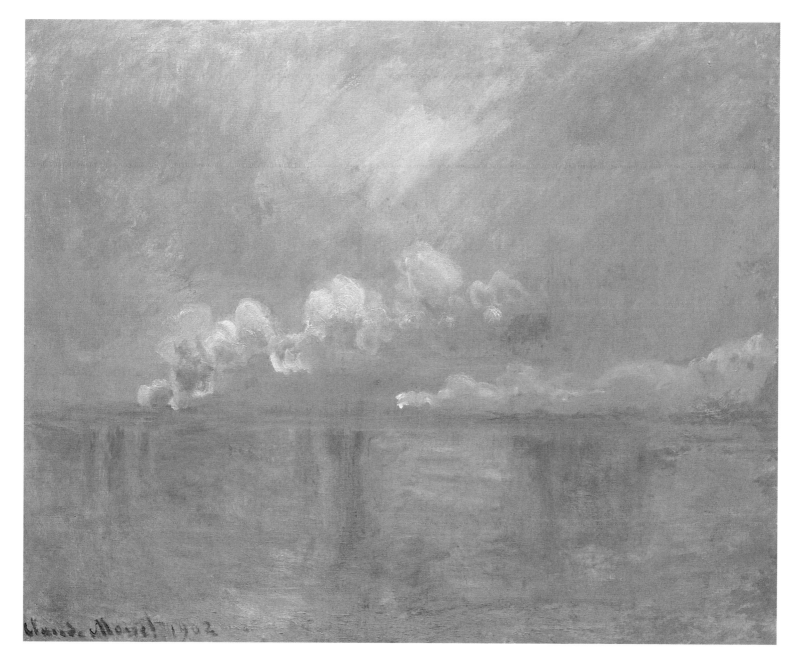

Cat. 27

CLAUDE MONET *(French, 1840–1926)*

Charing Cross Bridge, Smoke in the Fog, 1902

Oil on canvas 73.07 x 91.14 cm

Musée Marmottan-Monet, Paris

Cat. 22
CLAUDE MONET *(French, 1840–1926)*
London, Boats on the Thames, c. 1900
Studies from the *Thames* series, Sketchbook 3
Graphite on paper 11 x 18 cm
Musée Marmottan-Monet, Paris

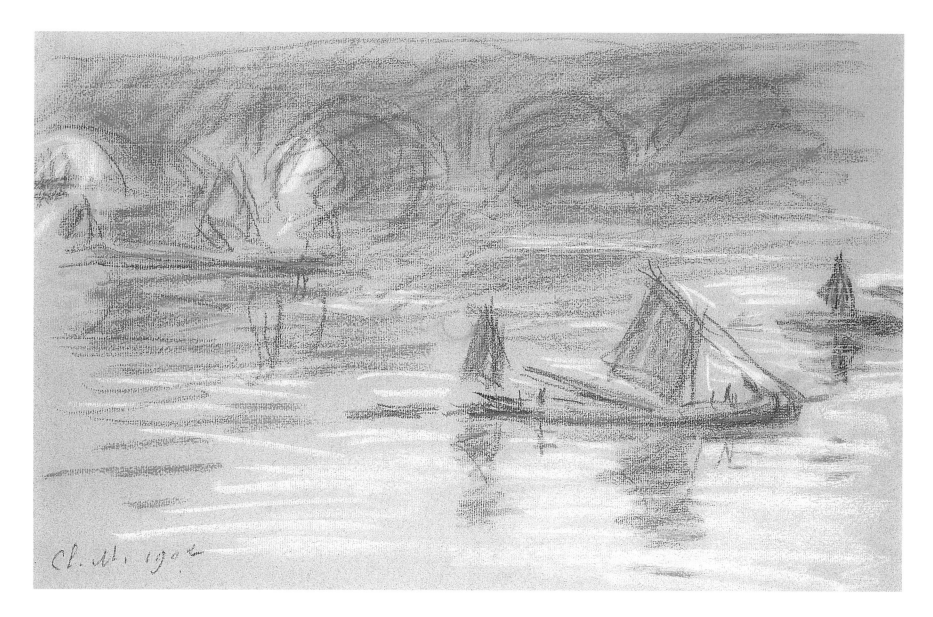

Cat. 28

CLAUDE MONET *(French, 1840–1926)*

Waterloo Bridge, Boats on the Thames, 1901

Pastel on blue-gray paper 31 x 48 cm

Private collection

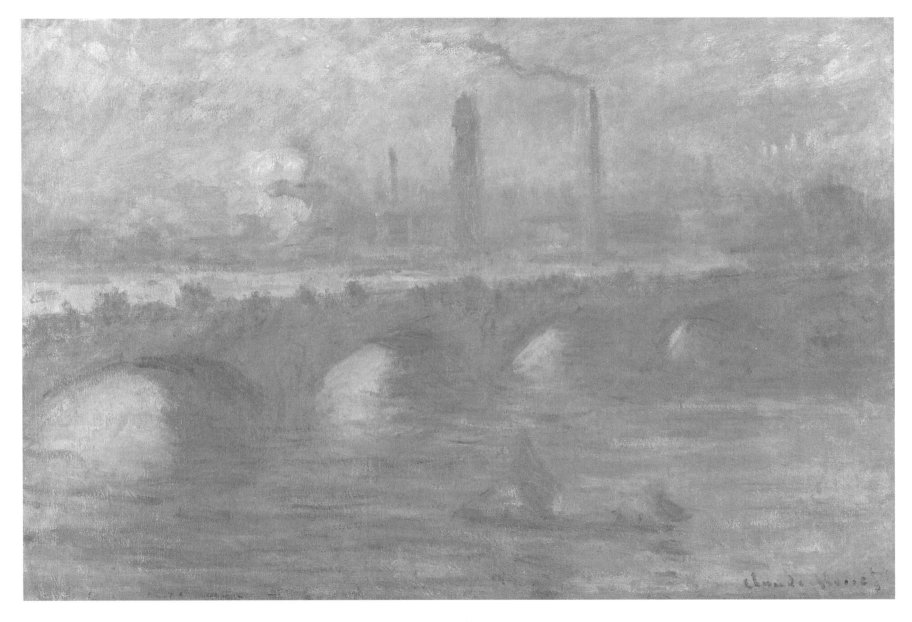

Cat. 29
CLAUDE MONET *(French, 1840–1926)*
Waterloo Bridge, Morning Fog, 1901
Oil on canvas 65.7 x 100.2 cm

Philadelphia Museum of Art
Bequest of Anne Thomson in memory of her father, Frank Thomson,
and her mother, Mary Elizabeth Clarke Thomson, 1954

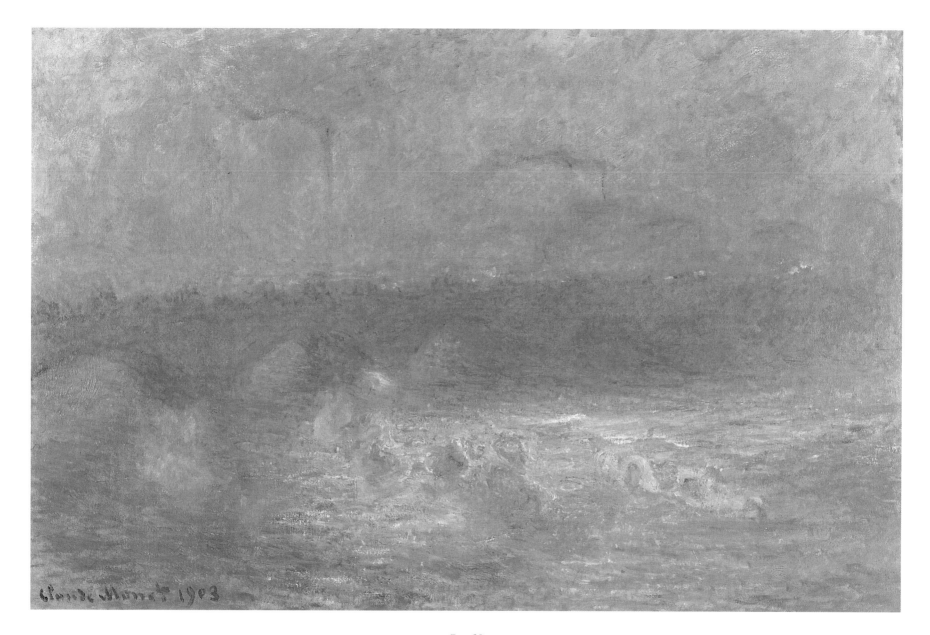

Cat. 30

CLAUDE MONET *(French, 1840–1926)*

Waterloo Bridge, Effect of Sun with Smoke, 1903

Oil on canvas 66.1 x 101 cm

The Baltimore Museum of Art

The Helen and Abram Eisenberg Collection

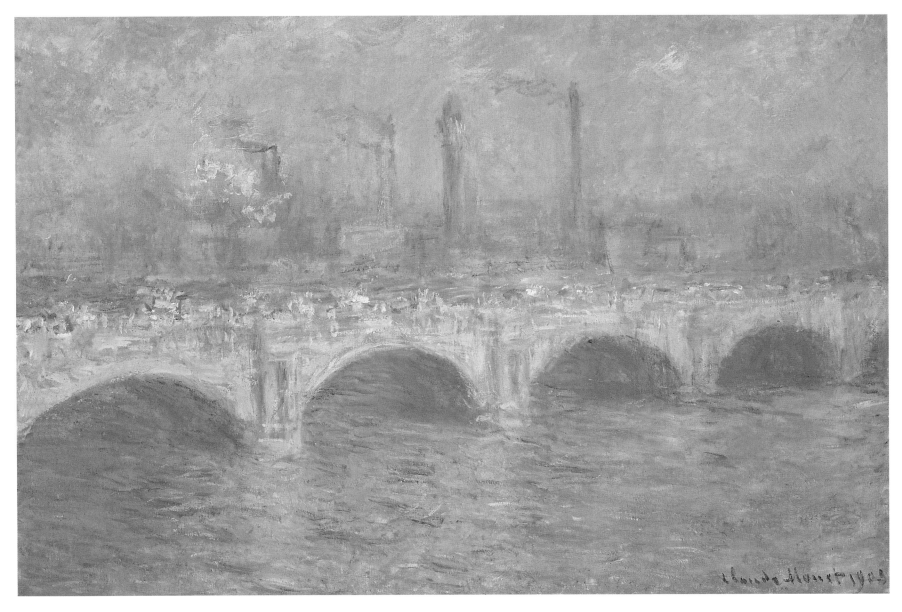

Cat. 31

CLAUDE MONET *(French, 1840–1926)*

Waterloo Bridge, London, c. 1903

Oil on canvas 64.45 x 100.33 cm

Carnegie Museum of Art, Pittsburgh

Acquired through the generosity of the Sarah Mellon Scaife Family

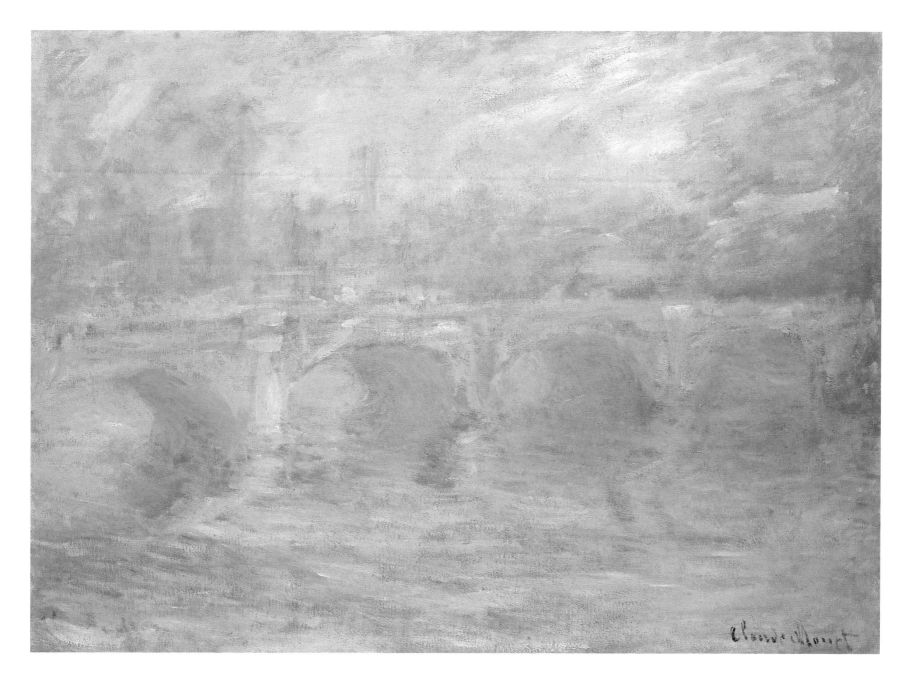

Cat. 32

CLAUDE MONET *(French, 1840–1926)*

Waterloo Bridge, London, at Sunset, 1904

Oil on canvas 65.5 x 92.7 cm

National Gallery of Art, Washington, D.C.

Collection of Mr. and Mrs. Paul Mellon

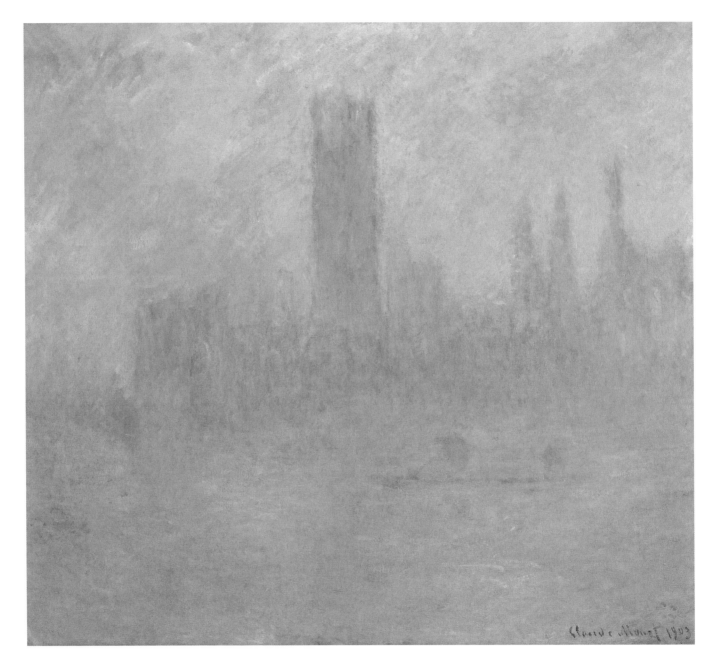

Cat. 33

CLAUDE MONET *(French, 1840–1926)*

Houses of Parliament in the Fog, 1903

Oil on canvas 81.33 x 92.45 cm

High Museum of Art, Atlanta
Great Painting Fund purchased in honor of Sarah Belle Broadnax Hansell

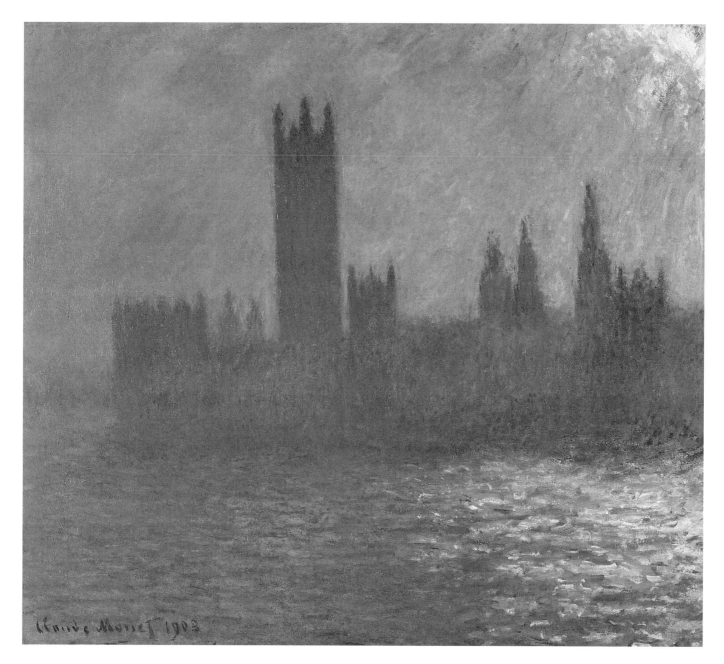

Cat. 34

CLAUDE MONET *(French, 1840–1926)*

Houses of Parliament, Effect of Sunlight, 1903

Oil on canvas 81.3 x 92.1 cm

The Brooklyn Museum of Art

Bequest of Grace Underwood Barton

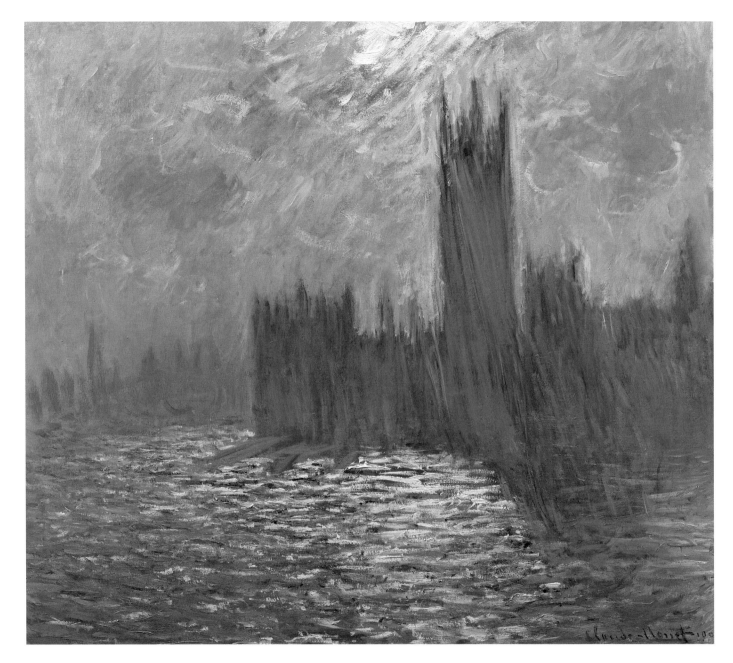

Cat. 35

CLAUDE MONET *(French, 1840–1926)*

Houses of Parliament, Reflections on the Thames, 1905

Oil on canvas 81.3 x 97 cm

Musée Marmottan-Monet, Paris

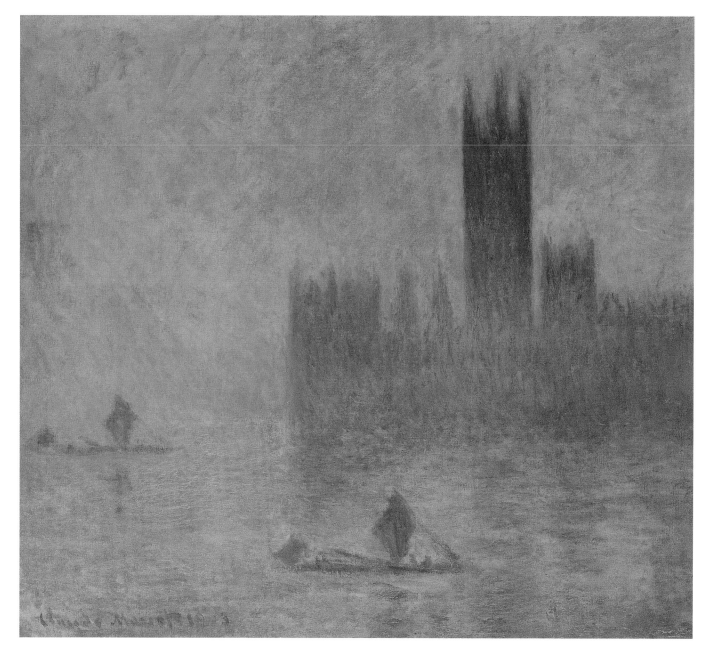

Cat. 36

CLAUDE MONET *(French, 1840–1926)*

Houses of Parliament, Effect of Fog, 1903

Oil on canvas 81.3 x 92.4 cm

The Metropolitan Museum of Art

Bequest of Julia W. Emmons, 1956

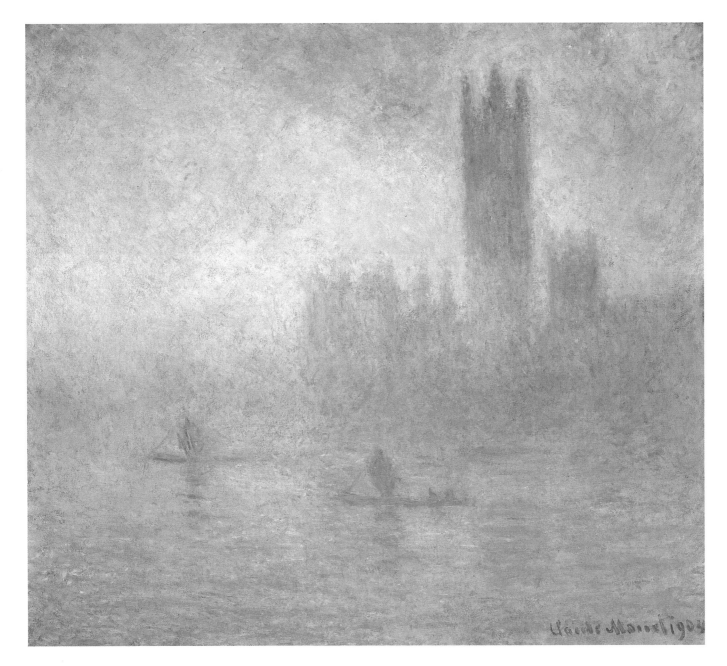

Cat. 37
CLAUDE MONET *(French, 1840–1926)*
Houses of Parliament, Effect of Fog, 1904
Oil on canvas 82.6 x 92.77 cm
Museum of Fine Arts, St. Petersburg, Florida
Museum purchase and partial gift of Charles C. and Margaret Stevenson Henderson

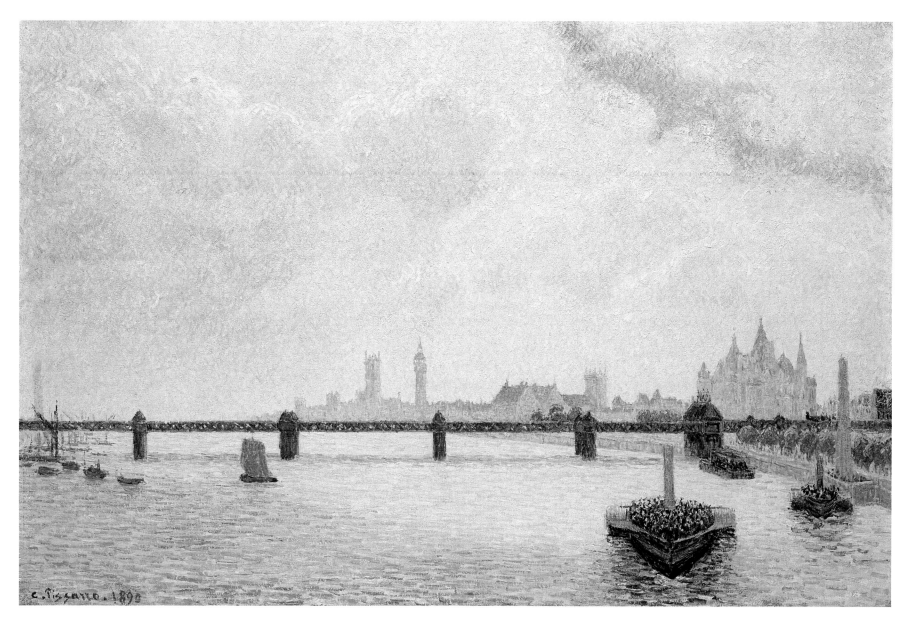

Cat. 38

CAMILLE PISSARRO *(French, 1830–1903)*

Charing Cross Bridge, London, 1890

Oil on canvas 60 x 92.4 cm

National Gallery of Art, Washington, D.C.

Collection of Mr. and Mrs. Paul Mellon

Cat. 39
JOSEPH PENNELL *(American, 1857–1926)*

Steamboat on the Thames, c. 1910

Watercolor on paper 19 x 27.8 cm

Prints and Photographs Division, Library of Congress, Washington, D.C.

Cat. 40
JOSEPH PENNELL *(American, 1857–1926)*
St Paul's, London, c. 1910
Watercolor and gouache on paper 24 x 36 cm
The Metropolitan Museum of Art
Rogers Fund, 1924

Cat. 41
JOSEPH PENNELL *(American, 1857–1926)*
Rose Cloud, c. 1910
Watercolor on paper 35.3 x 25.2 cm
Prints and Photographs Division, Library of Congress, Washington, D.C.

Cat. 42
JOSEPH PENNELL *(American, 1857–1926)*
The Obelisk, c. 1910
Watercolor on paper 25.2 x 35.3 cm
Prints and Photographs Division, Library of Congress, Washington, D.C.

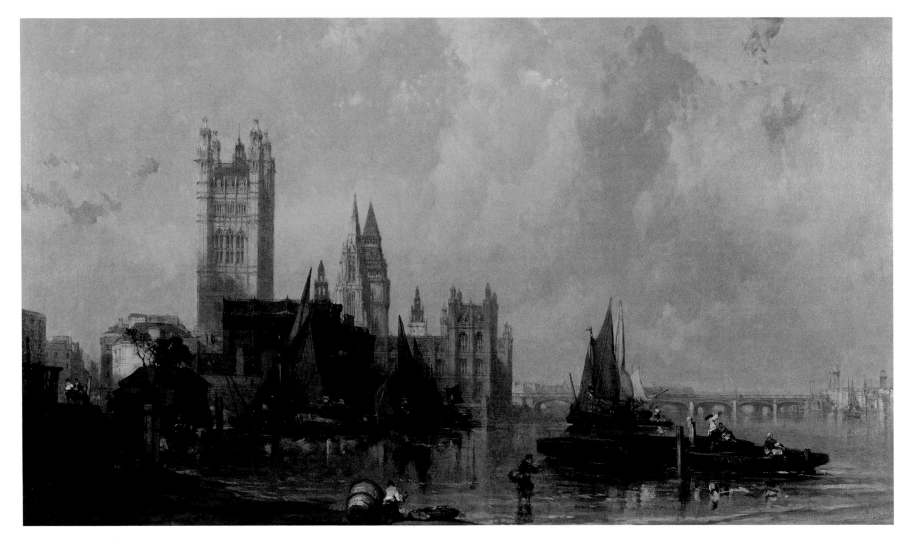

Cat. 43

DAVID ROBERTS *(British, 1796–1864)*

The Houses of Parliament from Millbank, 1861

Oil on canvas 61 x 106 cm

Museum of London

The acquisition of this painting was supported by the Heritage Lottery Fund

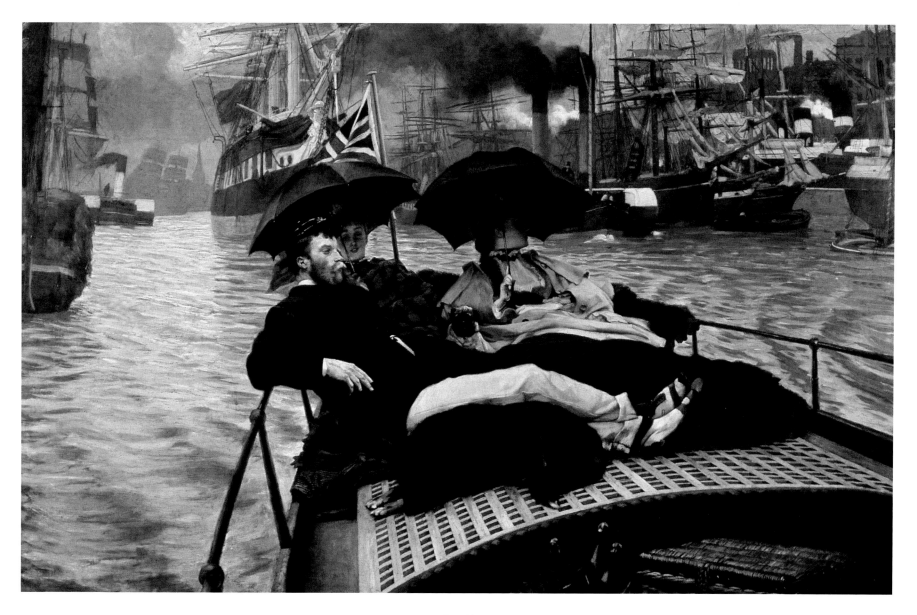

Cat. 44
JAMES TISSOT *(French, 1836–1902)*
The Thames, 1876
Oil on canvas 73 x 107.9 cm
Wakefield Art Gallery, Wakefield, England

Cat. 45

JAMES MCNEILL WHISTLER *(American, 1834–1903)*

The Last of Old Westminster, 1862

Oil on canvas 60.96 x 78.1 cm

Museum of Fine Arts, Boston

A. Shuman Collection

Cat. 46

JAMES MCNEILL WHISTLER *(American, 1834–1903)*

Battersea Reach, c. 1865

Oil on canvas 50.8 x 76.2 cm

Corcoran Gallery of Art, Washington, D.C.

Bequest of James Parmelee

Cat. 47

JAMES MCNEILL WHISTLER *(American, 1834–1903)*

Nocturne, c. 1870

Oil on canvas 27.9 x 46.2 cm

Mississippi Museum of Art, Jackson

Bequest of Sara Virginia Jones

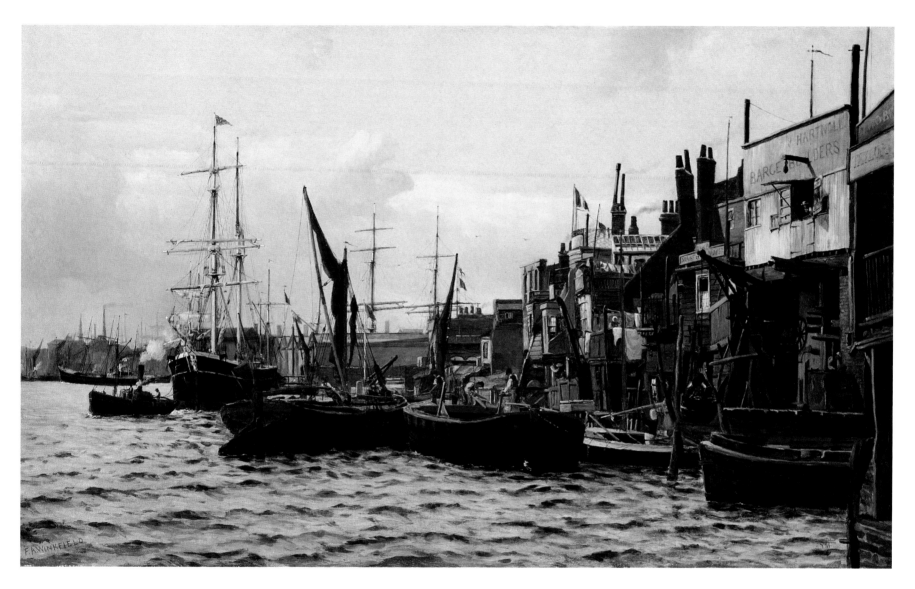

Cat. 48
F. A. WINKFIELD *(British, active 1873–1904)*
The Riverside at Limehouse, c. 1890
Oil on canvas 40.1 x 50.3 cm

Museum of London

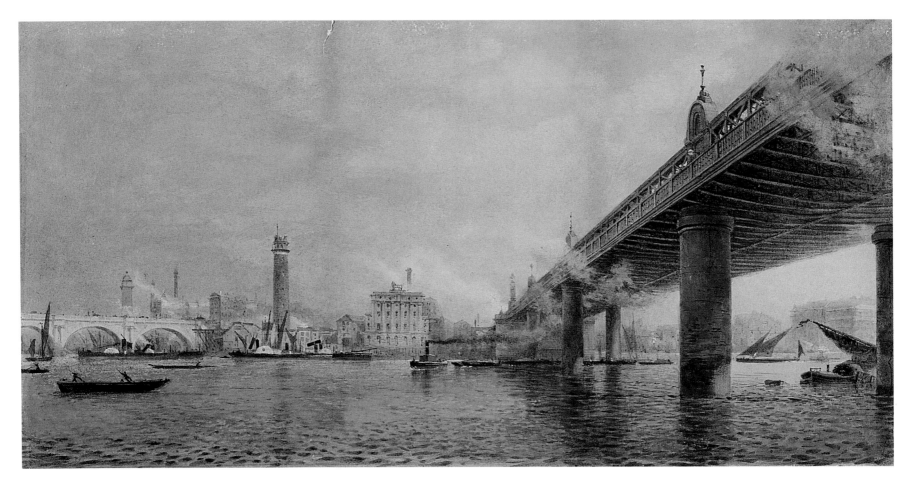

Cat. 49
UNKNOWN ARTIST
South Bank of the River Thames,
between Waterloo and Hungerford Bridges, c. 1870
Watercolor on paper 25.4 x 51.3 cm
Guildhall Library, Corporation of London

Cat. 50
HENRY EDWARD TIDMARSH *(British, 1854–1939)*
The River Thames from Blackfriars to Waterloo Bridge, 1900
Watercolor on paper 18.3 x 24.9 cm
Guildhall Library, Corporation of London

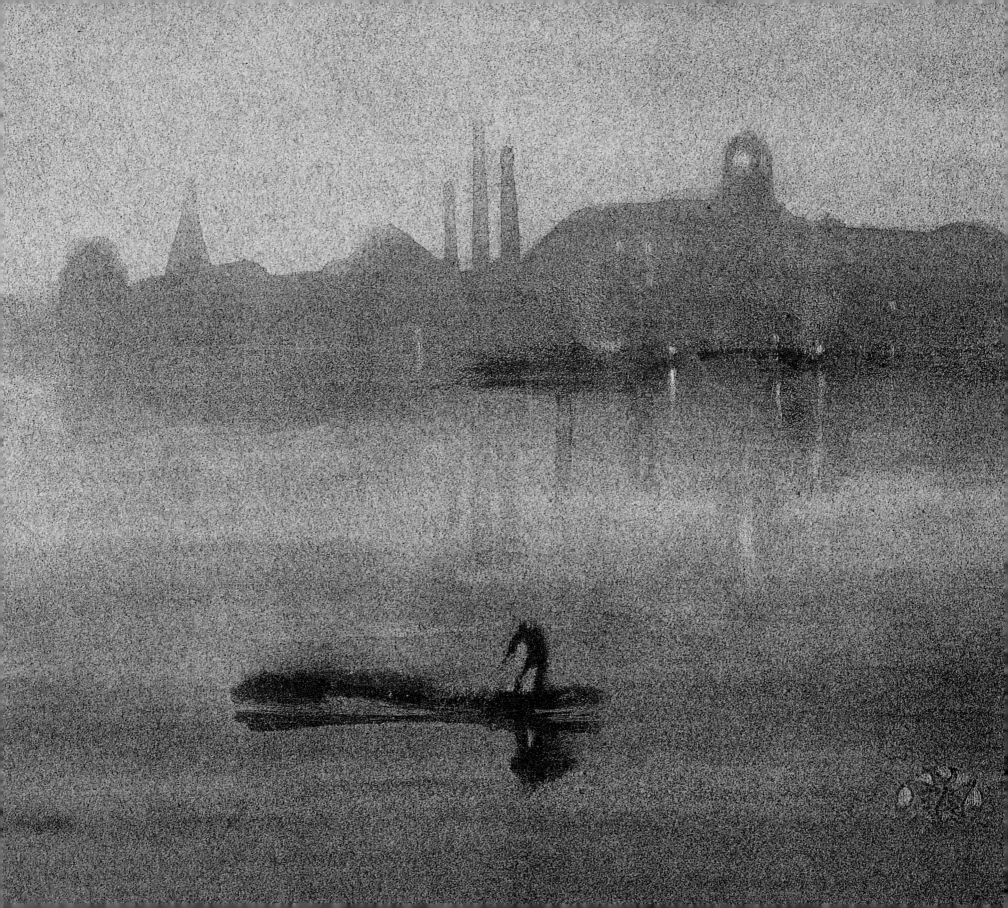

Catalogue | PRINTS

Cat. 51

CLIFFORD ADDAMS *(American, 1876–1942)*

Charing Cross Bridge, 1912

Drypoint on paper 14 x 26.3 cm

Museum of Fine Arts, St. Petersburg, Florida
Museum purchase with funds provided by
the Collectors Circle

Cat. 52

CLIFFORD ADDAMS
(American, 1876–1942)

Blackfriars, 1914

Etching and drypoint on paper
13.2 x 38.6 cm

Guildhall Library,
Corporation of London

Cat. 53

CLIFFORD ADDAMS *(American, 1876–1942)*

Limehouse, 1912

Etching and drypoint on paper 17.8 x 33.5 cm

Museum of Fine Arts, St. Petersburg, Florida

Museum purchase

Cat. 54

FÉLIX BUHOT *(French, 1847–1898)*

Westminster Clock Tower, 1884

Etching, aquatint, and drypoint on paper

28.59 x 40.03 cm

Print Collection, Miriam and Ira D. Wallach Division

of Art, Prints, and Photographs

The New York Public Library, Astor, Lenox, and Tilden Foundations

Cat. 55

FÉLIX BUHOT *(French, 1847–1898)*

Westminster Palace, 1884

Etching, drypoint, aquatint, and stipple on paper

Sheet: 31.2 x 44.5 cm Plate: 29.1 x 39.9 cm

The Baltimore Museum of Art

The George A. Lucas Collection, purchased with funds from the State of Maryland,

Laurence and Stella Bendann Fund, and contributions from individuals, foundations,

and corporations throughout the Baltimore community

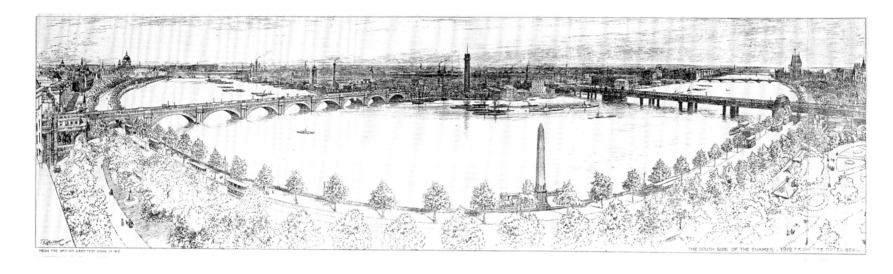

Cat. 57
T. RAFFLES DAVISON (*British, 1853–1937*)
The South Side of the Thames from the Hotel Cecil, 1912
Lithograph on paper 16.5 x 62.2 cm

Guildhall Library, Corporation of London

Cat. 56
DAVID YOUNG CAMERON (*British, 1865–1945*)
Waterloo Bridge, c. 1899
Etching on paper 18.5 x 14 cm

Museum of Fine Arts, St. Petersburg, Florida
Museum purchase

Cat. 58

GUSTAVE DORÉ *(French, 1832–1883)*

A selection from *London: A Pilgrimage* by Blanchard Jerrold, London: Grant & Co., 1872

The Docks – The Concordia

Billingsgate – Landing the Fish

Westminster Stairs – Steamers Landing

London Bridge

The Houses of Parliament by Night

First edition book with wood engravings 44 x 35 cm

Museum of Fine Arts, St. Petersburg, Florida

Museum purchase

Cat. 59
HENRI GUÉRARD *(French, 1846–1897)*
Westminster Bridge, before 1887
Drypoint on paper 24.14 x 15.25 cm
Museum of Fine Arts, St. Petersburg, Florida
Museum purchase

Cat. 60
FRANCIS SEYMOUR HADEN *(British, 1818–1910)*
Battersea Reach, 1863
Etching and drypoint on paper Plate: 15 x 22.7 cm
The Baltimore Museum of Art
The Garrett Collection

Cat. 61

FRANCIS SEYMOUR HADEN *(British, 1818–1910)*

Whistler's House, Old Chelsea, 1863

Etching and drypoint on chine paper 15.7 x 33 cm

The Baltimore Museum of Art
The Conrad Collection

Cat. 62

FRANCIS SEYMOUR HADEN *(British, 1818–1910)*

Battersea Bridge, after 1868

Etching and drypoint on paper 25 x 30.4 cm

Prints and Photographs Division, Library of Congress,
Washington, D.C.

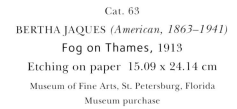

Cat. 63
BERTHA JAQUES *(American, 1863–1941)*
Fog on Thames, 1913
Etching on paper 15.09 x 24.14 cm
Museum of Fine Arts, St. Petersburg, Florida
Museum purchase

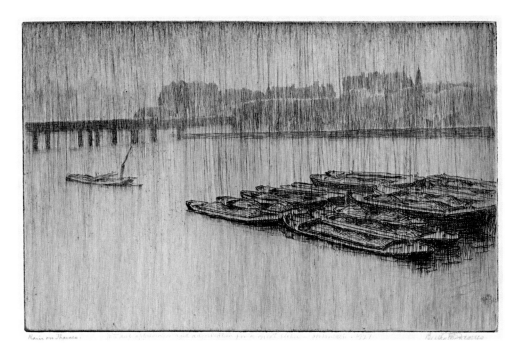

Cat. 64
BERTHA JAQUES *(American, 1863–1941)*
Rain on Thames, 1913
Etching on paper 15.09 x 23.82 cm
Museum of Fine Arts, St. Petersburg, Florida
Museum purchase

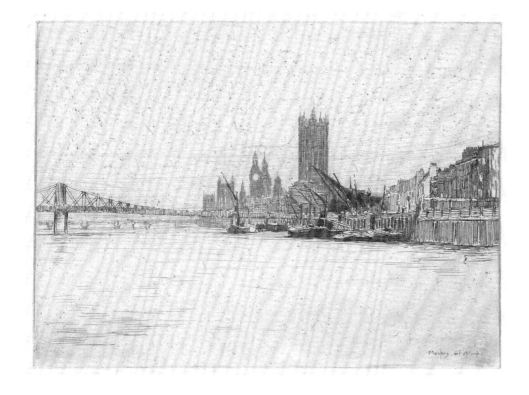

Cat. 65

MORTIMER MENPES *(British, b. Australia, 1855–1938)*

Westminster

Etching on paper, 1889

Plate I from *The Grey River* **by Justin McCarthy**
and Mrs. Campbell Praed

London: Messrs. Selley and Co. Ltd., 1889

Print Collection, Miriam and Ira D. Wallach Division of Art,
Prints and Photographs,
The New York Public Library, Astor, Lenox, and Tilden Foundations

Cat. 66

JOHN O'CONNOR *(British, 1830–1889)*, engraved by H. Adlard

Thames Embankment from Somerset House, 1873

Steel engraving on paper 20.3 x 37.6 cm

Guildhall Library, Corporation of London

Cat. 67

JOSEPH PENNELL *(American, 1857–1926)*

Vauxhall Bridge, 1893

No. 1 in the *Easter Set*

Etching on paper 9.4 x 15 cm

Frederick Keppel Memorial Collection, Print Collection,
Miriam and Ira D. Wallach Division of Art,
Prints and Photographs,
The New York Public Library, Astor, Lenox,
and Tilden Foundations

Cat. 68

JOSEPH PENNELL *(American, 1857–1926)*

The Tower Bridge, 1893

No. 5 in the *Easter Set*

Etching on paper 9.1 x 22.6 cm

Frederick Keppel Memorial Collection,
Print Collection, Miriam and Ira D. Wallach
Division of Art, Prints and Photographs
The New York Public Library, Astor, Lenox, and Tilden Foundations

Cat. 71

JOSEPH PENNELL *(American, 1857–1926)*

The Savoy, 1895

Etching on paper 19.69 x 25.41 cm

Prints and Photographs Division, Library of Congress,
Washington, D.C.

Cat. 72

JOSEPH PENNELL *(American, 1857–1926)*

Lanark Wharf, 1895

Etching on paper image: 20.01 x 27.64 cm

Museum of Fine Arts, St. Petersburg, Florida
Museum purchase with funds provided
by the Docent Class of 2003

Cat. 73

JOSEPH PENNELL *(American, 1857–1926)*

London Bridge to Tower Bridge, 1905

Etching on paper

Sheet: 31.1 x 24.1 cm Image: 25.4 x 20.3 cm

Museum of Fine Arts, St. Petersburg, Florida
Museum purchase with funds provided
by the Collectors Circle

Cat. 74

JOSEPH PENNELL *(American, 1857–1926)*

Waterloo Towers, 1906

Drypoint on paper 21.6 x 27.8 cm

Museum of Fine Arts, St. Petersburg, Florida
Museum purchase with funds provided by Jennifer Hardin and Emmanuel Roux

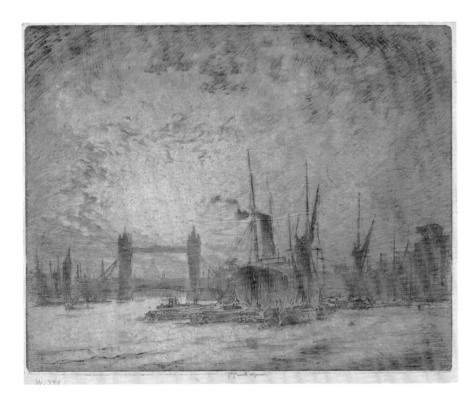

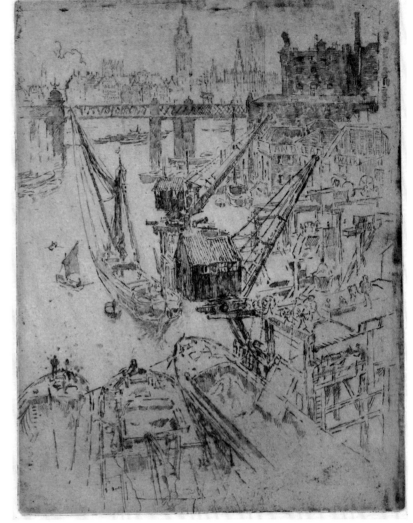

Cat. 75

JOSEPH PENNELL *(American, 1857–1926)*

Tower Bridge, Evening, 1905

Etching on paper 22.6 x 28 cm

Prints and Photographs Division, Library of Congress,
Washington, D.C.

Cat. 76

JOSEPH PENNELL *(American, 1857–1926)*

The Works at Waterloo, 1906

Etching on paper 28 x 21.7 cm

Prints and Photographs Division, Library of Congress,
Washington, D.C.

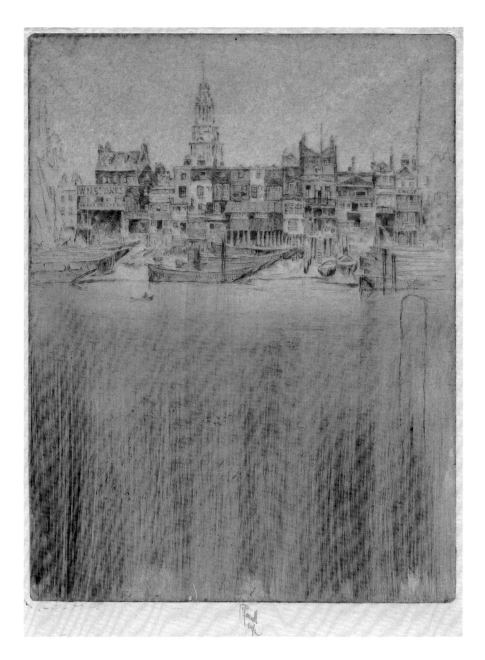

Cat. 77
JOSEPH PENNELL *(American, 1857–1926)*
Limehouse, 1906
Etching on paper 27.64 x 21.6 cm
Prints and Photographs Division, Library of Congress, Washington, D.C.

Cat. 78

JOSEPH PENNELL *(American, 1857–1926)*

Westminster, Evening, 1909

Mezzotint and drypoint on paper 30 x 44.5 cm

Prints and Photographs Division, Library of Congress,
Washington, D.C.

Cat. 79

JOSEPH PENNELL *(American, 1857–1926)*

The City, Evening, 1909

Mezzotint and drypoint on paper 25.2 x 38 cm

Prints and Photographs Division, Library of Congress, Washington, D.C.

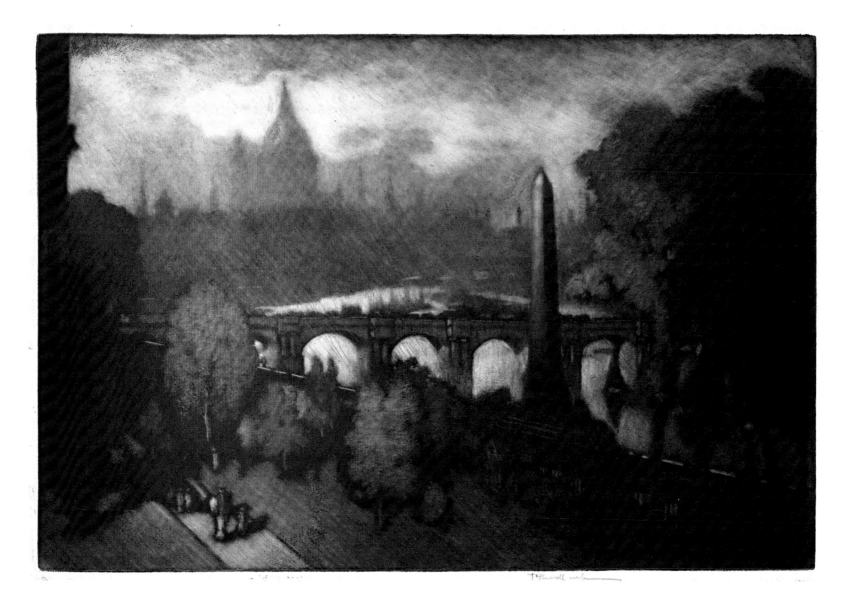

Cat. 80

JOSEPH PENNELL *(American, 1857–1926)*

The Shower, London, 1909

Mezzotint and drypoint on paper 24.78 x 37.49 cm

Museum of Fine Arts, St. Petersburg, Florida
Museum purchase with funds provided
by the Collectors Circle

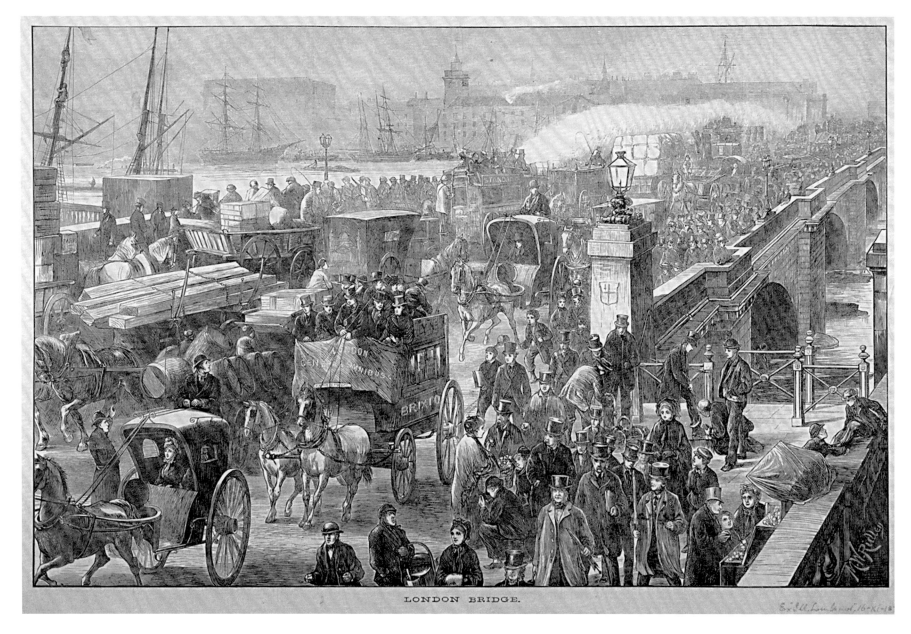

LONDON BRIDGE.

Cat. 81

MATTHEW WHITE RIDLEY *(British, 1837–1888)*

London Bridge, 1872

Wood engraving on paper 31 x 48.8 cm

Guildhall Library, Corporation of London

Cat. 82
THÉODORE ROUSSEL *(French, 1847–1926)*
Chelsea Palaces, 1890–97
Color etching and aquatint on hand-colored mount Mount: 26.4 x 29.2 cm

The Metropolitan Museum of Art
Harris Brisbane Dick Fund and The Elisha Whittelsey Collection
The Elisha Whittelsey Fund, by exchange, 1954

Cat. 83
NED SWAIN *(British, 1847–1902)*
Westminster from the River Thames, 1884
Etching on paper 17.8 x 25.4 cm

Guildhall Library, Corporation of London

THAMES EMBANKMENT.

Cat. 84
ROBERT KENT THOMAS *(British, 1816–1884)*
Thames Embankment, Steamboat Landing Pier
at Westminster Bridge, 1864
Chromolithograph on paper 20.3 x 35.6 cm

Guildhall Library, Corporation of London

THAMES EMBANKMENT.

Cat. 85
ROBERT KENT THOMAS *(British, 1816–1884)*
Thames Embankment, Landing Stairs, Roads and
Ornamental Gardens between Hungerford
and Waterloo Bridges, 1863
Chromolithograph on paper 23.4 x 36.1 cm

Guildhall Library, Corporation of London

Cat. 86

UNKNOWN ARTIST

Progress of the Construction of the
New Blackfriars Bridge, 1868

Wood engraving on paper 22.9 x 34.3 cm

Guildhall Library, Corporation of London

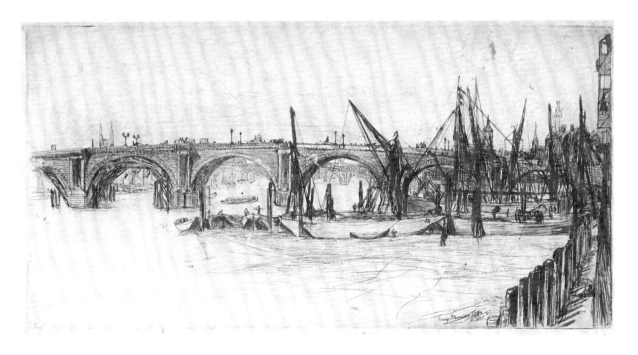

Cat. 87

PERCY THOMAS *(British, 1846–1922)*

Blackfriars Bridge, 1862

Etching on paper 14 x 27.9 cm

Guildhall Library, Corporation of London

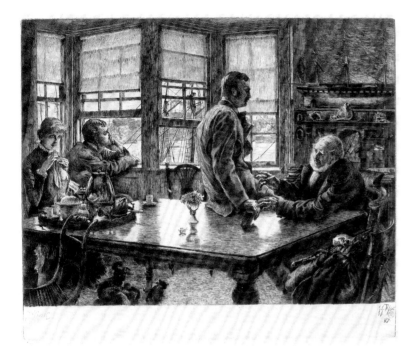

Cat. 88

JAMES TISSOT *(French, 1836–1902)*

The Prodigal Son: The Departure, 1881–82

Etching on paper Sheet: 49.8 x 61.7 cm

Plate: 31.1 x 37.5 cm

The Baltimore Museum of Art

Gift of Elizabeth Wrenn, Eleanor de Ghize, Francis Jencks, and Gardner Jencks

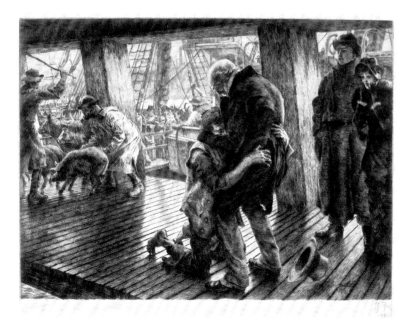

Cat. 89

JAMES TISSOT *(French, 1836–1902)*

The Prodigal Son: The Return, 1881–82

Etching on paper Sheet: 49.8 x 61.7 cm

Plate: 31.1 x 37.5 cm

The Baltimore Museum of Art

Gift of Elizabeth Wrenn, Eleanor de Ghize, Francis Jencks, and Gardner Jencks

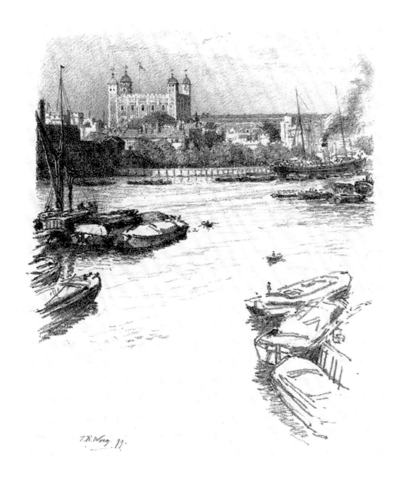

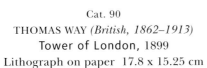

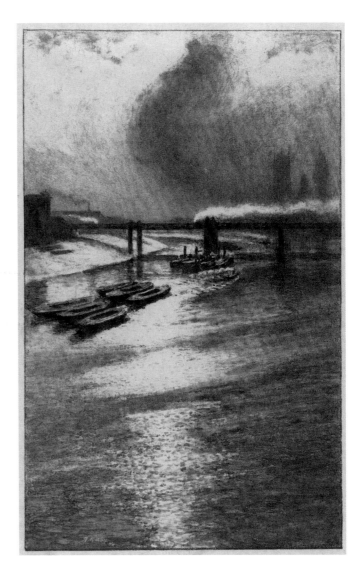

Cat. 90
THOMAS WAY *(British, 1862–1913)*
Tower of London, 1899
Lithograph on paper 17.8 x 15.25 cm

Museum of Fine Arts, St. Petersburg, Florida
Museum purchase with funds provided by the Collectors Circle

Cat. 91
THOMAS WAY *(British, 1862–1913)*
The Smoke Cloud, Charing Cross Bridge, c. 1900
Lithograph on paper 21.4 x 13.5 cm

Prints and Photographs Division, Library of Congress, Washington, D.C.

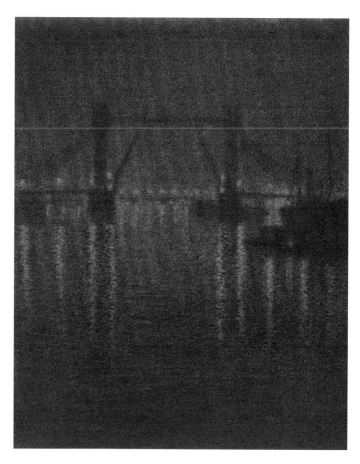

Cat. 92

THOMAS WAY *(British, 1862–1913)*

Afterglow, Lower Pool, c. 1900

Color lithograph on paper 14.1 x 16.4 cm

Prints and Photographs Division, Library of Congress, Washington, D.C.

Cat. 93

THOMAS WAY *(British, 1862–1913)*

The Gate of London, c. 1900

Color lithograph on paper 16.1 x 13.3 cm

Prints and Photographs Division, Library of Congress, Washington, D.C.

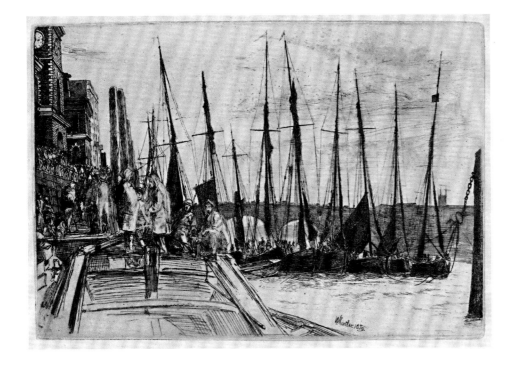

Cat. 94

JAMES MCNEILL WHISTLER *(American, 1834–1903)*

Billingsgate, 1859

Etching on paper 15.25 x 22.87 cm

Museum of Fine Arts, St. Petersburg, Florida
Gift of Robert J. Hager in memory of Martha Louise Hager

Cat. 95

JAMES MCNEILL WHISTLER *(American, 1834–1903)*

The Pool, 1859

Etching on paper Sheet: 24.5 x 34 cm

Plate: 13.9 x 21.2 cm

The Baltimore Museum of Art
The George A. Lucas Collection, purchased with funds from
the State of Maryland, Laurence and Stella Bendann Fund,
and contributions from individuals, foundations, and corporations
throughout the Baltimore community

Cat. 96

JAMES MCNEILL WHISTLER *(American, 1834–1903)*

Black Lion Wharf, 1859

Etching and drypoint on paper Sheet: 23.3 x 31.2 cm

Plate: 14.8 x 22.5 cm

The Baltimore Museum of Art

The George A. Lucas Collection, purchased with funds from the State of Maryland, Laurence and Stella Bendann Fund, and contributions from individuals, foundations, and corporations throughout the Baltimore community

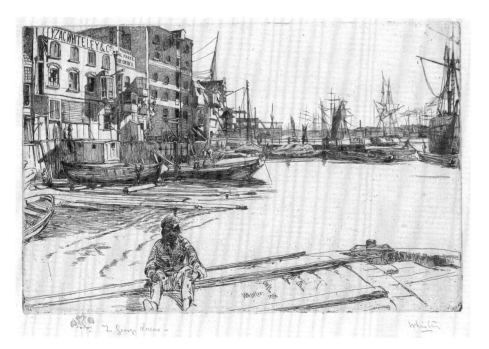

Cat. 97

JAMES MCNEILL WHISTLER *(American, 1834–1903)*

Eagle Wharf, 1859

Etching and drypoint on paper Sheet: 23.4 x 30.1 cm

Plate: 13.6 x 21.4 cm

The Baltimore Museum of Art

The George A. Lucas Collection, purchased with funds from the State of Maryland, Laurence and Stella Bendann Fund, and contributions from individuals, foundations, and corporations throughout the Baltimore community

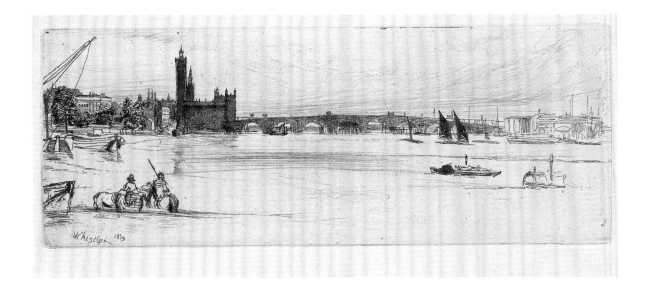

Cat. 98

JAMES MCNEILL WHISTLER *(American, 1834–1903)*

Old Westminster Bridge, 1859

Etching on paper Plate: 7.4 x 20 cm

The Baltimore Museum of Art

The Garrett Collection

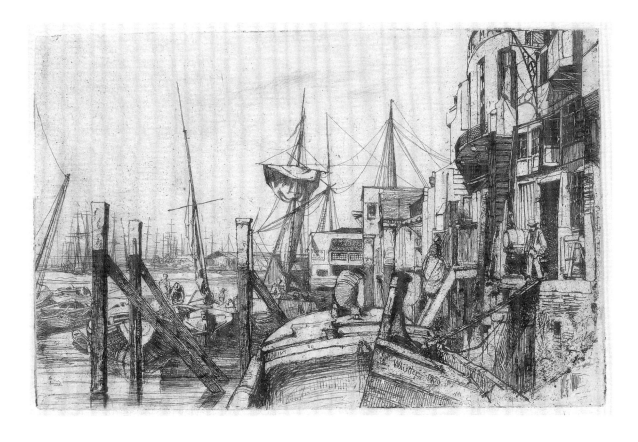

Cat. 99

JAMES MCNEILL WHISTLER *(American, 1834–1903)*

Limehouse, 1859

Etching on paper Sheet: 24.5 x 33.9 cm

Plate: 12.7 x 20 cm

The Baltimore Museum of Art

The George A. Lucas Collection, purchased with funds

from the State of Maryland, Laurence and Stella Bendann Fund,

and contributions from individuals, foundations,

and corporations throughout the Baltimore community

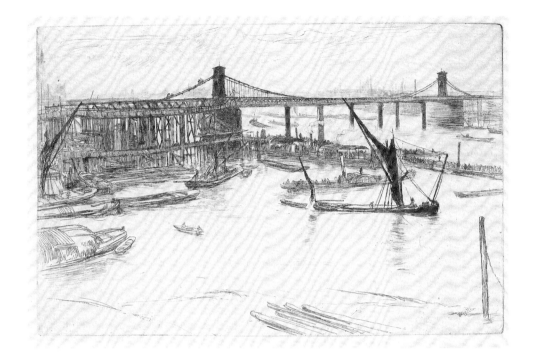

Cat. 100

JAMES MCNEILL WHISTLER *(American, 1834–1903)*

Old Hungerford Bridge, 1861

Etching on paper 16 x 23.6 cm

The Baltimore Museum of Art
The George A. Lucas Collection, purchased with funds from the
State of Maryland, Laurence and Stella Bendann Fund,
and contributions from individuals, foundations, and corporations
throughout the Baltimore community

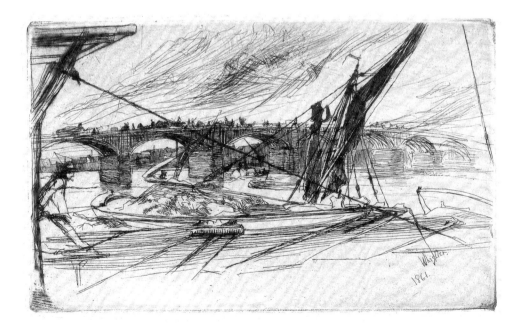

Cat. 101

JAMES MCNEILL WHISTLER *(American, 1834–1903)*

Vauxhall Bridge, 1861

Etching on paper

Sheet: 15.2 x 21 cm

Plate: 6.9 x 11.4 cm

The Baltimore Museum of Art
The George A. Lucas Collection, purchased with funds from the
State of Maryland, Laurence and Stella Bendann Fund, and
contributions from individuals, foundations, and corporations
throughout the Baltimore community

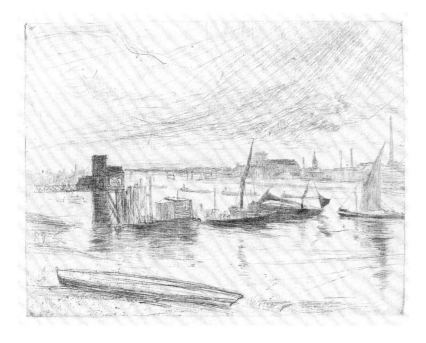

Cat. 102

JAMES MCNEILL WHISTLER *(American, 1834–1903)*

Early Morning, Battersea, 1861

Drypoint on paper Sheet: 13.8 x 17.5 cm

Plate: 11.3 x 15 cm

The Baltimore Museum of Art
The George A. Lucas Collection, purchased with funds from
the State of Maryland, Laurence and Stella Bendann Fund,
and contributions from individuals, foundations, and corporations
throughout the Baltimore community

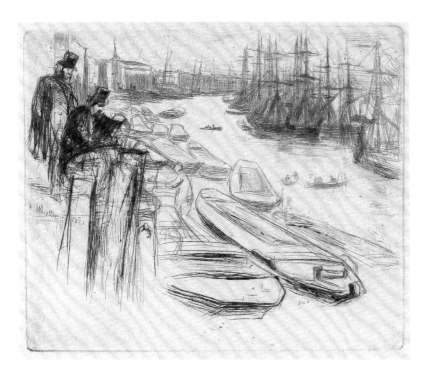

Cat. 103

JAMES MCNEILL WHISTLER *(American, 1834–1903)*

The Little Pool, 1861

Etching and drypoint on paper

Sheet: 21.8 x 27.9 cm Plate: 10.4 x 12.6 cm

The Baltimore Museum of Art
The George A. Lucas Collection, purchased with funds from the
State of Maryland, Laurence and Stella Bendann Fund,
and contributions from individuals, foundations, and
corporations throughout the Baltimore community

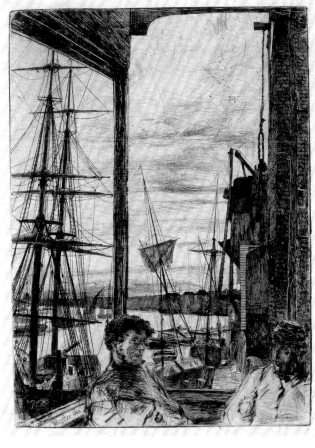

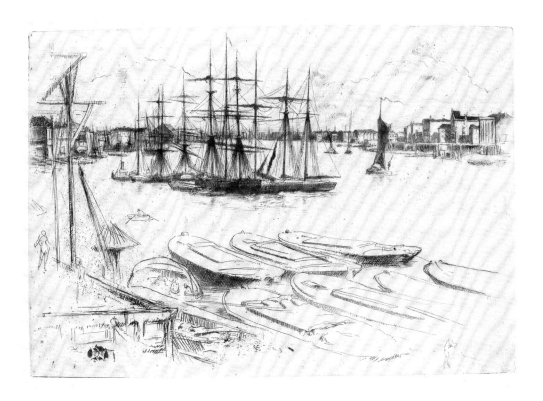

Cat. 104

JAMES MCNEILL WHISTLER *(American, 1834–1903)*

Rotherhithe, 1860

Etching and drypoint on Japan paper

Sheet: 38.5 x 26.5 cm

The Baltimore Museum of Art
The George A. Lucas Collection, purchased with funds from
the State of Maryland, Laurence and Stella Bendann Fund,
and contributions from individuals, foundations, and corporations
throughout the Baltimore community

Cat. 105

JAMES MCNEILL WHISTLER *(American, 1834–1903)*

The Large Pool, 1879

Etching and drypoint on paper

Sheet: 27.9 x 35.6 cm

Plate: 18.8 x 27.5 cm

The Baltimore Museum of Art
The George A. Lucas Collection, purchased with funds from the State of Maryland,
Laurence and Stella Bendann Fund, and contributions from individuals, foundations,
and corporations throughout the Baltimore community

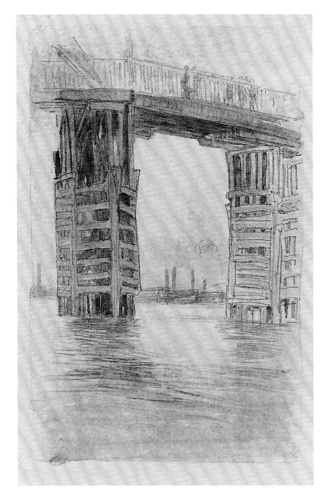

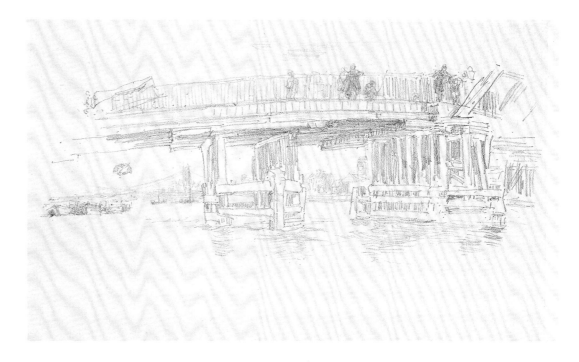

Cat. 106

JAMES MCNEILL WHISTLER *(American, 1834–1903)*

The Tall Bridge, 1878

Lithotint on paper 27.9 x 18.5 cm

S. P. Avery Collection, Miriam and Ira D. Wallach Division of Art,
Prints and Photographs
The New York Public Library, Astor, Lenox,
and Tilden Foundations

Cat. 107

JAMES MCNEILL WHISTLER *(American, 1834–1903)*

Old Battersea Bridge, 1879

Transfer lithograph on paper 27.9 x 35.6 cm

The Baltimore Museum of Art

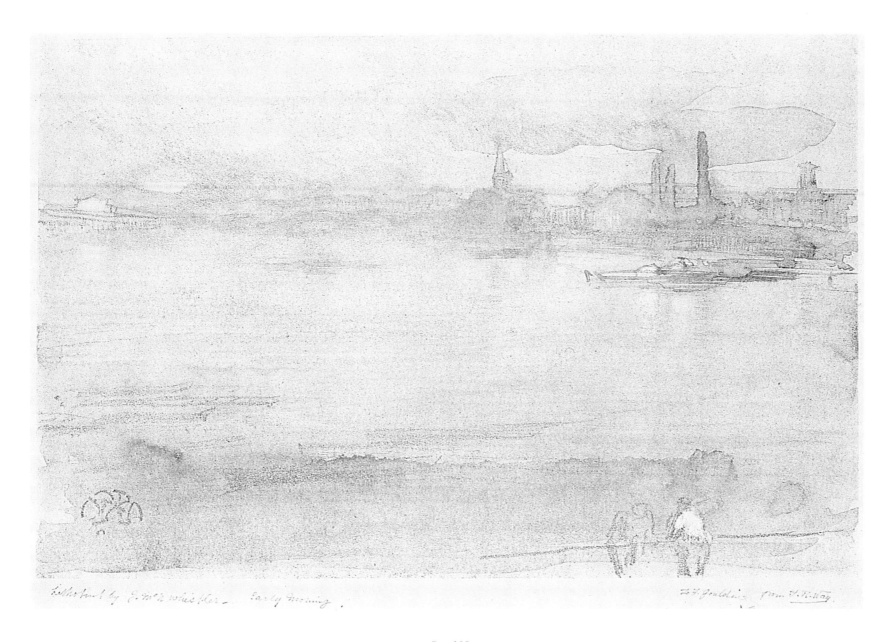

Cat. 108

JAMES MCNEILL WHISTLER *(American, 1834–1903)*

Early Morning, 1878

Lithotint on paper

Sheet: 18 x 26 cm Image: 16.5 x 26 cm

The Baltimore Museum of Art
Gift of Mrs. Matthew H. Hirsh, Baltimore

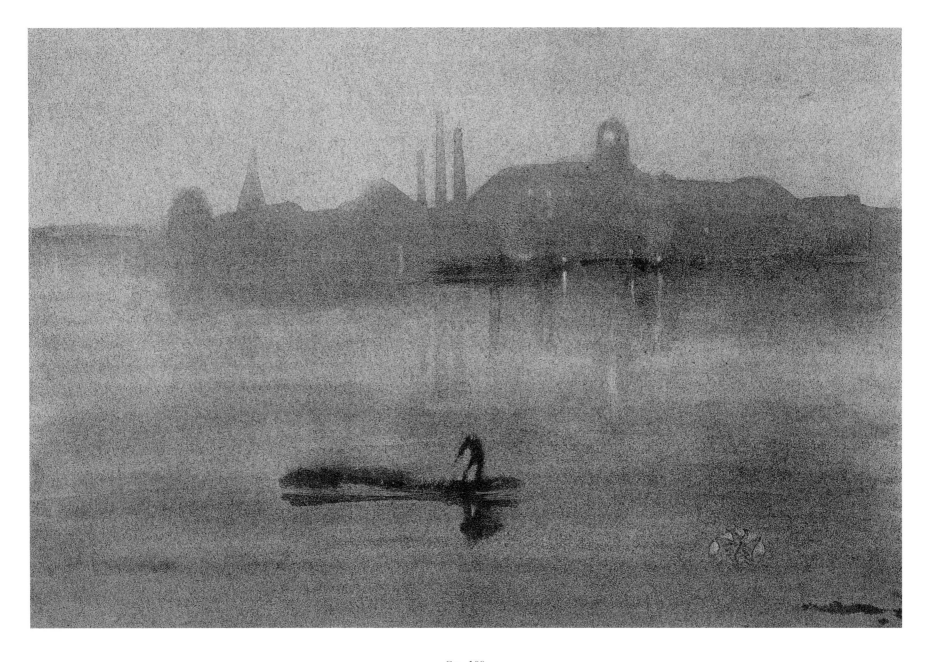

Cat. 109

JAMES MCNEILL WHISTLER *(American, 1834–1903)*

Nocturne: The River at Battersea, 1878

Lithotint on paper 17.3 x 25.7 cm

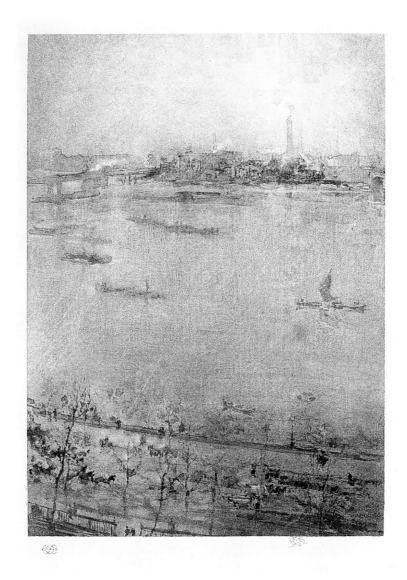

Cat. 110
JAMES MCNEILL WHISTLER *(American, 1834–1903)*
The Thames, 1896
Lithotint on paper
Sheet: 30 x 21.5 cm Image: 26.5 x 18.7 cm
The Baltimore Museum of Art
The Conrad Collection

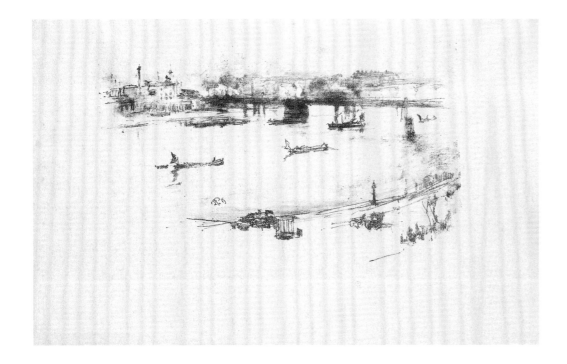

Cat. 111

JAMES MCNEILL WHISTLER *(American, 1834–1903)*

Charing Cross Railway Bridge, 1896

Transfer lithograph on paper Image: 13 x 21 cm

The Baltimore Museum of Art

Gift of Alfred R. and Henry G. Riggs, in Memory of General

Lawrason Riggs

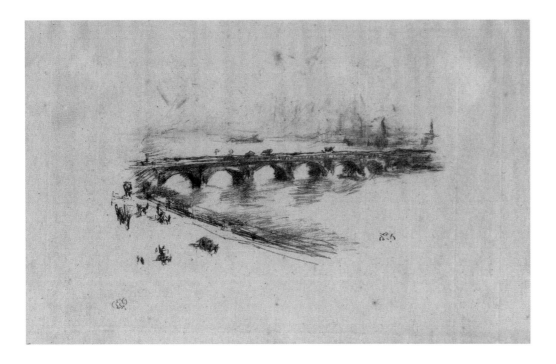

Cat. 112

JAMES MCNEILL WHISTLER *(American, 1834–1903)*

Evening, Little Waterloo Bridge, 1896

Transfer lithograph on paper Sheet: 20 x 30.6 cm

Prints and Photographs Division, Library of Congress,

Washington, D.C.

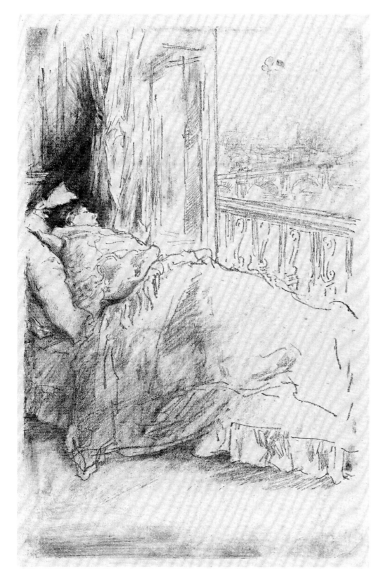

Cat. 113
JAMES MCNEILL WHISTLER *(American, 1834–1903)*
By the Balcony, 1896
Transfer lithograph on paper 21.3 x 15 cm

Print Collection, Miriam and Ira D. Wallach Division of Art,
Prints and Photographs
The New York Public Library, Astor, Lenox, and Tilden Foundations
Bequest of Edward G. Kennedy

Cat. 114
JAMES MCNEILL WHISTLER *(American, 1834–1903)*
Savoy Pigeons, 1896
Transfer lithograph on paper Image: 19.6 x 13.7 cm

The Baltimore Museum of Art
Purchase Fund

Cat. 115

WILLIAM WYLLIE *(British, 1851–1931)*
Tower Bridge, c. 1895
Etching on paper 33 x 54.6 cm

Guildhall Art Gallery, London

Catalogue | PHOTOGRAPHS

Cat. 116

ALVIN LANGDON COBURN *(British, b. United States, 1882–1966)*

Houses of Parliament, 1909

Photogravure 21.6 x 17.3 cm

Museum of Fine Arts, St. Petersburg, Florida

Museum purchase with funds provided by Dr. Robert L. and Chitranee Drapkin

Cat. 117

ALVIN LANGDON COBURN *(British, b. United States, 1882–1966)*

St. Paul's from the River, 1909

Photogravure 17.8 x 16.5 cm

Museum of Fine Arts, St. Petersburg, Florida

Museum purchase with funds provided by the Collectors Circle

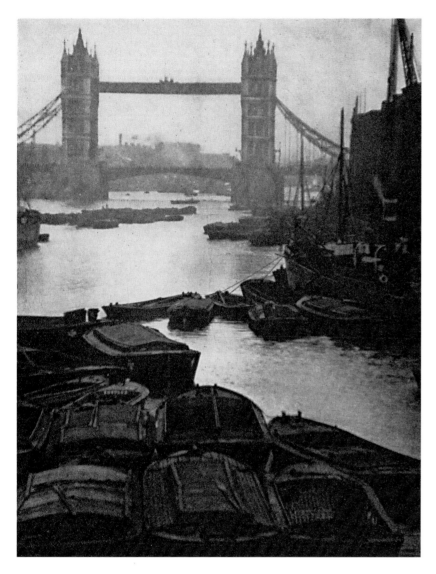

Cat. 118

ALVIN LANGDON COBURN *(British, b. United States, 1882–1966)*

The Tower Bridge, 1909

Photogravure 21.1 x 16.5 cm

Museum of Fine Arts, St. Petersburg, Florida

Museum purchase with funds provided by the Collectors Circle

Cat. 119

ALVIN LANGDON COBURN *(British, b. United States, 1882–1966)*

The Bridge—London (Waterloo Bridge), 1909

Photogravure 20.96 x 16.52 cm

Museum of Fine Arts, St. Petersburg, Florida

Museum purchase with funds provided by the Collectors Circle

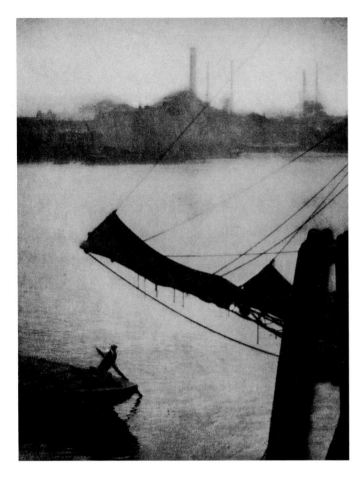

Cat. 121
ALVIN LANGDON COBURN *(British, b. United States, 1882–1966)*
Thameside Twilight, c. 1909
Photogravure 13.34 x 20.96 cm

Museum of Fine Arts, St. Petersburg, Florida
Museum purchase with funds provided by the Collectors Circle

Cat. 120
ALVIN LANGDON COBURN
(British, b. United States, 1882–1966)
Wapping, 1909
Photogravure Sheet: 21.7 x 17 cm

The Baltimore Museum of Art
Gift of Mr. and Mrs. Guy Tilghman Hollyday

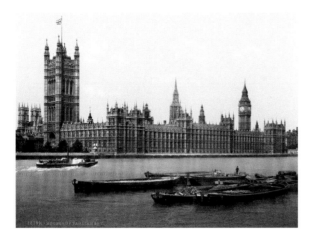

Cat. 122

DETROIT PUBLISHING COMPANY

Houses of Parliament, c. 1905

Photochrom 16.5 x 22.3 cm

Prints and Photographs Division,
Library of Congress, Washington, D.C.

Cat. 123

DETROIT PUBLISHING COMPANY

Thames Embankment, c. 1905

Photochrom 16.5 x 22.3 cm

Prints and Photographs Division,
Library of Congress, Washington, D.C.

Cat. 124

DETROIT PUBLISHING COMPANY

London Bridge, c. 1905

Photochrom 16.5 x 22.3 cm

Prints and Photographs Division,
Library of Congress, Washington, D.C.

Cat. 125

ROGER FENTON *(British, 1819–1869)*

Waterloo Bridge, c. 1854

Albumen print 29 x 41.8 cm

Courtesy of the Royal Photographic Society at the National
Museum of Photography,
Film, & Television, Bradford, England

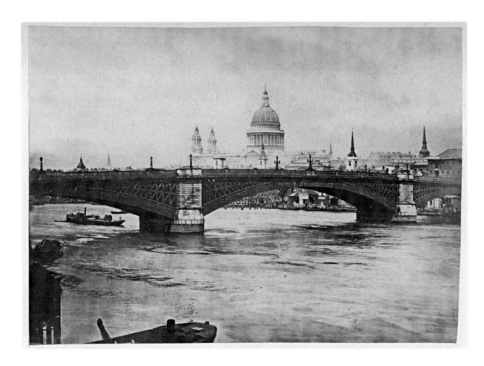

Cat. 126

FRANCIS FRITH *(British, 1822–1898)*

Southwark Bridge, c. 1867

Albumen print 10 x 13.9 cm

Illustration from *The Book of the Thames from Its Rise
to Its Fall* by Mr. and Mrs. S.C. Hall,
London: Alfred W. Bennett; Virtue & Co., 1867
Museum of Fine Arts, St. Petersburg, Florida
Museum purchase with funds provided
by Dr. Robert L. and Chitranee Drapkin

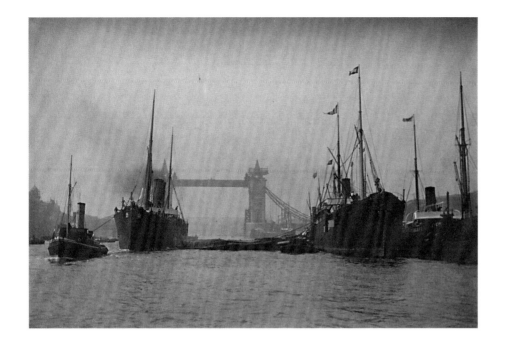

Cat. 127

JOSEPH GALE *(British, c. 1835–1906)*

Barges and Ships on the Thames, c. 1890

Platinum print 12.1 x 18.1 cm

Courtesy of the Royal Photographic Society at the National
Museum of Photography, Film, & Television, Bradford, England

Cat. 128

CHARLES JOB *(British, 1853–1930)*

The Thames below London Bridge, n.d.

Bromoil print 26 x 34.6 cm

Courtesy of the Royal Photographic Society at the National
Museum of Photography, Film, & Television, Bradford, England

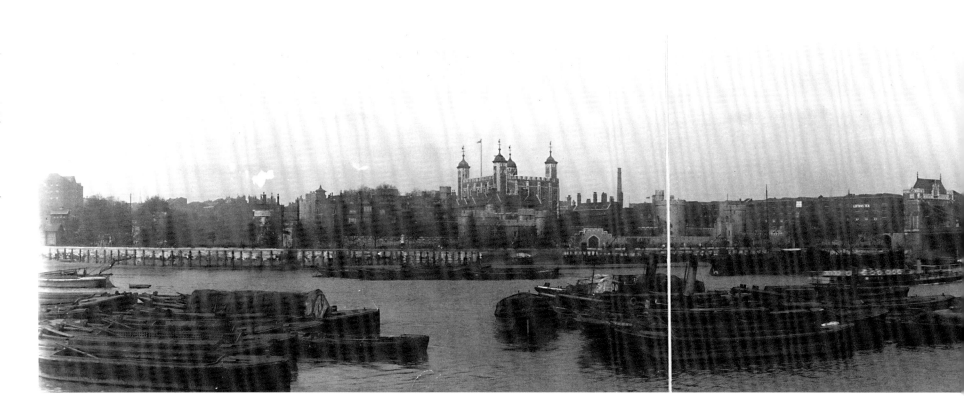

Cat. 129
NOTMAN PHOTOGRAPHIC COMPANY
Panoramic View of the Tower of London
and Tower Bridge, c.1900
Gelatin silver print 24.78 x 133.76 cm
Prints and Photographs Division, Library of Congress, Washington, D.C.

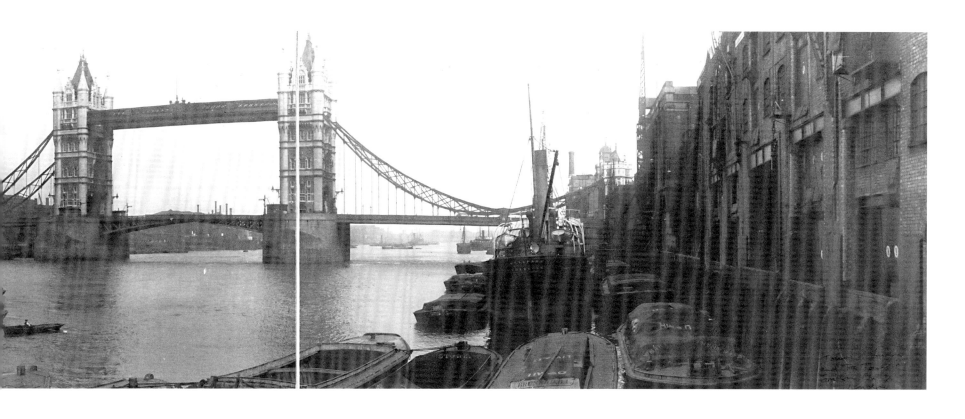

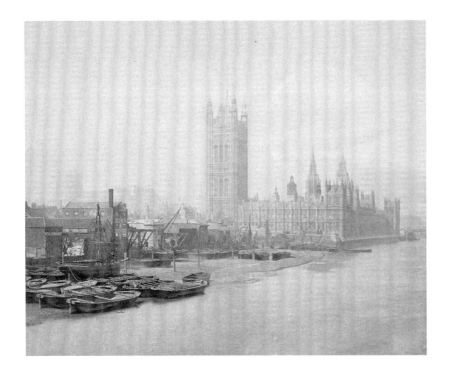

Cat. 130
WILLIAM STRUDWICK *(British, active late 19th century)*
Houses of Parliament from Lambeth Bridge, 1860s
Albumen print 23.6 x 28.6 cm
Victoria and Albert Museum, London

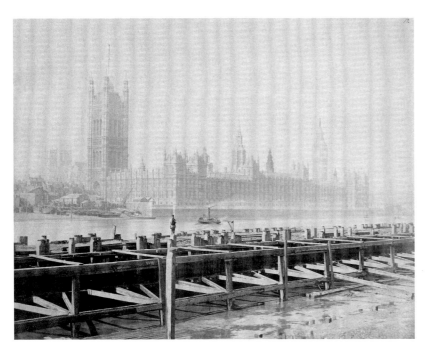

Cat. 131
WILLIAM STRUDWICK *(British, active late 19th century)*
Houses of Parliament from Bishop's Walk, 1860s
Albumen print 22.1 x 28.3 cm
Victoria and Albert Museum, London

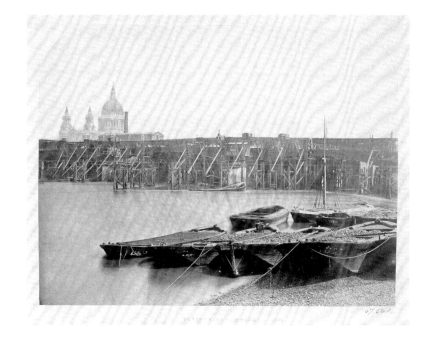

Cat. 132

WILLIAM STRUDWICK *(British, active late 19th century)*

New Blackfriars Bridge under Construction, c. 1869

Albumen print 18 x 23.5 cm

Victoria and Albert Museum, London

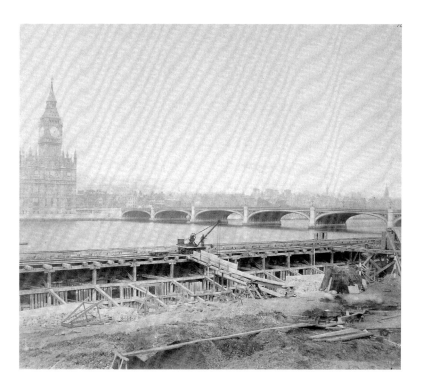

Cat. 133

WILLIAM STRUDWICK *(British, active late 19th century)*

Westminster Bridge, 1860s

Albumen print 24.8 x 28 cm

Victoria and Albert Museum, London

The Frozen River *A. J. Ransome*

Cat. 134

A. J. RANSOME *(British, active late 19th century)*

The Frozen River, 1895

Platinum print 10.4 x 6.9 cm

Courtesy of the Royal Photographic Society at the National Museum of
Photography, Film, & Television, Bradford, England

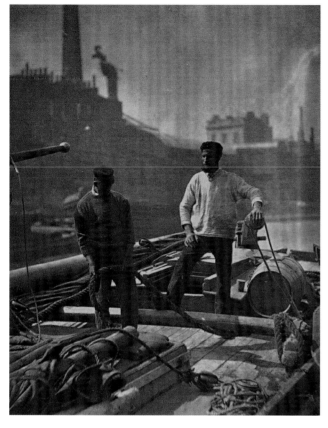

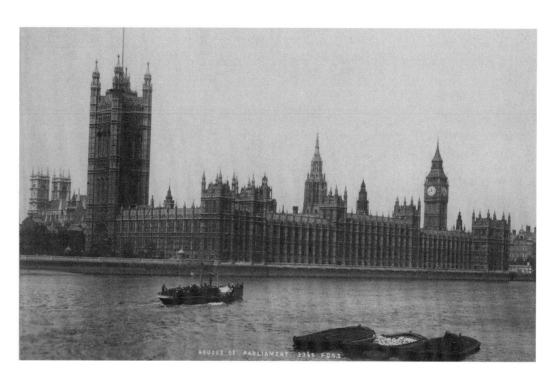

Cat. 135

JOHN THOMSON *(British, 1837–1872)*

Workers on the Silent Highway

from *Street Life in London*, 1876

Woodburytype 11.4 x 8.9 cm

Prints and Photographs Division, Library of Congress, Washington, D.C.

Cat. 136

UNKNOWN PHOTOGRAPHER

London, Houses of Parliament, n.d.

Albumen print 27.9 x 35.5 cm

Prints and Photographs Division, Library of Congress,
Washington, D.C.

Cat. 137
BENJAMIN LLOYD SINGLEY
(American, active early 20th century)
and Keystone View Company
Overlooking the Thames at 11 O'clock at Night, London, England, c. 1903
Stereograph 8.9 x 17.8 cm
Prints and Photographs Division, Library of Congress, Washington, D.C.

Cat. 138
KEYSTONE VIEW COMPANY
Waterloo Bridge and Somerset House, c. 1900
Stereograph 8.8 x 17.8 cm
Prints and Photographs Division, Library of Congress, Washington, D.C.

Cat. 141

R. Y. YOUNG; AMERICAN

STEREOSCOPIC COMPANY

Westminster Bridge and the Houses

of Parliament, England, 1901

Stereograph 8.8 x 17.8 cm

Prints and Photographs Division, Library of Congress,

Washington, D.C.

Cat. 142

J. F. JARVIS'S STEREOSCOPIC VIEWS

Westminster Bridge and

St. Thomas's Hospital, 1887

Stereograph 8.8 x 17.8 cm

Prints and Photographs Division, Library of Congress,

Washington, D.C.

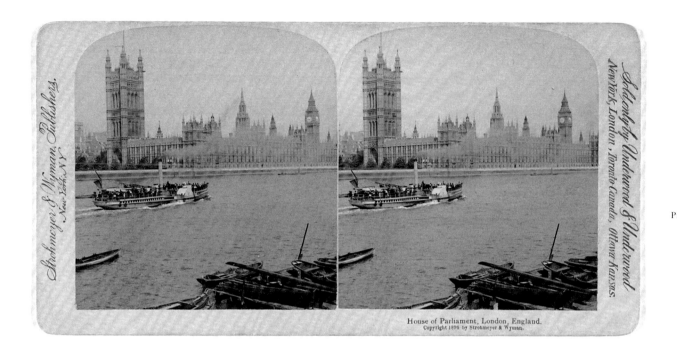

Cat. 143

STROHMEYER & WYMAN

Houses of Parliament,
London, England, c. 1896
Stereograph 8.8 x 17.8 cm

Prints and Photographs Division, Library of Congress,

Washington, D.C.

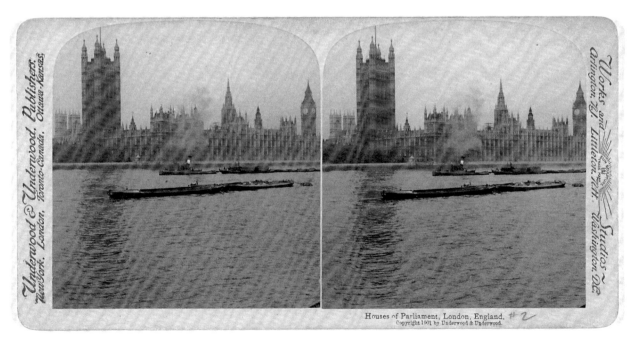

Cat. 144

UNDERWOOD & UNDERWOOD

Houses of Parliament,
London, England, 1901
Stereograph 8.8 x 17.8 cm

Prints and Photographs Division, Library of Congress,

Washington, D.C.

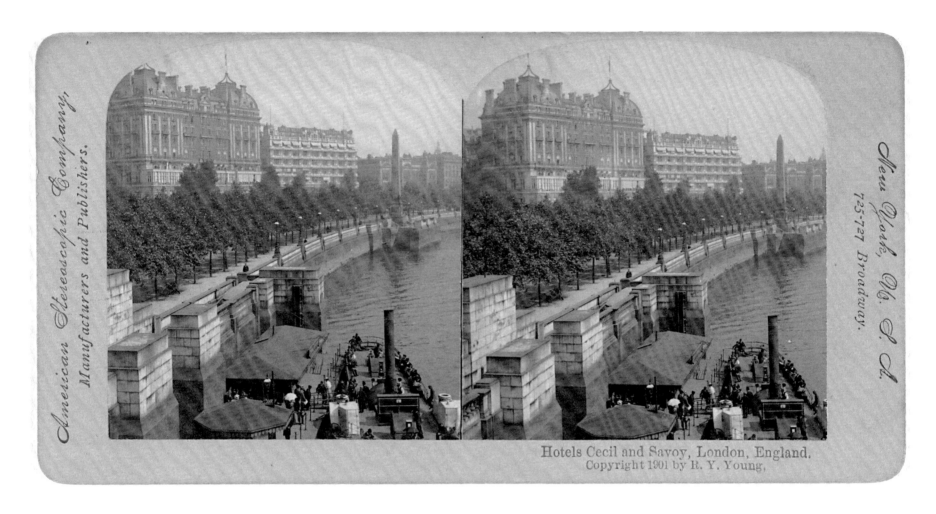

American Stereoscopic Company, Manufacturers and Publishers.

New York, U. S. A. 725-727 Broadway.

Hotels Cecil and Savoy, London, England.
Copyright 1901 by R. Y. Young,

Cat. 145
R. Y. YOUNG; AMERICAN STEREOSCOPIC COMPANY
Hotels Cecil and Savoy, London, England, 1901
Stereograph 8.8 x 17.8 cm
Prints and Photographs Division, Library of Congress, Washington, D.C.

Cat. 146
GEORGE WASHINGTON WILSON *(British, 1823–1893)*
St. Paul's Cathedral and Blackfriars Bridge, London, n.d.
Albumen print 27.9 x 35.5 cm

Prints and Photographs Division, Library of Congress, Washington, D.C.

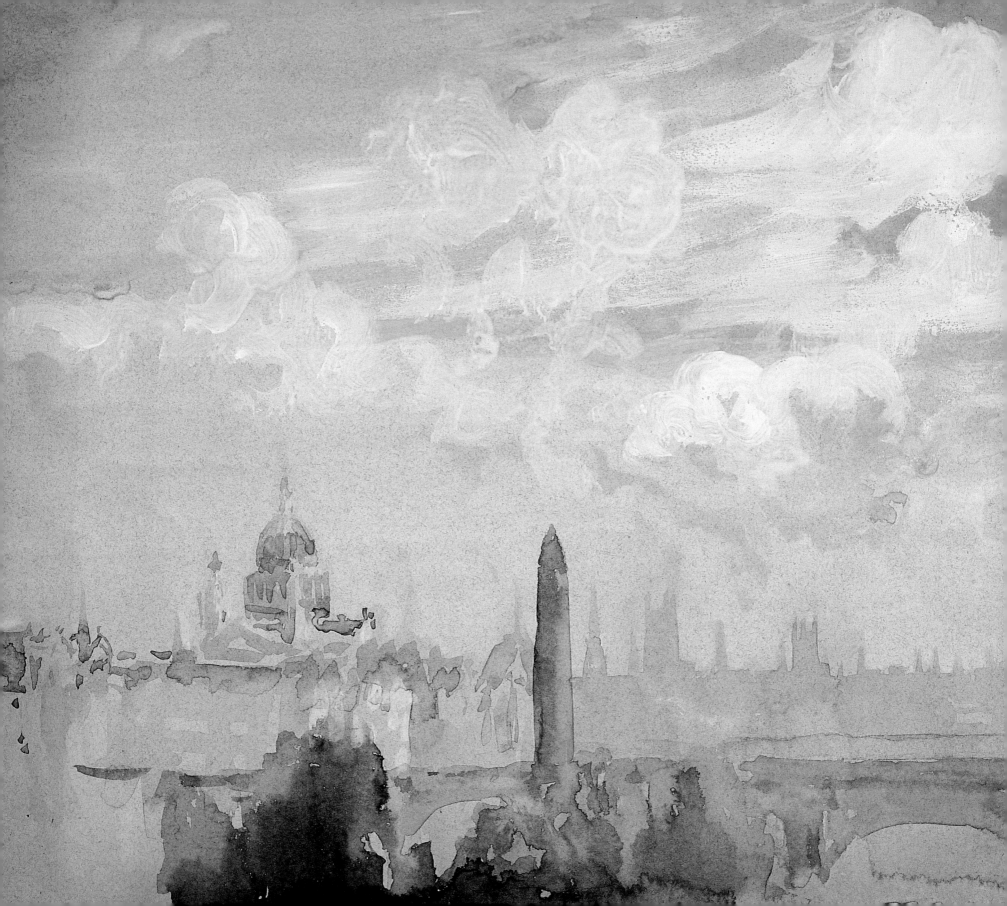

The Thames on Paper

IMAGINING LONDON'S RIVER IN AN ERA OF ARTISTIC CHANGE

Jennifer Hardin

The liveliness and diversity of London's river as described in such textual documents as guidebooks and fiction were paralleled in visual representations of the Thames between Chelsea and Greenwich from 1859 to 1914, especially in watercolors, prints, and photographs. Straightforward, factual images of the river abounded in the latter part of this period, particularly as photographs became more easily produced, but the voice of the documentor, topographer, and illustrator in many instances became more interpretive and individualistic by the century's end. Groups of artists working in all three media increasingly insisted that their works were Art with a capital A. Watercolor, the topographer's favored medium in Britain, continued to be applied to the purpose of faithful renderings of an actual landscape or cityscape, but by the 1880s such documentary views also reflected changes in the art world in terms of composition and manner of execution. Concurrently, the field of illustration became dominated by more mechanized forms of reproduction, which led illustrators to set themselves apart from prevailing commercial trends. This period included the revival of etching, a medium that one of its champions, the French critic Philippe Burty, believed "bridge[d] the gap between painting and engraving."[1]

Produced at the onset of the etching revival, James McNeill Whistler's *Thames Set*, or *A Series of Sixteen Etchings of Scenes on the Thames and Other Subjects*, begun in 1859 and published in 1871, was one of the most influential bodies of work with respect to Thames imagery, not only in printmaking but also in photography. Whistler turned the notion of topographic landscape on its head. With such titles as *The Little Pool* and *Evening, Little Waterloo Bridge* (cats. 103, 112), he compelled viewers to look closely at the image. Such prints negated the sense of London's immensity by providing only fragmentary glimpses of the city and its river.[2]

Whistler's paintings, prints, artistic theories, and writings had a critical influence on his contemporaries and subsequent generations.[3] Just as Whistler moved easily between painting and printmaking, the etching revival brought forth the idea of the painter-printmaker, producing new relationships between the two media. Later in the century, photographers sought to ally themselves with painting by creating photographs that invoked such contemporary currents as naturalism and impressionism. Landscape photographs were stripped of their topographic function and evoked the surfaces of artistic prints, which often held meanings beneath the depicted subject. The expressive, referential, and symbolic works of the American expatriate photographer Alvin Langdon Coburn even won the admiration of the literary giant Henry James, despite their perceived mechanical origins.[4] However, the largest single outpouring of Thames imagery came from another American expatriate artist, Joseph Pennell, who made illustrations, prints, and watercolors of the river. By the early twentieth century even works produced for information and entertainment recalled the Thames aesthetic set forth by Whistler and those inspired by him. Works on paper and photographs were often made in situ and thus convey the immediacy of image makers' experiences of the river, which can be contrasted with those of painters and printmakers who distilled their experiences in the studio.

Documentation, Topography, and Art in an Era of Change on the River

During this era of rapid development in science and technology, photography became the ultimate means of making accurate landscapes and cityscapes, and photographs began to replace documentary and topographic works once made in other media. Nevertheless, the existence of commissioned topographic watercolors of the Thames, such as those by E. Hull and John Crowther (cats. 16, 17, 5), demonstrates the medium's enduring nature, particularly with respect to its traditional role in the visual arts in Britain.

Topography provides a record of a site or a city, a kind of documentary landscape. In Britain, topography is closely allied with the history of watercolor painting: nowhere else in Europe did watercolor so occupy artists and patrons from the mid-eighteenth to the mid-nineteenth century. Its portability and ability to convey color often made it the chosen medium for topographic landscapes. In the late eighteenth and early nineteenth centuries, landscape artists looked to watercolors by the Reverend William Gilpin, who codified the aesthetic notion of the picturesque (the idea that a view is pleasing to the eye, recalling the imaginative aspects of a painting). This aesthetic informed the early topographic watercolors of J. M. W. Turner and Thomas Girtin. Girtin produced a dramatic panorama in oil of London along the Thames, the *Eidometropolis*, in 1802 (no longer extant), which he created from highly finished studies in watercolor (c. 1801, Cambridge, Fitzwilliam Museum). Girtin's watercolors have been noted for their more natural approach to light and atmosphere relative to his contemporaries' work.[5] Watercolorists continued to use

the medium to create topographic landscapes throughout the nineteenth century. On occasion, their roles as providers of factual information about a site did not prevent them from making more expressive statements about the river, as in the case of Henry Edward Tidmarsh (cat. 50).

Photographers followed earlier aesthetic approaches to topographic landscape in their compositions and published their own interpretations of the picturesque. George Washington Wilson, who, like Francis Frith, had one of the period's most successful photographic firms (cat. 146), wrote that a picturesque photograph should represent a vantage point that travelers might find on their own. It should have a straightforward composition that asks no questions and subtly allows the eye to rest on a particular point.[6]

Roger Fenton's photographed landscapes reflect his knowledge of Gilpin's watercolors.[7] Fenton trained as a painter in Paris and later, in 1853, helped found the Photographic Society of London. Until 1862, he documented places in London and objects at the British Museum and made portraits of the royal family, turning these rote tasks into accomplished photographs inspired by past artistic models. His views of the Thames have their origins in the endeavors of the Architectural Photographic Association and the Antiquarian Photographic Club (cat. 125).[8] Yet, they may have also been a response to Henry Fox Talbot's calotypes of the river in the 1840s, such as Talbot's view of Waterloo Bridge (Bradford, England, Royal Photographic Society Collection, National Museum of Photography, Film, and Television). Built in 1817 by John Rennie, Waterloo Bridge was consistently celebrated as the "finest" and most "noble" bridge on the Thames, possessing a "simple grandeur" that could not "fail to excite the stranger's admiration." Even French guidebooks noted that the neoclassical sculptor Antonio Canova called it "the most beautiful bridge in the world."[9] Fenton's vantage point was probably the Adelphi Terrace, near where Elizabeth and Joseph Pennell later lived: the mundane rooftops and bankside activities are contrasted with the partial profile of the bridge in its stately lope across the river.[10] His photograph predates the Victoria Embankment, which utterly changed the nature of the river and its banks between Blackfriars and Westminster Bridges.

The Victoria, Albert, and Chelsea Embankments represented one of the most substantial changes in and along the river up to the late twentieth century. The Thames Embankments were initiated by Joseph Bazalgette, appointed chief engineer in 1855 for the new Metropolitan Board of Works. After nearly three years' delay, Bazalgette's plan for a sewer system began to be implemented; it was to run parallel to the Thames to avoid the dumping of raw waste into the river. Opened officially in 1870, the Victoria Embankment housed not only the lifesaving sewer that averted such dreaded epidemics as cholera but also a railway line below ground. Above, it created an attractive park, Victoria Embankment Gardens, and a boulevard for pedestrians and vehicular traffic. The mile-long Victoria Embankment alone reclaimed thirty-seven acres of land from the Thames.[11]

The Embankments and their construction are represented in a range of media, a convergence of old and new methods of documentation and factual representation. Dominating the field for color printing at midcentury was the chromolithograph. One such print by the little-known Robert Kent Thomas depicts a straightforward scheme for the Victoria Embankment with the Houses of Parliament and Westminster Pier (cat. 84). Another chromolithograph by Thomas, looking downriver, imagines a more fanciful view of Bazalgette's proposal—replete with references to Rome and classical antiquity (cat. 85).[12] Considered one of the greatest engineering projects of the nineteenth century, the Embankments' construction employed nearly 20,000 people at once during various stages. Enthralled by this massive effort, Hull and E. A. Goodall applied the topographer's medium of watercolor to document it. Hull's pair of watercolors (cats. 16, 17) depicting the building of the Victoria Embankment were commissioned by Captain George Ernest Augustus Ross, a stockbroker who sponsored other London views, especially of buildings slated for demolition.[13] The momentous activities even attracted Goodall, a more well-known and well-traveled watercolorist (cat. 11).[14] In contrast to Hull's rendering in which the Houses of Parliament and St. Paul's Cathedral provide a frame of reference, Goodall's major focus is on the construction itself: huge pieces of lumber to create the Embankment's framework dominate the foreground, and the newly introduced steam shovel is being operated at right. Secondarily, Goodall depicts the elegant profile of Waterloo Bridge and wistfully delineates the Victoria Tower and Big Ben, while the Shot Tower rises above this scene of human industry.

Photographs from the 1860s that document the building of the Embankments and bridges provide striking comparisons between earlier and newer methods of topography. They con-

vey the medium's ability to transport the viewer to a particular place and time while emphasizing the transformations along the Thames. Three such photographs were made by William Strudwick (cats. 131-33). Strudwick documented 1860s London in numerous photographic views, and sold them to the Victoria and Albert Museum near the time of their creation, in 1868 and 1869.[15] *Houses of Parliament from Bishop's Walk* (cat. 131) shows the construction of the Albert Embankment on the south side of the Thames before its completion in 1869. It emphasizes the wooden framework's linear structure, while the nearly new, Gothic-inspired Houses of Parliament provide a monumental backdrop, contrasting architecture influenced by old English models and modern engineering. The standing male figure provides a sense of scale, while the steamboat—drawn in with graphite, as movement could not yet be consistently captured in photography—adds a picturesque note.

Photographs could, on occasion, show the city's air quality. In Strudwick's albumen print of the Albert Embankment's construction and the new Westminster Bridge (completed 1862), smog seems to hang over the city (cat. 133). *New Blackfriars Bridge under Construction* (cat. 132) also documents London's building boom of the 1860s. St. Paul's, more palely silhouetted on the horizon, is juxtaposed with an industrial smokestack. Coal in lighterboats on the Thames south bank that helped to produce the fantastic atmospheres so attractive to Whistler, Claude Monet, and others—and the subject of the foreground of Charles-François Daubigny's painting (cat. 6)—awaits distribution across the city.

The many phases of building along the river were frequently reported in *The Illustrated London News*, accompanied by wood engravings. In one illustration, *Progress of the Construction of New Blackfriars Bridge* (cat. 86), the inclusion of people working on the wharves and at the foot of the bridge produces a more animated effect than Strudwick's photograph, communicating a hubbub of human activity and suggesting the great anticipation of the bridge's completion. George Chambers and John O'Connor, among other artists, gave expression to civic and governmental pride in major building projects. Chambers's watercolor (cat. 4) captures the exuberance of the populace at the completion of Blackfriars Bridge, while the steel engraving (cat. 66) after John O'Connor's oil painting (Museum of London) allows the viewer to contemplate the completed Victoria Embankment. Such major monuments as St. Paul's co-exist comfortably with the industry of the metro-

polis, its smokestacks, river traffic, and train station seen in the distance, as the Empire's accomplishments provide leisure time for those who could take advantage of it.

Although photography became the major medium for documentation and topography after the 1860s, nonphotographic representations of the Thames continued to be made. John Crowther's *Waterloo Bridge: Ebb Tide Taken from Charing Cross Railway Bridge* (cat. 5) is among the 437 drawings and watercolors of London (Guildhall Library) commissioned by Sir Chadwyck-Healey and made between 1879 and 1895. Like Hull's watercolors, this large group has its origins in the idea of documenting London in an era of change. Chadwyck-Healey, a fellow of the Society of Antiquaries, feared that, in the name of progress, London's landscape was changing too rapidly. Where the earlier views by Hull used tonal washes to carefully render the Thames-side buildings and a variety of rivergoing craft, Crowther's watercolor not only depicts the bridge's splendid profile, but also communicates a sensitivity to light and atmosphere.[16] His focus on the delicately toned sky (possibly in the morning hours) and the reflections on the Thames allied him with the later artistic era of the 1880s and 1890s. The 1880s were characterized by a shift toward naturalism, exemplified by the art of the French painter Jules Bastien-Lepage who showed his work in London. His art prompted the admiration of such British painters as George Clausen and Frederick Goodall.[17]

If *Waterloo Bridge* demonstrates Crowther's transformation of the topographer's task through his application of contemporary currents in art, the American expatriate painter Frank Myers Boggs built on the idea of topography to produce large scale canvases for important exhibitions. Excelling at cityscapes, Boggs was described by the critic Theodore Child as "one of the most successful and one of the most promising of the young painters in Paris." First employed as a wood engraver for *Harper's Weekly*, Boggs later studied with the French academic painter Jean-Léon Gérôme, who encouraged him to focus on landscape. Boggs's tonal, painterly palette in *On the Thames* is not unlike Bastien-Lepage's 1882 painting (cats. 2, 3), and Boggs went to London for several months after Bastien's last trip there. Such paintings as *The Thames, London* (cat. 3), with the Tower of London as a backdrop, share with the topographic tradition the idea of easily read city views. Its scale sets it apart: Boggs's monumental *The Thames, London* must have been made for exhibition, possibly for the Salon or the Royal Academy. *On the Thames River* was included in the

1884 Salon as *Sur la Tamise, près Londres*. Probably sited near the docklands, this smaller, more tonal painting has been compared to works by Whistler and the impressionists.[18]

The Thames as Social Document

Apart from communicating the idea of historic preservation, only a small group of image makers intentionally conveyed social messages in their representations of the Thames. Art and social critique are fused in Gustave Doré's illustrations for the 1872 book *London: A Pilgrimage*, by the British journalist Blanchard Jerrold. One of the period's most popular illustrators, Doré also contributed to *The Illustrated London News*. Visiting London in 1868 during his collaboration on *London* with Jerrold, he created hundreds of drawings. A number of them diverged from Jerrold's intent, perhaps altered following Doré's experiences during the violence of the Paris Commune. While Jerrold sought to portray types and views representative of the city, Doré paid no great heed to details, placing Norman arches on London Bridge, for example. The expressive means by which Doré depicted London are most apparent in the dock scenes. To emphasize the brutal nature of life along the river, Doré blocked out much of the sky and heightened the tangled profusion of ships' masts and rigging.

Rooted in the imagination, Doré's illustrations nevertheless addressed a very real and timely subject:[19] the great disparity between social classes was one of the most important concerns of nineteenth-century London. Doré's illustrations recall the subject of the book *London Labour and the London Poor* by the journalist and sociologist Henry Mayhew, first published in 1851 and reissued four times between 1861 and 1865. The meaning of some of Doré's illustrations runs counter to passages in Jerrold's text. In the manner of a travel guide, Jerrold characterized Westminster and London Bridges as full of special appeal: "It is from the bridges that London wears her noblest aspect—whether by night or by day, or whether seen from Westminster, or that ancient site [London Bridge] which the genius of Rennie covers with a world famous pile." He closes the book by describing the Thames as the "Silent Highway," asserting that "Along this Highway the artist in quest of the picturesque and subjective in landscape finds the best subjects for his pencil."[20] In contrast, one of Doré's illustrations with the Thames and Westminster Bridge sets a different tone: the Houses of Parliament loom in the distance, while homeless men attempt to sleep on the bridge as a well-dressed lady walks past, a nocturne with a social message (fig. 26). Such images diverge greatly from sentimental Victorian genre painting and other illustrations of the day.

fig. 26 Gustave Doré *(French, 1832–1883)*
Westminster Bridge at Night
Wood engraved illustration
From *London: A Pilgrimage* by Jerrold Blanchard,
London: Grant & Co., 1872

Another collaborative publication from the 1870s, *Street Life in London* by the photographer John Thomson and the writer Adolphe Smith, had a more cohesive message. Like Doré's illustrations, *Street Life in London* expressed the disparity between London's comfortable Victorian middle and upper classes and the working classes. In both image and text, the authors sought to reveal daily lives and livelihoods rather than perpetuating a general notion of types, focusing instead on "true types."[21] Smith's commentary brings us close to working-class people, enumerating their labors and introducing them as individuals. In his only known Thames image, Thomson appears to have photographed the two bargemen onboard their vessel, heroicizing them as they head downstream (cat. 135). They are resolute and monumental: the serious expression of the bargeman at right suggests the stalwart fishing folk who would later be drawn, painted, and etched by Winslow Homer.

Even if this joint effort attempted to convey a unified message, Smith's text introducing Thomson's bargemen is ambivalent. He roundly criticized the Watermen's Company for giving licenses to "the most unworthy persons" who compromised "the safety of property on the river." He stressed that the conditions in which the bargemen lived needed to be ameliorated, and looked forward to a time when they "will be more worthy of the noble river on which they earn their living."[22]

Illustrators on London's River

The images by Doré and Thomson reveal the changing nature of the field of illustration in the 1870s. Wood engraving, as in the case of Doré, was by far the most standard method for producing illustrations, in both fiction and nonfiction books. Wood engravings littered the popular press, in such publications as the *Illustrated London News*. Numerous illustrated newspapers, including the American publication *Harper's Weekly*, modeled themselves after the *News*. By the 1860s, the *Illustrated London News* had a circulation of roughly 200,000 and engaged such illustrators as Phiz, Constantin Guys, Goodall, and Matthew White Ridley (cat. 81), and had reproduced Fenton's Crimean photographs as wood engravings.[23] Although it reported on events at home and abroad, the *News*'s wood-engraved masthead proclaimed that its nexus was the imperial capital, London, with the heart of London, St. Paul's Cathedral, rising from the Thames. The *Illustrated London News* remained one of the most popular papers throughout the remainder of the century and shifted its methods of reproduction and printing with the latest trends in technology. Toward the end of the century, photographic reproductions began to be used increasingly in books and periodicals, and illustrations were more cheaply and easily reproduced, especially through halftone. Guidebooks once illustrated with wood engravings began using photographs.[24]

Early photographic illustrations were, however, extremely labor intensive to produce. Photographs had to be tipped into a book by hand, but wood engravings could be printed at the same time as the text. One of the later examples of wood-engraved illustration is Augustus Hare's *Walks in London* of 1884, which was both written and for the most part illustrated by him.[25] Near the end of the popular use of wood engraved illustrations, Hare's illustrations seem old-fashioned. *The Churchyard of the Savoy* (fig. 27), with the Parliament buildings quaintly framed in the distance, recalls the picturesque tradition of an earlier era and represents a site soon to be demolished to make way for the grand hotels along the Embankment. Illustrated guidebooks, like the illustrated press, flourished in this period, and one of the most popular with respect to the river was Mr. and Mrs. S. C. Hall's *The Book of the Thames* (fig. 28).[26] In contrast to the wood-engraved illustrations popular for travel literature, Francis Frith's photographs embellishing a new edition of the Halls' *The Book of the Thames* in 1867 were mounted individually on its pages (cat. 126). Frith initially took up the medium in the 1850s to illustrate his own writings, and by 1862 he had a lively business publishing and distributing photographic prints in Reigate, similar to Wilson's in Aberdeen.[27] The immediacy of Frith's photograph *Southwark Bridge* with St. Paul's is strikingly modern compared to wood-engraved illustrations in the volume (fig. 29). By century's end, a number of prominent illustrators sought to separate themselves from trends in mass reproduction and the popular press, through such means as the Society of Illustrators, based in London and founded in 1894. Indeed, cheap-looking, mass-produced guides that were photographically illustrated provide a stark contrast to limited-edition travelogues and the Halls' 1867 book. A glance at such penny guides made at the turn of the century by John Heywood, including his *River Thames, London to Kingston*, with photographic illustrations from Frith & Company, make the difference evident.[28]

Many of the major artists who imaged the Thames supported themselves through illustration, even the Barbizon painter Daubigny.[29] Winslow Homer made his livelihood this way at the beginning of his painting career. Trained as a lithographer in the 1850s, he soon began drawing for wood engravers who then carved the blocks, as in his illustrations for such journals as *Every Saturday* and *Harper's Weekly*. Homer joined the American Water Color Society (established 1866) in 1876, a few years after he began producing watercolors seriously. Historic and contemporary British watercolors may have inspired the founding of the Water Color Society. In one of the first and largest displays of British art in the United States (1857–58, New York, Philadelphia, and Boston), roughly half of the works were watercolors, including examples by Turner and David Roberts.[30] The previous generation of American landscape painters, the Hudson River School, rarely worked in the medium. Those who used watercolor at midcentury had been born or trained in England; many were skilled printmakers.[31] Homer, who may very well have seen the British art exhibition

fig. 27 Augustus J. C. Hare and T. Sulman *(active late 19th century)*
The Churchyard of the Savoy
Wood engraved illustration
From *Walks in London* by Augustus J. C. Hare,
New York: George Routledge & Sons, 1884

fig. 28
Cover inset with albumen print
From *The Book of the Thames from Its Rise to Its Fall*
by Mr. and Mrs. S. C. Hall, London: Alfred W. Bennett;
Virtue & Co., 1867

HOUSES OF PARLIAMENT.

fig. 29
Houses of Parliament
Wood engraved illustration
From *The Book of the Thames from Its Rise to Its Fall*
by Mr. and Mrs. S. C. Hall,
London: Alfred W. Bennett; Virtue & Co., 1867

in Boston, and Childe Hassam excelled at watercolor, Hassam often using the medium for his illustrations, which he made through the late 1890s.

Homer's earliest watercolors, made around 1873, dialogue with his illustrations. However by 1881, the date of *Houses of Parliament*, he had virtually abandoned journalistic work. The origins of this large-scale watercolor (cat. 15) are almost as mysterious as the image itself. Following an exhibition of his daring Gloucester watercolors, Homer left for England in March 1881, intending to paint on the coast for the summer, but he stayed for nearly two years.[32] *Houses of Parliament* is his only visual response to London. Never one for urban subjects, Homer reduced the roar of the city, rendering the entire work in tones of gray and blue-gray and minutely depicting the distant profile of antlike pedestrians and vehicles streaming across Westminster Bridge. There is a hush over the river and an emphasis on the reflections of the late afternoon sun on the water. As in Monet's Parliament paintings, Homer diminished the river's general chaotic nature, emphasizing the monumentality of Charles Barry's structure. Rather than painting the atmosphere between himself and the buildings as did Monet, Homer produced a tonal mood that, although it may not stem from a knowledge of Whistler's nocturnes, shares with them nonetheless a similar spirit. In 1880 Henry James called for American artists to look closely at British watercolors for inspiration, especially those on a grander scale. Homer left for England after positive reviews of his Gloucester watercolors from critics suggested that he had succeeded where the impressionists had failed in creating a new response to nature.[33]

In contrast to Homer's independent image, Hassam's London watercolors can be connected to a book project, *Three Cities* (1899). Hassam began as an apprentice to a wood engraver, but soon made his own illustrations, doing so until the late 1890s. Like Homer, Hassam worked as an illustrator in Boston, but his mature style was informed by French impressionism. In the spring of 1886 Durand-Ruel exhibited a group of impressionist paintings in New York, and that fall Hassam headed to France to further his painting career. He enrolled at the Académie Julian in Paris, living in the same building as the American painter Boggs.[34] Before returning to New York in 1889, Hassam stopped in London. His view of Charing Cross Bridge from that date (private collection) is akin to a topographic landscape, although its composition is more daring, because it omits at right most of Cleopatra's Needle, the an-

cient Egyptian obelisk installed in 1878 on the Victoria Embankment. Hassam depicted lively city scenes throughout his career, as an illustrator, painter, and, after 1915, printmaker. In a 1913 interview, he pronounced that a "portrait of a city, you see, is in a way like the portrait of a person—the difficulty is to catch not only the superficial resemblance but the inner self. The spirit, that's what counts, and one should strive to portray the soul of a city with the same care as the soul of a sitter."[35]

After a trip to London in 1897, Hassam produced a collection of reproductions from his drawings, paintings, and watercolors in the book *Three Cities*, representing scenes in New York, London, and Paris. Travelogues and guidebooks abounded in this period, often copiously illustrated, but *Three Cities* contains just four words of text, the headings that introduce each of the three sections, as in "London" (fig. 30). The book is entirely composed of illustrations and their captions, the Thames making up roughly half of the London section. Only a handful of Hassam's Thames watercolors and paintings are extant.[36] Two set in the evening include an oil, *Houses of Parliament, Early Evening* (cat. 13), which is nearly the size of Homer's watercolor, and an undated watercolor, *Big Ben* (cat. 14). With a vantage point from the Surrey side of the river, looking across Westminster Bridge to the Houses of Parliament, *Big Ben* dates to Hassam's second London trip. It can be compared to yet another view of Parliament in *Three Cities* (fig. 31) that depicts pedestrians as they cross the bridge or look out onto the grey river, possibly on a rainy evening. After his return to the United States, Hassam referenced Whistler by titling his works "Nocturnes." Like Hassam's *Big Ben*, *Houses of Parliament* is depicted at night, a time favored by Whistler, but its impressionist brushwork sets it apart from Whistler. The Thames shimmers in the evening light as the faint glow of Big Ben draws our eye to the background, while the Victoria Tower dominates the composition. It is strikingly similar to a work in *Three Cities*, but from the reproduction, it is difficult to discern if it, too, is a night scene.

Like his compatriots Homer and Hassam, Joseph Pennell worked as an illustrator. Pennell was among those who banded together in 1894 to create the Society of Illustrators, inviting Whistler to be its vice president. Its first and only publication, *A London Garland*, paired poetry celebrating London with illustrations by its members, including Walter Crane, Edwin Austin Abbey, William Wyllie, and Pennell. Whistler allowed the reproduction of his Thames painting *Nocturne—Blue and Silver,*

fig. 30 Childe Hassam *(American, 1859–1935)*
London
Illustration introducing "London" section
From *Three Cities* by Childe Hassam, New York: R. H. Russell, 1899

fig. 31 Childe Hassam *(American, 1859–1935)*
Westminster Bridge
Illustration
From *Three Cities* by Childe Hassam, New York: R. H. Russell, 1899

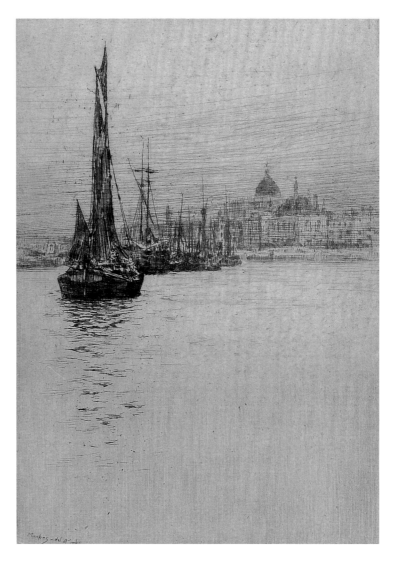

fig. 32
Cover for *The English Hours* by Henry James
Illustrated by Joseph Pennell
New York: Houghton, Mifflin and Company; Cambridge, Mass.:
Riverside Press, 1905

fig. 33 Mortimer Menpes *(British, b. Australia, 1855–1938)*
Below Waterloo Bridge
Etching on paper
Plate II from *The Grey River* by Justin McCarthy and Mrs. Campbell Praed,
London: Messrs. Selley and Co. Ltd., 1889

Chelsea (London, Tate Gallery) to accompany H. E. Henley's poem "Nocturne," while Pennell's nighttime scene depicting the Thames Embankment with Cleopatra's Needle served as the final illustration. Unlike Homer and Hassam, Pennell clung to his career as an illustrator, rarely venturing beyond work in black and white. He contributed illustrations to publications by such writers as William Dean Howells, Robert Louis Stevenson, and Henry James. Pennell had illustrated James's article on London in 1888 for *Harper's*, which was later reprinted in James's *English Hours* (1905, fig. 39), the whole of which was also illustrated by Pennell. Indeed, Pennell's illustrations often accompanied travel writing, including James's *A Little Tour of Italy* (1900) and *The Stream of Pleasure* (1891), a lively account by Elizabeth Robins Pennell of a boat journey with Joseph Pennell on the upper Thames. Pennell excelled at cityscapes and landscapes, yet these were too filtered through his personal style to be characterized as topographic. In *Pen Drawing and Pen Draughtsmen*, he responded to the decline in artistic quality of illustrations, dominated by "rank color, sham Beardsleys, and photos,"[37] by producing a celebration of the art past and present. His own artwork proves to be one of the most substantial on the Thames outside that of his mentor, Whistler.

The Allure of the Thames in the Era of the Etching Revival

Alongside those working in the documentary, topographic, or illustration modes were image makers whose artistic intentions superseded any desire for actuality or for communicating social messages. Whistler's Thames etchings provided a model for his contemporaries and for a younger generation: they inspired the creation of more individualistic and expressive interpretations of the river, many of which were conceived as series. The general critical acceptance of Whistler's etchings relative to his paintings[38] and their broader distribution perhaps led to this outpouring, as did the publication of his *Thames Set* in 1871, which had a profound impact on artists years after Whistler etched the last plate. With the notable exception of the lithographer Thomas R. Way, Whistler's followers contributed to the etching revival and the notion of the painter-etcher.

The etching revival was led in part by the French printmaker Auguste Delâtre, who opened his Paris print shop in 1847. Such Barbizon landscape painters as Charles Jacque and Charles-François Daubigny made the revival's earliest prints.

Daubigny's dealer Alfred Cadart, along with the artists Félix Bracquemond, Whistler's friend Alphonse Legros, and Edouard Manet, helped to found the Société des Aquafortistes (Society of Etchers) in 1862.[39] In a supportive preface to their first publication, the critic Théophile Gautier perceived the etching as a response to the mechanized accuracy of the photograph, as well as to other commercial and popular printing processes like lithography and wood engraving.[40]

Whistler and his brother-in-law, the physician Seymour Haden, were at the forefront of the etching revival.[41] Haden had made etchings since 1844, but late in 1858 he had a press installed at his medical offices in London. The next year one of his prints was accepted at the Paris Salon and, no doubt inspired by the younger Whistler, he produced his first etchings out of doors. Haden's Thames etchings were largely rural in subject. They were executed in a picturesque style stemming from early nineteenth-century Romanticism and his interest in the seventeenth-century prints he collected, especially those by Rembrandt and the topographer Wenceslaus Hollar. In concert with the French critic Burty, Haden propounded the need to distinguish artistic prints from journalistic wood engravings and chromolithographs made by the thousands. Haden limited his editions and signed his prints with special dedications, expounding on his approach in *About Etching*.[42] Around 1863 he and Whistler planned to co-produce a Thames series, and Haden's three known prints of the Thames at London (although notably these are in the area of Chelsea, where Whistler lived) were probably slated for this joint project (cats. 60–62).[43] His reputation in etching grew, but after 1868, Haden's urban Thames imagery is virtually nonexistent.

No other printmaker pursued the dockland areas with as much zeal as Whistler. As opposed to Haden's more genteel approach, Whistler reveled in the filthy picturesque, even relocating from Chelsea to Wapping to immerse himself in the life and atmosphere of the wharves and sailor towns. These prints were bold in their subject, execution, and composition. The *Thames Set* has been perceived as influenced by Whistler's association with realist artists in Paris, the etchings of Charles Meryon, the drawings of Charles Keene, and such artistic precedents as Rembrandt and William Hogarth.[44] Significantly, Whistler avoided London's grand monuments pointed out in contemporary guidebooks. One exception is *Old Westminster Bridge*, a diminutive view of the Houses of Parliament and Charles Labelye's 1750 bridge before its demolition (cat. 98). Its scale re-

calls vignettes from illustrated guide books (figs. 27, 29), and it is one of the *Thames Set* etchings to be heavily influenced by topography. Here, the Thames is seen from bank to bank, with boats of all kinds dotting the river, as in topographic views by Kent and Hull.[45] In only one other *Thames Set* etching did Whistler include a London landmark: in the background of *Rotherhithe*, the dome of St. Paul's is minutely rendered, nearly obscured by masts and rigging.

As he worked through the series, Whistler moved away from the realism that infused his first portfolio, the *French Set* (1859), and toward a newfound aesthetic. In *Black Lion Wharf, Eagle Wharf,* and *The Pool* (cats. 95–97), figures in the foreground nearly abut the picture plane; while much of the middle ground remains untouched by the etching needle, the background contains more detailed renderings of Thames-side architecture.[46] This compositional method reverses that of topography, where the middle ground, a focal point, guides the eye into the distance. Contrasting these works with two others from the *Thames Set, Limehouse* and *Old Westminster Bridge*, as well as with *Billingsgate* (made during this period, but not in the *Thames Set*) (cats. 99, 98, 94), reveals the radical nature of the three prints. Only *Early Morning, Battersea* (cat. 102), a more ephemeral drypoint included in the series, suggests Whistler's direction in painting: atmospheric effects on a subject. Otherwise, the later part of his print oeuvre depicting the Thames is dominated by lithographs, transfer lithographs, and lithotints, merging the notion of drawing and painting with printmaking.

First exhibited in part at the Royal Academy in 1860, Whistler's Thames etchings were shown sporadically until the *Thames Set*'s 1871 publication.[47] However, one of Whistler's early followers, Percy Thomas, must have had special access to Whistler's Thames prints. Thomas was a son of the lawyer Serjeant Thomas, who agreed to sponsor Whistler's production of the *Thames Set* and to finance Delâtre's printing of it in London.[48] Like Whistler in *Old Westminster Bridge*, Thomas took as his subject a bridge on the verge of destruction (cat. 87). As opposed to Whistler's dark, bold lines, Thomas used masses of fine, light lines to build form.[49]

Aestheticized views of the Thames grew in number after the publication of the *Thames Set* and Whistler's "Ten O'Clock" lecture, which expressed his aesthetic theory of "art for art's sake." He also attracted great international attention in 1879 during the trial for his libel suit against the critic, watercolorist,

and promoter of pre-Raphaelite values, John Ruskin.[50] In 1880 Mortimer Menpes met Whistler at the Fine Art Society, which had commissioned the first major etchings by Whistler in almost two decades. Over the next several years, Menpes and the painter Walter Sickert became Whistler's "Followers," assisting the "Master" with his art. Menpes helped Whistler print the *Venice Set*, mostly at his home where he had set up his own press. Like Whistler, he was drawn to the art of Japan and journeyed there in 1887 to prepare for an exhibition at Dowdeswell Gallery.[51]

Little Japanese influence can be found, however, in *The Grey River*, a book Menpes produced with the writers Justin McCarthy and Mrs. Cambell Praed in 1889. His suite of prints, twelve original etchings bound in the book, travels along the Thames in an orderly manner. The opening plate is *Westminster* (cat. 65), and turning the pages we move eastward and downstream, ending the journey at the docklands. The final plate is *A Distant View of the City*.[52] In its summary, suggestive approach, *Westminster*, seen just above Lambeth Bridge, shows the Houses of Parliament in the background. The buildings are rendered in lighter tones of brown, implying both distance and the atmosphere enveloping them. In its sparseness, it diverges from the second plate, *Below Waterloo Bridge* (fig. 33), which is more heavily worked. The dome of St. Paul's in the background reveals Menpes's intimate knowledge of Whistler's *Venice Set*: St. Paul's in Menpes's hands resembles Venice's Santa Maria della Salute, often depicted by Whistler. Here, Menpes obscures the cathedral's dome and the surrounding buildings from view by broad horizontal lines evocative of fog. *Limehouse* (fig. 34), plate 8, recalls the backgrounds of Whistler's Thames etchings, but without Whistler's radical compositional devices in the foreground and middle ground. This print may relate to contemporary photographs of this famous stretch of Thames waterfront.[53] Menpes's prints in *The Grey River* stem from Whistler's subject matter and technique but differ in their logical progression downstream, following the course of a penny steamer.

In their accompanying text, McCarthy and Praed painted a more suggestive picture than many travel writers. In one passage, a Thames scene reinterprets a view that Monet or any other contemporary would have experienced during the 1880s and 1890s:

Out of the mist rise a curious chaos of shapes and strokes written black upon the greyness—the battle-

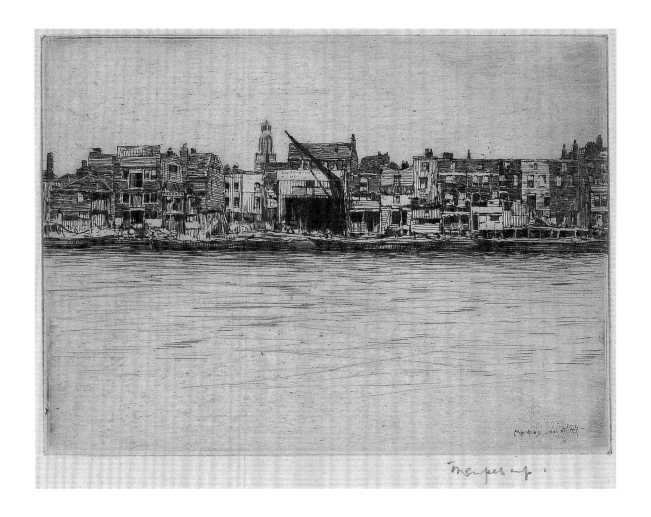

fig. 34 Mortimer Menpes *(British, b. Australia, 1855–1938)*
Limehouse
Etching on paper
Plate VIII from *The Grey River* by Justin McCarthy and Mrs. Campbell Praed,
London: Messrs. Selley and Co. Ltd., 1889

mented tops and grotesque forms of great gas cylinders, the coarse lines and bars of a railway bridge—a flying engine, dragon-like, spitting smoke; here and there the obelisk form of a factory chimney…. It is an impression of many tones of grey—river, embankment, piles, ships, sky—no metallic grey, but all tender and poetic, as though heaven had let down a curtain of gauze. Even the streaks and patches of colour—the piles of new red brick on the wharves, and the yellow of the hay-barges struggling for a moment ineffectually though the haze—melt away again into the same shadowy neutrality.[54]

This passage at once recalls the "Landscape" portion of Charles Baudelaire's influential 1859 Salon review that termed industrial smokestacks "obelisks of industry,"[55] and reminds us of Whistler's 1885 "Ten O'Clock" lecture. The authors' "Grey River" is more Whistlerian than impressionist, although there is a parallel with Monet's feeling for the city, as in the descriptions of people and vehicles crowding Waterloo Bridge against an industrial backdrop, and the trains chugging across Charing Cross Bridge. Monet, however, translated these forms and the atmosphere enveloping them with tones that were rarely gray.

With its movement and drama, *The Smoke Cloud, Charing Cross Bridge* by Thomas R. Way (cat. 91) recalls Monet's Charing Cross paintings in its view with the Houses of Parliament in the background (cats. 24–27) and reveals how expressively Way could use the medium in black and white. By contrast, his *Tower of London* (cat. 90) is more topographic in nature, suitable for travel literature. Indeed, he made illustrations for three travel-related books between 1897 and 1907.[56] Way associated with Whistler professionally through his father's lithography company. The elder Thomas Way encouraged Whistler to take up lithography in 1878, but within the family firm, the young Way worked closely with Whistler while he produced his first lithographs, as well as his last at the Savoy Hotel. Begun in the late 1890s, Way's own Thames series contains over thirty images.[57] More than Menpes's etchings, the feeling of these prints vary, particularly when Way experimented with color lithography: *Afterglow, Lower Pool* (cat. 92) contains subtle tones evocative of seeing the subject through the fog, while *The Gate of London* (cat. 93), a nighttime view of Tower Bridge, is composed of dramatic reds, yellows, and greens.

Three key Thames prints by the American artist Clifford Addams reveal how diverse styles could serve different moods.

Addams studied architecture in Philadelphia and took classes at the Pennsylvania Academy of the Fine Arts, where he won the Cresson Travelling Scholarship in 1899. He soon left for Europe, entering Whistler's Académie Carmen in Paris, but following Whistler to London in 1902.[58] *Charing Cross Bridge* and *Limehouse* (cats. 51, 53) could not be more different in execution, although both date to 1912. In the former, Addams exploits both the sheet's blank space that suits the subject's modernity, and a high horizon line on which sits a small-scale Houses of Parliament. Addams privileges industry on the south bank (the smokestack) over architecture on the north, and the print's topographic nature is undercut by the addition of figures in the lower portion of the sheet. Relative to Menpes's more straightforward rendering of the waterfront, *Limehouse*, a heavily worked print with four states, suggests another era. This picturesque enclave, one of the few detours in East London outside the docks and one of the few docklands areas often depicted in artistic prints in the wake of Whistler's *Thames Set*, is recognizable by its distinctive church tower visible from the river. The tower belonged to Limehouse's key landmark, St. Anne's Parish Church, designed by Nicholas Hawksmoor, a student of Christopher Wren, the architect of St. Paul's. Addams's print thus evokes an earlier period, suggestive of Rembrandt and his era. The 1914 print, *Blackfriars* (cat. 52), appeared in even more states, the example from Guildhall being state IV.[59] Wider than *Limehouse*, it is one of the most expansive views of the river apart from panoramas by the Canadian photographic firm Notman and Company, and the architectural draftsman T. Raffles Davison (cats. 129, 57). *Blackfriars* focuses on river traffic and on industrial buildings along the Thames. Addams's architectural background served him in all three prints' delicate, labor-intensive renderings. These details are occasionally countered by his tendency to include fanciful elements, such as the nude female at right in state III of *Limehouse*, which suggests a more visionary approach to the river.

Theodore Roussel's *Chelsea Palaces*, like Addams's *Limehouse*, also references old London in its depiction of Chelsea's seventeenth-century Lindsay House (cat. 82). The print's minute scale and its highly aestheticized presentation recall Roussel's association with Whistler. A painter and watercolorist, the French expatriate took up printmaking in 1888 at Whistler's encouragement.[60] The print's title invites a comparison to Whistler's Venetian palazzos, but the reference is close to home: Roussel's British contemporaries referred to Chelsea

as "a village of palaces."[61] The small scale of *Chelsea Palaces* functions to draw in the viewer, like Whistler's late lithographs made from the Savoy Hotel (cats. 110–114). Roussel enhanced the print's preciousness by designing an elaborately embellished mount, which became his practice. This example, mounted on his *Scarab, Grecian Key, and Fly Pattern*, is framed in his *Stag and Flower Pattern*.[62] If this visual extravaganza were not enough, Roussel turned his single-toned version of *Chelsea Palaces* into a colored etching and aquatint, using five different plates. Its colors are expressive and nonnaturalistic—the gray Thames is a deep blue, and the sky is flecked with bright red and yellow. It is Roussel's only colored Thames print and his most complex image.

European and American painter-printmakers outside Whistler's intimate circle were equally inspired by his aesthetics in general and the *Thames Set* in particular. The Scottish painter-etcher Sir David Young Cameron produced his *London Set* in 1899. Cameron focused on architectural subject matter, richly delineating interiors and exteriors of Gothic churches.[63] While his early work betrayed the combined influences of Rembrandt, Meryon, and Whistler (e.g., *Thames Warehouses*, 1890, Fine Arts Museums of San Francisco), his mature prints referenced Meryon's style only. His Venetian scenes challenged Whistler's in their sense of light and atmosphere, and *London Set* must have been similarly produced. Less atmospheric than Cameron's Venetian palaces, and decidedly modern, is *Waterloo Bridge* (cat. 56) from the *London Set*. With an unusual vantage point from the foot of the bridge as if on the river, the print looks south toward the river's more ramshackle Surrey side. Its composition departs greatly from such topographic imagery as Fenton's and Crowther's Waterloo Bridges and stereoviews that look toward the more elegant Somerset House (cat. 138). Cameron directs our vision to the surface of the bridge and the rapid rhythm of the colonnaded arches, akin to the rushing modernist perspective found in an anonymous watercolor depicting Charing Cross Bridge (cat. 49). Although a stylistic departure from Whistler, Cameron's prints still compelled the critic Walter Pater to compare them to another art form, and one that Whistler regularly invoked. For Pater, they were "music in space."[64]

Few artists focused on the Thames bridges from such an angle. Henri Guérard's view of Westminster Bridge (cat. 59) is another exception. Unlike the heavily worked surface of Cameron's bridge, Guérard distilled and stylized his subject.

Here, the great Clock Tower appears simplified and slender relative to other images of it. Equally stylized are its reflections and those of Westminster Bridge on the water. Guérard used long vertical lines over paler tones of brown to form the buildings and produce the image's atmospheric softness. Inflected by impressionism and japonisme, his etched oeuvre largely contains marine subjects. A contemporary described him as "a modernist, a follower of Manet, a landscapist, seascapist, *japoniste*, fantasist, an alchemist, and an experimentalist… like many painters who take up printmaking he is enthralled by the different processes and 'progressive equipment.'"[65]

In contrast to Guérard, Félix Buhot distanced himself from the impressionists, but he shared with them subject matter and an interest in capturing atmospheric effects. Buhot's two major Thames prints used techniques in combination, including etching, drypoint, aquatint, and roulette. Buhot's *Westminster Clock Tower* (cat. 54) appears to be an evening scene, capturing Londoners going to and fro over the Thames. The tumult is enhanced by his use of "symphonic margins," a device he invented, exploiting it in a way that both extended the print's subject matter and related to its meaning. Here, a miniature topographic view of the Thames stretches across the top margin, while the Pool of London with large ships appears in a vignette at right. In the second Thames print, *Westminster Palace* (cat. 55), the ensemble of buildings is seen as if in a topographical view, roughly from the vantage point of one of Strudwick's 1860s photographs (cat. 131). But Buhot's margins undermine the idea of topography, with their architectural details and imaginary vignettes, including a mythological sea creature, a couple in renaissance costume, and a baroque carriage. Buhot began his career in applied art, as a fan painter, and he often added unusual painterly touches to his prints, in gouache and colored inks, and printed them on rare and antique papers toned in such liquids as tea or dipped in turpentine and edged with gold.[66]

The American artist and founder of the Chicago Society of Etchers, Bertha Jaques took her cue from French artists and the impressionists in her Thames series, as well as from Whistler and Japanese art. As had Homer and Hassam, Jaques began her career working as a magazine illustrator. She was also an amateur photographer. After her marriage to Dr. Willem K. Jaques, she grew interested in etching, and her husband installed in their home a small printing press that he converted to print etchings. Jaques traveled to Japan in 1908,[67]

and *Rain on Thames* (cat. 64) is directly inspired by such Japanese prints as those by Hiroshige. Here, she suggests the idea of a downpour through slashing vertical strokes laid over the forms of the barges, bridge, and the buildings on the opposite shore. Capturing effects of fog represented more of a challenge (cat. 63), which she met by rendering the distant buildings in pale tones of brown ink and intricate vertical-horizontal cross-hatching: they read as one completed silhouetted form. When Jaques began these etchings, more than forty years had passed since the publication of Whistler's *Thames Set.*

Pictorial Effects on the Thames

The photographic medium's near equivalent of the painter-etcher was the pictorialist. Pictorialism emerged in Britain in the mid-1880s—a pivotal decade in photography—and was the aesthetic favored by the Linked Ring. Founded in 1892 by a group of photographers who broke with London's Photographic Society, the Linked Ring emphasized progressive artistic aesthetics, including what was termed photographic impressionism. They discounted documentary and scientific photography and the derivative and sentimental photographs that were included in Photographic Society exhibitions. Artists and critics began to dismiss artistic works shown at the Society that were often imitative of those by Henry Peach Robinson. Since the late 1850s, Robinson had used combination printing in his genre scenes, producing cloying and false effects.[68] Naturalism, via the popularity of Bastien-Lepage's paintings, informed much painting in the 1880s, and this approach was adopted in the world of artistic photography. The physician and amateur photographer Peter Henry Emerson proved the most critical of Robinson's aesthetic. In 1886 Emerson theorized that the finest art imitated the effects of nature on the eye, privileging photography—especially platinum prints and photogravure—over other graphic media. Photography could better duplicate the perspective of human sight, and for Emerson, it was second only to painting, which produced images in color. In painting he favored the Barbizon school and was friends with the British painter and Bastien-Lepage follower, Thomas Frederick Goodall.[69]

There were, of course, exceptions to the aesthetic values held by the Photographic Society. In *The Frozen River* (cat. 134), A. J. Ransome departed from the sentimental imagery of Robinson and his followers. Ransome's photograph evokes Whistler's 1860 painting *The Thames in Ice* (see fig. 7, p. 23), echoing its vertical composition, with the large ship at left and the view of the river beyond. Ransome enhanced the photograph's artfulness by creating its special mount with borders drawn in graphite, recalling the practice of such painter-etchers as Roussel. Like Whistler and Roussel, Ransome invited close viewing with the small scale of his work, which belies the photograph's dramatic subject matter. He focused on the power of nature and its superiority over human achievements. With only a narrow strip of river remaining navigable, the Thames freeze of February 1895 wrought havoc on shipping activities and the livelihoods of all who worked the river, impacting thousands of lightermen and watermen.[70]

Events on the river compelled pictorial photographers to step outside their usual roles. Colonel Joseph Gale's photographs also differed from the sentimental subject matter of his contemporary Robinson and from the technical manipulations of Linked Ring members such as George Davison, although he became an early member in 1892. An architect by training, Gale had been making photographs since Whistler began his *Thames Set* in 1859.[71] Like Bastien-Lepage and the naturalist painters in Britain, especially Clausen and Goodall, Gale favored rustic scenes with clarity and rich detail: his Link code name was the "Rambler." *Barges and Ships on the Thames* (cat. 127) is an exception to his rural landscapes, created just before Tower Bridge's completion in June 1894. As a platinum print it calls to mind Emerson's preferences for photographic prints. Boats lying in the Pool of London dominate the composition and serve as a metaphor for Britain's imperial status, using the era's last great Thames crossing, the gothic-inspired Tower Bridge by the architect Horace Jones, as a backdrop.

Like Colonel Gale, the stockbroker Charles Job was also an amateur photographer and a member of the Linked Ring. His *Thames below London Bridge* (cat. 128), in warm brownish tones, on a heavy textured paper favored by the photographic impressionists, must surely date to his period with the Ring. As with works by Whistler, Menpes, and Pennell, its title reveals the setting as the working Thames. Like Gale, Job concentrated on pastoral imagery and used combination printing to maximize the power of skies.[72] Here, Job achieves dramatic effects in this spiritually infused scene of the sun breaking through the clouds. The Thames almost seems to sparkle as the sun's reflections strike its surface.

The poetic imagery of the American expatriate Alvin Langdon Coburn dominates pictorialist photographers' interpretations of the Thames, culminating in his 1909 *London* portfolio.

Perhaps it took a photographer with little notion of the city to express and rediscover it in his art, not unlike Whistler's experience in Venice. Not more than eighteen years old, Coburn emerged onto the London photographic scene in 1899, when he arrived with a distant cousin, the eccentric American photographer F. Holland Day. In 1900 Day included nine of Coburn's photographs in the *New School of American Pictorial Photography* exhibition at the Royal Photographic Society. One critic claimed that the exhibition did more for pictorial photography than the Linked Ring ever had, while another described it as "the ravings of a few lunatics."[73] Coburn was at the forefront of a new way of seeing in photography and even captured the attention of Henry James, who later collaborated with Coburn in a project to "illustrate" his collected works.[74]

In 1903, Coburn received his first one-person show at the Camera Club of New York and later that year attended Arthur Wesley Dow's school in Ipswich, Massachusetts. In his influential book *Composition* (1899) and in his classes, the painter Dow advocated the design principles of Japanese art and Whistlerian aesthetics, but he also incorporated photography into his teaching.[75] Delving into the relationship between painting and photography, Coburn invoked Whistler several times in his *Autobiography*. He described Whistler's art as "photographic," no doubt referring to Whistler's tonal works with their soft forms enshrouded by mist, as in later pictorialism. He described himself and the photographers Edward Steichen and Frank Eugene as the "Whistlers of Photography."[76] In 1909 he traveled to Detroit to photograph the Whistlers in Charles Freer's collection, feeling that he had "met" Whistler through Freer.[77] In that year, Coburn also purchased his home Thameside on the river near Hammersmith Bridge, where he set up a press to make gravures.[78] He issued the portfolio *London* in 1909, which was advertised in *Camera Work* as "marvels of impressionism," with an introduction by Hilaire Belloc, a writer, historian, and member of Parliament. *London* included several views of the Thames, so central to the city's identity (cats. 116–120). We know from the existence of *The Dome of St. Paul's*, his frontispiece for volume five of Henry James's collected novels and tales, and the serene bluish-green gravure *Thameside Twilight* (cat. 121), which he later gave to Dow, that his Thames views extended beyond those in *London*.[79]

The plates in *London* present differing aesthetics using the same gravure medium. The suite of images, in contrast to Menpes's travelogue-style progression, moves from location to location, from the docks to a park and back to the river with *St. Paul's*, the next in the suite being *Trafalgar Square*. Subverting a logical progression allows the viewer to focus on the images themselves and their symbolic content. *London*'s third image, *The Bridge—London* (*Waterloo Bridge*) (cat. 119), with its radical cropping, is the most dramatically modernist. Number ten, *Wapping* (cat. 120), is a direct homage to Whistler, with its aestheticization of the lone lighterman and the industrial buildings in the background. *Houses of Parliament* (cat. 116) recalls the technique of mezzotint with its warm, murky surface; shrouded in fog and smoke, Charles Barry's buildings emerge mysteriously on the riverbanks. Three elements that Coburn articulated as significant subject matter for him can all be found in the Thames images from *London*: unusual vistas in cities, clouds, and "the rhythmic beauty and poetry of liquid surfaces."[80] All three are combined in plate six, *St. Paul's from the River* (cat. 117), composed with utmost care, where a cloud hovers over the cathedral's dome.

Imagery such as clouds in Coburn's work functions as metaphors and as catalysts to elicit an emotional response. The playwright and amateur photographer George Bernard Shaw wrote that in landscape, Coburn "drives at the poetic, and invariably seizes something that plunges you into a mood, whether it is a mass of cloud brooding over a river, or a great lump of a warehouse. . . ." Shaw's unpublished text for *London* compared Coburn's photogravures to Whistler's works, and also to mezzotints, continuing the pictorialist invocation of more traditional printmaking techniques.[81]

Coburn and Pennell: Rivals in Art and Illustration

Perhaps it is not a coincidence, then, that a group of six mezzotints by Pennell, the peak of his Thames prints, appeared in 1909, the same year as Coburn's *London* portfolio. Shaw was a neighbor of the Pennells, making an appearance as the "Socialist" in Elizabeth Pennell's memoir *Our House; And London out of Our Windows* (fig. 35). Coburn and Pennell as American expatriates surely would have known, or known of, each other. Both artists admired Whistler, both illustrated works by Henry James, and both had homes that faced the Thames. Shortly before Coburn first visited London, Joseph Pennell attacked the very idea of artistic photography and was especially critical of pictorialists who strove to make photographs look like the more artistic media of charcoal or

DOWN TO ST. PAUL'S

Our House
And London out of Our Windows

BY

Elizabeth Robins Pennell

With Illustrations by
Joseph Pennell

Boston and New York
Houghton Mifflin Company
The Riverside Press Cambridge
1912

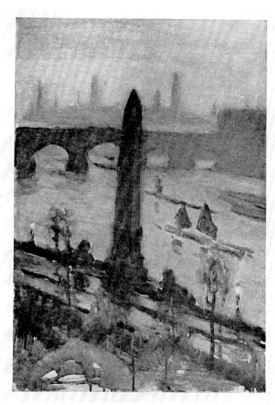

CLEOPATRA'S NEEDLE FROM OUR WINDOWS

fig. 35
Frontispiece by Joseph Pennell and title page
From *Our House and London Out of Our Windows* by Elizabeth
Robins Pennell, New York and Boston: Houghton, Mifflin and
Company and Riverside Press, 1912

fig. 36
Cleopatra's Needle from Our Windows by Joseph Pennell
Illustration
From *Our House and London Out of Our Windows* by Elizabeth Robins
Pennell, New York and Boston: Houghton, Mifflin and Company
and Riverside Press, 1912

aquatint.[82] He also criticized the amateur status of many photographers, as in the case of Gale and Job.

Pennell's stance with respect to photography, including pictorialism, is important to consider in light of the major collaboration that took place between Coburn and James for James's collected works. Like Pennell, James was skeptical about photography's status as art. However, after meeting the young Coburn in 1905, who had been engaged by Richard Watson Gilder of the *Century Magazine* to make portraits of the era's great men, James began to reconsider the medium's ability to communicate artistic ideas. The following year, James and Coburn began an intense collaboration to create frontispieces for James's collected works. The hard-to-please James was enthralled by Coburn's results: his photographs, like James's prose, were highly descriptive, yet symbolic. James doubted that illustrations could suitably accompany his fiction. Pennell had, in fact, only illustrated James's nonfiction. After Coburn began supplying frontispieces for James, Pennell approached the author about illustrating *The American Scene*, but his offer was soundly rejected.[83] Pennell's later London works should be seen in the context of the changing role of illustration and attitudes to photography in the early twentieth century.

Pennell's output signals in a formidable manner the impact of his artistic predecessors and contemporaries and of the river as an environment. His early prints were influenced in idea by Whistler's *Thames Set*. Some prints strongly recall Whistler's technique and approach to subject matter, such as *Lanark Wharf* (cat. 72), comparable to such Whistler etchings as *Limehouse* (1859, cat. 99). Others evoke the Thames's activity and commerce, allied both with photographs of the period and with modernist painters' depictions of it (cats. 76, 10).

The twenty prints in his *Easter Set* included ten views of the Thames (for example, cats. 67–70). In the *Easter Set*, Pennell's progression from his starting point at Vauxhall Bridge is not so enigmatic as Coburn's *London*, but it does not unfold as readily as Menpes's suite, moving back and forth from day to night, and concluding with the small night scene, *Cleopatra's Needle* (cat. 70). Like the 1860s documentors of the river, he commemorated construction projects. However, his etching of the partially built Tower Bridge (cat. 68) is intimately scaled, as were many of Whistler's prints, belying the bridge's actual stature. Calling London "the most etchable place in the world," Pennell claimed that the prints were not "the result of a tour in search of the picturesque"; they were "not etchings *of* London" but "etchings *in* London,"[84] emphasizing his subjective response over the notion of topography.

Pennell's 1909 mezzotints recall the more subjective moods of Whistler and Monet. In works like *The City, Evening; Westminster, Evening;* and *The Shower, London* (cats. 78–80), the time of day and the effects of weather are essential to their meaning. Like Whistler, who looked out over the river while living in Chelsea, and Monet at the Savoy Hotel producing his *Vues de la Tamise*, Pennell lived with views of the river from the Victoria Embankment near Charing Cross Station, just upstream from the Savoy. Elizabeth Pennell commemorated their domestic vantage point in *Our House*:

[Q]uiet though it may be, [the view] is never dull as I watch it from my high windows. To the front I look out on the Thames: down to St. Paul's, up to Westminster, opposite to Surrey, and, on a clear day as far as the hills. Trains rumble across the bridges, trams screech and clang along the Embankment, tugs, pulling their lines of black barges, whistle and snort on the river…. At night myriads of lights come out, and always, at all hours and all seasons, there is movement and life,—always I seem to feel the pulse of London even as I have its roar in my ears.[85]

While making prints for his public, actual mezzotints that rivaled pictorial photographs, privately Pennell produced a series of watercolors from his window view on the Thames. Could this large body of watercolors depicting Waterloo Bridge and St. Paul's perhaps be inspired by or responding to Monet's *Views of the Thames*? Monet's 1904 Durand-Ruel exhibition received so much attention in the press that he claimed to be slightly embarrassed by it.[86] Any artist who depicted London following that exhibition would have had to take Monet's Thames series into account. Clearly, Pennell knew of Monet's work, as Pennell's mentor Whistler and Monet were close friends. Elizabeth Pennell also reviewed Monet's 1904 exhibition, anonymously, for the London *Star*. In it, she critiqued Octave Mirbeau's essay accompanying the catalogue, since Mirbeau had not acknowledged Monet's artistic forebears, especially Whistler. His absence was especially acute, as he had made transfer lithographs and his last lithotint (cats. 110–14) from the nearly the same vantage point as Monet's series. In addition, she objected to the nonnaturalistic colors used by Monet, especially a shade of green she never saw from her window.

Joseph Pennell's watercolors of Waterloo Bridge with St. Paul's are essentially a series, although one that perhaps held personal significance for the artist.[87] These no doubt date from about 1909. Three of Pennell's 1909 mezzotints also depict this subject. Further, they can be related to *Our House* of 1911, since a number of images of Waterloo Bridge with St. Paul's are used as illustrations throughout the book (figs. 35, 36). One of these watercolors depicts a Thames steamboat (cat. 39), probably in the early morning light, with Waterloo Bridge more loosely delineated. In another, Pennell uses blue-gray paper and includes the obelisk on the Embankment in the foreground (cat. 42). Dispensing with contour lines, he depicts the city's lively profile, while the sky and clouds predominate. This conceit is intensified in a vertical composition: a mass of pink clouds occupies almost the entire sheet, while the bridge is barely suggested along the lower edge by a few strokes of gray wash (cat. 41). These watercolors are the visual echoes of Elizabeth Pennell's reflections on this scene: "Over the river, when fog and mist do not envelop it as in a shroud, the clouds—the big, low, heavy English clouds—float and drift and scurry and whirl and pile themselves into mountains with a splendour that might have inspired Ruskin…."[88] As they had John Constable a century before, clouds attracted Pennell. In contrast to his seemingly mechanized medium, they also appealed to Coburn. Pennell used watercolor, which invoked the tradition of English topographic and picturesque landscape. Yet his brush and palette were freer, less exacting and scientific, as in the wet-on-wet technique of *St. Paul's, London* (cat. 40), where the sky in the composition is infused with yellows and oranges. Pennell was inspired by his view of the river, as had been Turner, Whistler, and Monet. The expressiveness of these watercolors reveals the impact of the Thames in art and actuality in the early years of the twentieth century.

Pennell was making his images at a critical moment in the history of printmaking and illustration. He sought to uphold traditional modes of fine art illustration, feeling embattled in particular with respect to the idea that photography could be art. The successful collaboration between Coburn and James must have been a blow to his ego, but more significantly to his mind, a substantial step in the wrong artistic direction. As he wrote in *Pen Drawing and Pen Draughtsmen*, "The painter and the photographer who, for the moment are supreme, neither care nor know anything" of fine printing.[89] Pennell left London in 1914, at the outbreak of World War I. The British Empire began its decline and the river began to lose much of its former activity and allure for artists. The nature of artistic creativity shifted strongly in other directions, and few artists were drawn to the Thames compared to the period between Whistler's *Thames Set* and World War I. Whether their reflections were direct or filtered through time, artists producing works on paper provide us with a fascinating glimpse into London's river, and the correspondence among many media suggest how the Thames was perceived in actuality and in the imagination during this rich artistic period.

I would like to express my sincerest appreciation to Fronia W. Simpson, Jordana S. Weiss, and Denise Bergman who provided invaluable insight and comments on drafts of this essay, to Liza Oliver who kindly donated her time to provide research support, and, finally, to Emmanuel Roux who, despite the efforts of Charley, Frances, Ivan, and Jeanne, helped make it possible to complete the text.

1. The 1863 article by Philippe Burty in the *Gazette des Beaux-Arts*, as quoted in Michel Melot, *The Impressionist Print*, New Haven and London: Yale University Press, 1996, p. 46.

2. Whistler's thoughts asserting the artfulness of his works, rather than their connection to actuality, are recalled in Mortimer Menpes, *Whistler As I Knew Him*, London: Adam and Charles Black, 1906, p. 122. Escorting a journalist through his exhibition, Whistler challenged a critic who appears to have been taken aback by the scale of his work, "It is very small—isn't it? Very small, indeed. And if you come quite close you can smell the varnish. That is a point, distinctly a point. It will enable you to discover that the picture is an oil colour." Whether a print or a painting, the idea that the work was a *picture* rather than a representation or a narrative was essential.

3. See, for example, *From Realism to Symbolism: Whistler and His World*, exhibition catalogue, New York: Columbia University, 1971; Robert H. Getscher, *The Stamp of Whistler*, exhibition catalogue, Oberlin, OH: Allen Memorial Art Museum, 1977; Erik Denker, *Whistler and His Circle in Venice*, exhibition catalogue, London: Merrel; Washington, DC: Corcoran Gallery of Art, 2003; and most recently Linda Merrill et al., *After Whistler: The Artist and His Influence on American Painting*, exhibition catalogue, Atlanta: High Museum of Art, 2003.

4. Ralph F. Bogardus, *Pictures and Texts: Henry James, A. L. Coburn, and New Ways of Seeing in Literary Culture*, Ann Arbor, MI: UMI Press, 1984.

5. Lindsay Stainton, *British Landscape Watercolours, 1600–1860*, Cambridge: Cambridge University Press, 1985, pp. 10–14, 43–45.

6. George Washington Wilson's article was published in the *British Journal of Photography* in 1864. As quoted in Françoise Heilbrun, "Around the World: Explorers, Travelers, and Tourists," in Michel Frizot, ed. *A New History of Photography*, Cologne: Könemann, 1998, pp. 156–57.

7. Heilbrun in Frizot 1998, p. 155.

8. A lawyer by profession, Fenton had studied painting with Paul Delaroche in Paris between 1841 and 1844. For Fenton's biography, see John Hannavy, *Roger Fenton of Crimble Hall*, Boston: David R. Godine, 1976, pp. 17, 21–22, 30, 35; and also Valerie Lloyd, "Roger Fenton and the Making of a Photographic Establishment," in *The Golden Age of British Photography*, ed. Mark Haworth-Booth, exhibition catalogue, London: Victoria and Albert Museum; New York: Aperture, 1984, pp. 70–76. See also Mike Weaver, "Artistic Aspirations: The Lure of Fine Art," in Frizot 1998, pp. 185; and Heilbrun, "Explorers, Travelers, and Tourists," in Frizot 1998, pp. 155–57.

9. Mr. and Mrs. S. C. Hall, *The Book of the Thames: From Its Rise to Its Fall*, London: Alfred W. Bennett, 1867 (1st pub. 1859), pp. 171–72; G. F. Cruchley, *Cruchley's London in 1864: A Handbook for Strangers*, London: G. F. Cruchley, p. 293; The quote, "Canova disait de ce pont que c'était le plus beau du monde," from *Londres et ses environs*, Cornhill: Baily Frères, 1862, p. 128. Further, Black's guidebook believed that the bridge inspired the "admiration of all beholders," see *Black's Guide to London and Its Environs*, Edinburgh: Adam & Charles Black, 4th ed., 1871, p. 229.

10. *Waterloo Bridge* has been reproduced in Gavin Stamp's excellent study of London architectural photographs as possibly by Roger Fenton, and was drawn from the collection of the National Monuments Record. See Gavin Stamp, *The Changing Metropolis: Earliest Photographs of London, 1839–1879*, New York: Viking, 1984, p. 159. The present example is from the Collection of the Royal Photographic Society whose Fenton holdings came from Fenton's heirs and is further identified as Fenton's on the photograph's period mount.

11. Stephen Halliday's recent book devotes a chapter to Bazalgette. See Halliday, *Making the Metropolis*, London: Breedon Books Publishing, 2003, pp. 125–51. For a history entirely devoted to the Embankments, see Dale H. Porter, *The Thames Embankment: Environment, Technology, and Society in Victorian London*, Akron: University of Akron Press, 1998.

12. These lithographs were published and distributed by the well-known and successful firm of Day & Son. Founded in London in 1829 as Day and Haghe, Day & Son received the honor of being appointed "lithographers to the Queen" in 1838. Chromolithographs were one of the most important means of color reproduction in Europe and the United States during this period. For an excellent study of the medium and its popularity in the United States, see Peter C. Marzio, *Chromolithography, 1840–1900, The Democratic Art: Pictures for a 19th-Century America*, Boston: David R. Godine; Ft. Worth: Amon Carter Museum, 1979.

13. Database record on watercolors by E. Hull (probably Edward Hull) consulted by the author at the Museum of London, September 2, 2003. My thanks to the Museum of London's Curator of Paintings, Prints, and Drawings Mark Bills for providing guidance with respect to the museum's collection and searching its database with me.

14. Like Fenton, E. A. Goodall went to the Crimea to document the war, and he produced over sixty-five watercolors for *The Illustrated London News*. See Christopher Wood, *Dictionary of Victorian Painters*, Antique Collectors' Club: Woodbridge, Suffolk, England, 1981, p. 180. Goodall belonged to the Old Water-Colour Society and the Royal Watercolour Society and was the son of the engraver Edward Goodall and brother of the Royal Academician Thomas Frederick Goodall. The latter, a naturalist painter, also made photographs and was a friend of the photographer Peter Henry Emerson. Emerson promoted naturalistic photography in the 1880s.

15. Two of these photographs (cats. 131, 132) are reproduced in Stamp 1984, pp. 143 and 162, as by an unknown photographer. The National Art Library at the Victoria and Albert houses letters between Strudwick and the museum's first director, Henry Cole. I am grateful to Kate Best at the Victoria and Albert Museum who checked the museum's original registers, discovering the origins of these photographs. The authorship and titles are from a series of correspondence with the author from October 30 to November 9, 2004.

16. Crowther lived in Chelsea in the 1880s, and exhibited regularly at the Royal Academy between 1876 and 1898. See typescript and exhibition pamphlets, Guildhall Library Print Room, Crowther file. My thanks to John Fisher, head of Prints, Maps, and Drawings at Guildhall Library, for making these available.

17. For a discussion of naturalism and photography see Gabriel P. Weisberg, *Beyond Impressionism: The Naturalist Impulse*, New York: Abrams, 1992, pp. 24–47. For the impact on British art, including a discussion of George Clausen, and also the relationship between the painter Thomas Frederick Goodall (E. A. Goodall's brother and also a photographer) and Peter Henry Emerson, see Weisberg, pp. 108–17. Clausen's posthumous tribute to Bastien, "Jules Bastien-Lepage as Artist," recalling the intense discussion surrounding Bastien's work, is included in André Theurieut, *Jules Bastien-Lepage and His Art: A Memoir*, London: T. Fisher Unwin, 1891, pp. 111–20.

18. Child's review appeared in the *Art Amateur*, August 1884, page 54, and is quoted in Doreen Bolger, *American Paintings in the Metropolitan Museum of Art*, vol. 3, New York: Metropolitan Museum of Art, 1980, pp. 180–82. Bolger suggests Boggs's possible knowledge of Whistlerian aesthetics, but also links him to the pre-impressionist painter Johan Barthold Jongkind.

19. Alan Woods counters readings of Doré's illustrations as realistic representations of London. See Woods, "Doré's *London*: Art and Evidence," *Art History*, vol. 1, no. 3, September 1978, pp. 341, 345–47. In 1868 the Doré Gallery also opened on New Bond Street in London. Between that date and its closing in 1892, over 2.5 million people saw the gallery, attesting to Doré's popularity throughout this period.

20. For both quotes see Gustave Doré and Blanchard Jerrold, *London: A Pilgrimage*, New York: Harper Brothers, 1890 [first U.S. ed.], p. 190.

21. For a discussion of Mayhew and Thomson see Thomas Prasch, "Photography and the Images of the London Poor," in *Victorian Urban Settings*, Debra N. Mancoff and D. J. Trela, eds. 1996, pp. 179–94. The sociological perspective of Thomson and Smith's project allowed for documentation of the individual both in images and interviews by Thomson and Smith in the text.

22. My thanks to Mike Seaborne, Curator of Photographs, Museum of London, and author of *Photographer's London, 1839–1994*, London: Museum of London, 1995, for making the Museum of London's example of *Street Life in London* available to me.

23. The *Illustrated London News* was started by Herbert Ingram in 1842 who realized that the circulation of newpapers increased when illustrations were introduced along with the text.

24. For the challenges in producing photographic illustrations in nineteenth-century publishing, see Sylvie Aubenas, "The Photograph in Print: Multiplication and Stability of the

Image," in Frizot 1998, pp. 225–31. For an overview of book and magazine illustration in the United States, see David Tatham, *Winslow Homer and the Illustrated Book*, Syracuse, NY: Syracuse University Press, 1992, pp. 1–20. Tatham notes that advances in technology, especially the electrotype and the high-speed rotary press, allowed for illustrated weeklies to flourish and to have massive circulation figures. See Tatham 1992, pp. 6–7.

25. Augustus J. C. Hare, *Walks in London*, 2 vols., New York: Routledge, 1884. For Hare's statement, "The illustrations, with two or three exceptions, are from my own sketches taken on the spot, and carefully transferred to wood," p. ix.

26. First published in the critical date of 1859, the Halls' book was reprinted several times following this date until about 1890. The three major editions after the first were 1867, 1869, and c. 1880. Both the 1867 and 1869 versions intermingled albumen prints with wood engravings. The first edition had contained wood-engraved illustrations only, and the later printings returned to that format, revealing the difficulty of incorporating photographs as illustrations during this period.

27 Francis Frith bought out much of Fenton's photographic studio, including equipment and negatives, when Fenton left the field in 1862 to return to law. For Frith's importance in nineteenth-century photography, see Haworth-Booth, *The Golden Age of British Photography*, 1984, pp. 49, 83; and Helmut Gernhsheim, *The Rise of Photography, 1850–1880: The Age of Collodion*, New York and London: Thames and Hudson, 1988, p. 159. For Frith's participation in the Halls' publication, see Helmut Gernsheim, *Incunabula of British Photographic Literature*, London and Berkeley, Scolar Press, 1984, entry no. 352. See also Lucien Goldschmidt and Weston J. Naef, *The Truthful Lens: A Survey of the Photographically Illustrated Book, 1844–1914*, New York: Grolier Club, 1980, p. 203.

28 *Heywood's Illustrated Guides* were consulted in the pamphlet collection at Guildhall Library, London, see especially nos. 20885 of 1898 and 3173i of c. 1909.

29. Even as late as 1866, Daubigny produced small vignettes for tourist books. See Melot 1996, p. 19. With respect to the artists included in this exhibition, an exception is Monet who was not active in this arena.

30. Kathleen A. Foster, "The Pre-Raphaelite Medium: Ruskin, Turner, and the American Watercolor," in Linda S. Ferber and William H. Gerdts, *The New Path: Ruskin and the American Pre-Raphaelites*, exhibition catalogue, Brooklyn: The Brooklyn Museum, 1985, p. 81. The exhibition was held in New York and other cities in the Northeast. For a full accounting, see Susan P. Casteras, "1857–58 Exhibition of English Art in America and Critical Responses to Pre-Raphaelism," in *The New Path*, pp. 109–33. Cooper also notes the importance of a huge exhibition of watercolors, including 200 British ones, held at New York's National Academy of Design in 1873. See Helen A. Cooper, *Winslow Homer Watercolors*, exhibition catalogue, Washington, DC: National Gallery of Art; New Haven and London: Yale University Press, 1986, p. 18.

31. Theodore E. Stebbins, Jr., *American Master Drawings and Watercolor: A History of Works on Paper from the Colonial Times to the Present*, New York: Harper & Row, Inc., and the Drawing Society, 1976, p. 148.

32. Homer may have stayed in London over three months, arriving at Liverpool on March 25 and moving to Cullercoats, a fishing village on the North Sea, in June or July. See Cooper 1986, pp. 80–91; Nicolai Cikovsky and Franklin Kelly, *Winslow Homer*, exhibition catalogue, Washington, DC: National Gallery of Art; New Haven: Yale University Press, 1995, cat. no. 107; and also John Wilmerding, "Winslow Homer's English Period," *The American Art Journal*, November 1975, pp. 60–69.

33. Cooper 1986, pp. 75–78.

34. Boggs is one of the few artists that Hassam admitted to remembering from Paris, perhaps as both shared an interest in city scenes. H. Barbara Weinberg, *Childe Hassam: American Impressionist*, exhibition catalogue, New York: Metropolitan Museum of Art, New York, 2004, pp. 13–14, 18.

35. Hassam as quoted in Ulrich W. Hiesinger, *Childe Hassam: American Impressionist*, exhibition catalogue, Munich and New York: Prestel, 1999, p. 181.

36. Hassam exhibited his London works sporadically after his 1897 trip. Included among the exhibitions of Thames works through 1905 recorded in Weinberg 2004 are two watercolors made along the Thames during his 1889 trip to London, *Under the Obelisk, Thames Embankment* and *The Thames, Victoria Embankment* and in the February 1890 American Water Color Society exhibition in New York. The former was also shown twice in 1891 at two sin-

gle-artist exhibitions at Doll and Richards in Boston. Perhaps made during the 1898 trip to London, he exhibited *Riverbend on the Thames* at the American Water Color Society in February and March of 1899; and again at the Cincinnati Art Museum's annual that summer, which may not be the same work as *River Bank on the Thames* shown at the Art Institute of Chicago in late 1899. Many London works were included in the 1900 Macbeth Gallery show, *Works by Childe Hassam of New York, London, and Paris*, which appears to be listed in the Roullier Galleries exhibition. Out of the nine London works in *Twenty-seven Drawings by Childe Hassam*, four appear to be of the Thames. Both 1900 shows were no doubt related to his *Three Cities* book, published in 1899; out of the twelve London plates, five were Thames scenes. Later that fall he showed two Thames works, a *Nocturne*, "*Big Ben*," and his *Houses of Parliament* at Boston's St. Boltoph Club. In 1902 *Houses of Parliament* was included in a group exhibition at the Minneapolis Society of Fine Arts, and four Thames watercolors were shown in Boston at Doll and Richards in November 1902. Number 40, *Westminster Bridge* may very well be the *Big Ben* in the Corcoran's collection. See Weinberg 2004, pp. 375–76, 380–81.

37. Joseph Pennell's *Pen Drawing and Pen Draughtsmen* was first published in 1889 and was reprinted in 1894 and 1897, the last revised edition being in 1920. The above quote is taken from a discussion of the decline in quality of illustrated French magazines, but applies in general to Pennell's thoughts on the field. See a reprint of the 1920 edition, Pennell, *Pen Drawing and Pen Draughtsmen: Their Work and Their Methods*, New York: Da Capo Press, 1977, p. 59.

38. Whistler's etchings were selected for exhibition at the Salons, whereas his paintings of the same period were not. Even the progressive poet Mallarmé, who was a friend of Monet, preferred Whistler's etchings to his paintings. See Luce Abélès in *Turner Whistler Monet: Impressionist Visions*, exhibition catalogue, Toronto: Art Gallery of Ontario in association with the Tate Gallery, 2004, p. 166.

39. Delâtre printed for many artists associated with the etching revival. For the revival's major figures and the Society of Etchers in Paris, see Melot 1996, pp. 17, 25, 49–51. See also Katharine A. Lochnan, *The Etchings of James McNeill Whistler*, exhibition catalogue, New Haven and London, 1984, p. 50. In 1865, the very year Daubigny and Cadart went to London and met with Whistler, Daubigny met Monet at Trouville in Normandy. See Melot 1996, p. 17. In the mid-1870s, Cadart and Burty continued to promote artistic prints, publishing books and writing manifestos that supported their position. See also Jesusa Vega, "Whistler and the New Concept of the Print," in *Whistler and Sickert*, exhibition catalogue, Madrid: Fundaçion "La Caixa," 1998, pp. 228–32.

40. Gautier as quoted in Melot 1996, p. 49.

41. Melot 1996, pp. 36–40.

42. In 1880 Haden founded and became president of the Society of Painter-Etchers. Lochnan 1984, pp. 140, 143. For Haden's later involvement with etchings and his and Burty's efforts with respect to the medium, see Melot 1996, pp. 39–40. See also Seymour Haden, *About Etching*, London: The Fine Art Society, 1879. Haden spent part of 1882 on an American lecture tour where Joseph Pennell heard him speak, following which Pennell joined Haden's Society of Etchers. Pennell left the Society in 1890, the same year that it became the Royal Society of Etchers.

43. Melot 1996, p. 39. Haden was also an amateur photographer. See Lochnan 1984, p. 99. For the interaction between Whistler and Haden see Lochnan 1984, especially the second chapter, pp. 67–146.

44. In her 1984 study of Whistler's body of prints, Katharine Lochnan has thoroughly and eloquently analyzed the *Thames Set*, writing that works like *Eagle Wharf* reveal Whistler's increasing knowledge of Japanese prints, the influence of one of the Society of Etchers, Félix Bracquemond, and the impact of contemporary scientific theories. See Lochnan 1984, pp. 77–110 and 116–27.

45. *Old Westminster Bridge* is briefly compared to Hollar, but otherwise goes unanalyzed in Lochnan 1984, p. 76. Yet, Whistler's prints depicting Vauxhall and Old Hungerford Bridges made in early 1861 are discussed in her book.

46. Lochnan 1984, pp. 85–95.

47. Lochnan 1984, p. 116.

48. A painter as well as an etcher, Thomas also received training at the Royal Academy Schools, learning printmaking from Delâtre, and possibly Whistler, and exhibiting at the

Royal Academy from 1867. He joined Haden's Society of Painter-Etchers in 1881, shortly after contributing to *English Etchings*. Wood 1981, p. 470. For the arrangement between Whistler and Serjeant Thomas, who died in 1862, see Lochnan, 1984, pp. 120, 127, 137. See also Melot 1996, p. 39.

49. Thomas continued to produce scenes of London near the Thames, as revealed by the etching *Upper Thames Street* (1882, London, Guildhall Library). He later participated in the compilation, *English Etchings*, that also included *Westminster from the River Thames* by Ned Swain (cat. 83), which is number thirty-nine in *English Etchings*.

50. Many prints by painter-etchers in this exhibition, with the exception of Haden and Thomas, date after 1880, suggesting that if these artists had Whistlerian affinities, they did not find them until after the trial, in which Whistler was the victor, that had at its center the meaning of artistic aesthetics. See Linda Merrill, *A Pot of Paint: Aesthetics on Trial in Whistler v. Ruskin*, Washington, DC: Smithsonian Institution Press, 1992, and Lochnan et al. 2004.

51. The Australian-born Menpes also painted, but he is better known for his prints. During his trip, he gained first-hand knowledge of Japanese art and met the Japanese artist Kawanabe Kyōsai but somewhat lost favor with Whistler. Whistler, whose aesthetic derived in part from Japanese models, had never been to Japan and became slightly envious of Menpes's experiences there. Although a period of tension with Whistler over Menpes's trip to Japan followed, Menpes still produced admiring painted and etched portraits of Whistler. See Menpes, *Whistler As I Knew Him*; Kenneth M. Guichard, *British Etchers, 1850–1940*, London: Robin Garton, Ltd., 1981, p. 57; and *The Prints of Mortimer Menpes: A Private Collection*, London: Sotheby's, 1995.

52. Menpes made little attempt in his *Grey River* etchings to reverse the drawing on the etching plate, as in *Westminster*.

53. As a comparison to Whistler's Thames prints, Katharine Lochnan reproduces a photograph dated c. 1885 in the collection of Britain's Royal Commission on Historical Monuments. The photograph is strikingly similar to Menpes's conception of *Limehouse*. See Lochnan 1984, p. 88, plate 110.

54. Justin McCarthy, Mrs. Campbell Praed, and Mortimer Menpes, *The Grey River*, London, 1889, p. 22. These prints could possibly have been started prior to Menpes' departure, however.

55. Baudelaire as quoted in Jonathan Mayne, trans. and ed., *The Mirror of Art: Critical Studies by Baudelaire*, Garden City, NY: Doubleday Anchor Books, 1956, p. 287.

56. These illustration projects by Way include *Later Relics of Old London* (1897), *The Ancient Halls of the City* (1903), and *The Thames from Chelsea to the Nore* (1907). See Getscher 1977, p. 222.

57. Brought up in his father's lithography business, Way first trained at art schools in South Kensington, but in 1886 traveled to Paris to attend the Académie Julian. See Getscher 1977, p. 222.

58. Addams was left to his own devices traveling in Europe, armed only with a letter of introduction from Mrs. William Merritt Chase to John Singer Sargent. Following a stay in London, Addams traveled to Paris, where he may have met Whistler. In 1900, he married Whistler's British pupil and later apprentice Inez Bate, Whistler's *massière* at the Académie Carmen. The couple returned to London in 1902 and remained in close contact with Whistler until his death in 1903. Getscher 1977, p. 258. Meg Hausberg revised Getscher's view that Addams did not make prints until about 1915, believing that he started as early as 1902, see Hausberg, "The Life and Work of Clifford Addams," in *Clifford Addams: Etchings and Drypoints*, sale catalogue, London: Lott & Gerrish, 1984, n.p. See also Simon Houfe, "American in London," *Country Life*, November 8, 1984, pp. 1431, 1433.

59. Hausberg 1984, n.p., notes eight states altogether for *Blackfriars*, see cat. no. 40.

60. Roussel and Whistler were neighbors in Chelsea. Guichard 1981, p. 57. See also the Centre for Whistler Studies: The Correspondence, www.whistler.arts.gla.ac.uk/biog/Rous_T.html.

61. Mortimer Menpes and G. E. Mitton, *The Thames*, London and Watford: George W. Jones, 1906, p. 225.

62. Margaret Dunwoody Hausberg, *The Prints of Théodore Roussel: A Catalogue Raisonné*, Bronxville, NY: 1991, p. 168.

63. Educated at the Glasgow Academy and the Edinburgh School of Art, Cameron moved to London and was elected an Associate to the Royal Society of Painter-Etchers in 1889. Con-

currently with Alphonse Legros, he became a Fellow of the Society in 1895. He exhibited his works internationally and joined the International Society of Sculptors, Painters, and Gravers that Whistler helped to found in 1898. Guichard 1981, p. 32. Of the twelve works in the *London Set*, only one other is a Thames image, *Thames Warehouses*. See also Frank Rinder, *Etchings of D. Y. Cameron and a Catalogue of His Etched Work*, Edinburgh: Otto Schulze & Co., 1912; *Waterloo Bridge* is reproduced as plate 22.

64. Pater as quoted in Rinder 1912, p. xxii. The *London Set* was printed in an edition of thirty-five.

65. Married to Manet's favorite pupil Eva Gonzales, Guérard was Manet's printer. After 1880 Guérard produced prints for the *Gazette des Beaux-Arts*. Henri Beraldi's *Les Graveurs du XIXe Siècle*, vol. VIII, 1880, as quoted in Melot 1996, p. 120.

66. Melot 1996, pp. 134–37. One of the early promoters of the painter-etchers, the French critic Philippe Burty authored the introduction to Keppel's New York sale catalogue of Buhot's work. See Burty, *Catalogue of an Exhibition of the Etched Work of Félix Buhot*, New York: Frederick Keppel and Co., 1888.

67. Many of Bertha Jaques's photographs recall those of the British nineteenth-century photographer Anna Atkins. Founded by Jaques in 1910, the Chicago Society of Etchers influenced etching in the United States especially in the first half of the twentieth century, see Joby Patterson, *Bertha E. Jaques and the Chicago Society of Etchers*, Madison: Fairleigh Dickinson University Press, 2002. See also Reed Anderson, *American Etchers Abroad, 1880–1939*, exhibition catalogue, Lawrence: Spencer Museum of Art, University of Kansas, 2004, pp. 94–95.

68. Combination prints were made from a number of negatives printed at the same time, in combination, onto one sheet of photographic paper.

69. Emerson's ideas were first made available in a lecture, "Photography, a Pictorial Art," given in 1886. He included and expanded on many of these ideas in his 1889 book, *Naturalistic Photography for Students of the Art*. Nevertheless, Emerson reversed his position in 1891 and may have been encouraged to do so by Whistler. An anonymous painter had demonstrated to Emerson—who was also an amateur naturalist in the literal sense of the word—that Nature and Art should not be confused. Ian Booth, "Peter Henry Emerson: Art and Solitude," in *The Golden Age of British Photography*, Mark Haworth-Booth, ed., pp. 154–62. See also Beaumont Newhall, *The History of Photography*, pp. 141–42, 145. An excerpt from *Naturalistic Photography* can be found in Vicki Goldberg, ed., *Photography in Print: Writings from 1816 to the Present*, Albuquerque: University of New Mexico, 3rd printing, 1994, pp. 190–98.

70. Archives at the Museum of London's Museum in Docklands, files for "Events, Frozen River," that contain information accompanying a photograph of Tower Bridge and the Thames in the ice by A. R. Grierson, neg. no. 3275. The Museum in Docklands houses the Port of London Authority's archive. The freezing of the Thames was a memorable occurrence, being also described in Ben Jonson, *London, Historical and Descriptive: A Reading-Book for Schools*, London: Blackie and Son, 1906, p. 228. The Thames rarely froze after the construction of New London Bridge in 1822. Previous generations celebrated these winter events with the great Frost Fairs. See Malcolm Warner, *The Image of London: Views by Travellers and Emigrés, 1550–1920*, exhibition catalogue, London: Barbican Art Gallery, 1987, cats. 47 and 59.

71. Later, Gale became an Honorary Fellow of the Royal Photographic Society. See Margaret Harker, *The Linked Ring: The Secession Movement in Photography in Britain, 1892–1910*, London: Royal Photographic Society; Heinemann, 1979, p. 152.

72. Job exhibited with the Ring and the Royal Photographic Society. He became a Fellow of the Society in 1895 and joined the Linked Ring in 1900. Harker 1979, p. 154.

73. As quoted in Newhall, *The History of Photography*, New York: Museum of Modern Art, 1982, pp. 158, 160.

74. Bogardus 1984.

75. Stieglitz characterized Coburn's photographs in this 1903 exhibition as original and unconventional. Alvin Langdon Coburn, *Alvin Langdon Coburn, Photographer: An Autobiography*, Helmut and Alison Gernsheim, eds. New York: Dover Publications, 1978, p. 22. F. Moffatt, *Arthur Wesley Dow*, exhibition catalogue, Washington, DC: National Collection of Fine Arts, Smithsonian Institution, 1977, p. 95.

76. Coburn also owned a reproduction of Whistler's painting *Old Battersea Bridge*. Coburn, *An*

Autobiography, 1978, pp. 38, 44. See also Mike Weaver, *Alvin Langdon Coburn: Symbolist Photographer 1882–1966*, New York: Aperture, 1986, p. 29; and Moffatt, 1977, p. 96. During this course the 200 students learned of the death of Whistler and responded with a variety of artistic homages. See Moffatt 1977, p. 99.

77. Coburn 1978, p. 62; for Coburn's reproduction of Whistler's painting *Battersea Bridge*, see Weaver 1986, p. 12. A few of Coburn's photographs of Freer and his Whistler collection are reproduced in David Park Curry, *James McNeill Whistler at the Freer Gallery of Art*, exhibition catalogue, New York and London: Freer Gallery of Art in Association with W. W. Norton & Co., 1984, p. 22.

78. Coburn learned to make and print his own photogravures, attending the London County Council School of Photo-Engraving from 1906 to 1909. Coburn, *Autobiography*, p. 74. Earlier, Peter Henry Emerson had also produced photogravures that he printed himself. He also likened them to etchings, believing that with the exception of platinum prints they were most suited to his natural, photographic aesthetic. Newhall 1982, pp. 141–45.

79. Coburn's *Dome of St. Paul's* is reproduced as figure 5 in Bogardus 1984, p. 29. Some images from *London* appeared in other printing processes years before, as in *The Bridge—London*, a gum-bichromate over platinum print from 1903 or before, and *London Bridge* as a gelatin silver print in 1904 (Stieglitz Collection, Metropolitan Museum of Art). *Thameside Twilight* is a gravure with blue-green tonalities in the Museum of Fine Arts, St. Petersburg, collection. It was not included in *London* but formerly belonged to Arthur Wesley Dow. Dow may have received it as a gift from Coburn, perhaps about the time of their 1911 trip to the American West. See James L. Enyeart, *Harmony of Reflected Light: The Photographs of Arthur Wesley Dow*, Santa Fe: University of New Mexico Press, 2001, plate 62.

80. Coburn 1978, p. 46.

81. Coburn met Shaw during his second stay in London in 1904 through photographer and Linked Ring member Frederick Evans. Shaw's reference to mezzotints from Coburn 1978, p. 74. The Shaw quotation is from the preface to Coburn's one-person exhibition at the Royal Photographic Society in 1906. Stieglitz noted that Shaw's text had been reprinted in other publications, but he chose to do so again in volume 15 of *Camera Work* in 1906. See *Alfred Stieglitz: Camera Work, The Complete Illustrations, 1903–1917*, Cologne: Taschen, 1997, pp. 313–15.

82. Joseph Pennell's "Is Photography among the Fine Arts?" was published in the *Contemporary Review* in 1897. It has been reprinted in Vicki Goldberg, ed., *Photography in Print: Writings from 1816 to the Present*, Albuquerque: University of New Mexico, 3rd printing, 1994, pp. 210–13.

83. The collaboration between Coburn and James is discussed in Bogardus 1984, especially pp. 9–22. For Pennell's relationship with James during this period, see Bogardus 1984, pp. 68–69.

84. Pennell's *Easter Set* consulted at the New York Public Library was published by Boussod, Valadon, & Cie., number five of twelve sets. This example is inscribed, "to F. Keppel, Xmas 1914." The portfolio draws its name from the time of its completion, Easter 1894.

85. Elizabeth Robins Pennell, *Our House; And London out of Our Windows*, Boston and New York: Houghton Mifflin Company, 1912, pp. 342–43.

86. In a letter to Georges Lecomte of May 14, 1904, Monet thanks Lecomte for his exhibition review in *La Petite République*, although he doesn't believe that he deserves all the praise, "bien que je ne pense pas mériter de tels éloges." He refers more generally to the critical response in a letter to Gustave Geffroy, June 4, 1904: "Certes, la presse me comble cette fois avec exagération d'éloges…." See Daniel Wildenstein, *Claude Monet: Biographie et catalogue raisonné*, vol. 4, Lausanne and Paris: La Bibliothèque des Arts, 1985, p. 365, letter number 1725; and p. 366, letter number 1732 respectively. The latter has been translated into English as, "There's no doubt this time that the Press has overdone it with the praise they've showered on me…" and is included in a selection of Monet's correspondence, see Richard Kendall, ed. *Monet by Himself*, New York: Barnes & Noble Books, 2004, p. 140.

87. See Mahonri Sharp Young, "The Remarkable Joseph Pennell," *The American Art Journal*, Spring 1970, vol. 2, no. 1, pp. 83, 91. Pennell's late watercolors have yet to be thoroughly studied. While evidence in his papers might disprove it, writers have claimed Pennell insisted that he never wanted to be a painter.

88. Elizabeth Pennell 1912, p. 344.

89. Pennell, *Pen Drawing and Pen Draughtsmen* 1977, p. xii.

List of Works

This list of works in the catalogue is arranged in alphabetical order by artist. Works by the same artist are in chronological order, with the exception of Monet, whose works are grouped by theme, and Whistler, whose paintings and prints are separated.

Clifford Addams
(American, 1876–1942)
Charing Cross Bridge, 1912
Drypoint on paper
14 x 26.3 cm
Museum of Fine Arts, St. Petersburg, Florida
Museum purchase with funds provided by the Collectors Circle
2003.11
Cat. 51

Clifford Addams
(American, 1876–1942)
Limehouse, 1912
Etching and drypoint on paper
17.8 x 33.5 cm
Museum of Fine Arts, St. Petersburg, Florida
Museum purchase
2004.7
Cat. 53

Clifford Addams
(American, 1876–1942)
Blackfriars, 1914
Etching and drypoint on paper
13.2 x 38.6 cm
Guildhall Library, Corporation of London
k1234668
Cat. 52

Jules Bastien-Lepage
(French, 1848–1884)
The Thames, London, 1882
Oil on canvas
56.7 x 77.2 cm
Philadelphia Museum of Art
John G. Johnson Collection, 1917
J 892
Cat. 1

Frank Myers Boggs
(American, 1855–1926)
On the Thames, 1883
Oil on canvas
98.4 x 130.8 cm
The Metropolitan Museum of Art
George A. Hearn Fund, 1909
09.26.2
Cat. 2

Frank Myers Boggs
(American, 1855–1926)
Untitled (The Thames, London),
c. 1883–87
Oil on canvas
132.8 x 157.58 cm
Chrysler Museum of Art, Norfolk, Virginia
Gift of Walter P. Chrysler, Jr.
71.838
Cat. 3

Félix Buhot
(French, 1847–1898)
Westminster Clock Tower, 1884
Etching, aquatint, and drypoint on paper
28.59 x 40.03 cm
Print Collection, Miriam and Ira D. Wallach Division of Art, Prints and Photographs
The New York Public Library, Astor, Lenox, and Tilden Foundations
Cat. 54

Félix Buhot
(French, 1847–1898)
Westminster Palace, 1884
Etching, drypoint, aquatint, and stipple on paper
Sheet: 31.2 x 44.5 cm
Plate: 29.1 x 39.9 cm
The Baltimore Museum of Art
The George A. Lucas Collection, purchased with funds from the State of Maryland, Laurence and Stella Bendann Fund, and contributions from individuals, foundations, and corporations throughout the Baltimore community
BMA 1996.48.12997
Cat. 55

David Young Cameron
(British, 1865–1945)
Waterloo Bridge, 1899
Etching on paper
18.5 x 14 cm
Museum of Fine Arts, St. Petersburg, Florida
Museum purchase
TR 30.2004
Cat. 56

George Chambers
(British, active 1848–1862)
Opening of the New Blackfriars Bridge by Queen Victoria, 1869
Watercolor on paper
33.5 x 54.6 cm
Guildhall Library, Corporation of London

q2319964
Cat. 4

Alvin Langdon Coburn
(British, b. United States, 1882–1966)
The Bridge—London (Waterloo Bridge), 1909
Photogravure
20.96 x 16.52 cm
Museum of Fine Arts, St. Petersburg, Florida
Museum purchase with funds provided by the Collectors Circle
2003.12
Cat. 119

Alvin Langdon Coburn
(British, b. United States, 1882–1966)
Houses of Parliament, 1909
Photogravure
21.6 x 17.3 cm
Museum of Fine Arts, St. Petersburg, Florida
Museum purchase with funds provided by Dr. Robert L. and Chitranee Drapkin
2004.28
Cat. 116

Alvin Langdon Coburn
(British, b. United States, 1882–1966)
St. Paul's from the River, 1909
Photogravure
17.8 x 16.5 cm
Museum of Fine Arts, St. Petersburg, Florida
Museum purchase with funds provided by the Collectors Circle
2004.14
Cat. 117

Alvin Langdon Coburn
(British, b. United States, 1882–1966)
The Tower Bridge, 1909
Photogravure
21.1 x 16.5 cm
Museum of Fine Arts, St. Petersburg, Florida
Museum purchase with funds provided by the Collectors Circle
2003.13
Cat. 118

Alvin Langdon Coburn
(British, b. United States, 1882–1966)
Wapping, 1909
Photogravure
Sheet: 21.7 x 17 cm
The Baltimore Museum of Art
Gift of Mr. and Mrs. Guy Tilghman Hollyday
BMA 1978.73.10D1
Cat. 120

Alvin Langdon Coburn
(British, b. United States, 1882–1966)
Thameside Twilight, c. 1909
Photogravure
13.34 x 20.96 cm
Museum of Fine Arts, St. Petersburg, Florida
Museum purchase with funds provided by the Collectors Circle
2003.8
Cat. 121

John Crowther
(British, 1837–1902)
Waterloo Bridge: Ebb Tide Taken from Charing Cross Railway Bridge, 1888
Watercolor on paper
14 x 25.4 cm
Guildhall Library, Corporation of London
q8032956
Cat. 5

Charles-François Daubigny
(French, 1817–1878)
St. Paul's from the Surrey Side, 1873
Oil on canvas
44 x 81.3 cm
National Gallery, London
NG2876
Cat. 6

T. Raffles Davison
(British, 1853–1937)
The South Side of the Thames from the Hotel Cecil, 1912
Lithograph on paper
16.5 x 62.2 cm
Guildhall Library, Corporation of London
p7499764
Cat. 57

André Derain
(French, 1880–1954)
The Houses of Parliament from Westminster Bridge, 1906
Oil on canvas
73.6 x 92 cm
The Cleveland Museum of Art
Leonard C. Hanna, Jr., Fund
1983.67
Cat. 7

André Derain
(French, 1880–1954)
London Bridge, 1906
Oil on canvas
66.08 x 99.12 cm

The Museum of Modern Art, New York
Gift of Mr. and Mrs. Charles Zadok
195.1952
Cat. 9

André Derain
(French, 1880–1954)
View of the Thames, 1906
Oil on canvas
73.3 x 92.2 cm
National Gallery of Art, Washington, D.C.
Collection of Mr. and Mrs. Paul Mellon
1985.64.12
Cat. 10

André Derain
(French, 1880–1954)
Big Ben, London, c. 1906
Oil on canvas
79 x 98 cm
Musée d'Art moderne, Troyes, France
Cat. 8

Detroit Publishing Company
Houses of Parliament, c. 1905
Photochrom
16.5 x 22.3 cm
Prints and Photographs Division, Library of
Congress, Washington, D.C.
LC-DIG-ppmsc-08560
Cat. 122

Detroit Publishing Company
London Bridge, c. 1905
Photochrom
16.5 x 22.3 cm
Prints and Photographs Division, Library of
Congress, Washington, D.C.
LC-DIG-ppmsc-08569
Cat. 124

Detroit Publishing Company
Thames Embankment, c. 1905
Photochrom
16.5 x 22.3 cm
Prints and Photographs Division, Library of
Congress, Washington, D.C.
LC-DIG-ppmsc-08580
Cat. 123

Gustave Doré
(French, 1832–1883)
London: A Pilgrimage by Blanchard Jerrold
London: Grant & Co., 1872
First edition book with wood engravings
44 x 35 cm

Museum of Fine Arts, St. Petersburg, Florida
Museum purchase
TR 37.2004
Cat. 58

Roger Fenton
(British, 1819–1869)
Waterloo Bridge, c. 1854
Albumen print
29 x 41.8 cm
Courtesy of the Royal Photographic Society at
the National Museum of Photography, Film, &
Television, Bradford, England
2003-5001.2.21638
Cat. 125

Francis Frith
(British, 1822–1898)
Southwark Bridge, c. 1867
Albumen print
10 x 13.9 cm
Illustration from *The Book of the Thames from Its
Rise to Its Fall* by Mr. and Mrs. S. C. Hall, Lon-
don: Alfred W. Bennett; Virtue & Co., 1867
Museum of Fine Arts, St. Petersburg, Florida
Museum purchase with funds provided by
Dr. Robert L. and Chitranee Drapkin
Cat. 126

Joseph Gale
(British, c. 1835–1906)
Barges and Ships on the Thames, c. 1890
Platinum print
12.1 x 18.1 cm
Courtesy of the Royal Photographic Society at
the National Museum of Photography, Film, &
Television, Bradford, England
2003-5001.2.21669
Cat. 127 [incorrect Gale from the RPS inserted
on p. 153; its title is *Thames with Tower Bridge*]

E. A. Goodall
(British, 1819–1908)
Construction of the Victoria Embankment,
1865
Watercolor on paper
35.7 x 55.8 cm
Museum of London
64.69
Cat. 11

John Atkinson Grimshaw
(British, 1836–1893)
**The Thames by Moonlight with Southwark
Bridge,** 1884
Oil on canvas

74.98 x 127.08 cm
Guildhall Art Gallery, London
1781
Cat. 12

Henri Guérard
(French, 1846–1897)
Westminster Bridge, before 1887
Drypoint on paper
24.14 x 15.25 cm
Museum of Fine Arts, St. Petersburg, Florida
Museum purchase
2003.32
Cat. 59

Francis Seymour Haden
(British, 1818–1910)
Battersea Reach, 1863
Etching and drypoint on paper
Plate: 15 x 22.7 cm
The Baltimore Museum of Art
The Garrett Collection
BMA 1946.112.6021
Cat. 60

Francis Seymour Haden
(British, 1818–1910)
Whistler's House, Old Chelsea, 1863
Etching and drypoint on chine paper
15.7 x 33 cm
The Baltimore Museum of Art
The Conrad Collection
BMA 1932.17.37
Cat. 61

Francis Seymour Haden
(British, 1816–1910)
Battersea Bridge, after 1868
Etching and drypoint on paper
25 x 30.4 cm
Prints and Photographs Division, Library of
Congress, Washington, D.C.
LC-DIG-ppmsca-06827
Cat. 62

Childe Hassam
(American, 1859–1935)
Big Ben, 1897 or 1907
Gouache and watercolor over charcoal on
gray-brown paper
22.24 x 29.55 cm
The Corcoran Gallery of Art,
Washington, D.C.
Bequest of James Parmelee
41.11
Cat. 14

Childe Hassam
(American, 1859–1935)
Houses of Parliament, Early Evening, 1898
Oil on canvas
33 x 41.5 cm
Private collection
Cat. 13

Winslow Homer
(American, 1836–1910)
The Houses of Parliament, 1881
Watercolor on paper
32.4 x 50.2 cm
Hirshhorn Museum and Sculpture Garden,
Smithsonian Institution
Gift of Joseph H. Hirshhorn, 1966
66.2488
Cat. 15

E. Hull
(British, active 19th century)
**The Thames Embankment Works between
Charing Cross Bridge and Westminster,** 1865
Watercolor with gouache on paper
24.7 x 36.2 cm
Museum of London
91.175/2
Cat. 16

E. Hull
(British, active 19th century)
**The Thames Embankment Works between
Waterloo and Blackfriars Bridges,** 1865
Watercolor with gouache on paper
24.3 x 36.2 cm
Museum of London
91.175/1
Cat. 17

Bertha Jaques
(American, 1863–1941)
Fog on Thames, 1913
Etching on paper
15.09 x 24.14 cm
Museum of Fine Arts, St. Petersburg, Florida
Museum purchase
2004.6.1
Cat. 63

Bertha Jaques
(American, 1863–1941)
Rain on Thames, 1913
Etching on paper
15.09 x 23.82 cm
Museum of Fine Arts, St. Petersburg, Florida
Museum purchase

2004.6.2
Cat. 64

J. F. Jarvis's Stereoscopic Views
Westminster Bridge and St. Thomas's
Hospital, 1887
Stereograph
8.8 x 17.8 cm
Prints and Photographs Division, Library
of Congress, Washington, D.C.
LC-DIG-ppmsca-06809
Cat. 142

Charles Job
(British, 1853–1930)
The Thames below London Bridge, n.d.
Bromoil print
26 x 34.6 cm
Courtesy of the Royal Photographic Society at
the National Museum of Photography, Film,
& Television, Bradford, England
1991-5084.0017
Cat. 128

Keystone View Company
Waterloo Bridge and Somerset House,
c. 1900
Stereograph
8.8 x 17.8 cm
Prints and Photographs Division, Library
of Congress, Washington, D.C.
LC-DIG-ppmsca-06807
Cat. 138

Georges Lemmen
(Belgian, 1865–1916)
Thames Scene, the Elevator, c. 1892
Oil on canvas
84.51 x 108.02 cm
Museum of Art, Rhode Island School
of Design
Anonymous gift
57.166
Cat. 18

Henri Le Sidaner
(French, 1862–1939)
St. Paul's from the River, 1906–07
Oil on canvas
90.23 x 91.5 cm
Walker Art Gallery, National Museums,
Liverpool
Board of Trustees of the National Museums
and Galleries on Merseyside
WAG 2373
Cat. 19

Hayley Lever
(American, 1876–1958)
London Docks, c. 1900–10
Oil on canvas
101.67 x 127.08 cm
Spanierman Gallery, LLC, New York
Cat. 20

William Alister MacDonald
(British, 1861–1956)
Timber Wharf and Dust Shoot—Site of
County Hall, 1906
Watercolor on paper
24.4 x 40.6 cm
Guildhall Art Gallery, London
1148
Cat. 21

Mortimer Menpes
(British, b. Australia, 1855–1938)
12 etchings on paper from **The Grey River**
by Justin McCarthy and Mrs. Campbell Praed.,
London: Messrs. Selley and Co. Ltd., 1889
40 cm (height)
Print Collection, Miriam and Ira D. Wallach
Division of Art, Prints and Photographs,
The New York Public Library, Astor, Lenox,
and Tilden Foundations
Cat. 65

Claude Monet
(French, 1840–1926)
Cleopatra's Needle and Charing Cross
Bridge, c. 1899
Oil on canvas
64.81 x 81.33 cm
Private collection
Cat. 23

Claude Monet
(French, 1840–1926)
Charing Cross Bridge, Overcast Day, 1900
Oil on canvas
60.6 x 91.5 cm
Museum of Fine Arts, Boston
Given by Janet Hubbard Stevens in memory of
her mother, Janet Watson Hubbard
1978.465
Cat. 24

Claude Monet
(French, 1840–1926)
Charing Cross Bridge, Reflections on the
Thames, 1901–04
Oil on canvas
65.1 x 100.3 cm

The Baltimore Museum of Art
The Helen and Abram Eisenberg Collection
BMA 1945.94
Cat. 25

Claude Monet
(French, 1840–1926)
Charing Cross Bridge, Smoke in the Fog,
1902
Oil on canvas
73.07 x 91.14 cm
Musée Marmottan-Monet, Paris
5001
Cat. 27

Claude Monet
(French, 1840–1926)
Charing Cross Bridge, 1903
Oil on canvas
73.07 x 104.1 cm
The Saint Louis Art Museum
Museum purchase
22.1915
Cat. 26

Claude Monet
(French, 1840–1926)
Waterloo Bridge, Boats on the Thames,
1901
Pastel on blue-gray paper
31 x 48 cm
Private collection
Courtesy of Wildenstein & Co., New York
Cat. 28

Claude Monet
(French, 1840–1926)
Waterloo Bridge, Morning Fog, 1901
Oil on canvas
65.7 x 100.2 cm
Philadelphia Museum of Art
Bequest of Anne Thomson in memory of her
father, Frank Thomson, and her mother, Mary
Elizabeth Clarke Thomson, 1954
1954-66-6
Cat. 29

Claude Monet
(French, 1840–1926)
Waterloo Bridge, Effect of Sun with Smoke,
1903
Oil on canvas
66.1 x 101 cm
The Baltimore Museum of Art
The Helen and Abram Eisenberg Collection
BMA 1976.38
Cat. 30

Claude Monet
(French, 1840–1926)
Waterloo Bridge, London, c. 1903
Oil on canvas
64.45 x 100.33 cm
Carnegie Museum of Art, Pittsburgh
Acquired through the generosity of the Sarah
Mellon Scaife Family
67.2
Cat. 31

Claude Monet
(French, 1840–1926)
Waterloo Bridge, London, at Sunset, 1904
Oil on canvas
65.5 x 92.7 cm
National Gallery of Art, Washington, D.C.
Collection of Mr. and Mrs. Paul Mellon
1983.1.28
Cat. 32

Claude Monet
(French, 1840–1926)
Houses of Parliament, Effect of Fog, 1903
Oil on canvas
81.3 x 92.4 cm
The Metropolitan Museum of Art
Bequest of Julia W. Emmons, 1956
56.135.6
Cat. 36

Claude Monet
(French, 1840–1926)
Houses of Parliament, Effect of Sunlight,
1903
Oil on canvas
81.3 x 92.1 cm
The Brooklyn Museum of Art
Bequest of Grace Underwood Barton
68.48.1
Cat. 34

Claude Monet
(French, 1840–1926)
Houses of Parliament in the Fog, 1903
Oil on canvas
81.33 x 92.45 cm
High Museum of Art, Atlanta
Great Painting Fund purchased in honor of
Sarah Belle Broadnax Hansell
60.5
Cat. 33

Claude Monet
(French, 1840–1926)
Houses of Parliament, Effect of Fog, 1904
Oil on canvas

82.6 x 92.77 cm
Museum of Fine Arts, St. Petersburg, Florida
Museum purchase and partial gift of Charles
C. and Margaret Stevenson Henderson
1979.5
Cat. 37

Claude Monet
(French, 1840–1926)
**Houses of Parliament, Reflections on the
Thames,** 1905
Oil on canvas
81.3 x 97 cm
Musée Marmottan-Monet, Paris
5007
Cat. 35

Claude Monet
(French, 1840–1926)
**London, Towers of the Houses of Parlia-
ment and Boats on the Thames,** c. 1900
Studies from the *Thames* series, Sketchbook 3
Graphite on paper
11 x 18 cm
Musée Marmottan-Monet, Paris
5134
Cat. 22

Notman Photographic Company
**Panoramic View of the Tower of London
and Tower Bridge,** c. 1900
Gelatin silver print
24.78 x 133.76 cm
Prints and Photographs Division, Library of
Congress, Washington, D.C.
PAN FOR GEOG-England no.3
Cat. 129

John O'Connor
(British, 1830–1889)
Engraved by H. Adlard
**Thames Embankment from
Somerset House,** 1873
Steel engraving on paper
20.3 x 37.6 cm
Guildhall Library, Corporation of London
p7499770
Cat. 66

Joseph Pennell
(American, 1857–1926)
London Bridge, 1893
No. 19 in the *Easter Set*
Etching on blue paper
9.8 x 7.2 cm
Prints and Photographs Division, Library of
Congress, Washington, D.C.

LC-DIG-ppmsca-06817
Cat. 69

Joseph Pennell
(American, 1857–1926)
The Tower Bridge, 1893
No. 5 in the *Easter Set*
Etching on paper
9.1 x 22.6 cm
Frederick Keppel Memorial Collection, Print
Collection, Miriam and Ira D. Wallach Division
of Art, Prints and Photographs
The New York Public Library, Astor, Lenox,
and Tilden Foundations
Cat. 68

Joseph Pennell
(American, 1857–1926)
Vauxhall Bridge, 1893
No. 1 in the *Easter Set*
Etching on paper
9.4 x 15 cm
Frederick Keppel Memorial Collection, Print
Collection, Miriam and Ira D. Wallach Division
of Art, Prints and Photographs
The New York Public Library, Astor, Lenox,
and Tilden Foundations
Cat. 67

Joseph Pennell
(American, 1857–1926)
Cleopatra's Needle, 1894
No. 20 in the *Easter Set*
Etching and aquatint on paper
9.7 x 22.6 cm
Frederick Keppel Memorial Collection, Print
Collection, Miriam and Ira D. Wallach Division
of Art, Prints and Photographs
The New York Public Library, Astor, Lenox,
and Tilden Foundations
Cat. 70

Joseph Pennell
(American, 1857–1926)
Lanark Wharf, 1895
Etching on paper
20.01 x 27.64 cm
Museum of Fine Arts, St. Petersburg, Florida
Museum purchase with funds provided by the
Docent Class of 2003
2003.30
Cat. 72

Joseph Pennell
(American, 1857–1926)
The Savoy, 1895

Etching on paper
19.69 x 25.41 cm
Prints and Photographs Division, Library of
Congress, Washington, D.C.
LC-DIG-ppmsca-06815
Cat. 71

Joseph Pennell
(American, 1857–1926)
London Bridge to Tower Bridge, 1905
Etching on paper
Sheet: 31.1 x 24.1 cm
Image: 25.4 x 20.3 cm
Museum of Fine Arts, St. Petersburg, Florida
Museum purchase with funds provided by the
Collectors Circle
2003.10
Cat. 73

Joseph Pennell
(American, 1857–1926)
Tower Bridge, Evening, 1905
Etching on paper
22.6 x 28 cm
Prints and Photographs Division, Library of
Congress, Washington, D.C.
LC-DIG-ppmsca-06826
Cat. 75

Joseph Pennell
(American, 1857–1926)
Limehouse, 1906
Etching on paper
27.64 x 21.6 cm
Prints and Photographs Division, Library of
Congress, Washington, D.C.
LC-DIG-ppmsca-06821
Cat. 77

Joseph Pennell
(American, 1857–1926)
Waterloo Towers, 1906
Drypoint on paper
21.6 x 27.8 cm
Museum of Fine Arts, St. Petersburg, Florida
Museum purchase with funds provided by
Jennifer Hardin and Emmanuel Roux
2003.29
Cat. 74

Joseph Pennell
(American, 1857–1926)
The Works at Waterloo, 1906
Etching on paper
28 x 21.7 cm
Prints and Photographs Division, Library of

Congress, Washington, D.C.
LC-DIG-ppmsca-06822
Cat. 76

Joseph Pennell
(American, 1857–1926)
The City, Evening, 1909
Mezzotint and drypoint on paper
25.2 x 38 cm
Prints and Photographs Division, Library of
Congress, Washington, D.C.
LC-DIG-ppmsca-06823
Cat. 79

Joseph Pennell
(American, 1857–1926)
The Shower, London, 1909
Mezzotint and drypoint on paper
24.78 x 37.49 cm
Museum of Fine Arts, St. Petersburg, Florida
Museum purchase with funds provided by the
Collectors Circle
2003.7
Cat. 80

Joseph Pennell
(American, 1857–1926)
Westminster, Evening, 1909
Mezzotint and drypoint on paper
30 x 44.5 cm
Prints and Photographs Division, Library of
Congress, Washington, D.C.
LC-DIG-ppmsca-06832
Cat. 78

Joseph Pennell
(American, 1857–1926)
The Obelisk, c. 1910
Watercolor on paper
25.2 x 35.3 cm
Prints and Photographs Division, Library of
Congress, Washington, D.C.
LC-USZC4-12473
Cat. 42

Joseph Pennell
(American, 1857–1926)
Rose Cloud, c. 1910
Watercolor on paper
35.3 x 25.2 cm
Prints and Photographs Division, Library of
Congress, Washington, D.C.
LC-USZC4-12471)
Cat. 41

Joseph Pennell
(American, 1857–1926)
St. Paul's, London, c. 1910
Watercolor and gouache on paper
24 x 36 cm
The Metropolitan Museum of Art
Rogers Fund, 1924
1924.49.1
Cat. 40

Joseph Pennell
(American, 1857–1926)
Steamboat on the Thames, c. 1910
Watercolor on paper
19 x 27.8 cm
Prints and Photographs Division, Library of
Congress, Washington, D.C.
LC-USZC4-12472
Cat. 39

Camille Pissarro
(French 1830–1903)
Charing Cross Bridge, London, 1890
Oil on canvas
60 x 92.4 cm
National Gallery of Art, Washington, D.C.
Collection of Mr. and Mrs. Paul Mellon
1985.64.32
Cat. 38

A. J. Ransome
(British, active late 19th century)
The Frozen River, 1895
Platinum print
10.4 x 6.9 cm
Courtesy of the Royal Photographic Society at
the National Museum of Photography, Film, &
Television, Bradford, England
2003-5001.2.21640
Cat. 134

Matthew White Ridley
(British, 1837–1888)
London Bridge, 1872
Wood engraving on paper
31 x 48.8 cm
Guildhall Library, Corporation of London
q6889687
Cat. 81

David Roberts
(British, 1796–1864)
The Houses of Parliament from Millbank,
1861
Oil on canvas
61 x 106 cm

Museum of London
The acquisition of this painting was supported
by the Heritage Lottery Fund
2002.75
Cat. 43

Théodore Roussel
(French, 1847–1926)
Chelsea Palaces, 1890–97
Color etching and aquatint on hand-colored
mount
Mount: 26.4 x 29.2 cm
The Metropolitan Museum of Art
Harris Brisbane Dick Fund and The Elisha
Whittelsey Collection
The Elisha Whittelsey Fund, by exchange,
1954
54.640.1ab
Cat. 82

Benjamin Lloyd Singley
(American, active early 20th century)
and **Keystone View Company**
**Overlooking the Thames at 11 O'clock at
Night, London, England,** c. 1903
Stereograph
8.9 x 17.8 cm
Prints and Photographs Division, Library of
Congress, Washington, D.C.
LC-DIG-ppmsca-06824
Cat. 137

Strohmeyer & Wyman
Houses of Parliament, London, England,
c. 1896
Stereograph
8.8 x 17.8 cm
Prints and Photographs Division, Library of
Congress, Washington, D.C.
LC-DIG-ppmsca-06811
Cat. 143

Strohmeyer & Wyman
London Bridge, London, England, 1896
Stereograph
8.8 x 17.8 cm
Prints and Photographs Division, Library of
Congress, Washington, D.C.
LC-DIG-ppmsca-06805
Cat. 140

William Strudwick
(British, active late 19th century)
Houses of Parliament from Bishop's Walk,
1860s
Albumen print

22.1 x 28.3 cm
Victoria and Albert Museum, London
59.415
Cat. 131

William Strudwick
(British, active late 19th century)
**Houses of Parliament from Lambeth
Bridge,** 1860s
Albumen print
23.6 x 28.6 cm
Victoria and Albert Museum, London
59.403
Cat. 130

William Strudwick
(British, active late 19th century)
Westminster Bridge, 1860s
Albumen print
24.8 x 28 cm
Victoria and Albert Museum, London
59.377
Cat. 133

William Strudwick
(British, active late 19th century)
**New Blackfriars Bridge under
Construction,** c. 1869
Albumen print
18 x 23.5 cm
Victoria and Albert Museum, London
67.541
Cat. 132

Ned Swain
(British, 1847–1902)
Westminster from the River Thames, 1884
Etching on paper
17.8 x 25.4 cm
Guildhall Library, Corporation of London
p542511220209
Cat. 83

Percy Thomas
(British, 1846–1922)
Blackfriars Bridge, 1862
Etching on paper
14 x 27.9 cm
Guildhall Library, Corporation of London
q2319852
Cat. 87

Robert Kent Thomas
(British, 1816–1884)
**Thames Embankment, Landing Stairs,
Roads and Ornamental Gardens between
Hungerford and Waterloo Bridges,** 1863

Chromolithograph on paper
23.4 x 36.1 cm
Guildhall Library, Corporation of London
p7499669
Cat. 85

Robert Kent Thomas
(British, 1816–1884)
**Thames Embankment, Steamboat Landing
Pier at Westminster Bridge,** 1864
Chromolithograph on paper
20.3 x 35.6 cm
Guildhall Library, Corporation of London
p7499563
Cat. 84

John Thomson
(British, 1837–1872)
Workers on the Silent Highway
from *Street Life in London,* 1876
Woodburytype
11.4 x 8.9 cm
Prints and Photographs Division, Library of
Congress, Washington, D.C.
LC-DIG-ppmsca-06825
Cat. 135

Henry Edward Tidmarsh
(British, 1854–1939)
**The River Thames from Blackfriars to
Waterloo Bridge,** 1900
Watercolor on paper
18.3 x 24.9 cm
Guildhall Library, Corporation of London
k1235030
Cat. 50

James Tissot
(French, 1836–1902)
The Thames, 1876
Oil on canvas
73 x 107.9 cm
Wakefield Art Gallery, Wakefield, England
WAK 41966
Cat. 44

James Tissot
(French, 1836–1902)
The Prodigal Son: The Departure, 1881–82
Etching on paper
Sheet: 49.8 x 61.7 cm
Plate: 31.1 x 37.5 cm
The Baltimore Museum of Art
Gift of Elizabeth Wrenn, Eleanor de Ghize,
Francis Jencks, and Gardner Jencks
BMA 1973.93 1b
Cat. 88

James Tissot
(French, 1836–1902)
The Prodigal Son: The Return, 1881–82
Etching on paper
Sheet: 49.8 x 61.7 cm
Plate: 31.1 x 37.5 cm
The Baltimore Museum of Art
Gift of Elizabeth Wrenn, Eleanor de Ghize,
Francis Jencks, and Gardner Jencks
BMA 1973.93.1d
Cat. 84

Underwood & Underwood
Houses of Parliament, London, England,
1901
Stereograph
8.8 x 17.8 cm
Prints and Photographs Division, Library of
Congress, Washington, D.C.
LC-DIG-ppmsca-06810
Cat. 144

Unknown artist
**Progress of the Construction of the New
Blackfriars Bridge,** 1868
Wood engraving on paper
22.9 x 34.3 cm
Guildhall Library, Corporation of London
q2319941
Cat. 86

Unknown artist
**South Bank of the River Thames, between
Waterloo and Hungerford Bridges,** c. 1870
Watercolor on paper
25.4 x 51.3 cm
Guildhall Library, Corporation of London
k1234562
Cat. 49

Unknown photographer
London, Houses of Parliament, n.d.
Albumen print
27.9 x 35.5 cm
Prints and Photographs Division, Library of
Congress, Washington, D.C.
LC-DIG-ppmsca-06813
Cat. 136

Unknown photographer
Tower Bridge (Raised), c. 1906
Stereograph
8.8 x 17.8 cm
Prints and Photographs Division, Library of
Congress, Washington, D.C.
LC-DIG-ppmsca-06806
Cat. 139

Thomas Way
(British, 1862–1913)
Tower of London, 1899
Lithograph on paper
17.8 x 15.25 cm
Museum of Fine Arts, St. Petersburg, Florida
Museum purchase with funds provided by the
Collectors Circle
2003.9
Cat. 90

Thomas Way
(British, 1862–1913)
Afterglow, Lower Pool, c. 1900
Color lithograph on paper
14.1 x 16.4 cm
Prints and Photographs Division, Library of
Congress, Washington, D.C.
LC-DIG-ppmsca-06818
Cat. 92

Thomas Way
(British, 1862–1913)
The Gate of London, c. 1900
Color lithograph on paper
16.1 x 13.3 cm
Prints and Photographs Division, Library of
Congress, Washington, D.C.
LC-DIG-ppmsca-06819
Cat. 93

Thomas Way
(British, 1862–1913)
The Smoke Cloud, Charing Cross Bridge,
c. 1900
Lithograph on paper
21.4 x 13.5 cm
Prints and Photographs Division, Library of
Congress, Washington, D.C.
LC-DIG-ppmsca-06820
Cat. 91

James McNeill Whistler
(American, 1834–1903)
The Last of Old Westminster, 1862
Oil on canvas
60.96 x 78.1 cm
Museum of Fine Arts, Boston
A. Shuman Collection
39.44
Cat. 45

James McNeill Whistler
(American, 1834–1903)
Battersea Reach, c. 1865
Oil on canvas
50.8 x 76.2 cm

Corcoran Gallery of Art, Washington, D.C.
Bequest of James Parmelee
41.30
Cat. 46

James McNeill Whistler
(American, 1834–1903)
Nocturne, c. 1870
Oil on canvas
27.9 x 46.2 cm
Mississippi Museum of Art, Jackson
Bequest of Sara Virginia Jones
1991.147
Cat. 47

James McNeill Whistler
(American, 1834–1903)
Billingsgate, 1859
Etching on paper
15.25 x 22.87 cm
Museum of Fine Arts, St. Petersburg, Florida
Gift of Robert J. Hager in memory of Martha
Louise Hager
1986.20
Cat. 94

James McNeill Whistler
(American, 1834–1903)
Black Lion Wharf, 1859
Etching and drypoint on paper
Sheet: 23.3 x 31.2 cm
Plate: 14.8 x 22.5 cm
The Baltimore Museum of Art
The George A. Lucas Collection, purchased
with funds from the State of Maryland,
Laurence and Stella Bendann Fund, and
contributions from individuals, foundations,
and corporations throughout the Baltimore
community
BMA 1996.48.9088
Cat. 96

James McNeill Whistler
(American, 1834–1903)
Eagle Wharf, 1859
Etching and drypoint on paper
Sheet: 23.4 x 30.1 cm
Plate: 13.6 x 21.4 cm
The Baltimore Museum of Art
The George A. Lucas Collection, purchased
with funds from the State of Maryland,
Laurence and Stella Bendann Fund, and
contributions from individuals, foundations,
and corporations throughout the Baltimore
community
BMA 1996.48.9075
Cat. 97

James McNeill Whistler
(American, 1834–1903)
Limehouse, 1859
Etching on paper
Sheet: 24.5 x 33.9 cm
Plate: 12.7 x 20 cm
The Baltimore Museum of Art
The George A. Lucas Collection, purchased
with funds from the State of Maryland,
Laurence and Stella Bendann Fund, and
contributions from individuals, foundations,
and corporations throughout the Baltimore
community
BMA 1996.48.12325
Cat. 99

James McNeill Whistler
(American, 1834–1903)
Old Westminster Bridge, 1859
Etching on paper
Plate: 7.4 x 20 cm
The Baltimore Museum of Art
The Garrett Collection
BMA 1946.112.5957
Cat. 98

James McNeill Whistler
(American, 1834–1903)
The Pool, 1859
Etching on paper
Sheet: 24.5 x 34 cm
Plate: 13.9 x 21.2 cm
The Baltimore Museum of Art
The George A. Lucas Collection, purchased
with funds from the State of Maryland,
Laurence and Stella Bendann Fund, and
contributions from individuals, foundations,
and corporations throughout the Baltimore
community
BMA 1996.48.12326
Cat. 95

James McNeill Whistler
(American, 1834–1903)
Rotherhithe, 1860
Etching and drypoint on Japan paper
Sheet: 38.5 x 26.5 cm
The Baltimore Museum of Art
The George A. Lucas Collection, purchased
with funds from the State of Maryland,
Laurence and Stella Bendann Fund, and
contributions from individuals, foundations,
and corporations throughout the Baltimore
community
BMA 1996.48.7637
Cat. 104

James McNeill Whistler
(American, 1834–1903)
Early Morning, Battersea, 1861
Drypoint on paper
Sheet: 13.8 x 17.5 cm
Plate: 11.3 x 15 cm
The Baltimore Museum of Art
The George A. Lucas Collection, purchased
with funds from the State of Maryland,
Laurence and Stella Bendann Fund, and
contributions from individuals, foundations,
and corporations throughout the Baltimore
community
BMA 1996.48.11672
Cat. 102

James McNeill Whistler
(American, 1834–1903)
The Little Pool, 1861
Etching and drypoint on paper
Sheet: 21.8 x 27.9 cm
Plate: 10.4 x 12.6 cm
The Baltimore Museum of Art
The George A. Lucas Collection, purchased
with funds from the State of Maryland,
Laurence and Stella Bendann Fund, and
contributions from individuals, foundations,
and corporations throughout the Baltimore
community
BMA 1996.48.11669
Cat. 103

James McNeill Whistler
(American, 1834–1903)
Old Hungerford Bridge, 1861
Etching on paper
16 x 23.6 cm
The Baltimore Museum of Art
The George A. Lucas Collection, purchased
with funds from the State of Maryland,
Laurence and Stella Bendann Fund, and
contributions from individuals, foundations,
and corporations throughout the Baltimore
community
BMA 1996.48.11671
Cat. 100

James McNeill Whistler
(American, 1834–1903)
Vauxhall Bridge, 1861
Etching on paper
Sheet: 15.2 x 21 cm
Plate: 6.9 x 11.4 cm
The Baltimore Museum of Art
The George A. Lucas Collection, purchased
with funds from the State of Maryland,

Laurence and Stella Bendann Fund, and
contributions from individuals, foundations,
and corporations throughout the Baltimore
community
BMA 1996.48.11667
Cat. 101

James McNeill Whistler
(American, 1834–1903)
Early Morning, 1878
Lithotint on paper
Sheet: 18 x 26 cm
Image: 16.5 x 26 cm
The Baltimore Museum of Art
Gift of Mrs. Matthew H. Hirsh, Baltimore
BMA 1988.1383
Cat. 108

James McNeill Whistler
(American, 1834–1903)
Nocturne: The River at Battersea, 1878
Lithotint on paper
17.3 x 25.7 cm
S.P. Avery Collection, Miriam and Ira D. Wal-
lach Division of Art, Prints and Photographs
The New York Public Library, Astor, Lenox,
and Tilden Foundations
Cat. 109

James McNeill Whistler
(American, 1834–1903)
The Tall Bridge, 1878
Lithotint on paper
27.9 x 18.5 cm
S. P. Avery Collection, Miriam and Ira D. Wal-
lach Division of Art, Prints and Photographs
The New York Public Library, Astor, Lenox,
and Tilden Foundations
Cat. 106

James McNeill Whistler
(American, 1834–1903)
The Large Pool, 1879
Etching and drypoint on paper
Sheet: 27.9 x 35.6 cm
Plate: 18.8 x 27.5 cm
The Baltimore Museum of Art
The George A. Lucas Collection, purchased
with funds from the State of Maryland,
Laurence and Stella Bendann Fund, and
contributions from individuals, foundations,
and corporations throughout the Baltimore
community
BMA 1996.48.9074
Cat. 105

James McNeill Whistler
(American, 1834–1903)
Old Battersea Bridge, 1879
Transfer lithograph on paper
27.9 x 35.6 cm
The Baltimore Museum of Art
1941.240
Cat. 107

James McNeill Whistler
(American, 1834–1903)
By the Balcony, 1896
Transfer lithograph on paper
21.3 x 15 cm
Print Collection, Miriam and Ira D. Wallach
Division of Art, Prints and Photographs
The New York Public Library, Astor, Lenox,
and Tilden Foundations
Bequest of Edward G. Kennedy
Cat. 113

James McNeill Whistler
(American, 1834–1903)
Charing Cross Railway Bridge, 1896
Transfer lithograph on paper
Image: 13 x 21 cm
The Baltimore Museum of Art
Gift of Alfred R. and Henry G. Riggs,
in Memory of General Lawrason Riggs
BMA 1943.32.360
Cat. 111

James McNeill Whistler
(American, 1834–1903)
Evening, Little Waterloo Bridge, 1896
Transfer lithograph on paper
Sheet: 20 x 30.6 cm
Prints and Photographs Division, Library of
Congress, Washington, D.C.
LC-DIG-ppmsca- 06828
Cat. 112

James McNeill Whistler
(American, 1834–1903)
Savoy Pigeons, 1896
Transfer lithograph on paper
Image: 19.6 x 13.7 cm
The Baltimore Museum of Art
Purchase Fund
BMA 1937.85
Cat. 114

James McNeill Whistler
(American, 1834–1903)
The Thames, 1896
Lithotint on paper
Sheet: 30 x 21.5 cm

Image: 26.5 x 18.7 cm
The Baltimore Museum of Art
The Conrad Collection
BMA 1932.17.19
Cat. 110

George Washington Wilson
(British, 1823–1893)
**St. Paul's Cathedral and Blackfriars
Bridge, London,** n.d.
Albumen print
27.9 x 35.5 cm
Prints and Photographs Division, Library of
Congress, Washington, D.C.
LC-DIG-ppmsca-06814
Cat. 146

F. A. Winkfield
(British, active 1873–1904)
The Riverside at Limehouse, c. 1890
Oil on canvas
40.1 x 50.3 cm
Museum of London
53.29
Cat. 48

William Wyllie
(British, 1851–1931)
Tower Bridge, c. 1895
Etching on paper
33 x 54.6 cm
Guildhall Art Gallery, London
1617
Cat. 115

**R. Y. Young; American Stereoscopic
Company**
Hotels Cecil and Savoy, London, England,
1901
Stereograph
8.8 x 17.8 cm
Prints and Photographs Division, Library of
Congress, Washington, D.C.
LC-DIG-ppmsca-06812
Cat. 145

**R. Y. Young; American Stereoscopic
Company**
**Westminster Bridge and the Houses
of Parliament, England,** 1901
Stereograph
8.8 x 17.8 cm
Prints and Photographs Division, Library of
Congress, Washington, D.C.
LC-DIG-ppmsca-06808
Cat. 141

Chronology COMPILED WITH THE ASSISTANCE OF LIZA OLIVER AND LISA MCVICKER

Selected Historical Events

1837

Queen Victoria ascends the throne of Great Britain.

1852

Following his 1851 coup d'état that ended France's Second Republic, Napoleon III proclaims the start of the Second Empire.

1853

Crimean War begins between Russia and Turkey. Britain and France ally with Turkey, and the war ends in 1856.

1858

France establishes official relations with Japan.

1859

Charles Darwin publishes *On the Origin of Species by Natural Selection.*

Construction begins on the Suez Canal, which is completed in 1869.

1860

Abraham Lincoln is elected president of the United States.

France establishes sustained relations with Japan.

1861

Civil War breaks out in the United States. It ends in 1865.

Britain's Prince Albert dies of typhoid, and Queen Victoria goes into mourning for the remaining forty years of her life.

1862

Lincoln issues Emancipation Proclamation, freeing slaves in the United States.

1870

Franco-Prussian War is declared in July. After main French army surrenders at Sedan, the provisional Third Republic is declared in an attempt to defend Paris, but the Prussian siege of Paris in September is ultimately successful.

1871

After Paris surrenders in January, the new French National Assembly begins to negotiate peace with Prussia. Afraid of the restoration of the monarchy, in March insurgents in Paris form the Commune, a Republican municipal government. In May, the Commune falls at the attack of troops from the French government based in Versailles.

Prussia becomes an independent and unified nation.

1873

Death of Napoleon III.

1875

Britain buys just under half the shares of the Suez Canal in order to prevent its complete control by the French.

1876

Queen Victoria is proclaimed Empress of India.

United States celebrates its centennial.

1882

British fleet invades Alexandria, ending joint French and British rule in Egypt.

1887

Queen Victoria celebrates her Golden Jubilee. Her Diamond Jubilee is ten years later.

1899

Boer War begins. It is won by the British in 1902, giving them access to precious raw materials and major trade routes.

1901

Death of Queen Victoria makes her sixty-four-year reign the longest in British history.

Edward VII, Victoria's eldest son, assumes the British throne until his death in 1910.

1914

World War I begins.

Cultural and Visual Arts Events

1853

After success of London's Great Exhibition in 1851, New York holds its Crystal Palace Exposition.

1855

First Universal Exposition is held in Paris, outside of which Gustave Courbet sets up his Realist Pavilion intended as a rebellion against academic art.

1859

First Paris Salon to include an exhibition of photography. In his review, Charles Baudelaire dismisses the idea of photographs as art. Salon debut of painter James Tissot and printmakers James McNeill Whistler and Seymour Haden.

1860

Claude Monet enrolls in the Académie Suisse, where he meets Camille Pissarro, among other artists.

1862

Société des Aquafortistes (Society of Etchers) is founded in Paris.

1863

Salon des Refusés is held with permission of Napoleon III, where Edouard Manet exhibits his controversial *Déjeuner sur l'Herbe,* and Whistler *The White Girl, Symphony in White, No.1.* Other participants include Paul Cézanne, Henri Fantin-Latour, Johan Barthold Jongkind, and Pissarro.

Baudelaire's essay, "Le Peintre de la vie moderne," central to the impressionists' formation, is published in Le Figaro.

1864

Union Centrale des Beaux-Arts Appliqués à l'Industrie, later to become the Union Centrale des Arts Décoratifs, is founded, contributing to the development of art nouveau in France.

1867

Second Universal Exposition, held in Paris, features a large exhibition of Japanese art.

Death of Baudelaire.

After works by Monet, Pissarro, Frédéric Bazille, Pierre-Auguste Renoir, and Alfred Sisley are rejected by the Salon, Courbet, Camille Corot, and Charles-François Daubigny try unsuccessfully to help the artists organize an independent exhibition.

The Société Libre des Beaux-Arts is established in Belgium.

1869

Paul Durand-Ruel establishes *La Revue internationale de l'art et de la curiosité,* which ceases publication in 1870.

1870

Daubigny and Corot resign in protest from the Salon jury when Monet's works are refused for its exhibition.

1873

Daubigny buys one of Monet's works painted in Holland.

Whistler exhibits at the Durand-Ruel Gallery in Paris.

1874

Historic first exhibition of thirty artists of the Société anonyme des artistes peintres, sculpteurs, graveurs, etc., is held in Nadar's studio in Paris. Press reviews attack the works, especially for their lack of finish, as in Louis Leroy's review, which dismisses the artists as merely impressionists, a term inspired by Monet's *Impression, Sunrise.* Monet, Edgar Degas, Berthe Morisot, Pissarro, Sisley, Renoir, and Cézanne later become known as the impressionists. Tissot declines the invitation of his good friend Degas to participate in the exhibition.

1876

Second exhibition of the Société anonyme is held at the Durand-Ruel Gallery. Morisot exhibits the first series of impressionist landscapes of five harbor views of the Isle of Wight, adjacent to Monet's works.

The Centennial Exposition is held in Philadelphia.

1877

Third exhibition of the Société anonyme (members now refer to themselves as impressionists) at the Durand-Ruel Gallery.

Embarrassed by the quality of American Art shown at Philadelphia's Centennial Exposition relative to European art exhibits, and objecting to the exclusion of younger artists from the National Academy of Design's shows, a group of progressive, mostly European-trained artists form the Society of American Artists in New York the following year.

1878

First exhibition of the Society of American Artists in New York.

Third Universal Exposition, held in Paris, incorporates the Salon.

1879

Fourth Impressionist Exhibition. Monet's paintings hang in a room with those of Pissarro.

1880

Fifth Impressionist Exhibition, without the participation of Monet, who pursues other exhibition venues.

1881

Sixth Impressionist Exhibition. Monet does not participate.

1882

Seventh Impressionist Exhibition. Durand-Ruel chooses paintings on behalf of Monet.

1883

Belgian exhibition group Les XX is formed, spawning the growth of art nouveau, and later incorporating the work of many neo-impressionists.

After living in London since 1871, Tissot returns to Paris and has a successful one-person exhibition at the Palais de l'Industrie.

1884

Neo-impressionist works, including those by Georges Seurat and Paul Signac, appear at the Société des Artistes Indépendants in Paris.

1885

Retrospective of the naturalist painter Jules Bastien-Lepage is held in Paris, after his death in 1884.

International Exposition is held in Antwerp.

1886

Eighth and final Impressionist Exhibition includes Seurat's *Afternoon on the Island of the Grande Jatte.*

Jean Moréas's symbolist manifesto, Le Symbolisme, is published in Le Figaro.

Cézanne, Paul Gauguin, and Vincent van Gogh, as well as Seurat, have been developing distinctive artistic styles, later termed post-impressionism.

Durand-Ruel opens his first exhibition in New York, Works in Oil and Pastel by the Impressionists of Paris.

Monet participates in an exhibition of Les XX for the first time, showing with them once more in 1889.

Childe Hassam moves to Paris to study after having worked as an illustrator in Boston.

1887

Synthetism, a stylistic approach, appears in the works of Gauguin, Paul Sérusier, and Emile Bernard.

Monet and Whistler exhibit at the Georges Petit Gallery in Paris.

Hassam first exhibits at the Paris Salon. Inclusion of Seurat's *Grande Jatte* in Les XX's annual exhibition greatly influences Georges Lemmen and Henry Van de Velde and leads to the creation of a branch of neo-impressionism in Belgium.

Durand-Ruel opens a permanent gallery in New York.

1888

Childe Hassam exhibits at the Paris Salon.

1889

Fourth Universal Exposition is held in Paris. Bastien-Lepage's *The Thames, London,* is exhibited as are Tissot's *Prodigal Son* paintings. Hassam shows four paintings in the American section and is awarded a bronze medal.

Hassam exhibits again at the Salon. He leaves Paris to return the United States, stopping in London beforehand and making a number of Thames views.

Monet's largest exhibition to date, at the Georges Petit Gallery in Paris, displays 145 of his paintings along with thirty-six sculptures by Rodin.

1890

Monet spends much of the 1890s painting works in series, beginning with the *Grainstacks* of 1890 to 1891.

1892

Monet begins series of paintings of Rouen Cathedral, completed in 1894.

1893

World's Columbian Exposition in Chicago includes some impressionist paintings, but mostly the official art of the Salon. Fifteen paintings by Winslow Homer dominate the American section.

1894

Second International Exposition is held in Antwerp.

Les XX vote for their own dissolution, giving way to La Libre Esthétique and continuing the tradition set by Les XX of exhibiting decorative arts.

1897

Retrospective exhibition of Sisley's paintings at the Georges Petit Gallery in Paris (a critical and financial failure—no paintings are sold).

Hassam leads the secession from the Society of American Artists in New York to form Ten American Painters who exhibit together from 1898 to 1918. Often identified with the American strain of impressionism, The Ten were at odds with the Society of American Artists whom Hassam accused of seeking "to exhibit what they thought would sell." The Ten would also model their exhibitions after Whistler's more spacious and harmonious installations.

International Exposition is held in Brussels.

1898

Death of Félix Buhot and the poet Stéphane Mallarmé.

Henri Le Sidaner visits Bruges. Attracted by symbolism and the works of Les XX and La Libre Esthétique, he lives there from 1899 to 1900.

First exhibition of Ten American Painters opens at Durand-Ruel Gallery in New York.

1899

Retrospective of Corot is held alongside works of Monet, Pissarro, Sisley, and Renoir at the Durand-Ruel Gallery in Paris.

Arthur Wesley Dow publishes his influential book Composition.

1900

Fifth Universal Exposition is held in Paris. For the first time an entire gallery is devoted to impressionism.

1901

Alliance Provinciale des Industries d'Art, a branch of art nouveau, is founded in France.

1904

Louisiana Purchase Exposition is held in St. Louis.

1905

Derain and Matisse exhibit at the Salon des Indépendants, and at the Salon d'Automne, where they are given the name "fauves."

International Exposition is held in Liège.

1906

Gauguin exhibition held at the Salon d'Automne influences the fauves.

1908

Monet travels to Venice and begins a series of Venetian waterscapes.

1910

Second International Exposition is held in Brussels.

Bertha Jaques founds the Chicago Society of Etchers.

1913

English exhibiting society named the London Group is formed.

International Exposition is held in Ghent.

Artistic Events Pertaining to London and the Thames

1851

Death of J. M. W. Turner.

Henry Mayhew, founder of Punch, publishes his book London Labour and the London Poor.

Great Exhibition of the Works of Industry of All Nations opens at the Crystal Palace in London's Hyde Park.

1853

Photographic Society of London is founded (becomes the Royal Photographic Society in 1894).

1854

Roger Fenton begins photographic work for the British Museum, which continues through 1858.

1859

James McNeill Whistler moves to London and begins etchings of the Thames, some of which are published in 1871 as *Sixteen Etchings of Scenes on the Thames.*

Inspired by Whistler, Seymour Haden makes his first etchings out-of-doors.

Hippolyte Taine takes his first long sojourn in London, followed by two more visits in 1862 and 1871.

Alfred Sisley leaves London after two years and returns to Paris.

Sir Charles Barry, architect of the Houses of Parliament, dies.

1860

Whistler exhibits three of his Thames etchings and receives favorable reception of his painting *At the Piano* at the Royal Academy. Later in the year, he begins paintings of the Thames River.

1861

Deeply moved by Barry's death, David Roberts begins the first of a series of seven paintings of London's architectural monuments. The idea of painting a London series had originally been suggested to him by Turner, who thought of himself as being too old to start one.

1862

Charles Baudelaire writes a favorable review of Whistler's Thames etchings exhibited in Paris at Martinet's gallery. Whistler's painting *White Girl* is rejected by the Royal Academy.

Roberts exhibits the first four paintings of his London series, including The Houses of Parliament from Millbank, at the Royal Academy's Summer Exhibition.

Whistler moves to Chelsea.

Japonisme is first made familiar to the London art scene at the International Exhibition held in South Kensington.

Fenton sells his studio's contents, much of which is bought by Francis Frith, and returns to the legal profession.

1865

Charles-François Daubigny first visits London, followed by another stay in 1870.

1866

Haden publishes *About Etching.*

1868

Gustave Doré, whose gallery has opened on Bond Street, begins illustrations for *London: A Pilgrimage.*

1870

Before October 6, Claude Monet and Camille Pissarro each flee to London in the wake of the Franco-Prussian War. In London, Daubigny introduces Monet to the dealer Paul Durand-Ruel, also in exile.

Monet paints his first views of the Thames.

Durand-Ruel opens the First Exhibition of the Society of French Artists at the German Gallery in London; eight more are held there by summer 1874. Between 1882 and 1905, Durand-Ruel sporadically holds other exhibitions at temporary locations in London.

1871

James Tissot settles in London after the fall of the Commune.

Whistler's Sixteen Etchings of Scenes on the Thames is published, known as the Thames Set. He begins exhibiting in smaller London galleries including that of Durand-Ruel and initiates his paintings of the Thames at night, known as "moonlights," later called "nocturnes," the latter proposed by his patron Frederick R. Leyland in 1872.

Durand-Ruel puts Pissarro in contact with Monet. Three months later, both artists exhibit at the International Exposition at the South Kensington Museum (today the Victoria and Albert Museum). Works by both are refused by the Royal Academy.

Durand-Ruel makes his first recorded purchase of works by Monet.

Monet and Pissarro return separately to France.

1872

Doré's engravings of modern London life are published in *London: A Pilgrimage*, a book project begun in collaboration with the journalist Blanchard Jerrold in 1868.

Initially refused by the Royal Academy, Whistler's Arrangement in Grey and Black, No. 1: Portrait of the Painter's Mother is exhibited after an Academy member threatens to resign. Offended, Whistler never again submits work to the Academy.

Taine's Notes sur l'Angleterre is published.

1874

Sisley visits London for the second time.

1876

Whistler paints his first watercolors of the Thames.

Tissot's The Thames is exhibited at the Royal Academy.

Félix Buhot first visits England. He returns in 1879 and 1884.

1877

Photographer John Thomson and writer Adolphe Smith publish *Street Life in London.*

1878

Thomas Way shows Whistler the finer points of lithography. With the assistance of Way's son, Thomas R. Way, Whistler produces his first lithographs of the Thames.

Whistler publishes Whistler v. Ruskin: Art and Art Critics, an account of the trial in which he sued John Ruskin for libel and won.

Ruskin exhibits his collection of watercolors by Turner at the Fine Art Society. The National Gallery mounts a separate display of Turner's watercolors.

1879

After declaring bankruptcy and losing his house, Whistler is commissioned by the Fine Art Society to make a set of Venice etchings, exhibited in December 1880.

John Crowther is commissioned by Sir Chadwyck-Healy to document London and its historic places, making over 400 drawings and watercolors through 1895.

1880

In a letter to art critic Théodore Duret, Monet expresses his wish to paint several views of the Thames.

Mortimer Menpes leaves art school to become an assistant to Whistler, who teaches him the art of etching.

1881

Winslow Homer arrives in London where he completes one known watercolor of the Thames, *The Houses of Parliament.* Later, he travels to the fishing village and artists' colony of Tyne and Wear.

1882

Tissot exhibits *The Prodigal Son in Modern Life* at the Dudley Gallery, including paintings and etchings of the subject, and returns to Paris.

1883

Joseph Pennell establishes a residence in London after marrying writer Elizabeth Robins.

1884

Pennell and Whistler meet.

Whistler has his first large exhibition of watercolors at the Dowdeswell Gallery.

1885

Whistler delivers his "Ten O'Clock" lecture, a defense of his credo, "art for art's sake," at the Royal Academy.

John Atkinson Grimshaw of Leeds settles in London until 1887. He is recognized for his large-scale "nocturnes," including those of the Thames, at such venues as the Royal Academy.

Menpes joins the Society of British Artists and accompanies Whistler and American artist William Merritt Chase to Belgium and Holland. In Amsterdam they see the International Exhibition.

1886

Whistler publishes *Propositions*, a treatise on etchings, and his "Ten O'Clock" lecture. In June, he is elected president of the Society of British Artists. He is forced to resign in 1888 due to its preference for showing foreign artists.

New English Art Club is founded in reaction to the conservatism of Royal Academy. Founding members include Whistler, Menpes, and John Singer Sargent.

Pennell, with Whistler and Way as his witnesses, sues Whistler's former "follower" Walter Sickert, who had claimed that Pennell's transfer lithographs were not original prints.

Colonial and Indian Exhibition is held at South Kensington in order to demonstrate the British Empire's wealth and power abroad.

1887

Monet visits London and Whistler urges him to exhibit with the Society of British Artists. He sends four paintings through Theo van Gogh to its Winter Exhibition.

1888

Henry James publishes his essay of London in the December edition of *The Century*, illustrated by Pennell.

Monet visits Sargent in London for three days in mid-July.

Monet introduces Whistler to Stéphane Mallarmé, who later translates the "Ten O'Clock" lecture into French.

Painter Theodore Roussel begins to make prints, encouraged by Whistler.

Georges Lemmen joins Les XX and exhibits with them from 1889 to 1897.

1889

Childe Hassam visits London, before returning to New York.

Pennell publishes *Pen Drawing and Pen Draughtsmen*.

1890

Whistler publishes collected writings, entitled *The Gentle Art of Making Enemies*. He begins making lithographs again and ceases in 1896.

George Davison's lecture at the Royal Society of Art, *Impressionism in Photography*, is published.

Pissarro visits London with his son Lucien, who has been exhibiting with Les XX, and with neo-impressionist painter Maximilien Luce; Lucien will move to London by year's end. Pissarro paints *Charing Cross Bridge*, but will soon abandon neo-impressionism.

1891

Monet makes a brief trip to London where he visits Whistler and exhibits at the New English Art Club.

1892

Pissarro returns to London and paints a series on Kew Gardens.

Dedicated to elevating photography to the status of fine art, a group of English photographers separates from the Royal Photographic Society to establish the Brotherhood of the Linked Ring, which lasts until 1909.

Whistler has a very successful retrospective exhibition in London.

Buhot meets Whistler and Pennell.

Whistler moves to Paris.

Lemmen visits London with a friend and returns to his Brussels studio to complete *Thames Scene, The Elevator*.

1893

Monet exhibits with the New English Art Club in London for the second time.

1894

Pennell, inspired by Whistler's *Thames Set*, publishes his *Easter Set*, which features twenty prints of London, half of which are Thames views.

1895

Pennell publishes *Modern Illustration*.

Seymour Haden is knighted for his contribution to etching.

1896

While caring for his dying wife at the Savoy Hotel in London, Whistler makes his last lithographs of the Thames.

1898

Whistler is elected president of the International Society of Sculptors, Painters, and Gravers. He lives in both Paris and London until his death in 1903.

Monet makes a brief trip to London. While there, he takes part in the first exhibition of the International Society of Sculptors, Painters, and Gravers.

Pennell publishes *Lithography and Lithographers*.

1899

In London for one month, Monet begins painting his first views of the Thames, from his balcony at the Savoy Hotel. Upon Monet's return to Giverny, Durand-Ruel reserves eleven Thames paintings.

American Clifford Addams attends Whistler's Paris Académie Carmen, and meets British artist and Whistler's chief pupil, or *massière*, Inez Bate. They later marry.

Scottish painter-etcher Sir David Young Cameron produces his *London Set*.

Hassam publishes *Three Cities* with forty-nine views of Paris, London, and New York.

Alvin Langdon Coburn travels to England with photographer F. Holland Day.

The Guildhall Art Collection exhibits a large number of paintings by Turner.

1900

Day includes nine photographs by Coburn at the *New School of American Pictorial Photography* exhibition at the Royal Photographic Society.

Monet makes a two-month trip to London, where he once again stays at the Savoy Hotel to continue work on his series.

Pissarro begins a series of views of the Seine at Paris inspired by Monet's *Thames* series.

1901

Monet makes his last trip to London to work on his *Views of the Thames*. On arrival, he is forced to make pastels of the river while his supplies and eighty-three canvases are held up in customs. During his three-month stay, he and Sargent witness Queen Victoria's state funeral. There, he meets Henry James.

1902

Coburn is elected a member of the New York Photo-Secession founded by Alfred Stieglitz. The following year he is elected a member of the Linked Ring in London.

Clifford and Inez Addams move to London and become apprenticed to Whistler, staying in close contact with Whistler until his death in 1903.

Monet begins a two-year process of reworking *Views of the Thames* at his home in Giverny.

Durand-Ruel exhibits the first of Monet's *Thames* series at his New York gallery.

1903

Fearful that his Thames paintings are overworked, Monet destroys some of them.

1904

Monet exhibits thirty-seven *Views of the Thames* at Durand-Ruel's gallery in Paris.

Later, he shows thirteen Thames paintings at the Cassirer Gallery in Berlin.

Monet returns to London hoping to find a location in the city to show his *Thames* series, yet this is never realized.

Wynford Dewhurst's *Impressionist Painting* is published in London with a dedication to Monet.

Coburn meets George Bernard Shaw on his second trip to London.

1905

André Derain is sent to London by dealer Ambroise Vollard to paint his own views of the Thames as a result of the well-known success of Monet's *Views of the Thames* exhibited the previous year.

Monet's *Waterloo Bridge* is bought by the National Gallery of Ireland, Dublin.

Monet includes several Thames paintings in a large exhibition of his and Rodin's work at Copley Hall, Boston, entitled *Loan Collection of Paintings by Claude Monet and 11 sculptures by Rodin*.

Major posthumous retrospectives of Whistler's work are held in London and Paris.

1906

The Royal Photographic Society holds the exhibition *Alvin Langdon Coburn: Photographs*; a foreword by Shaw accompanies the exhibition's brochure.

Derain returns to London to continue work on his *Thames* series. At the Salon d'Automne, Derain first shows one of his London canvases along with paintings from the south of France. Henri Le Sidaner works in London from 1906 to 1907, using the divisionist technique of the neo-impressionists, with emphasis on a "delicately harmonious palette."

1907

Four of Derain's London paintings are shown in Brussels at *La Libre Esthétique*.

1908

Joseph and Elizabeth Pennell publish their biography, *The Life of James McNeill Whistler*.

Joint Franco-British exhibition is held in London.

1909

Coburn's portfolio *London* is published with an introduction by Hilaire Belloc. Coburn travels to Detroit to photograph Charles Freer's collection of Whistlers. He also buys Thameside, a house near Hammersmith Bridge.

1910

A Turner wing is added to the Tate Gallery.

1911

Walter Greaves's work is exhibited by William Marchant in the Goupil Gallery of London. The Pennells severely damage Greaves's reputation by claiming that he had plagiarized Whistler's work.

1912

Elizabeth Pennell's *Our House; And London out of Our Windows* is published with illustrations by Joseph Pennell. The Pennells leave London for New York in 1914 at the beginning of World War I.

Events Affecting London's Urban Landscape

1836

London's first railway system, London & Greenwich, opens.

1845

Hungerford Suspension Bridge is completed but later dismantled to construct Hungerford Railway Bridge, a.k.a. Charing Cross Railway Bridge, in 1864.

Cremorne Gardens and Victoria Park open.

1847

Victoria Street begins to be laid out and is completed in 1851, resulting in the demolition of the slums around Tothill Street.

Houses of Parliament, part of Charles Barry's New Palace of Westminster, opens.

1848

Work begins on Battersea Park.

Waterloo Station opens.

1849

Coal Exchange opens next to Billingsgate Fish Market on Lower Thames Street.

1850

North London Line between Bow and Camden Town opens.

1851

South Eastern Railway is rebuilt.

Victoria Street opens.

1852

New Houses of Parliament is completed.

Architectural Museum at Cannon Wharf is created.

1853

Tivoli Tea Gardens close due to the construction of Battersea Park.

1854

Gothic revival clock towers are erected on both sides of London Bridge.

1855

Victoria Docks open, extending from Bow Creek to Gallions Reach.

Joseph Bazalgette is appointed chief engineer of the new Metropolitan Board of Works.

1857

Sir Charles Barry's Clock Tower with the bell "Big Ben" of the New Palace of Westminster is completed.

1858

The "Great Stink" results from the Thames being treated as an open sewer. Temporary measures are taken to deodorize the river by the Metropolitan Board of Works until a more permanent solution is found. Bazalgette designs a new sewer system for London.

Chelsea Bridge is completed.

The first permanent building of the South Kensington Museum is completed. Further additions are made to the building from 1862 to 1871 and 1879 to 1884.

1859

Demolition begins of Old Westminster Bridge, completed in 1861.

Westminster Palace Hotel, designed by W. and A. Moseley, is begun and completed in 1861.

National Portrait Gallery opens to the public.

1860

Sir Charles Barry's Victoria Tower of the New Palace of Westminster is completed and connected to Parliament.

Union of Benefices Act is passed, allowing for the demolition of churches in London at the discretion of the bishop.

1862

Thames Embankment Bill is passed to improve sanitary condition of the Thames, and Bazalgette's embankment design is implemented by the Metropolitan Board of Works.

New Westminster Bridge and Lambeth Bridge are completed.

The State Paper office designed by Sir John Soane is demolished to make room for Scott's Foreign and India Offices.

Church of St. Albin in the slums of Hoburn is completed.

1863

Hungerford Suspension Bridge of 1845 and Hungerford Market are demolished to build a railway bridge and make way for the West End terminus of the South-Eastern Railway.

Metropolitan Railway opens from Paddington to Farrington Street, becoming the first underground railway in the world.

1864

Construction begins on Victoria Embankment.

Charing Cross Station opens and Hungerford Railway Bridge, familiarly referred to as Charing Cross Railway Bridge, is completed.

Cannon Street Railway Bridge and Ludgate Hill Railway Bridge are built.

Temporary timber bridge is built by the London, Chatham and Dover Railway to travel to and from Ludgate and Herne Hills.

Blackfriars Station opens.

1865

Lanham Hotel opens in Portland Place. Old Blackfriars Bridge is demolished.

New Blackfriars Bridge is built at the foot of Ludgate Hill by the London, Chatham & Dover Railway Company.

Ludgate Hill Station and Charing Cross Hotel are opened.

1866

Work begins on Albert Embankment from Westminster to Vauxhall Bridge on Thames's south side.

Extension of London Bridge Station to Charing Cross and Cannon Street is completed after four years of work begun in 1862, requiring the clock tower of 1854 to be moved to Swanage and St. Thomas's Hospital to Lambeth.

Cannon Street Station adjacent to Southwark Bridge is completed after construction began in 1864.

Royal College of Physicians on Warwick Lane is demolished.

Metropolitan Commons Act is passed, encouraging the development of more parks for public recreation.

1867

Cannon Street Station Hotel opens.
St. Stephen's Church on East India Dock Road opens.

Church of St. Mary Somerset on Upper Thames Street is demolished.

1868

Building begins on the new St. Thomas's Hospital, now opposite the Houses of Parliament on the south side of the Thames, where Monet will later paint.

St. Pancras Station, Paddington Underground Station, and Kensington Station open.

Railway line from Westminster Bridge to South Kensington opens.

Extension of underground Metropolitan Railway to South Kensington is completed.

River footway along the Victoria Embankment between Temple and Westminster Bridge opens to public.

Completion of Millwall Docks next to West India Docks.

1869

Albert Embankment, Holburn Viaduct, and new Blackfriars Bridge open.

1870

Victoria Embankment from Westminster to Temple officially opens after completion of underground Metropolitan Railway line to Blackfriars.

1871

Construction begins on Chelsea Embankment.

St. Thomas's Hospital is completed.

Queen Victoria Street and Metropolitan District Railway's Mansion House Station open.

St. Bride's Street, built in conjunction with the Holburn Viaduct, is completed. Like London Bridge Station and the Holburn Viaduct, it required the demolition of large areas of Old London.

Royal Albert Hall of Arts and Sciences in Hyde Park, designed by Francis Fowke and Henry Scott, opens.

1872

Victoria Embankment is planted with trees and the Embankment Gardens are opened.

Sir Christopher Wren's Church of St. Mildred next to the Royal Exchange is demolished.

Bethnal Green Museum opens.

1873

Royal Albert Bridge is completed.

Midland Grand Hotel at St. Pancras Station opens.

1874

Chelsea Embankment is completed.

Northumberland House on the Strand is demolished to create a direct route to Victoria Embankment.

Church of St. Martin Outwich at the corner of Bishopgate and Threadneedle is demolished for redevelopment of area.

West Ham Park opens east of All Saints Church.

1875

Society for Photographing Relics of Old London is founded by antiquarians intent on preserving visual records of the London that is swiftly vanishing. By 1886 the Society's main photographers, Alfred and John Bool and Henry Dixon, produce twelve series of photographs.

Coliseum in Regent's Park is demolished.

Surrey Dock basin is completed.

1876

Christopher Wren's Church of St. Michael on Thames Street near Queenhithe Dock is demolished.

Royal Aquarium opens in Westminster.

1877

Cremorne Gardens on the Thames's north bank is closed.

New building is erected for Billingsgate Fish Market next to the Custom House.

1878

Embankment is first lit by electricity.

Cleopatra's Needle is erected on Victoria Embankment.

Christopher Wren's Church of St. Dionis Backchurch is demolished.

1879

Electricity is installed on Waterloo Bridge.

Tolls are removed from all bridges below Battersea, wreaking havoc on the livelihoods of Thames boatmen.

1880

Opening of Royal Albert Docks, which extend for over one mile until they adjoin with Victoria Docks.

Grand Hotel opens on the Strand.

1881

Natural History Museum opens.

1882

Victoria Embankment is dedicated by Edward VII, then Prince of Wales.

Royal Courts of Justice buildings are completed on the Strand.

1883

Law Courts around New Palace Yard of Westminster Hall are torn down due to the opening of new Royal Courts of Justice in the Strand the previous year.

1884

Underground Inner Circle Railway is completed.

Cable-driven trams are first used on Highgate Hill.

1885

Hotel Metropole opens on Northumberland Avenue.

Shadwell Fish Market opens.

1886

Tilbury Docks open.

1887

Charing Cross Road opens from Charing Cross to Tottenham Court Road.

1889

Savoy Hotel opens.

Metropolitan Board of Works is replaced by London County Council.

1890

New Scotland Yard building on Victoria Embankment is completed.

Seamen's Hospital at Victoria and Albert Docks opens.

The new Battersea Bridge, designed by Bazalgette, is completed, replacing the 18th century timber bridge that had been closed to vehicular traffic in 1883.

Millbank Penitentiary, west of Houses of Parliament, is closed, and later demolished to make way for the Tate Gallery opening in 1897.

Hotel Victoria opens near Hotel Metropole on Northumberland Avenue.

1891

Palace Theatre and Waterlow Park open.

1893

Imperial Institute opens.

1894

Tower Bridge opens.

1896

Cecil Hotel opens next to Savoy Hotel.

1897

Blackwall Tunnel under Thames riverbed is completed to connect pedestrian and vehicle traffic from Blackwall to East Greenwich.

1899

Eastern station of London, Chatham, and Dover Railway is partially united with the western station of London, Brighton, and South Coast Railway to become Victoria Station.

Widening begins on the Strand's south side.

1900

Central London Railway opens.

1901

First electric trams are introduced from Shepherds Bridge to Acton and Kew Bridge.

1904

Greenland Dock is rebuilt.

1905

St. James Hall is demolished to build Piccadilly Hotel.

1907

Exeter Hall, built in 1831, is demolished and replaced by Strand Palace Hotel.

1908

East India Dock Road is doubled in width.

1911

A large portion of buildings surrounding the Palace of Westminster is cleared to create Victoria Tower Gardens by the Thames.

1913

The old Westminster Guildhall is torn down and replaced by the late Neo-Gothic Middlesex Guildhall designed by J. S. Gibson.

1914

The old Tivoli Music Hall on the Strand is torn down.

Appendix

French Artists Exhibiting at the Royal Academy Exhibitions in London 1860 and 1904

Compiled on the basis of Algernon Graves, *The Royal Academy of Arts: A Complete Dictionary of Contributors and Their Work from Its Foundation in 1769 to 1904* (East Ardsley, England: S. R. Publishers, 1970).

ANTONIN-CARLES, Jean.
1887	1788	Mrs. Henry White; bust.
	1789	The Countess de Gray; bust.

AUBLET, Albert.
1884	316	L'Enfant Rose.
1886	215	La Comtesse de Martel.
1887	272	Femme Turque à Brousse.
	436	Dans les roses trémières.
1888	433	Turc en prière.
	1030	La Petite Marquise.
1890	901	Mrs. Qarn.

BENNER, Jean.
1887	838	Roses.

BERTINOT, G.
1886	1519	Thisbé. After E. Long, R.A.

BLANCHARD, Auguste Thomas Marie.
1874	1251	The Vintage Festival. After Alma-Tadema
1878	1182A	Sculpture Gallery, Rome. After L. Alma Tadema, A.R.A.
	1188A	Picture Gallery, Rome. After L. Alma Tadema, A.R.A.
1880	1285	The Seasons. After L. Alma Tadema, R.A.
1882	1277	The torch dance. After L. Alma Tadema, R.A.
	1300	Le Connoisseur. After J.L. Messonier.
1883	1405	In the time of Constantine. After L. Alma Tadema, R.A.
1884	1400	The parting kiss. After L. Alma Tadema, R.A.
1886	1513	An oleander. After L. Alma Tadema, R.A.
1887	1576	Dolce far niente. After L. Alma Tadema, R.A.
1893	1473	A dedication to Bacchus. After L. Alma Tadema, R.A.

BONHEUR, François Auguste.
1857	300	Landscape and Cattle.
1873	1032	Going to Market.
1874	1345	Vue du Col de Canfranc, frontière d'Espagne, Pyrenées.

BONHEUR, Jules Isidore.
1875	1375	Tête de chien courant; bronze.
	1382	Tête de chien d'arrêt; bronze.
1876	1418	King Pépin le Bref in the arena.

BONHEUR, Mlle. Marie Rosa.
1869	163	Moutons Ecossais.
	317	Moutons des Pyrenées.

BONNAT, Léon J. F.
1878	352	Mrs. Courtenay Bodley.
1885	639	Christ.

BOUGUEREAU, William Adolphe.
1884	783	La Nuit.
1892	250	"Distraction."
1894	210	Amour piqué.
1895	243	Baigneuse.
1896	529	Summer-time.
1898	252	Les petites amies.
1899	356	Elégie.
1900	297	La Vierge aux Lys.
1903	150	Printemps.
1904	217	"Ora pro nobis."

BOURGOGNE, Pierre.
1888	1009	Ma Première chasse-nature morte.

BRACQUEMOND, Joseph Auguste, called Félix.
1861	798	Enamel; a man's head.
1869	812	Portrait.
1882	1295	The rabbit, etching.
1882	1307	The cock, etching.
1891	1596	Parti perdu. After J. L. Meissonier.

BRUN, Alexandre.
1882	1472	Le Pont des Saints Pères, Paris.

CARLES, Antonin
1882	1671	Mrs. Hartmann

(See also ANTONIN-CARLES)

CAROLUS-DURAN, Emile A.
1883	308	The Countess of Dalhousie.
1886	493	Miss Robbins.
1887	556	Mademoiselle Marie-Anne Carolus-Duran.
	904	Madame la Vicomtesse Greffulhe.
	983	Everard A. Hambro, Esq.
1888	153	Monsieur Pasteur.
	494	Comtesse di Rigo.

CHANET, Henri.
1883	894	The wood-cutter's daughter.

CHARTRAN, Théobald.
1881	370	Thomas Gibson Bowles, Esq.
	516	Mrs. Charles Waring.
1883	1264	Geoffrey, } children of
	1265	George, } T. Gibson
	1266	Sydney, } Bowles, Esq.

CHATROUSSE, Emile.
1887	1890	"La Lecture"; statuette, marble.

CHAUVEL, Théopile Narcisse.
1886	1477	Autumn leaves. After Vicat Cole, R.A.
1888	1608	Summer showers. After Vicat Cole, R.A.
1893	1450	Cambria's coast. After B.W. Leader, A.R.A.
	1452	"Connais-tu le pays?" After J. Rolshoven.
1897	1595	A wet roadside. After B.W. Leader, A.R.A.

CLAUDEL, Camille.

Year	No.	Title
1886	1832	Une Etude; head, bronze.

COLAROSSI, Filippo.

Year	No.	Title
1884	1806	La Vendetta; bust, bronze.
1888	2015	Portrait; bust, terra-cotta.

CORDIER, Mlle. A. Delville.

Year	No.	Title
1860	860	Madame la Comtesse A. de S.
	867	Lambert Bey.
1876	820	Lucia.
	1209	Giovanina.
1877	1305	Young woman playing on the mandoline.
1878	1282	Jewish woman of Algiers.
1882	1399	Portrait miniature on ivory.
	1419	Miniature of a lady; on ivory.

COROT, Jean Baptiste Camille.

Year	No.	Title
1869	152	Les Nymphes.
	422	Figures with Landscape.

COURTRY, Charles Louis.

Year	No.	Title
1884	1429	Homeless. After A. H. Marsh.

DAGNAN-BOUVERET, Pascal, A. J.

Year	No.	Title
1884	738	Vaccination.

DARAGON, Laurent.

Year	No.	Title
1878	1513	Une jeune fille; bust.
	1529	L'Abbé Testroy, Chanoine au Chapitre de St. Denis, ancien aumônier en chef des Armées de France; bust.

DARMESTETER, Madame Arsène

Year	No.	Title
1891	54	"Le five o'clock."
1894	451	Portrait of the artist.

DAUBIGNY, Charles François.

Year	No.	Title
1866	150	Moonrise.
1867	205	Thames at Woolwich.
1869	158	Un paysage sur les bords de L'Oise; soleil couchant.
1870	1011	On the banks of the Oise.

DE MONVEL, Boutet. [Louis-Marie Boutet de Monvel]
6, Rue du-Val-de-Grace, Paris.

Year	No.	Title
1892	240	L'éternel espoir. "Combien de vieux parents, etc."
1898	464	A mixed team.

DE TRIQUETTI, Baron Henri.

Year	No.	Title
1862	1077	Dante and Virgil; group in bronze.

DE VASSELOT, Anatole Marquet.

Year	No.	Title
1875	1260	Chloé à la fontaine; marble.
	1345	Mdlle. Sombreuil; marble.
1883	1613	Fleur de Mai; bust, marble.

DIDIER, J.

Year	No.	Title
1872	499	Roman bullocks.

FANTIN-LATOUR, Henri

Year	No.	Title
1862	384	Still life.
1864	212	Flowers.
	259	Flowers.
1865	179	Fruit and flowers.
1866	297	Flowers and fruit.
	568	Fruit.
	570	do.
	583	do.
	593	do.
1867	495	Fruit and flowers.
	500	do.
1869	290	Autumn flowers.
1870	86	Mr. and Mrs. Edwin Edwards.
1876	74	Gillyflowers and cherry blossoms.
1877	388	Basket of Roses.
	390	Roses.
1878	955	La Lecture.
	1030	La famille D.
1879	1438	Spring flowers.
1880	473	Roses.
	564	Peonies.
1881	24	Mdlle. L. R.
	875	"La pluie d'or."
	894	Lilas et fleurs d'arbres fruitiers.
1882	94	La Brodeuse.
	352	Peonies.
	588	Mdlle. E. C. C.
1883	119	Fleurs d'automne.
	156	L'Etude.
	219	Passe-roses.
	1469	Fleurs d'été.
1884	335	A medley.
	357	Portrait of a lady.
	787	Roses.
1885	83	Sarah, daughter of James T. Budgett, Esq.
	854	Chrysanthemums.
	942	Roses.
1886	353	Double larkspurs.
	860	Roses.
	889	Lilies.
	1093	"Autour du piano."
1887	26	Fleurs variées.
	262	Grapes.
	919	Portrait of M. L. M.
1888	359	Fleurs de Normandie.
	1363	Ariane abandonné.
1889	103	Roses.
	112	Grapes.
	194	A posy.
	826	Verbena.
1890	13	Chrysanthèmes d'été.
	35	Roses trémières.
	651	Roses.
	1109	Première scène du "Rheingold" de R. Wagner.
1891	62	Roses et capucines.
	460	"These are the flowers of middle summer."
	984	Carnations.

	1110	Sonia, daughter of General Yanovski.
	1154	Panier de raisins.
1892	259	Peonies.
	716	Larkspurs.
	804	"Here without a thorn, the rose."
1893	67	Asters.
	650	Flowers of all hue.
	792	Phlox.
1894	208	Zinnias.
	261	Roses.
	696	Sweet Peas.
1895	82	Gifts of the mellowed year.
	624	A nosegay.
1896	40	"High midsummer pomps."
	49	Gerbes de roses-trémières.
1897	712	Roses.
	874	Zinnias.
1898	111	Grapes and peaches.
	244	The rosy wealth of June.
	251	Chrysanthèmes d'été.
1899	144	June.
	168	La coquette des blanches.
	336	Zinnias.
1900	135	Pieds d'Alouette.
	837	Roses.
1900	554	The rose and the ring.
1904	306	The 'prentice.

GAUGEAN, Edouard Henri.

1888	1577	The chaplain's daughter.
	1621	Flamma Vestalis. After E. Burne-Jones, A.R.A.

GÉRÔME, Jean Léon.

1870	118	The death of Marshal Ney.
	985	Jerusalem.
1871	144	Cléopatre apportée à César dans un tapis.
	1150	A vendre.
1888	205	Le barde noir.
1893	1826	Bellona; statue, bronze and ivory.

GILBERT, Achille Isidore.

1882	1271	On the alert. After Rosa Bonheur; etching.
	1280	A foraging party. After Rosa Bonheur; etching.
1884	1409	Harvest home in olden times.
	1410	Return from the chase in olden times.

GIRAUDAT, Edgar.

1887	477	A street in a village near Paris.

GUDIN, Jean Antoine Théodore.

1871	1111	Washed ashore.
	1112	The happy return.
	1125	The sad departure.
1873	516	Threatening weather.
	940	Hope at last.

GUILLON, Adolphe Trenée.

1869	388	Moonlight scene at Cannes.

JACOTT, J. J.
20, Rue Ballini, Paris.

1874	1058	"L'Envie," from Dante. After A. Yvon.
	1066	"La Paresse." From Dante. After A. Yvon.

JACQUET, Achille.

1886	1450	Meadow sweet. After Fred Morgan.
1893	1385	The skirmishers. After E. Detaille.
1894	1502	Le Guide.

JACQUET, Jules.

1884	1399	"1814." After J. L. Meissonier.
1897	1608	Her first offering. After H. Schmalz.

LAFOND, J. E.
34, Rue Caselle, Paris.

1869	418	The Dauphin, Louis XVII in the Temple.

LAGUILLERMIE, Frédéric Auguste.

1878	1242	The prisoner. After J. L. Gérôme, etching.
1889	1696	Béatrice Cusance. After Van Dyck.

LA HAYE, Alexis.

1893	618	The new born child.

LAMOTTE, Alphonse.

1888	1692	A daughter of Eve. After L. Faler.
1889	1806	Les Etats Généraux, séance du 23 juin, 1789, Mirabeau, and the Duc de Brézé. After the high relief by Dalou.
1891	1718	La Cigale. After E. Hetzmacher.
1893	1463	L'amateur d'estampes.

LAPOSTELET, Charles.

1872	1100	Low tide at Trouville.

LAUGEE, François Desiré.

1871	587	St. Louis, King of France, serving the poor.
	845	Mrs. Wynne Finch.
	899	St. Clotilde distributing alms.
	911	Baptism of Clovis.
1872	442	Mr. Charles Bowen.
	519	Miss Clark.
	929	Edward Dicey Esq.
	1319	Portrait of a lady.
	1320	Hon. Mrs. Cowper Temple.
1873	3	Henry Dicey, Esq.
	280	Albert Dicey, Esq.
	1234	Mrs. Alexander Sellar.
	1242	Mrs. Westlake.
	1261	Mrs. Joseph Clo.
1874	1269	E. B. Cely Trevelian, Esq.

LECOMTE DUNOUY, Jules Jean Antoine.

1871	599	Une marchande d'Herculanum.

LE COUTEUX, Lionel Aristide.

1894	1377	Sheep on the Pyrénées. After Rosa Bonheur.

LEGROS, Alphonse.

1864	230	Ex Voto.
1865	455	"Oh! 'tis well for the fisherman's boy, as he shouts with his sister at play." *Tennyson.*
	715	Study of a head.
	866	A Spanish choir.
1866	254	The martyrdom of St. Stephen.
	599	A portrait.
	826	Interior of a Spanish Cathedral; etching.
1867	42	Study of a head.
	264	Cupid and Psyche.
	612	The communion.
1868	260	The refectory.
	461	Sir Thomas More showing some of Holbein's pictures to Henry the Eighth.
1869	185	A christening in France.
	489	A portrait.
	1096	An Etching; a study.
	1103	do. the death of St. Francis.
	1104	An Etching; a study.
	1105	do. do.
	1111	do.
1870	119	Scène de barricade.
	139	Prêtres au lutrin.
	228	Vieillard en prière.
1871	187	Chantre espagnol.
	351	Randle Wilbram, Esq. *Presentated by his tenantry.*
1872	184	Un pèlerinage.
	1140	Un prêche.
1873	981	La Bénédiction de la mer.
1874	24	Un Chaudronnier.
	1015	Le leçon de géographie.
1881	903	Saint Jérôme.
1882	1604	Charles Darwin. }
	1605	Orlando Martorelli. }
	1606	Alfred Tennyson. } medals, bronze.
	1607	Pierre Grégoire. }
	1608	Antonio Escovada. }
	1609	Maria Valvona.
	1676	The sailor.

LEPAGE, J. Bastien.

1878	277	Mrs. J. L. P. Lebègue (in fancy costume).
1879	149	Portrait de mon frere.
	156	do. of a gentleman.
1880	229	H. R. H. the Prince of Wales.

LEPEC, Charles.

1871	986	La dame de coeur.

LE RAT, Paul Edmé.

1888	1625	The Doge Loredano of Venice. After Giovanni Bellini.
1891	1577	The Boyhood of Chopin. After A. C. Gow, R.A.

LÉVY, Lucien.

1895	971	Quietude.

LORMIER, E.

1875	1361	Fisherwoman of Boulogne.

MARQUESTE, Laurent H.

1898	1825	The first steps; group, marble.

MARCELLO, Monsieur [Adèle d'Affry, Duchess of Castiglione Colonna].

1865	925	The children in the wood—group in marble.

MATTON, Miss Ida

1891	1941	Maman.
1894	1780	Sleep; relief, marble.

MENTA, Edouard.

1882	644	The shores of Lake Leman, near St. Gingolph.
1890	925	Le Cuisinier.
1891	456	Villefranche.

MERCIER, Miss Ruth.

1885	1343	Roses.
1902	857	Rocks near Cannes.
	873	Flowers at Cannes.

MEZZARA, Charles.

1890	589	Lady Randolph Churchill.

MERLE, Hugues.

1869	105	Laveuse d'Etretat.
	117	L'Ange du foyer.

MONGIN, Augustin.

1879	1235	"Friends or foes?" After H. G. Glindoni; etching.
1881	1219	Waiting for an answer. After E. Blair Leighton.

MONZIES, Louis.

1890	1574	Post horses. After J. L. Meissonier.

MOREAU, Adrien.

1877	1325	The dancing bear.

MOREAU, C.

1869	790	Plaisir d'enfant.

MORELL, D'Arcy.

1879	1355	A French farmstead-winter.

MOTTE, Henri

1882	582	The geese of the Capitol.
1902	927	The golden calf.

MURATON, Madame E.

1873	990	Poppies in a vase.

PELEZ, F.

1869	669	Palazzo Tomachi, Venice.

PHILIPPOTEAUX, Félix Emanuel Henri.

1875	613	La charge des cuirassiers français à Waterloo.
1876	1332	Charge of the English heavy cavalry at the Battle of Balaclava, Oct. 25, 1854.
1877	937	The battle of the Alma, October 27, 1854.
1879	652	The Life of Sir Frederick Ponsonby saved by the humanity of a French officer, at the Battle of Waterloo, June 18th, 1815.

POLLET, J.

1865	971	Bronze group. (French quotation from "Eloa" by Comte de Vigny.)

PORTEVIN. [Paul-Louis?]

1864	878	Joueur de billes.

RAJON, Paul Adolph.

1872	1268	Mrs. Siddons. After Gainsborough.
	1296	Gervartius. After Vandyck.
1875	1081	Non piangere. After Bonnel; etching.
	1102	J. S. Mill. After G. F. Watts, R.A.; etching.
	1113	Mrs. Rose. After F. Sandys; etching.
1876	1101	W. Sale, Esq. After W. W. Ouless.
	1145	The Armourer. After A. Fabri.
	1164	On the steps of the Capitol. After L. Alma-Tadema, A.R.A.
1877	1256	A Roman Emperor. After L. Alma-Tadema, A.R.A.
1883	1365	Une rêverie; etching.
1887	1422	The dead robin. After F. Walker, A.R.A.

RAVEL, Jules.

1879	246	The parting.

RAY, Maurice. Painter.

1904	956	St. George.

REGAMEY, Guillaume.

1869	333	Sur le terrain conquis: sentinelle de Tirailleurs Algériens.
	591	Clarion de Zouaves en tenue de campagne (Armée d'Afrique).
	601	Chasseur-à-cheval de la Garde Impériale en tenue de route.
1872	652	Escadron de l'armée de la Loire.
1873	1227	Les Hiboux.

REYNARD, F.

1869	212	Distribution de la Soupe, environs de Naples.

RIBOT, E.

1865	547	Les Retameurs.

RINGEL, Daniel.

1886	1795	Monsieur Jules Grévy, President of the French republic; medallion, bronze.

RIVAZ, Claude F.

1895	323	Absinthe.

RODIN, Auguste.
36, Rue de Fourmeaux, Paris.

1882	1596	St. Jean; bust, bronze.
1884	1667	L'âge d'airain; statue, bronze.

SAIN, Edouard Alexandre.

1874	1040	A Capri girl.

ST. PIERRE, Gaston.

1885	1075	Femme Arabe.

SALOMON, Adam.

1880	1561	Edwin Chadwick, Esq., C.B.; bust, marble.

SIGNOL, Emil.

1865	194	Christ descendu de la croix.
1866	295	The Holy Family.

THIRION, Eugène Romain.
7 bis, Impasse du Maine, Paris.

1874	681	Madame X.

TISSOT, James.

1864	408	(No title in the catalogue)
1872	389	An interesting story.
	644	Les Adieux.
1873	108	The Captain's daughter.
	121	The last evening.
	914	Too early.
1874	116	London Visitors.
	387	Waiting.
	690	The ball on shipboard.
1875	48	The bunch of lilacs.
	1233	Hush!
1876	113	The Thames.
	530	A convalescent.
	1098	The Thames; etching.
	1156	Quarrelling; etching.
1881	560	Quiet.
	981	"Goodbye" – on the Mersey.

VIGNON, Claude (Madame Rouvier).

1883	1626	A Mediterranean fisher boy; statue, bronze.

VILAMIL, P.

1861	636	La Jaca Adaluza.

WEISZ, Adolphe.
7, AvenueTrudaine, Paris.

1872	1093	"Will she, or won't she?"
1873	62	Effet de musique.
	94	"Je suis mon grand-père."

WINTERHALTER, François-Xavier.

1852	285	Florinde.
1853	96	Mrs. Baliol.
1856	123	Lady Clementina Villiers.
1867	257	Mrs. Vanderbyl.

* Artists' names and titles of works are given as they are in Graves's dictionary, which in turn follows the Royal Academy catalogues. Clarifications are in brackets.

Bibliography

Adelson, Warren, Jay E. Cantor, and William H. Gerdts. *Childe Hassam: Impressionist.* New York: Abbeville Press, 1999.

Adler, Kathleen. *Camille Pissarro: A Biography.* London: Batsford, 1978.

Andrew, Martin. *Francis Frith's Down the Thames.* Salisbury, Wiltshire: Frith Book Company, Ltd, 2001.

Arensberg, Walter Conrad. *Mr. Pennell's Etchings of London, to which is appended Mr. Pennell as a Printer by Frederick Keppel.* New York: Frederick Keppel & Co., 1906.

Arnold, Dana, ed. *The Metropolis and Its Image: Constructing Identities for London, c. 1750–1950.* Oxford [England] and Malden, MA: Blackwell Publishers, 1999.

Ashby-Sterry, J. *A Tale of the Thames.* London: Bliss Sands & Co., 1896.

Assouline, Pierre. *Grâces lui soient rendues: Paul Durand-Ruel, le marchand des impressionnistes.* Paris: Gallimard, 2002.

Bailey, Martin. *Van Gogh in England: Portrait of the Artist as a Young Man*, exh. cat. London: Barbican Gallery, 1992.

Bailly-Herzberg, Janine, ed. *Correspondance de Camille Pissarro [1865–1903].* 5 vols. Paris: Presses Universitaires de France, 1980–91.

Barbier, Carl Paul, ed. *Correspondance Mallarmé-Whistler: Histoire de la Grande Amitié de Leurs Dernières Années.* Paris: A. G. Nizet, 1964.

Barker, Felix. *London in Old Photographs, 1897–1914.* Boston: Little, Brown and Company, 1995.

Barton, Nicholas. *The Lost Rivers of London: A Study of Their Effects upon London and Londoners, and the Effects of London and Londoners upon Them.* London: Historical Publications, 1992.

Beam, Philip C. *Winslow Homer's Magazine Engravings.* New York: Harper & Row, 1979.

Belloc, Hilaire, and Alvin Langdon Coburn. *London.* London: Duckworth and Company; New York: Brentano's, 1909.

Bertram, Anthony. *A Century of British Painting, 1851–1951.* London and New York: Studio Publications, 1951.

Besant, Walter, Sir, and G. E. Mitton. *London, North of the Thames.* London: A. & C. Black, 1911.

Betjeman, John. *Victorian and Edwardian London from Old Photographs.* London: Batsford, 1969.

Bills, Mark. "David Roberts, *The Houses of Parliament from Millbank* and the London Series." *Apollo* 158, no. 498 (August 2003): 3–9.

Blackmore, John. *The London by Moonlight Mission: Being an Account of Midnight Cruises on the Streets of London During the Last Thirteen Years.* London: Robson and Avery, 1860.

Block, Jane. "A Neglected Collaboration: Van de Velde, Lemmen, and the Diffusion of the Belgian Style." In *The Documented Image: Visions in Art History*, ed. Gabriel P. Weisberg and Laurinda S. Dixon. Syracuse: Syracuse University Press, 1987.

_____. *Les XX and Belgian Avant-Gardism, 1868–1894.* Ann Arbor, MI: UMI Research Press, 1984.

Bogardus, Ralph F. *Pictures and Texts: Henry James, A. L. Coburn, and New Ways of Seeing in Literary Culture.* Ann Arbor, MI: UMI Research Press, 1984.

Brenneman, David A. *Monet: A View from the River*, exh. cat. Atlanta: High Museum of Art, 2001.

Brown, Bolton. "Pennellism and the Pennells." *Tamarind Papers* 7, no. 2 (Fall 1984): 49–71.

Bush, Graham. *Old London: Photographed by Henry Dixon and Alfred & John Bool for the Society for Photographing Relics of Old London.* London: Academy Editions; New York: St. Martin's Press, 1975.

Callen, Anthea. *The Impressionists in London: Hayward Gallery*, exh. cat. London: Arts Council of Great Britain, 1973.

Cameron, David Young, Sir. *Sir D. Y. Cameron, R. A. Modern Masters of Etching,* no. 7. London: Studio, 1925.

Camille Pissarro, 1830–1903, exh. cat. London: Arts Council of Great Britain, 1980.

Cardon, Roger. *Georges Lemmen (1865–1916).* Antwerp: Pandora, 1990.

Cikovsky, Nicolai, and Franklin Kelly. *Winslow Homer*, exh. cat. Washington, DC: National Gallery of Art; New Haven: Yale University Press, 1995.

Clunn, Harold P. *The Face of London: The Record of a Century's Changes and Development.* 3d ed. London: Simpkin Marshall, Ltd., 1932.

Coburn, Alvin Langdon. *Alvin Langdon Coburn, Photographer: An Autobiography.* Ed. Helmut and Alison Gernsheim. New York, Dover Publications, 1978.

Cooper, Helen A. *Winslow Homer Watercolors*, exh. cat. Washington, DC: National Gallery of Art; New Haven: Yale University Press, 1986.

Cosgrove, Denis E., and Stephen Daniels, eds. *The Iconography of Landscape: Essays on the Symbolic Representation, Design, and Use of Past Environments.* Cambridge [England] and New York: Cambridge University Press, 1988.

Cunningham, Peter. *Hand-Book of London, Past and Present.* London: John Murray, 1850 (first published 1849).

Curry, David Park. *James McNeill Whistler at the Freer Gallery of Art*, exh. cat. New York and London: Freer Gallery of Art in association with W. W. Norton & Company, 1984.

Dark, Sidney. *London.* New York: MacMillan Company, 1937.

De Maré, Eric Samuel. *The London Doré Saw: A Victorian Evocation.* London: Allen Lane, 1973.
Denker, Eric. *Whistler and His Circle in Venice*, exh. cat. London: Merrell; Washington, DC: Corcoran Gallery of Art, 2003.

Derain: Connu et Inconnu, exh. cat. Albi: Musée Toulouse-Lautrec, 1974.

Dickens's Dictionary of the Thames, from Its Source to the Nore. 1893. An Unconventional Handbook. London: Charles Dickens & Evans. Reprint. Oxford: Taurus Press, 1972.

Diehl, Gaston. *Derain.* New York: Crown Publishers, Inc., [1964].

Doré, Gustave, and Blanchard Jerrold. *London: A Pilgrimage.* London: Grant & Co., 1872.

Dorment, Richard, and Margaret F. MacDonald. *James McNeill Whistler*, exh. cat. New York: Harry N. Abrams, 1995.

Ellmers, Chris, and Alex Werner. *Dockland Life: A Pictorial History of London's Docks, 1860–2000.* London: Museum of London; Edinburgh: Mainstream Publishing, 2000.

Erlich, Blake. *London on the Thames.* Boston: Little, Brown, 1966.

"Exposition Claude Monet." *Les Arts de la Vie* 1 (June 1904).

Feldman, David, and Gareth Jones, eds. *Metropolis London: Histories and Representations since 1800.* London: Routledge Press, 1989.

Félix Buhot (1847–1898), exh. cat. Chicago: R. S. Johnson International, 1983.

Ferber, Linda S., and Barbara Dayer Gallati. *Masters of Color and Light: Homer, Sargent, and the American Watercolor Movement*, exh. cat. Washington, DC: Brooklyn Museum of Art in association with Smithsonian Institution Press, 1998.

Flint, Kate. *Impressionists in England: The Critical Reception.* Boston: Routledge & Kegan Paul, 1984.

Freeman, Judi. *The Fauve Landscape*, exh. cat. Los Angeles: Los Angeles County Museum of Art; New York: Abbeville Press, 1990.
Frizot, Michel, ed. *A New History of Photography.* Cologne: Könemann, 1998.

From Realism to Symbolism: Whistler and His World, exh. cat. New York: Columbia University, 1971.

Garton, Robin. *British Printmakers, 1855–1955: A Century of Printmaking from the Etching Revival to St. Ives.* Wiltshire: Garton & Co. in association with Scolar Press, 1992.

Gaunt, William. *The Restless Century: Painting in Britain 1800–1900.* London: Phaidon Press Limited, 1972.

Gernsheim, Helmut. *The Rise of Photography, 1850–1880: The Age of Collodion.* London and New York: Thames and Hudson, 1987.

Gibson, Charles Dana. *London as Seen by Charles Dana Gibson.* New York: Charles Scribner's Sons, 1897.

Girling, Brian. *Images of England: The City of London.* Stroud, Gloucestershire: Tempus Publishing Ltd, 2001.

Giry, Marcel. *Fauvism: Origins and Developments.* New York: Alpine Fine Arts Collection, Ltd., 1982, c 1981.

Gosling, Nigel. *Gustave Doré.* Newton Abbot [England]: Arts Book Society Readers Union Group, 1973.

The Greaves Brothers and Victorian Chelsea: An Exhibition. London: Royal Borough Kensington & Chelsea, 1968.

Greeley, Horace. *Glances at Europe: In a Series of Letters from Great Britain, France, Italy, Switzerland, &c., during the Summer of 1851. Including Notices of the Great Exhibition, or World's Fair.* New York: Dewitt & Davenport, 1851.

Haden, Francis Seymour, Sir. *About Etching.* London: Fine Art Society, 1879.

_____. *Sir Francis Seymour Haden, P.R.E.* Modern Masters of Etching, no. 11. London: Studio, 1926.

Hall, Roger, Gordon Dodds, and Stanley Triggs. *The World of William Notman: The Nineteenth Century Through a Master Lens.* Toronto: McClelland & Stewart, 1993.

Hall, Mr. and Mrs. S. C. *The Book of the Thames: From Its Rise to Its Fall.* London: Alfred W. Bennett, 1867 (first published 1859).

Halliday, Stephen. *Making the Modern Metropolis: Creators of Victoria's London.* London: Breedon Books Publishing, 2003.

Hamerton, Philip Gilbert. *Etchings and Etchers.* 3d ed. London: Macmillan and Co., 1880.

Hancock, Claire. *Paris et Londres au XIXe siècle: Représentations dans les guides et récits de voyage.* Paris: CNRS, 2003.

Hannavy, John. *Roger Fenton of Crimble Hall.* Boston: David R. Godine, 1976.

Hare, Augustus J. C. *Walks in London.* 2 vols. 1878. Reprint (2 vols. in 1). New York: George Routledge and Sons, 1884.

Harker, Margaret F. *The Linked Ring: The Secession Movement in Photography in Britain, 1892–1910.* London: Heinemann, 1979.

Harper, J. Russell, and Stanley Triggs. *Portrait of a Period: A Collection of Notman Photographs, 1859–1915.* Montreal: McGill University Press, 1967.

Hassam, Childe. *Three Cities.* New York: R. H. Russell, 1899.

Haworth-Booth, Mark, ed. *The Golden Age of British Photography, 1839–1900,* exh. cat. Millerton, NY: Aperture, 1984.

Hayward, William Stephens. *London by Night.* London: W. Oliver, 1885.

Henley, W. E., ed. *A London Garland.* London and New York: Macmillan and Company, 1895.

Herbert, James D. *Fauve Painting: The Making of Cultural Politics.* New Haven and London: Yale University Press, 1992.

Herbert, Robert L. *Neo-Impressionism,* exh. cat. New York: Solomon R. Guggenheim Museum, 1968.

Hiesinger, Ulrich W., *Childe Hassam: American Impressionist,* exh. cat. Munich and New York: Prestel, 1999.

Hobhouse, Hermione. *Lost London.* London: Macmillan Press, 1971.

Holt, Elizabeth Gilmore. *The Expanding World of Art, 1874–1902.* Vol. I., *Universal Expositions and State-Sponsored Fine Arts Exhibitions.* New Haven: Yale University Press, 1988.

Hopkinson, Tom, ed. *Treasures of the Royal Photographic Society 1839–1919.* New York: Focal Press, Inc., 1980.

House, John. *Monet: Nature into Art.* New Haven and London: Yale University Press, 1986.

_____. "New Material on Monet and Pissarro in London in 1870–71," *Burlington Magazine* 120 (October 1978): 636–42.

Howe, Julia Ward. *From the Oak to the Olive: A Plain Record of a Pleasant Journey.* Boston: Lee & Shepard, 1868.

Howgego, James L. *The Victorian and Edwardian City of London from Old Photographs.* London: Batsford, 1977.

Hyde, Ralph. *The Streets of London, 1880–1928: Evocative Watercolours by H. E. Tidmarsh.* Colchester, Essex: Red Scorpion in association with the Corporation of London, Guildhall Library, 1993.

Ingamells, John. "Greaves and Whistler." *Apollo* 89 (March 1969): 224–25.

James, Henry. *The Art of Travel: Scenes and Journeys in America, England, France, and Italy.* Ed. Morton Dauwen Zabel. Garden City, NY: Doubleday, 1958.

_____. *English Hours, with illustrations by Joseph Pennell.* Boston and New York: Houghton, Mifflin and Company, 1905.

_____. "London, with illustrations by Joseph Pennell." *Century* 37, no. 2 (December 1888): 219–39.

James McNeill Whistler, Walter Richard Sickert, exh. cat. Madrid: Fundación "la Caixa," 1998.

Jaques, Bertha E. *Concerning Etchings.* Chicago: Bertha E. Jaques, 1912.

Jerrold, Blanchard. *Life of Gustave Doré.* London: W. H. Allen, 1891.

Jouve, Michel, and Marie-Claire Rouyer. *La Représentation de Londres dans la Littérature et les Arts.* 3 vols. Talence, France: Maison des Sciences de l'Homme d'Aquitaine, 1983–1985.

Kendall, Richard, ed. *Monet by Himself.* New York: Barnes & Noble Books, 2004.

Kellermann, Michel. *André Derain: Catalogue raisonné de l'oeuvre peint.* Paris: Editions Galerie Schmit, 1992.

King, Lyndel Saunders. *The Industrialization of Taste: Victorian England and the Art Union of London.* Ann Arbor, MI.: UMI Research Press, 1985.

Knight, Charles. "The Silent Highway." In *London,* ed. Charles Knight, vol. 1. London: H. G. Bohn, 1851.

Labrusse, Rémi, and Jacqueline Munck, "André Derain in London (1906–07): Letters and a Sketchbook," *Burlington Magazine* 146 (April 2004): 243–60.

Lambourne, Lionel, and Jean Hamilton. *British Watercolours in the Victoria and Albert Museum: An Illustrated Summary Catalogue of the National Collection.* London: Sotheby Parke Bernet and the Victoria and Albert Museum, 1980.

Leblanc, Henri. *Catalogue de l'œuvre complet de Gustave Doré.* Paris: C. Bosse, 1931.

Lee, Jane. *Derain,* exh. cat. Oxford: Phaidon; New York: Universe, 1990.

Leslie, George. *Our River.* London: Bradbury, Agnew & Co., 1881.

Leslie, Henry. *Time and Tide: A Tale of the Thames.* London: T. H. Lacy, 1867.

Levine, Stephen. *Monet and His Critics.* New York: Garland Publications, 1976.

Levy, Mervyn, ed. *Whistler Lithographs: An Illustrated Catalogue Raisonné.* London: Jupiter Books, 1975.

Leymarie, Jean, and Michel Melot. *The Graphic Works of the Impressionists: Manet, Pissarro, Renoir, Cézanne, Sisley.* London: Thames and Hudson, 1972.

Library of Congress. *Joseph Pennell Memorial Exhibition,* exh. cat. Washington, DC: [Govt. Print. Off.], 1927.

Lloyd, Christopher. *Camille Pissarro.* Geneva: Skira; New York: Rizzoli, 1981.

Lochnan, Katharine A. *The Etchings of James McNeill Whistler,* exh. cat. New Haven and London: Yale University Press, 1984.

_____, et al. *Turner, Whistler, Monet: Impressionist Visions*, exh. cat. Toronto: Art Gallery of Toronto in association with Tate, 2004.

"London as it Strikes a Stranger." *Temple Bar*, 1862.

London from the Great Fire to the Great War: Being a Discursive Look at the Various Arts and Parts of the English Capital from 1666 to 1916. Davis: University of California, 1977.

Maidment, B. E. *Reading Popular Prints, 1790–1870.* 2d ed. Manchester and New York: Manchester University Press, 2001.

Mancoff, Debra N., and D. J. Trela. *Victorian Urban Settings: Essays on the Nineteenth-Century City and Its Contexts.* New York and London: Garland Publishing, Inc., 1996.

Marshall, Nancy Rose. "*Transcripts of Modern Life": The London Paintings of James Tissot, 1871–1882.* Ph.D. diss., Yale University, 1997.
Marshall, Nancy Rose, and Malcolm Warner. *James Tissot: Victorian Life / Modern Love*, exh. cat. New Haven: American Federation of Arts, Yale University Press, 1999.

Mayhew's London, being selections from "London labour and the London poor" (which was first published in 1851), [ed. Peter Quennell]. London: Spring Books, n.d.

McCarthy, Justin, Mrs. Campbell Praed, and Mortimer Menpes. *The Grey River.* London: Messrs. Selley and Co. Ltd., 1889.

McNamara, Carol, and John Siewert. *Whistler: Prosaic Views, Poetic Vision: Works on Paper from the University of Michigan Museum of Art*, exh. cat. New York: Thames and Hudson, 1994.

McNay, Walter L., ed. *Old London: A Series of Fifty Reproductions of Old Engravings Illustrative of the London of Our Ancestors.* London: Alexander Moring, Ltd., 1908.

Melot, Michel. *The Impressionist Print.* New Haven and London: Yale University Press, 1996.

Menpes, Mortimer. *The Thames; text by G. E. Mitton.* London: A. & C. Black, 1906.

_____. *Whistler As I Knew Him.* London: Adam and Charles Black, 1904.

Merrill, Linda, et al. *After Whistler: The Artist and His Influence on American Painting,* exh. cat. Atlanta: High Museum of Art, 2003.

Milkovich, Michael. *Homage to Camille Pissarro: The Last Years, 1890–1903*, exh. cat. Memphis, TN: Dixon Gallery, 1980.

Mirbeau, Octave. *Des Artistes. 2. série. Peintres et Sculpteurs 1897–1912; Musiciens 1884–1902.* Paris: E. Flammarion, 1924.

_____. *Claude Monet: Vues de la Tamise à Londres*, exh. cat. Paris: Galeries Durand-Ruel, 1904.

Monkhouse, W. Cosmo. *Pictures and Painters of the English School.* New York: A. W. Lovering, n.d.
Morice, Charles. "Vue de la Tamise à Londres, par Claude Monet." *Mercure de France*, no. 50 (June 1904).

Morier, James. *Martin Toutrond; or, Adventures of a Frenchman in London in 1831.* London: R. Bentley, 1849.

Nadel, Ira Bruce, and F. S. Schwarzbach, eds. *Victorian Artists and the City: A Collection of Critical Essays.* New York: Pergamon Press, 1980.

Nead, Lynda. *Victorian Babylon*, New Haven and London: Yale University Press, 2000.

Pagé, Suzanne, et al. *André Derain: Le peintre du "trouble moderne,"* exh. cat. Paris: Musée d'Art Moderne de la Ville de Paris, 1994.

Patterson, Joby. *Bertha E. Jaques and the Chicago Society of Etchers.* Madison and Teaneck, NJ: Fairleigh Dickinson University Press; London: Associated University Presses, 2002.

Pennell, Elizabeth Robins. *The Life and Letters of Joseph Pennell.* 2 vols. Boston: Little, Brown and Company, 1929.

_____. *Our House; And London out of Our Windows; With Illustrations by Joseph Pennell.* Boston and New York: Houghton Mifflin Company, 1912.

Pennell, Elizabeth Robins and Joseph. *The Life of James McNeill Whistler.* 2 vols. Philadelphia: J. B. Lippincott; London: W. Heinemann, 1908.

_____. *Lithography and Lithographers.* New York: Macmillan Company, 1915.

_____. *The Stream of Pleasure. A Narrative of a Journey on the Thames from Oxford to London.* New York: Macmillan & Co., 1891.

_____. *The Whistler Journal.* Philadelphia: J. B. Lippincott, 1921.

Pennell, Joseph. *The Adventures of an Illustrator, Mostly in Following His Authors in America & Europe.* Boston: Little, Brown and Company, 1925.

_____. *Etchers and Etching.* 4th ed. New York: Macmillan Company, 1929.

_____. *A Little Book of London.* Boston: Le Roy Phillips; London and Edinburgh: T. N. Foulis, n.d.

_____. *A London Reverie.* London: Macmillan and Co., 1928.

_____. *Modern Illustration.* London and New York: G. Bell, 1895.

_____. *Pen Drawing and Pen Draughtsmen, Their Work and Their Methods.* London and New York: Macmillan & Co., 1889.

Piper, David. *Artists' London.* New York: Oxford University Press, 1982.

Pissarro, Joachim. *Camille Pissarro.* New York: Harry N. Abrams, 1993.

Pissarro in England, exh. cat. London: Marlborough Fine Art, 1968.

Pocock, Tom. *Chelsea Reach: The Brutal Friendship of Whistler and Walter Greaves.* London: Hodder & Stoughton, 1970.

_____. *Walter Greaves, 1846–1930*, exh. cat. London: Leighton House Art Gallery and Museum, 1967.

Porter, Dale H. *The Thames Embankment: Environment, Technology, and Society in Victorian London.* Akron, OH: University of Akron Press, 1998.

Preston, Harley. *London and the Thames: Paintings of Three Centuries*, exh. cat. London: National Maritime Museum and Somerset House, 1977.

Reclus, Elisée. *Guide du voyageur à Londres et aux environs.* Paris: Hachette, [1860].

Renonciat, Annie. *La vie et l'œuvre de Gustave Doré.* Paris: ACR Edition; [Lausanne]: Bibliothèque des arts, 1983.

Rewald, John, ed. *Camille Pissarro: Letters to His Son Lucien.* 4th ed. London: Routledge & Kegan Paul, 1980.
Rewald, John, and Frances Weitzenhoffer, eds. *Aspects of Monet: A Symposium on the Artist's Life and Times.* New York: Harry N. Abrams, Inc., 1984.

Reynolds, Graham. *Painters of the Victorian Scene.* London: B. T. Batsford, Ltd., 1953.

Ribner, Jonathan. "The Thames and Sin in the Age of the Great Stink: Some Artistic and Literary Responses to a Victorian Environmental Crisis," *British Art Journal* 1, no. 2 (Spring 2000): 38–46.

Ritchie, Andrew Carnduff. *Masters of British Painting, 1800–1950*, exh. cat. New York: Museum of Modern Art, 1956.

Rosenthal, Donald A. *British Watercolors from the West Foundation*, exh. cat. Atlanta: High Museum of Art, 1988.

Russell, Francis Albert Rollo. *London Fogs.* London: Stanford, 1880.

Russell, John. *London.* New York: Harry N. Abrams, Inc., 1994.

Saint, Andrew, and Gillian Darley. *The Chronicles of London.* New York: St. Martin's Press, 1994.

Schneer, Jonathan. *London 1900: The Imperial Metropolis.* New Haven: Yale University Press, 1999.

Seiberling, Grace. *Monet in London*, exh. cat. Atlanta: High Museum of Art, 1988.

Shanes, Eric. *Impressionist London.* New York: Abbeville Press, 1994.

Shaw, G. Bernard. *Catalogue of an Exhibition of the Work of Alvin Langdon Coburn*, exh. cat. London: Royal Photographic Society of Great Britain, 1906.

Shepherd, Thomas H. *London and Its Environs in the Nineteenth Century*. London: Jones & Co. Temple of the Muses, 1829. Reprint. *London in the Nineteenth Century; With Historical and Descriptive Text by James Elmes*. London: Bracken Books, 1983.

Simmons, Linda Crocker, with Emily J. Nash. *Haden, Whistler, and Pennell: Three Master Printmakers in the Corcoran Gallery of Art*, exh. cat. Washington, DC: Corcoran Gallery of Art, 1990.

Snollaerts, Claire Durand-Ruel. "Pissarro and Durand-Ruel." *IFAR Journal* 6, nos. 1 & 2 (2003): 18–23.

Somerville, Stephen. *British Watercolours: A Golden Age, 1750–1850*. Louisville, KY: J. B. Speed Art Museum, 1977.

Spate, Virginia. *Claude Monet: Life and Work*. New York: Rizzoli, 1992.

Spencer, Robin, ed. *Whistler: A Retrospective*. New York: Wings Books, 1991, c. 1989.

Spencer, Robin. "Whistler's Subject Matter: Wapping 1860–1864," *Gazette des Beaux-Arts* (October 1982): 131–42.

Spurling, John. "A Foggy Stay in London." *Royal Academy Magazine,* no. 61 (Winter 1988): 42–44.

Stainton, Lindsay. *British Landscape Watercolours, 1600–1860*. Cambridge [England]: Cambridge University Press, 1985.

Stamp, Gavin. *The Changing Metropolis: Earliest Photographs of London, 1839–1879*. Harmondsworth, Middlesex, England: Viking, 1984.

Stamp, Gavin, and Colin Amery. *Victorian Buildings of London, 1837–1887: An Illustrated Guide*. London: The Architectural Press, 1980.

Steinorth, Karl, ed. *Alvin Langdon Coburn: Photographs 1900–1924*. Zurich and New York: Edition Stemmle, 1998.

Stern, David S., and Talma Zakai-Kanner. *Camille Pissarro and His Descendants*, exh. cat. Fort Lauderdale, FL: Museum of Art, 2000.

Stubbs, Burns A. *James McNeill Whistler: A Biographical Outline Illustrated from the Collections of the Freer Gallery of Art*. Washington, DC: Smithsonian Institution, 1950.
Stuckey, Charles F. *Claude Monet, 1840–1926,* exh. cat. New York: Thames and Hudson; Chicago: Art Institute of Chicago, 1995.

_____, ed. *Monet: A Retrospective*. New York: Hugh Lauter Levin Associates, Inc., 1985.

Sutton, Denys. *André Derain*. Garden City, NY: Phaidon, 1959.

Sweet, Frederick A. *James McNeill Whistler*, exh. cat. Chicago: Art Institute of Chicago, 1968.

Taine, Hippolyte. *Notes on England*. London: Strahan & Co., 1872.

Tariant, Eric. "Les Debuts des galleries d'art." *Conaissance des Arts,* no. 602 (February 2003): 80–85.

Tatham, David. "A Drawing by Winslow Homer: *Corner of Winter, Washington and Summer Streets*," *American Art Journal* 18, no. 3 (1986): 40–50.

_____. *Winslow Homer and the Illustrated Book*. Syracuse, NY: Syracuse University Press, 1992.

Tatlock, R. R. "Walter Greaves." *Burlington Magazine* 58 (1931): 262–.

Thiébault-Sisson. "Claude Monet et ses vues de Londres." *Le Temps* 19 (May 1904).

Timbs, John. *Clubs and Club Life in London. With Anecdotes of Its Famous Coffee Houses, Hostelries, and Taverns, from the Seventeenth Century to the Present Time*. London: Chatto and Windus, 1872.

_____. *Curiosities of London: Exhibiting the Most Rare and Remarkable Objects of Interest in the Metropolis, with Nearly Sixty Years' Personal Recollections*. London: J. C. Hotten, 1867. New ed., corr. and enl. Detroit: Singing Tree Press, 1968.

Tomson, Arthur. *Joseph Pennell, Reprinted by Permission of The Art Journal, London*. New York: Frederick Keppel & Co., n.d.

Treuherz, Julian. *Victorian Painting*. New York: Thames and Hudson, Ltd., 1993.

Triggs, Stanley. *Le Studio de William Notman: Objectif Canada = William Notman's Studio: The Canadian Picture*, exh. cat. Montreal: Musée McCord d'histoire canadienne, 1992.

_____. *William Notman: The Stamp of a Studio*, exh. cat. Toronto: Art Gallery of Ontario, 1985.

Urry, John. *Consuming Places*. London and New York: Routledge, 2002.

_____. *The Tourist Gaze: Leisure and Travel in Contemporary Societies*. London: Sage Publications, 1990.

Valmy-Baysse, J. (Jean). *Gustave Doré*. 2 vols. Paris: M. Seheur, 1930.

Venturi, Lionello. *Les Archives de l'Impressionisme: Lettres de Renoir, Monet, Pissarro, Sisley et Autres. Mémoires de Paul Durand-Ruel. Documents*. 2 vols. Paris and New York: Durand-Ruel, Éditeurs, 1939.

Walkowitz, Judith R. *City of Dreadful Delight: Narratives of Sexual Danger in Late-Victorian London*. Chicago: University of Chicago Press, 1992.

Walter Greaves, 1846–1930, & the Goupil Gallery, sales cat. London: M. Parkin Fine Art and Ranelagh Press, 1984.

Warner, Malcolm. *The Image of London: Views by Travellers and Emigrés 1550–1920*, exh. cat. London: Trefoil Publications in association with Barbican Art Gallery, 1987.

Way, Thomas R., and George R. Dennis, *The Art of James McNeill Whistler*. 3d ed. London: George Bell and Sons, 1905.

Weaver, Mike. *Alvin Langdon Coburn: Symbolist Photographer, 1882–1966: Beyond the Craft*, exh. cat. New York: Aperture Foundation, 1986.

Weightman, Gavin. *London's Thames*. London: John Murray, 2004.

Weinberg, H. Barbara. *Childe Hassam: American Impressionist*, exh. cat. New York: Metropolitan Museum of Art; New Haven and London: Yale University Press, 2004.

Wentworth, Michael. *James Tissot*. Oxford: Clarendon; New York: Oxford University Press, 1984.

_____. *James Tissot: Catalogue Raisonné of His Prints*, exh. cat. Minneapolis, MN: Minneapolis Institute of Arts, 1978.

Whistler, Sargent, and Steer: Impressionists in London from Tate Collections, exh. cat. Nashville, TN: Frist Center for the Visual Arts, 2002.

White, Gleeson, ed. *The Master Painters of Britain*. New York: The International Studio, 1909.

Whitehouse, Roger. *A London Album: Early Photographs Recording the History of the City and Its People from 1840 to 1915*. London: Secker and Warburg, 1980.

Wildenstein, Daniel. *Claude Monet: biographie et catalogue raisonné*, Lausanne: La Bibliothèque des arts. 5 vols. 1974–91.
Wildenstein and Company. *One Hundred Years of Impressionism: A Tribute to Durand-Ruel*, exh. cat. New York: 1970.

Wilmerding, John. "Winslow Homer's English Period," *American Art Journal* 7, no. 2 (November 1975): 60–69.

Woods, Alan. "Doré's *London*: Art and Evidence," *Art History* 1, no. 3 (September 1978): 341–59.

Wuerth, Louis A. *Catalogue of the Etchings of Joseph Pennell*. Boston: Little, Brown, 1928. Reprint. San Francisco: Alan Wofsy Fine Arts, 1988.

———. *Catalogue of the Lithographs of Joseph Pennell*. Boston: Little, Brown and Company, 1931.

Young, Ken, and Patricia L. Garside. *Metropolitan London: Politics and Urban Change, 1837–1981*. London: Edward Arnold, 1982.

Index

Photo Credits